千年古都西安

鄒宗緒主編

商務印書館（香港）有限公司
陝西人民美術出版社 合作出版

The Land Within the Passes

A History of Xian

Zou Zongxu

Translated by Susan Whitfield

VIKING

VIKING

Published by the Penguin Group
Penguin Books, 27 Wrights Lane, London w8 5tz, England
Viking Penguin, a division of Penguin Books USA Inc., 375 Hudson Street, New York,
 New York 10014, USA
Penguin Books Australia Ltd, Ringwood, Victoria, Australia
Penguin Books Canada Ltd, 2801 John Street, Markham, Ontario, Canada l3r 1b4
Penguin Books (NZ) Ltd, 182–190 Wairau Road, Auckland 10, New Zealand

Penguin Books Ltd, Registered Offices: Harmondsworth, Middlesex, England

First published in Chinese as *Qian Nian Gu Du Xi An* by
The Commercial Press Ltd, Hong Kong Branch, 1987
This translation first published by The Viking Press, New York
and by Viking, London, 1991

10 9 8 7 6 5 4 3 2 1

Copyright © The Commercial Press Ltd, Hong Kong Branch, 1987
This translation copyright © Penguin Books Ltd, 1991

Filmset in Linotron Garamond by Wyvern Typesetting Ltd, Bristol
Colour separation by Goody Colour Separation (Scanner) Ltd (HK)
Printed in Hong Kong by C & C Joint Printing Co. (HK) Ltd

A cip catalogue record for this book is available from the British Library

lccn: 88-51496

isbn 0-670-82391-0

1. Cultural and historical sites in central Shaanxi Province (*see map on pages 8–9*)

A. Gansu Province
B. Shaanxi Province
C. Henan Province

County towns and municipalities
1. Qianyang
2. Baoji Municipality
3. Fengxiang
4. Baoji
5. Taibai
6. Jingchuan
7. Lingtai
8. Qishan
9. Meixian
10. Fufeng
11. Linyou
12. Changwu
13. Ningxian
14. Binxian
15. Qianxian
16. Wugong
17. Zhouzhi
18. Zhengning
19. Xunyi
20. Chunhua

21. Liquan
22. Xingping
23. Huxian
24. Changan
25. Xian Municipality
26. Xianyang Municipality
27. Jingyang
28. Yaoxian
29. Tongchuan Municipality
30. Yijun
31. Huangling
32. Fuping
33. Gaoling
34. Lintong
35. Lantian
36. Weinan Municipality
37. Huaxian
38. Pucheng
39. Baishui
40. Huanglong
41. Chengcheng
42. Heyang
43. Hancheng Municipality
44. Huayin
45. Tongguan

46. Luonan
47. Dali
48. Yongshou
49. Sanyuan
50. Yongqi

Mountains, rivers and lakes
51. Laoye Peak
52. Mt Qi
53. Mt Ao
54. Qinling Mountains
55. Taibai Ridge
56. Mt Taibai
57. Donglaojun Peak
58. Mt Shouyang
59. Nanwu Platform
60. Mt Jingyunao
61. Mt Zhongnan
62. Mt Wangshun
63. Mt Fenghuang
64. Caolian Peak
65. Mt Li
66. Zuantian Peak
67. Mt Cuo'e
68. Mt Jiangjun

69. Mt Huanglong
70. Mt Huti
71. Fuye Peak
72. Mt Liang
73. Huanglong Mountains
74. Mt Mudan
75. Hua Mountains
76. Mt Hua
77. Mt Yao
78. Mt Cuihua
79. Da Peak
80. Wei River
81. Feng River
82. Yu River
83. Hao River
84. Chan River
85. Ba River
86. Jing River
87. Lao River
88. Yellow River

Archaeological sites, temples and sites of historical interest
89. Xiamengcun
90. Dafu Temple

91. Binxian Pagoda
92. Tai Pagoda
93. Ganquan Palace
94. Biyun Chanshi Pagoda
95. Tang Jiucheng Palace, Liquan inscribed Stele
96. Tang Jiucheng Palace
97. Daxingcun
98. Qin city of Yong
99. Chencang
100. Didianbao
101. Fengjiaju
102. Gugujiazhuang
103. Jiangchengbao
104. Diaoyutai
105. Gedibao
106. Shuangliuzhou
107. Zhougong Temple
108. Song Pagoda
109. Zhuge Wuhou Ancestral Hall
110. Hanjiajiang
111. Doumu Palace
112. Pingan Temple
113. Baxiantai
114. Xiangyang Temple

115. Shangban Temple
116. Lingyun Temple
117. Bajiacun
118. Qingqiu
119. Dongqucun
120. Zhangcun
121. Xialingbao
122. Jiangyuan
123. Shangdecun
124. Sui Tai Mausoleum
125. Dianzicun
126. Zaoyuancun
127. Youfengjie
128. Wugong Pagoda
129. Xiaowancun
130. Bayun Pagoda
131. Xianyou Temple
132. Louguan Platform
133. Changyang Palace
134. Lujiazhai
135. Zu'an Stone Inscription
136. Ji Mausoleum of Zhou king
137. Zhangba Temple
138. Chenping Temple
139. Huayang Temple

Translator's Note

This book concerns the history of a region which has great significance in the history of China, namely, the plain surrounding the present-day city of Xian in Shaanxi Province. It is an area bordered by mountains and transected by the Wei River, and is variously referred to as the Central Shaanxi Plain, or, less prosaically, as 'The Land Within the Passes' and 'The Land of Qin'. The capital cities of China discussed in this book – Feng, Hao, Xianyang, Daxing and Changan – were all located in this area. Plate 151 shows their relative positions.

I have tried where possible to give a straightforward translation of the text and therefore the views expressed are not my own. However, in some places I have modified the text to make it more accessible to Western readers and to correct certain inconsistencies.

The pinyin system of romanization has been used throughout for Chinese names. I have translated the descriptive parts of some names, for example by giving 'Wei River' instead of 'Weihe', but only where the need to convey information about geographical or architectural features is paramount.

目録

Contents

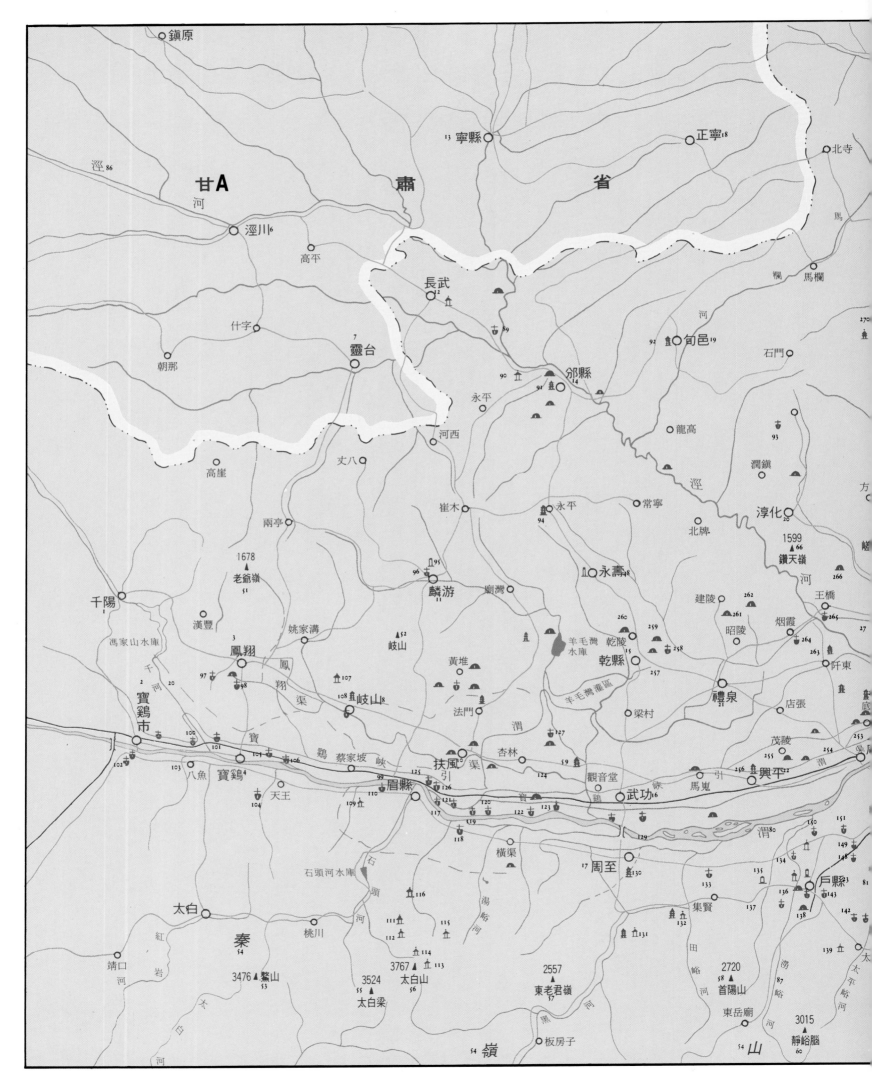

1. Cultural and historical sites in central Shaanxi Province (*see key on pages 4–5*)

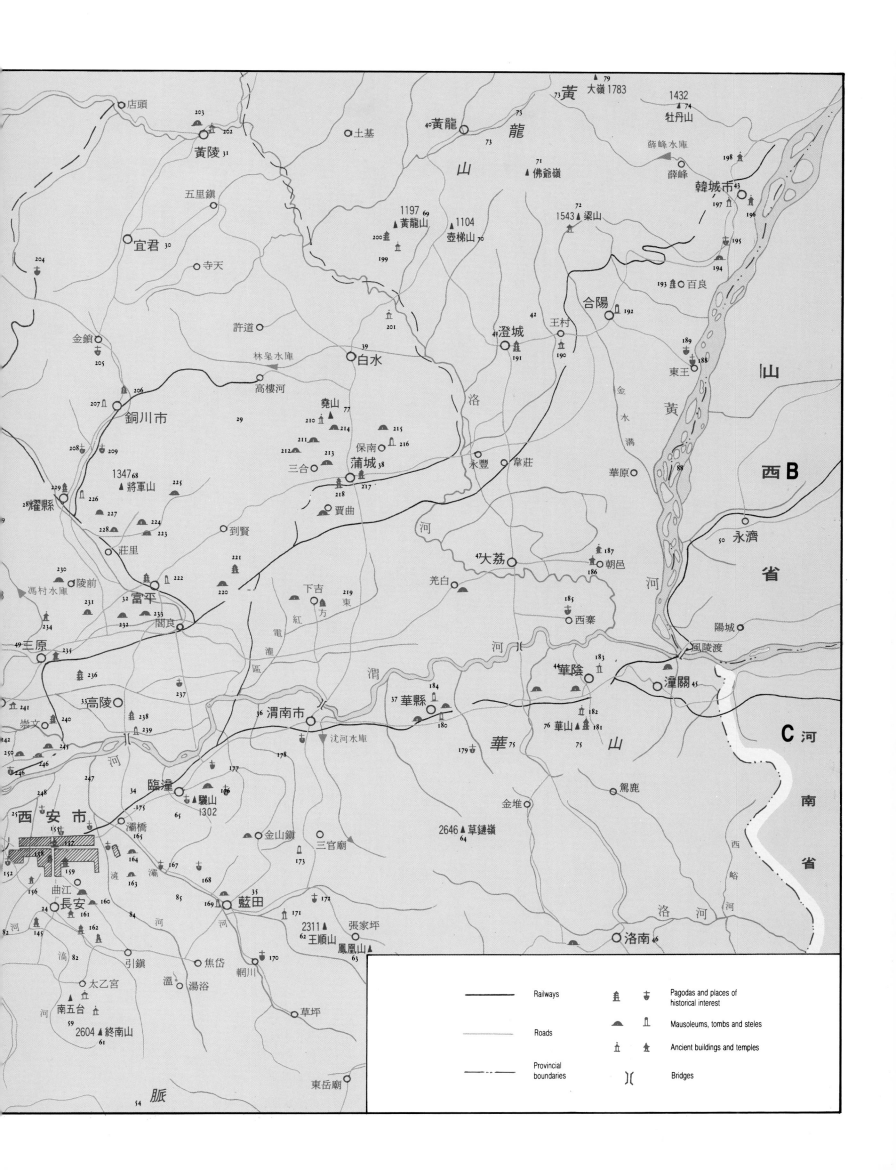

店頭

黃 79
大嶺 1783 1432
黃龍 73 74
73 牡丹山
40 黃龍 龍 薛峰水庫
203 山 71 198
土基 佛爺嶺 薛峰
黃陵 31 202 韓城市 43
197
五里鎮 196
1197 69 1104 195
宜君 30 黃龍山 壺梯山 76 72 194
寺天 200 1543 梁山
199 193 百良
許道 合陽
201 42 192
金鎖 39 澄城 王村
205 白水 41 190
206 高樓河 191
銅川市 堯山 77 洛 金 189
207 29 210 214 水 188
溝 東王
208 209 211 216
212 213 保南 華原 省
三合 蒲城 38 永豐 韋莊
229 1347 68 225 218 217
28 耀縣 226 將軍山 賈曲 河 西 B
227 大荔 187
228 223 到賢 47 朝邑
莊里 221 羌白 186
230 陵前 下吉 219 西寨 185 陽城
231 32 富平 220 東 風陵渡
234 232 222 方 河 川 華陰 183
閻良 渭 44 潼關 45
49 三原 235 華縣 182 駕鹿
236 37 180 181
33 高陵 237 渭南市 華山 76 金堆
241 238 178 179 75 75
240 沈河水庫 2646 草鏈嶺
242 250 245 239 64 河
246 247 177 176 南
248 臨潼 166 省
25 西安市 34 175 金山鎮 三官廟 西
137 65 驪山 173
152 159 164 1302
156 曲江 163 藍田 2311 張家坪
24 長安 160 85 169 35 62 王順山
82 145 161 162 84 171 172 鳳凰山 洛南 46
引鎮 焦岱 63
太乙宮 170
南五台 59 草坪
2604 終南山
61

脈 東岳廟
54

CHRONOLOGICAL TABLE

CHINA

	Period					
CHINA	**XIAN**	Paleolithic Period	Neolithic Period	Legendary Period	Shang	Western Zhou

XIAN entries:

- 1 million years BP: Lantian Man (*homo erectus*) lives on banks of Ba River
- 200,000 years BP: Dali Man (*homo sapiens*) lives in Dali County
- 6000 years BP: Banpo Man, representative of the Neolithic Yangshao culture, lives in a settled community
- 3000 years BP: settlements at Kexingzhuang and Kangjiacun, representative of Neolithic Longshan culture
- 2800 years BP: reign of the mythical Yellow Emperor
- 17th cent. BC: Hou Ji, mythical ancestor of the Zhou people
- 1136 BC: King Wen of the state of Zhou establishes his capital, Feng, on west bank of Feng River near Xian
- 1068 BC: King Wu of the state of Zhou builds another capital, Hao, on the east bank of the Feng River

THE WORLD

JAPAN
- 15,000 to 250,000 BP: Paleolithic period
- 10,000 BP: Neolithic period

KOREA

INDIA
- 3700 BC: written language
- 2250 BC: Harappan civilization appears
- 1750 BC: Aryan influx

EGYPT
- Paleolithic period
- 5000 BC: Appearance of agriculture and domestication of animals
- 3100–2686 BC: Early Dynastic period
- 2686–2181 BC: Old Kingdom
- 2133–1786 BC: Middle Kingdom
- 1570–1085 BC: New Kingdom

GREECE
- 6500 BC: first appearance of agriculture
- 3000 BC: the beginnings of settled life
- 1600–1100 BC: Mycenaean civilization
- 9th century BC: traditional date of the founding of Athens

ROME
- 754–509 BC: Roman Kingdom
- 754 BC: traditional date of the founding of Re

PERSIA

| Eastern Zhou: g and umn iod / Warring States Period | Qin | Western Han | Eastern Han | Three Kingdoms | Western Jin | Eastern Jin (Sixteen States) | Northern and Southern Dynasties | Sui |

350 BC: the state of Qin moves its capital to Xianyang

202 BC: Liu Bang, Emperor Gaozu, founds the Han dynasty, with its capital at Changan

194 BC: building the capital starts

138 BC: Zhang Qian is sent as an envoy from Changan to the Western Regions; the birth of the Silk Road

AD 12: the usurper Wang Mang establishes Changan as the western capital and Luoyang as the eastern capital of his short-lived Xin dynasty

AD 190: Dong Zhuo sacks Luoyang and moves capital to Changan

AD 319: Liu Yao proclaims himself King of Zhao (Former Zhao), with Changan as his capital

AD 351: Fu Jian proclaims himself King of Qin (Former Qin), with Changan as his capital

AD 386: Yao Chang proclaims himself Emperor of Qin (Later Qin), with Changan as his capital

AD 535: Yu Wentai proclaims himself Emperor of Western Wei, with Changan as his capital

AD 557: Yu Wenjue proclaims himself Emperor of Northern Zhou, with Changan as his capital

AD 581: General Yang Jian, Emperor Wen, founds the Sui dynasty, with Changan as his capital

3rd century BC: Jōmon culture

3rd century AD: Yayoi culture

6th century AD: Kofun culture

57 BC–AD 936: Silla

37 BC–AD 668: Koguryo

18 BC–AD 660: Paekche

321–184 BC: Maurya empire

1st century BC–3rd century AD: Kushana period

AD 320–570: Gupta empire

Foreign dominance

481 BC: Athens sacked by Persian army

86 BC: Athens sacked by Roman army

509–43 BC: the Republic

43 BC–AD 395: the Empire

AD 64: the sack of Rome

AD 330: Constantine moves the capital to Byzantium and names it Constantinople, or New Rome

AD 395–476: the Western Empire

AD 410: Rome sacked by the Goths

AD 455: Rome sacked by the Vandals

50–330 BC: ersian empire

AD 226–642: the Sassanid kingdom

600 **700** **800 900** **1100 1300 1350** **1400 1600** **1700 1800 1900**

| Tang (Five Dynasties) | Song | Yuan | Ming | Qing |

AD 582: Yu Wenkai designs the new capital, Daxing, on Mt Longshou

AD 618: Li Yuan, Emperor Gaozu, founds the Tang dynasty, with Daxing, renamed Changan, as his capital

AD 629: the Buddhist monk Xuan Zang sets out from Changan on a pilgrimage to India to collect scriptures

AD 631: first Japanese embassy at the Tang court

AD 654: Yan Lide directs thousands of labourers in building Changan

AD 904: Changan is largely destroyed and the capital moved to Luoyang in factional warfare at the end of the dynasty

AD 1272: Kublai Khan grants his son the title Prince Anxi, with Changan as his garrison

AD 1273: Prince Anxi builds Xiwang Palace near the Chan River

AD 1369: the Ming-dynasty general Xuda takes back the city and changes its name to Xian

AD 1374: Zeng Xiu, Governor of Shaanxi, restores Xian; the emperor Taizu grants his second son the title of Prince of Qin and builds a palace for him in Xian

c.552–c.645: Asuka period

c.645–710: Early Nara period

710–794: Nara period

794–897: Early Hei'an or Kōnin period

897–1185: Late Hei'an or Fujiwara period

1185–1333: Kamakura period

1333–1573: Muromachi period

1573–1600: Momoyama period

1600–1868: Edo or Tokugawa period

1868–1912: Meiji period

Koryo Kingdom

1392–1910: Choson (Yi) dynasty

1405: restoration of capital Hanyang (Seoul)

AD 1320–1413: Tughlug

AD 642: Cairo founded

AD 966: Cairo becomes an important Islamic town

From 13th century Cairo develops into a centre of trade and culture

AD 1801: Cairo becomes the capital of modern Egypt

AD 395–1453: the Eastern Empire

1502: modern Persia founded

I.

Land of Monarchs Since Ancient Times

From antiquity the Chinese have lived in the area around the city of Xian. The prehistoric hunter-gatherer communities gradually developed the techniques of agriculture and the domestication of animals, thereby transforming the natural environment and providing the basis of a more and more complex society. From the Western Zhou dynasty through the Qin, Western Han, Former Zhao, Former Qin, Later Qin, Western Wei, Northern Zhou, Sui and Tang dynasties, a period of over a thousand years, the capital of China was established here and, because it had originally been inhabited by the people of the state of Qin, this area was called Qinchuan – Land of Qin. It has the oldest and longest history of any metropolitan area in China, not only because of its political, economic and historical advantages, but also because of its unique geographical location.

The Eight Rivers

The Wei River, a tributary of the Yellow River, flows across central Shaanxi Province from Baoji Gorge in the west to Tong Pass in the east, forming a low-lying basin over 180 miles long and with an average elevation of approximately 1,640 feet. The Qinling Mountains rise to the south, while there are loess plateaus on its northern banks. The porous and fertile loess soil of this area together with its temperate climate and moderate rainfall have created an abundance of natural resources; it has been described from ancient times as 'a sacred land' or 'a heaven on earth'. However, the rainfall is erratic and, in order to maintain the area's agricultural economy, which for a long time played a vital role in the economy of the whole empire, the land had to be irrigated. This was facilitated by the fact that there were eight rivers: the Wei, Jing, Chan, Ba, Feng, Hao, Yu and Lao, traversing this land.

The Wei, the largest and most important of these, lies to the north of Xian and flows east across the whole province, entering the Yellow River at the Tong Pass. It has been the main source for irrigation and for water transportation since ancient times, with the Qin, Western Han and Tang dynasties all building their capitals on its banks.

The Jing is the Wei's largest tributary. The Zheng Guo and Bai Canals, dug in the Qin and Han dynasties respectively, both drew their water from this river and it played a crucial role in the irrigation system of central Shaanxi in ancient times.

The Ba, six miles east of Xian, was originally called Zishui but was renamed by Duke Mu of Qin to symbolize his hegemony (in Chinese *ba*) and its revised name is still used today. Its source is in Lantian County and it flows north, joining the Chan before it empties into the Wei. The Ba has to be crossed by travellers entering the capital from the west, and in the Qin and Han dynasties there were checkposts on the bridges.

The Chan is situated between the Ba River and Xian and, although small, it was the source of several famous lakes of the Tang capital, such as Lake Qujiang. The neolithic Yangshao culture of Banpo was discovered on its eastern bank.

The Feng River, to the west of Xian, has its source in the Qinling Mountains. In an ancient book of poetry, *Shijing*, it is said that Yu the Great, a mythical figure in Chinese folklore, spent thirteen years controlling and rechannelling the flood waters and that the Feng now flows east due to his efforts. The capitals of the Western Zhou dynasty, Feng and Hao, were built on its banks.

Also rising in the Qinling Mountains, the Yu River flows past Weiqu and Duqu in Fanchuan. It has continually changed course in its lower reaches and is now known as the Zao River. Fanchuan is an area renowned for its beautiful scenery which gives visitors the impression that they have suddenly entered into a landscape painting. In imperial times many high-ranking officials and aristocratic families lived in this region.

The Lao River lies to the south-west of Xian within Zhouzhi and Huxian Counties. It too has its source in the Qinling Mountains; it flows north, emptying into the Wei. Like the Yu it has frequently changed course. The Hao, also called Haoshui, originally flowed past the west of Xian, but its source dried up after the Tang dynasty and it gradually disappeared.

The above eight rivers are those mentioned by Sima Xiangru of the Han dynasty in his prose poem, *Shanglin Fu*. Together with the innumerable ponds and lakes in this area, they have long provided an abundant water supply for the capital city and surrounding farmland.

Strategic Passes

The geographical features of central Shaanxi Province played a vital role in its defence. The Wei River valley is surrounded by mountains; the Qinling to the south, and the Bei, Long and Xiao ranges to the north, west and east respectively. In the Qin dynasty the Hangu Pass (in Lingbao County, Henan Province) was established as a route through the Xiao Mountains and since then the area west of this has been known as Guannei (inside the pass). After the Han dynasty the Dazhen Pass was opened through the Long Mountains to the west (in Xilong County, Shaanxi Province), the Xiao Pass to the north-west (in Huan County, Gansu Province) and the Wu Pass to the south-east (south-east of Danfeng County, Shaanxi Province). The area contained within these four passes was then given the name Guanzhong (within the passes). According to the first official Chinese history, *Shiji*, written in the Han dynasty, 'Qin, a state within four passes, is padded with mountains and girded by the Wei.'

Topographically the land within the passes resembles a dustpan, higher in the south-east and lower in the north-west. The Qinling Mountains, a continuation of the Kunlun Mountains of the Tibetan massif, lie on an ancient east–west fault that traverses China and are the highest of the surrounding ranges. Towering and magnificent, they divide China into the different climatic zones of the north and south.

Mt Taibai, in the counties of Wugong, Meixian and Taibai, south-west of Xian, is, at 12,359 feet, the highest peak in the range. The snow on the peak never melts, and 'snow-covered Mt Taibai' is one of the 'eight sights of the land within the passes'.

Mt Zhongnan, also called Mt Taiyi, extends from Wugong County in the east to Lantian County in the west and thus it stands like a screen to the south of Xian. During the Han and Tang periods canals were dug to transport raw lacquer, timber and charcoal from the mountain to the capital.

A lower peak relatively close to Xian, Mt Cuihua also rises to the south of the city. In the valley at its foot are the ruins of the Taiyi Palace built by the Han-dynasty emperor Wu, and among the picturesque scenery on its summit is the Taiyi Pond formed in the Tang dynasty after a rock split. Mts Nanwutai and Wafeng are also places of scenic interest near here.

Mt Li, sixteen miles east of Xian, has many hot springs and is where the famous Huaqing Palace was built in the Tang dynasty. In the Tianbao period of the Tang (AD 742–56), Emperor Xuanzong and his favourite concubine, Lady Yang, spent each winter here. At that time 'the whole mountain was covered with palaces enclosed by winding walls', and 'a thousand gates were revealed one after another up to the peak of the mountain'. Huaqing Pond, which still exists today, was only a very small part of the palace complex, and what looks like a small mound in the distance is in fact the tomb of Qin Shi Huang Di, the First Emperor, two and a half miles to the east.

Mt Hua, in Huayin County to the east of Xian and close to the confluence of the Wei and Yellow Rivers, is one of the famous 'Five Mountains' of China. It stands 6,552 feet high and has three main granite peaks, which pierce the clouds. It is the most perilous of the Five Mountains to climb, but nevertheless it attracts a large number of tourists. The following verse gives an idea of the breathtaking view that rewards those who climb to the top. 'Mount Hua, with its perilous peaks and inaccessible cliffs, is like brocade embroidered with clouds. It rises high above the waters of the Yellow River, a rainbow hangs over the sky in the sunlight.'

The Bei Mountains to the north also provide this area with a natural defence. The open and dry plateaus on the southern side of these mountains are home to many magnificent imperial tombs of the Han and Tang dynasties.

In ancient times these mountains were probably densely forested and the banks of the Wei covered with stretches of woods and grass. The area was praised for its 'beautiful mountains, forests, rivers, valleys and abundant natural resources' in the Zhou dynasty. Forests of Chinese juniper, oak, willow, mulberry, three-bristle cudrania, pine and cypress grew on the lower slopes of Mt Qi. Other trees on the surrounding mountains included wingceltis, plum and bamboo. Although today the vegetation is not nearly as luxuriant as it was, the area is still suitable for agriculture, having an average annual rainfall of 550–700 mm, an average annual temperature above 10°C and a frost-free period of 207 days. However, the long periods of drought punctuated by sudden storms which can wash away great tracts of the loess plateaus have made prosperity precarious. Despite this, the area has long been of considerable economic importance.

Terraced Loess Plateaus

The region along both sides of the Wei River resembles an asymmetrical staircase. On the north bank the alluvial soil forms two distinct steps, while the Qinling Mountains to the south gradually descend to the plateaus that rise in one or two steps 600 to 1,600 feet above the water level on the south bank. The thick layer of loess soil that covers this area was originally blown from Siberia and is soft and fertile, although it lacks organic matter and nitrogen. It is also friable, and has been dissected by the rivers into numerous terraced plateaus of varying sizes and shapes. The better-known plateaus near Xian are Shaoling, Bailu, Tongren, Shenhe, Xiliu, Biyuan, Fengqi, Hongdu, Longshou and Leyou.

The Shaoling Plateau to the south of Xian lies between the Yu and Chan Rivers. Its name was first changed from Honggu in the Han dynasty to Duling (Du mausoleum) because the Han emperor Xuan was buried in Du County

on the plateau. Later Empress Xu, his wife, was buried in a small tomb to the south called Shaoling (Shao mausoleum) and the plateau was then called Shaoling Plateau. The Tang poet Du Fu once lived here.

The Bailu (White Deer) Plateau is situated between the Ba and Chan Rivers to the east of Xian, and extends from the confluence of the two rivers to the Qinling Mountains in the south. According to legend, in the time of King Ping of the Zhou dynasty there were white deer on the plateau, but it is also called the Baling Plateau because the Ba mausoleum of the Han-dynasty emperor Wen is here.

East of the Ba River is the Tongren (Bronze Man) Plateau. It is said that in the first year of the Jingchu period (AD 237) of the Wei dynasty Emperor Ming ordered a bronze statue depicting an immortal holding a plate of dew to be moved from Jianzhang Palace in the capital to Weigong Palace in Luoyang. However, it was too heavy and had to be abandoned on this plateau.

Opposite the Shaoling Plateau, between the Yu and Hao Rivers, is the Shenhe (Divine Grain) Plateau. It was named after a locally produced ear of millet which is said to have weighed over six pounds. Fanchuan, a region renowned for its scenery, is between this and Shaoling Plateau. At the northern end of the plateau is Xiangji Temple, described in the following verse by the Tang-dynasty poet Wang Wei: 'Xiangji Temple is concealed far in the cloudy peaks. These ancient forests have no paths. Where do the chimes sound from deep within the mountains?'

The Xiliu Plateau is nine miles south-west of Xian. In 158 BC the Han general Zhou Yafu stationed his troops here. He was one of the commanders involved in an offensive against the Xiongnu (Huns) but, unlike the other commanders, when the emperor came to visit he refused to let him enter without going through the usual checking procedures and, moreover, he refused to relinquish his role as supreme commander during the visit, as was the usual practice. Emperor Wen realized that Zhou Yafu was correct to enforce the camp's strict code of discipline without exception, and he commended his general. The Bi Plateau is to the north-west of Xian and the Zhou kings Wen and Wu and Prince Gong Dan were all buried here.

The Hongdu or Xianyang Plateau is between the Wei and Jing Rivers and in the period from the Western Han to the Tang dynasties was a burial ground. Nine of the eleven emperors of the Western Han are buried here. The tombs of Gaozu, Hui, Jing, Wu and Zhao (the Chang, An, Yang, Mao and Ping mausoleums respectively) are together known as 'The Five Tombs'. Before the reign of Emperor Yuan, each time an emperor was buried a county town was established beside the tomb to protect it, and high-ranking officials and rich families were relocated there. This forced relocation of wealthy families had also been carried out at the beginning of the Qin dynasty and for the same reason: away from their areas of influence such families would find it more difficult to build up a power base which could threaten the stability of the empire. The 'Youth of the Five Tombs'

thereafter became a nickname for profligate sons of the rich.

The Longshou and Leyou Plateaus are both near Xian. The former was within the Tang city of Changan, and the famous Hanyuan Hall in the Daming Palace was built at its end, north-east of the Greater Wild Goose Pagoda in south Xian. In the Tang dynasty this plateau was a tourist spot on the east bank of Lake Qujiang, which many people from the capital visited during the Chongyang Festival because of its excellent vantage point. The famous Black Dragon Temple also stands here.

It is not surprising, given the advantageous conditions that this land within the passes enjoys, that so many dynasties have established their capitals here. The line of Du Fu, 'land of monarchs since ancient times', truly reflects its unique position in Chinese history.

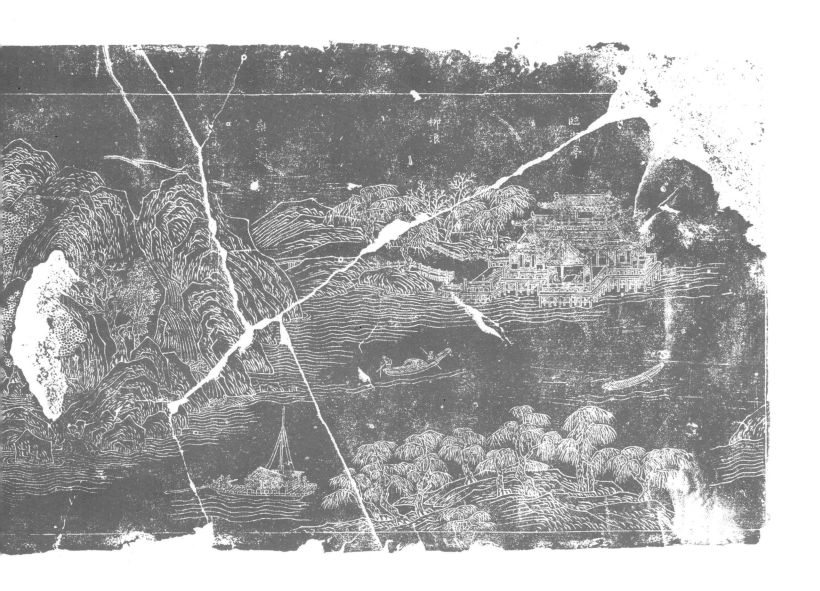

2

1. Cultural and historical sites in central Shaanxi Province (*see map on pages 8–9*)

2. Mt Zhongnan
Mt Zhongnan, also known as Mt Taiyi, is that section of the Qinling Mountains stretching from Wugong County in the west to Lantian County in the east. It towers above Xian and provides one of the two conditions for a city's ideal location according to traditional Chinese geomancy – mountains to the south (the other condition, water to the north, is met by the Wei River). These lines from a Tang-dynasty poem describe the mountain: 'Its layered slopes confront the Wei, its green peaks pierce the sky.'

3. The Qinling Mountains
(*overleaf*)
The Qinling Mountain range traverses central China, rising at the border of Gansu and Qinghai Provinces in the west and ending in central Henan Province to the east. It marks the division of northern and southern China with their different climatic zones. The section in Shaanxi Province is the highest section, with an elevation of 6,500–12,500 feet. The land within the passes borders the north-western slopes of the mountains.

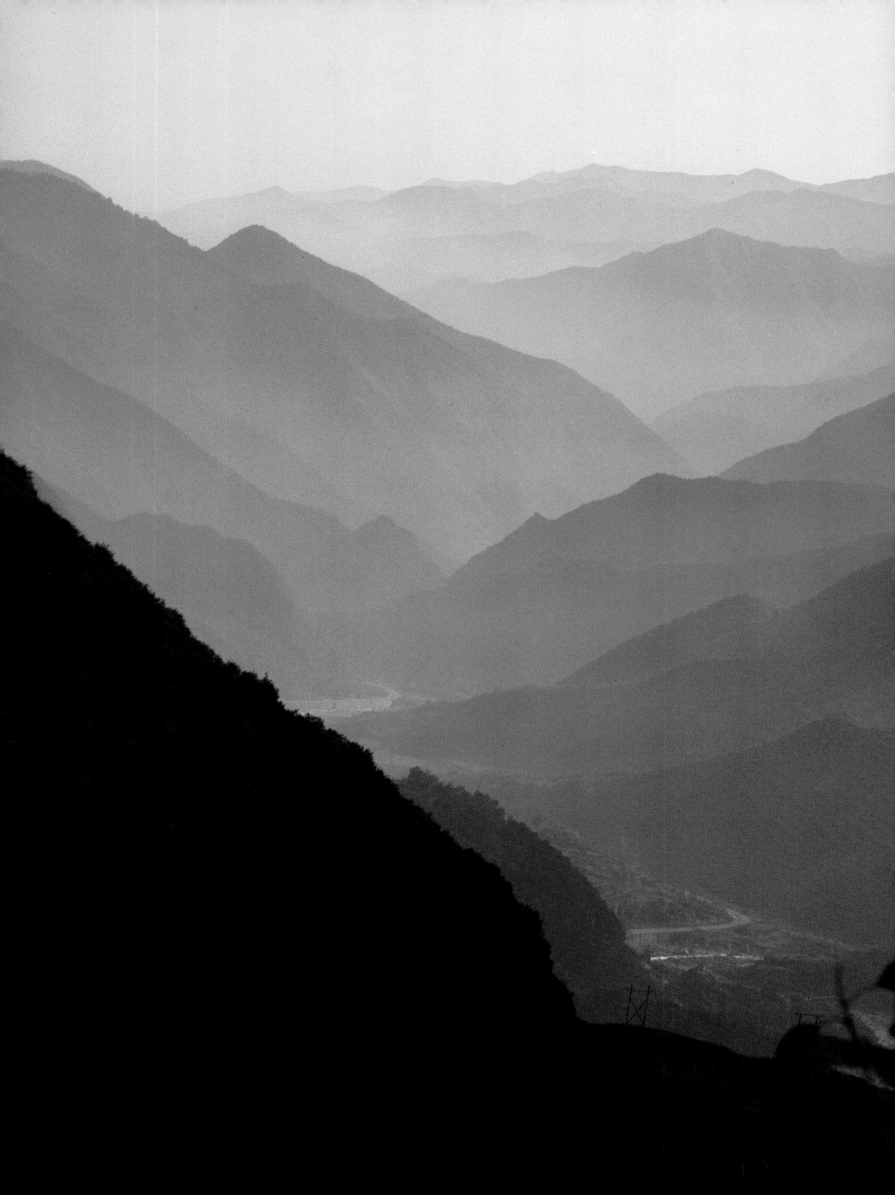

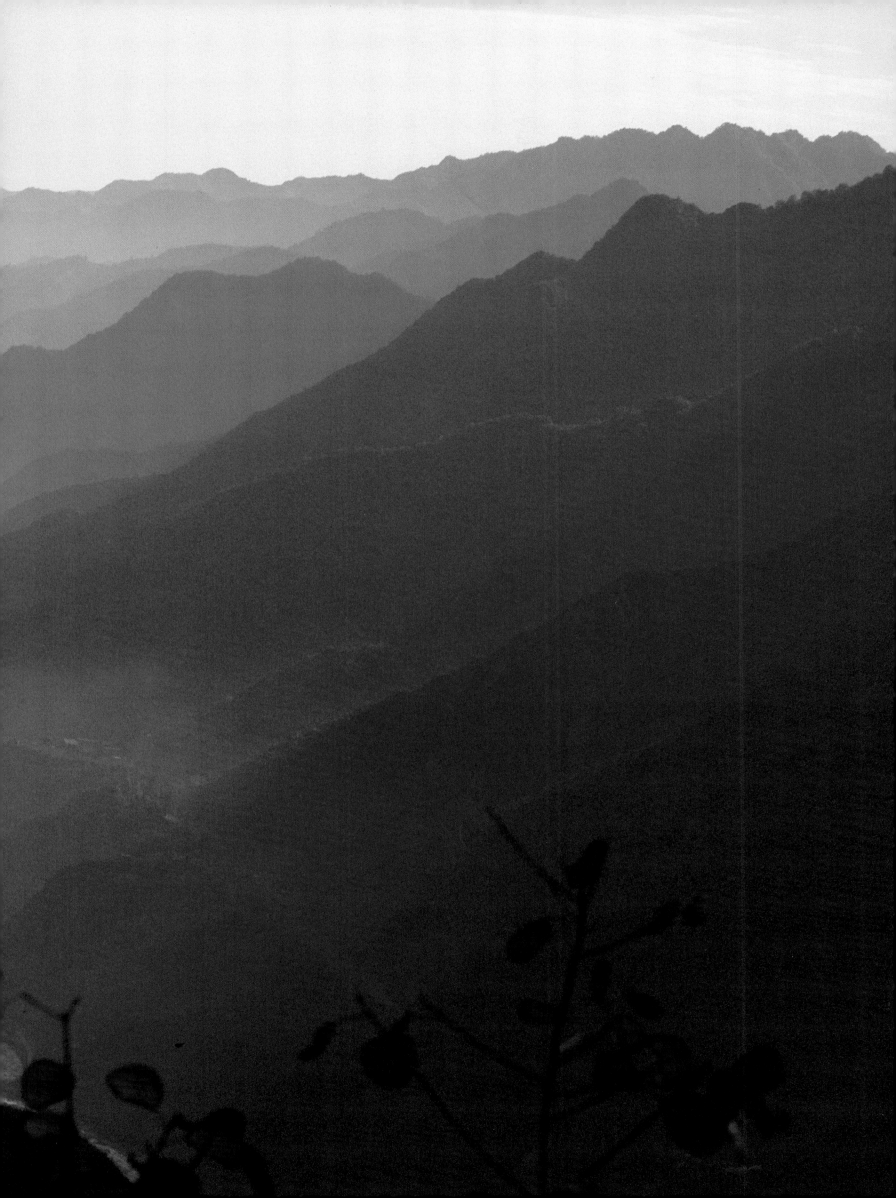

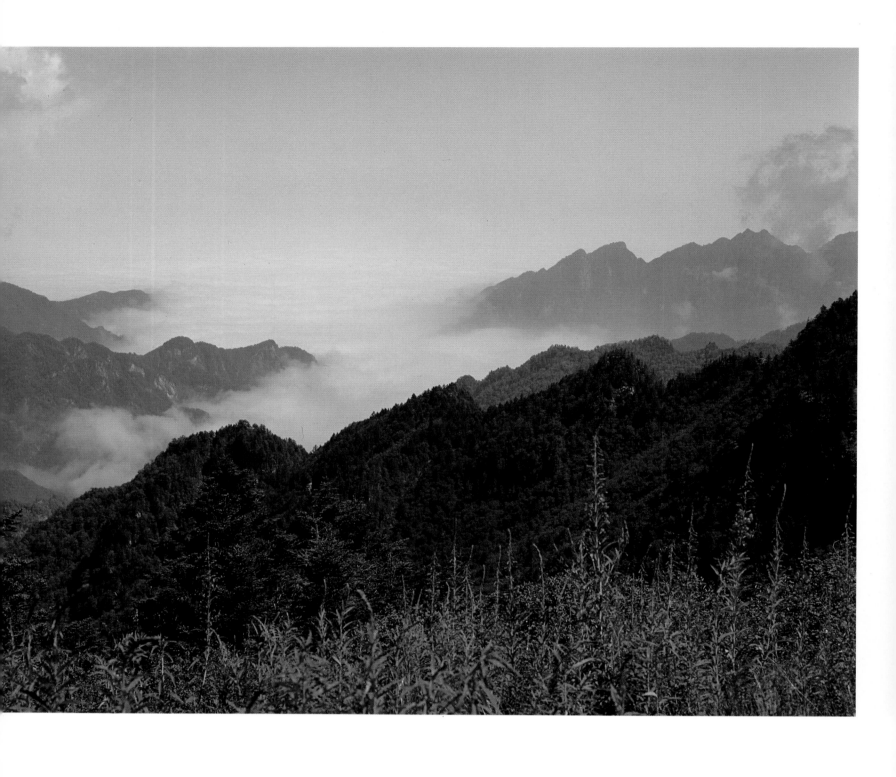

4. Mt Taibai
This is the highest peak in the
Qinling Range, rising 12,359 feet
above sea-level. Its snow-clad peak
and many lakes have ensured it a
position as one of the eight sights of
this region, and it is praised as the
Taibai Pearl.

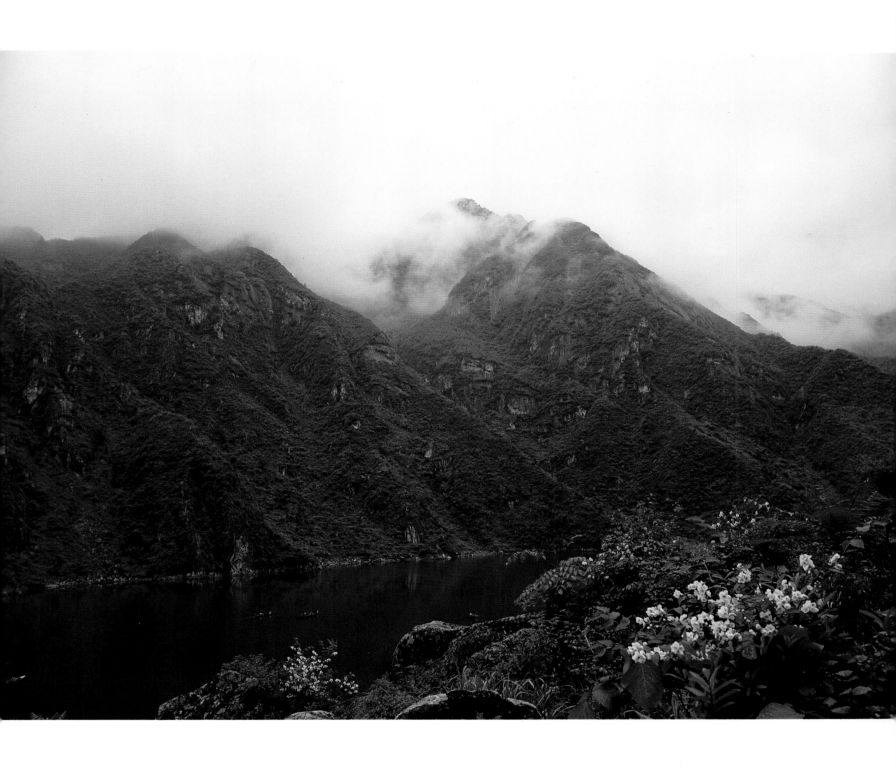

5. Mt Cuihua

This peak, at 8,453 feet above sea-level, is one of the highest points of Mt Zhongnan. A stream rising here flows down a valley to join the Yu River, passing the site of the Han-dynasty Taiyi Palace, built in 119 BC during the reign of Emperor Wu. The path leading to the summit follows a tortuous route, incorporating eighteen hairpin bends as it wends its way up the steep slopes, but there are many historical sites and some spectacular scenery to reward the visitor. The mountain lake is an ideal summer resort because of its cool weather and beautiful views.

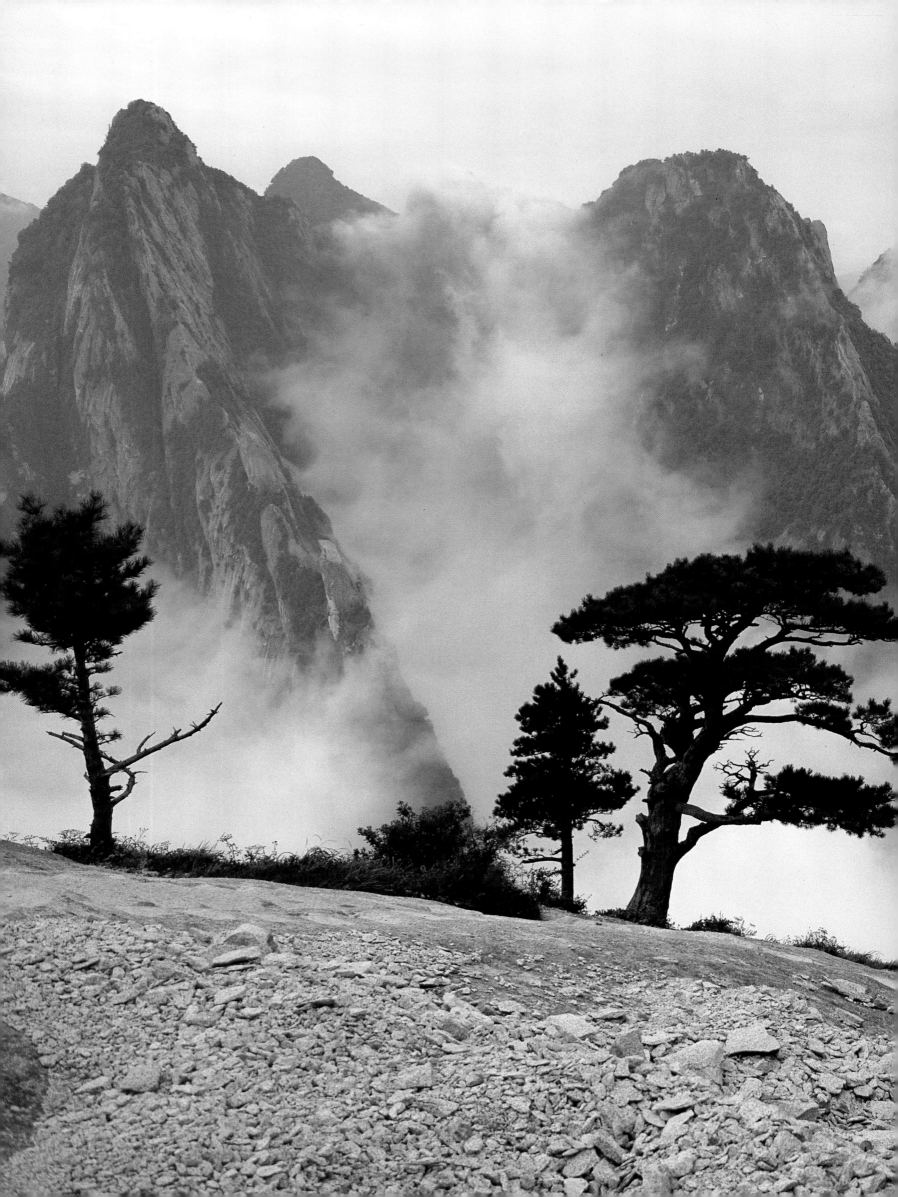

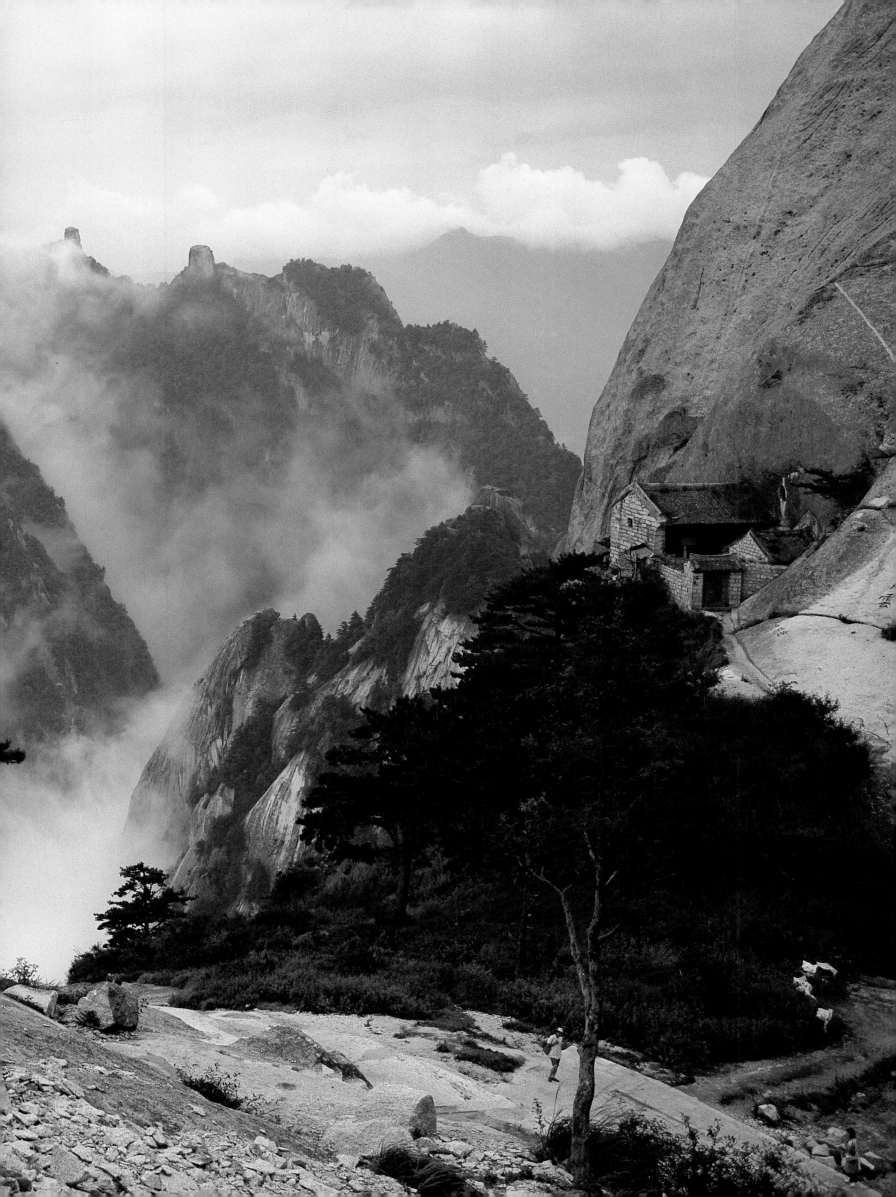

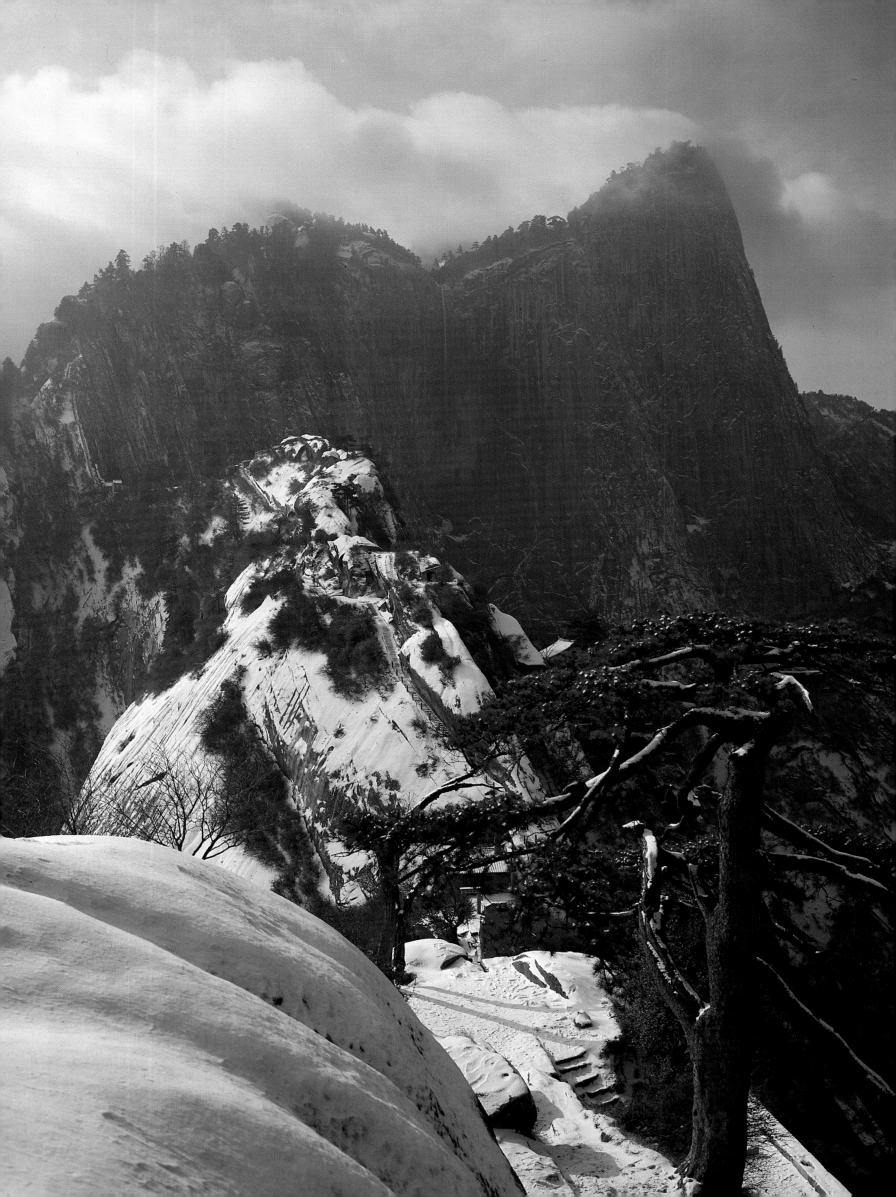

6. Mt Hua (*previous pages*)
One of the famous 'Five Mountains' of China, Mt Hua in the east of Shaanxi Province near the junction of the Wei and Yellow Rivers is renowned for its five peaks, which rise imposingly above the Wei River basin. According to a local tradition there has only been one path up the mountain since ancient times.

7. The west peak of Mt Hua
The west peak of Mt Hua is called Lianhua (Lotus) Peak. From the top it is almost a sheer drop to the Wei River on the west while the eastern slope also falls steeply, with Luoyan Peak rising opposite. Beyond this is the highest point of the mountain's Nan (South) Peak.

8. Twilight on Mt Li
Mt Li, east of Xian in Lintong County, is purported to be the place where the Lishan (Mt Li) tribe of the Shang dynasty lived. Another story says that the profusion of pines and cypresses covering its slopes resembled the mottled greenish-grey coat of a Li horse, hence its name. The beacon towers on the mountain top also have a story: the favourite concubine of King You of the Zhou dynasty refused to smile until he lit the beacon fires on Mt Li to muster the feudal lords and their forces to the capital. Because of her pleasure at seeing the armies ride into the capital, he lit them again, even though there was no enemy attack, at which provocation the feudal lords threatened to rebel. He only appeased them after having the concubine executed. At the foot of the mountain are the Huaqing hot springs, a favourite imperial pleasure resort in times past. Twilight on Mt Li is one of the eight scenic wonders of this area.

9. Loess plateaus of northern Shaanxi (*overleaf*)
These plateaus stretch across large parts of northern China. The loess is a fine, fertile yellow soil originally blown from the Mongolian steppes, and is over 300 feet deep in places. The northern Shaanxi loess plateaus have an elevation of about 5,000 feet. Due to its friable nature the top soil is easily washed away, so that the plateaus rise and fall, criss-crossed with ditches and abysses. The form of plateau shown in the picture is termed a 'comb loess ridge' by geographers.

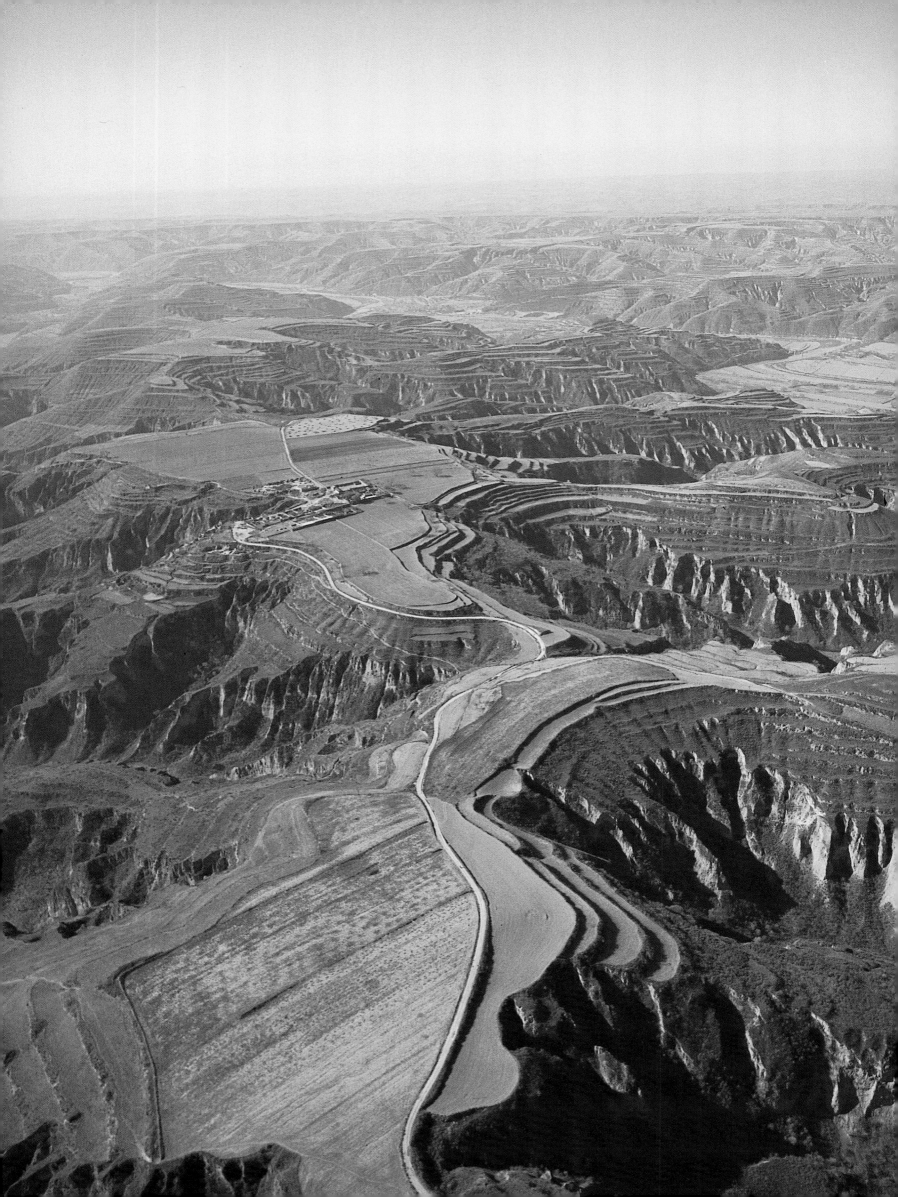

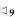9

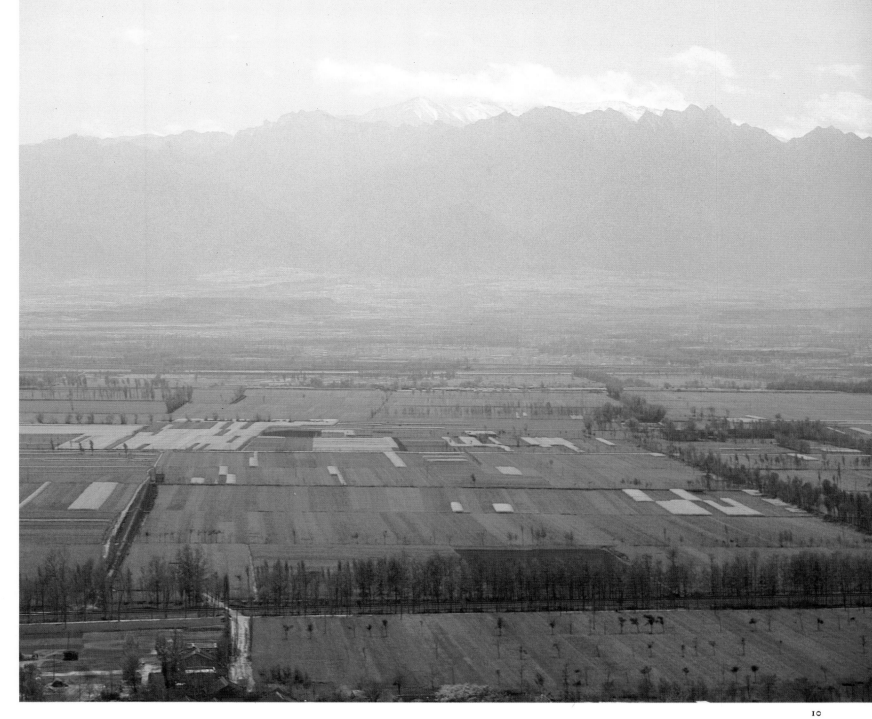

10

10. The land within the passes
The Wei River valley traversing central Shaanxi Province was the territory of the state of Qin in the Eastern Zhou period (770–221 BC), hence it is often called Qinchuan – Land of Qin. It is also known as Guanzhong – the land within the passes – because it is at the centre of four passes, the Tong, Dazhen, Wu and Xiao. The land within the passes now refers to the plain in the middle and lower reaches of the Wei River from the Tong Pass in the east to Baoji Gorge in the west.

11. Map showing the extent of the land within the passes

11

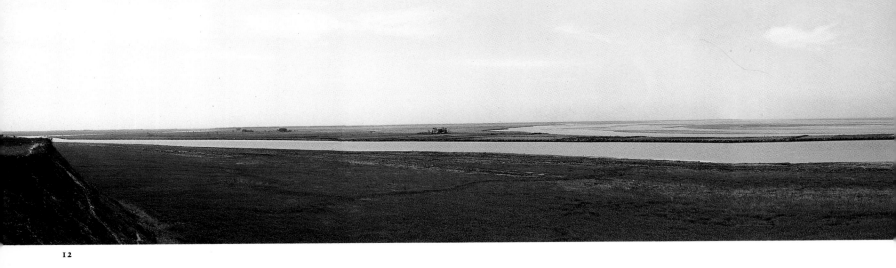

12. The confluence of the Wei and Yellow Rivers
The Wei is one of the eight rivers of this area and a major tributary of the Yellow River at its middle reaches. Its source is in Gansu Province to the west and it flows across central Shaanxi Province, joining the Yellow River near the Tong Pass. In the picture the Wei is in the foreground.

13. The Wei River
There were originally eight rivers in the region around Xian, the Jing, Wei, Ba, Chan, Feng, Hao, Lao and Yu, the Wei being the largest. It has been a source of irrigation water and a means of transport from ancient times, helping to produce a flourishing agricultural economy at its middle and lower reaches.

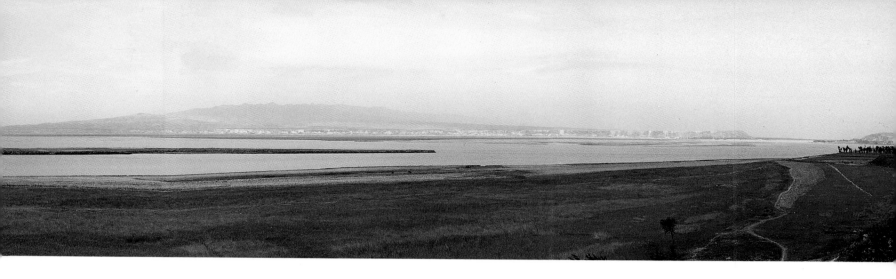

14. The clear and muddy waters of the Jing and Wei Rivers (*overleaf*)
Since ancient times the Jing and Wei Rivers have been alternately clear then muddy. It is recorded that in the Eastern Zhou the Wei was clear and the Jing muddy, but in the Northern and Southern dynasties the Jing became clear and the Wei muddy. Further changes were recorded during and after the Tang. Today when the weather is clear a distinct line between the clear and muddy waters of the two rivers can be seen at their confluence.

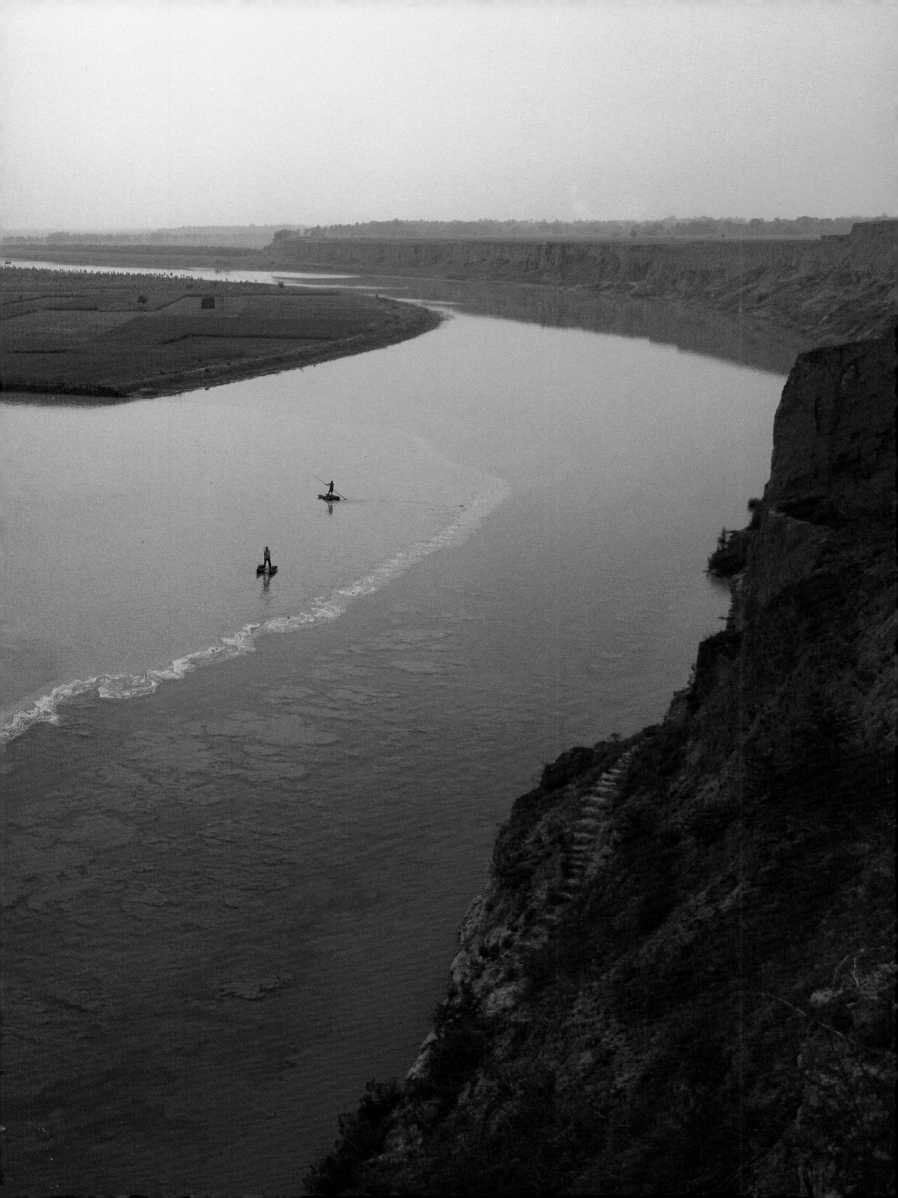

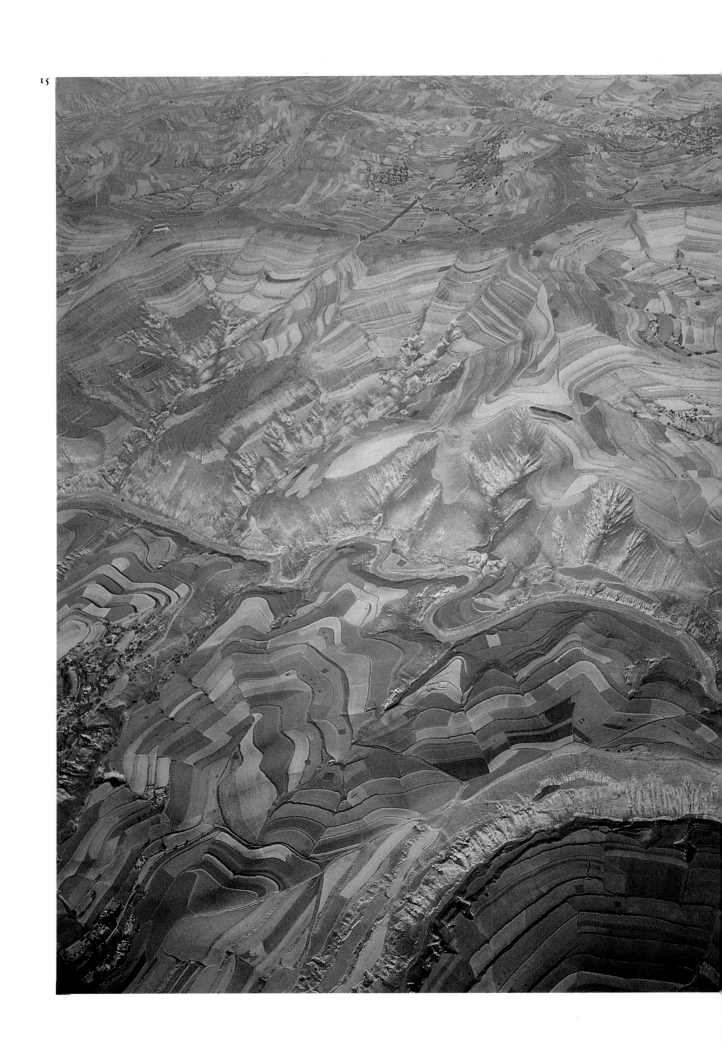

15. The Jing River

This rises at the eastern foot of Mt Liupan in the southern part of Ningxia Autonomous Region and flows across Gansu Province to Shaanxi Province, where it empties into the Wei. With a length of 280 miles it is the largest tributary of the Wei and also plays an important role in irrigation. In ancient times, the Zhengguo Canal was built in the Jing Valley.

16. Confluence of the Hao and Yu Rivers

The Hao River, which dried up in the Tang, rose in Shibie Valley in the Qinling Mountains and flowed north-west, passing twelve miles south-west of Xian. The Yu River rises in the Dayi Valley and passes nine miles south of Xian. The two rivers join near Xiangji Temple, the river then being called Jiaoshui or Fushui. This area is a well-known scenic spot and, because of a legend that says that Fan Kuai, a hero of the Western Han dynasty, was granted land here, it is called Fanchuan – Land of Fan.

16

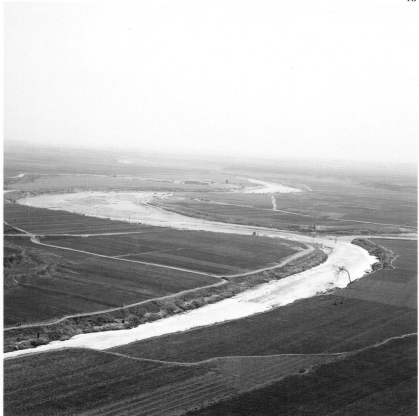

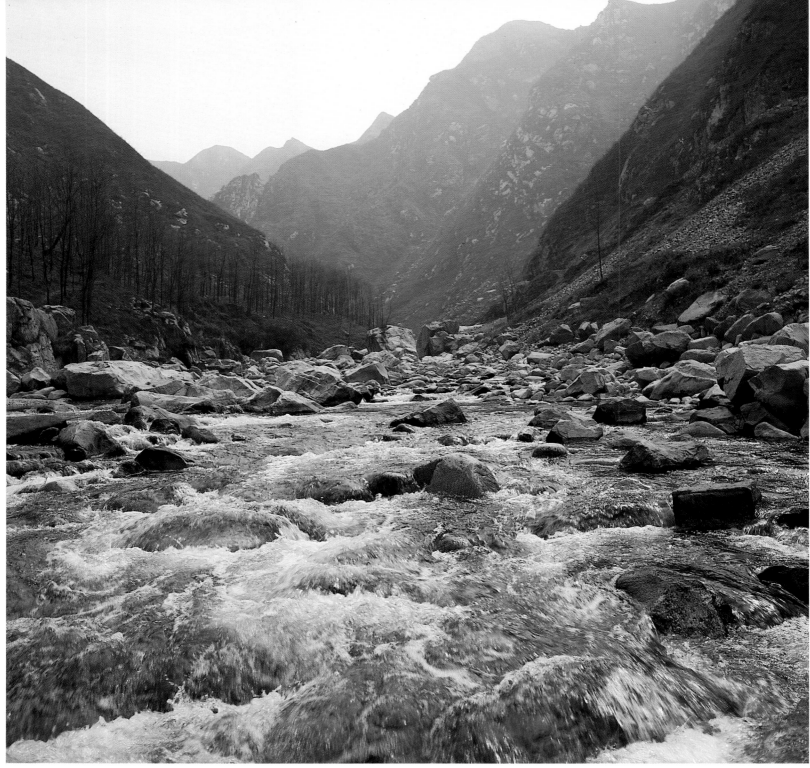

17. Feng Valley Pass
This pass through the Qinling
Mountains is one of the main routes
south from the city. The Feng River
flows down from the mountains,
passing by the ruins of the Zhou
capital Feng near Doumen before
emptying into the Wei in the north.

18. Wuzhang Plateau
The Wuzhang Plateau is to the west
of Xian, with the Qinling
Mountains to its south and the Wei
River to the north, with deep
chasms on both east and west,
forming a natural defence. In
ancient times it was used by
strategists to deploy their forces,
and the famous general of the Three
Kingdoms period, Zhuge Liang,
stationed his troops here. At the
northern end of the plateau is
Wuhou Temple, which houses a
statue and shrine to this general.

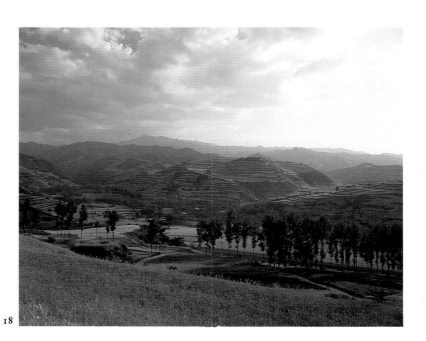

18

19

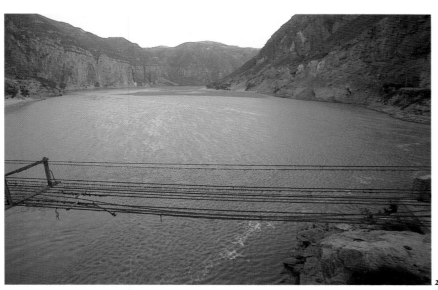

20

19. Weiqu Plateau
Weiqu in the Tang was a region where many imperial nobles and wealthy families lived, 'but a few feet from heaven', that is, in close proximity to the emperor. It is skirted by Duling and Fengqi Plateaus to the east and north and by the Zhao and Yu Rivers to the west and south.

20. Dragon Gate
About nineteen miles north of Hancheng County there is a gorge on the Yellow River, less than 100 feet at its narrowest point. A legend says that Yu the Great of the Xia dynasty controlled the river here, making it safe for traffic; hence this gorge is also called Yu Gate.

21. Dasan Pass
At the confluence of the Qian and Wei Rivers south of Baoji County, the pass is a vital passage linking Shaanxi and Sichuan Provinces. It used to be a very important pass, giving armies the opportunity to advance and attack or retreat and defend. The Sichuan–Shaanxi highway and Baoji–Chengdu railway line now pass through it.

21

22

23

38

22. Remains of the small south gate at Tong Pass

Tong Pass, the eastern gate of the land within the passes, was already established by the end of the Eastern Han dynasty, and its ruins now lie near Wucun Village in Tongguan County. It was of vital strategic importance, linking Shaanxi with Shaanxi and Henan Provinces. It was a very narrow pass which, when fortified, allowed only one carriage at a time to pass. It is recorded that 'with one man holding the pass even 10,000 troops could not get through'. The earthen walls faced with grey brick are 52 feet high by 26 feet thick and 3 miles in circumference. Battlements 98 feet high were built along the mountain ridges in the east and south-east. The remains of the fortifications at this pass are well preserved.

23. Ruins of the north gate of the Hangu Pass

The Hangu Pass, in Lingbao County, Henan Province, was the main pass to the east of the land within the passes. It was built by the Qin state before they unified China. The name Hangu, which means 'encased in the valley', accurately describes its position. The ruins still stand next to the Longhai railway line.

2.

From Lantian Man to the Yellow Emperor

The Wei River valley, as one of the earliest inhabited areas, holds an important position in the formation of Chinese civilization. Over the past few decades archaeologists have discovered numerous relics of ancient cultures hidden in this area. Lantian man, Dali man, Banpo and Kangjiacun represent settlements from paleolithic to neolithic times and offer a clear picture of the development of prehistoric man in this area.

Lantian Man – The Dawn of Civilization

The earliest human remains discovered in central Shaanxi Province are those of Lantian man which, from what is now known, are only slightly younger than the fossils of Yuanmou man found in Yunan Province.

In September 1963 a team of archaeologists discovered a lower jawbone near Chanjiawo in Lantian County. In May of the following year a skullcap was found at Gongwangling, thirty-one miles away. Both were probably from females. According to common practice they were named 'the Lantian species of the Chinese ape' or 'Lantian man' (*Sinanthropus lantianesis*). A large number of mammal bones and several dozen crudely made stone implements were discovered at the same time.

According to scientific methods of verification, Lantian man belongs to the *homo erectus* category of the hominid species, perhaps one of the earliest ape-like but upright walking men. In evolutionary terms he is of approximately the same period as the world-famous Peking man, appearing at the early stage of the pleistocene epoch in the quaternary period. However, he was both earlier and more primitive than Peking man. Scientific data show that he lived about one million years ago, while Peking man lived in the period between 700,000 to 200,000 years ago. This makes Lantian man the earliest example of *homo erectus* found in north Asia.

Fossils of over forty different animals were discovered at the same time as Lantian man. Most of them were forest animals such as the tiger, elephant, wild boar, giant panda and hair-capped deer. Then there were grassland animals such as the horse and the ox and also some, like the antelope, lion and large-horned deer, which ranged both the forest and grasslands. The giant panda, elephant and hair-capped deer are all animals that thrive in warmer conditions than those obtaining in northern China today and thus it is reasonable to assume that the temperature at that time was warmer and more humid, similar to the weather in the south of China today. It is probable that the northern lower slopes of the Qinling Mountains were then covered with sub-tropical primeval forests while there were stretches of grassland in the valleys.

The tools that Lantian man used were mainly made of stone and included alternately flaked choppers, scrapers, hand axes, cores, flakes, stone balls and other heavy chopping instruments. They were simple and crudely made, far less advanced than those from the neolithic period. Lantian man probably lived in hunting and gathering groups and, since there are no natural caves in this region, it is believed that he must have constructed some form of shelter, although no habitation sites have been discovered.

Dali Man

In 1978 a fairly complete skullcap of a young man was discovered at Duanjiazhen in Dali County, Shaanxi Province, and subsequently named 'Dali man'. He dates from a later period than both Lantian and Peking man, belong-

ing in the middle pleistocene era, about 200,000 years ago; he is classified as an early example of *homo sapiens*. Many stone tools and mammal fossils were also found at this site.

The upper pleistocene period covered the last of the four ice ages in China and ended about 12,000 years ago. It was at this time, when the weather was still cold and dry, that the north-west of China became covered with loess, blown from the Mongolian steppes. In the holocene period that followed there was a return to a warmer and wetter climate and the emergence of agriculture and domestication of animals, the neolithic or new stone age.

The Yangshao Culture – Banpo and Jiangzhai

The cultural remains of the neolithic age, discovered around Xian, were found mainly on the banks of the Chan, Ba and Li Rivers and in Lintong and Weinan Counties, with Banpo near Xian and Jiangzhai in Lintong being representative sites. Both these sites are also identified as belonging to the Yangshao culture, similar remains having first been discovered at Yangshao Village in Mianchi County, Henan Province. The Yangshao culture is characterized by primitive agriculture and painted pottery.

The Banpo site was discovered in 1953 and dates from 5000 to 3000 BC. It is three miles east of Xian in a beautiful situation facing the Chan River, with its back to the Bailu Plateau. The ruins were discovered to the north of the village and cover an area of at least 98,000 square yards, only a quarter of which has been excavated. It is a fairly intact site typical of the communities so far discovered in this area. It consists of three parts: a living area, pottery kilns and a burial ground. The layout of the houses is roughly similar to that in later villages in China.

The living area is at the centre of the area, covering almost 60,000 square yards and comprises houses, storage cellars and places for livestock. At its centre there was one large house, over 300 yards square, which archaeologists think must have been used for communal activities. However, this seems to have been built only during the later part of the occupation of this village and may indicate a change in the structure of the society. Around it are the remains of more than forty small houses that form an irregular circle. A long and deep defence ditch was dug around the living area, separating it from the burial ground to the north and the pottery kilns to the east. This regular and well-organized layout has been cited as evidence to suggest that the community at Banpo was structured according to clans or lineages, this view also being supported by the layout of the burial ground.

There was a small pit inside each house which was used as a fireplace for heating, cooking and lighting. The roof was supported by two or perhaps four wooden pillars on either side of the fireplace. Both the roof and the wall were flat and smooth, about eight inches thick and made of wooden boards, wooden strips and daub and wattle.

Pits next to the houses were used for storing food and utensils. Of the 200 or more that have been excavated, one still contained grains of foxtail millet (*setaria italica*), the most common crop of the Yangshao culture, and seeds of the Chinese cabbage (*brassica*), the earliest vegetable so far known to have been cultivated in north China. Gathering had declined in importance with the domestication of crops, but probably still had a role in these early agricultural communities.

Developed at the same time and closely linked with the cultivation of grain was the domestication of animals, remains of pigs and dogs having been discovered at Banpo. Dogs may have been used in hunting as well as for food. Fishing seems to have been another important activity, as a large number of fishing implements were found at Banpo and the fish is one of the main motifs on painted pottery from this site. Silkworm cocoons have also been found here.

The tools that Banpo man used were much more advanced than those of Lantian man, and include a large number of bone and pottery implements in addition to those made of stone. The stone tools were pecked, chipped and polished and included axes, adzes, chisels, knives and spades. Bone awls, needles, arrowheads, chisels, fishhooks and fish spears have all been found. The fish-hooks and the needles were extremely delicate, with sharp barbs and tiny holes. The earthenware scraper and knife were sharper than the stone knife. These were used for agriculture, hunting, fishing and simple handicrafts such as making clothes and weaving mats and cloth.

Pottery was very important and the techniques used in its manufacture were already of a reasonably high

standard. A pottery area with six kilns has been discovered to the east of the living area. In their basic conception these kilns are very similar to modern ones. Fifty to sixty varieties of pottery of different shapes and forms were known to have been in use, including the amphora, with a narrow mouth and pointed base, pots with narrow necks and large bodies, jars with wide mouths and small bases, gourd-shaped bottles, bowls, cups, plates, pots, steamers and tripodal cooking vessels. Most of the pottery found was made of coarse clay and sometimes decorated with basket or mat impressions. The finer pottery, the so-called painted pottery that is representative of this culture, in fact makes up only a small percentage of the total and was usually found in burials. There were primarily two forms of motif used for decoration on this finer pottery: realistic depictions of animals and fish, or abstract patterns. The fish was the most common motif but deer, birds and frogs are also found. The most attractive design is of a fish with the complete features of a human face, perhaps linked with some form of totem worship. Abstract patterns consist of various arrangements of triangles which seem to have been derived from the fish motif.

Carved on the outside rim of some of the pottery vessels are marks with regular forms and simple strokes. Over a hundred examples have been found, consisting of twenty-two varieties of graph with horizontal, vertical, slanting and forked strokes. A few examples of more complex graphs have also been found. These are now generally believed to be primitive symbols, perhaps precursors to writing.

The cemetery, where all adults were buried, is located to the north of the living section. The children were generally interred in jars next to the houses. Men and women were buried separately, females' tombs being richer in content. This has led some scholars to suggest that Banpo was a matriarchal society. Other evidence put forward to support this theory includes several Eastern Zhou and Western Han dynasty texts which mention an archaic matriarchal society.

Another site also representative of the Yangshao culture was discovered in 1972 at Jiangzhai in Lintong County, a large village typical of this culture, which shows a close affinity with Banpo. Most notable at the site are the sculptures, paintings, carved signs, decorative wall patterns, stone ink-slabs, paints and shell ornaments. While some of the carved and painted signs are similar to those found at Banpo, others are more structurally complex and are regarded as primitive characters by some. Although further evidence is needed before any of these characters can be identified as primitive progenitors of later characters, the marks that have been found so far from these two sites must lead to the conclusion that the history of Chinese writing goes back at least 6,000 years.

The Longshan Culture – Kexingzhuang and Kangjiacun

Neolithic remains dating from a later period than those at Banpo and Jiangzhai have also been discovered in central Shaanxi Province. These sites have much in common with Longshan-culture sites from the east of China, named after the representative site discovered in 1928 at Longshan, near Jinan in Shandong Province. Longshan culture is typified by its distinctive fine black pottery and therefore is also called the black-pottery culture. Unlike that of the Yangshao culture, this pottery usually has no surface decoration but is fashioned in more complicated shapes. However, the culture found at sites in Shaanxi, although it has much in common with the Longshan culture of the east coast, seems also to have been influenced by the indigenous Yangshao culture. It is therefore called the Shaanxi Longshan culture, the typesite of which is Kexingzhuang II.

From 1955 to 1957, 10 houses, 43 cellars, 3 pottery kilns, 261 tool fragments and a large number of pottery pieces were excavated at Kexingzhuang on the west bank of the Feng River in the western suburbs of Xian. Many grey tripodal vessels with hollow feet were found, typical of the Longshan culture, but with distinctive shapes. Some of the houses at that time consisted of two rooms joined by a passage, a considerable development from the one-room pattern of Banpo. Tools were more advanced and livestock included sheep, oxen and chickens as well as pigs and dogs. Whether the Yangshao culture was a matriarchal society or not, there are various reasons to believe that the Longshan culture was definitely a patriarchal society. Weighting the evidence are the phallic images in clay found at this site. These were probably used in worship; the character for ancestor found on later oracle-bone inscriptions certainly represented a phallus and also resembles the shape of the ancestral tablet central to ancestor worship. In addition, there were sheep scapulas for divination, suggesting the rudiments of religious activity had started. There is no evidence that these existed in the Yangshao culture.

In 1986 inscribed pieces of bone were found at a Longshan-culture site at Huayuancun in Doumen, some miles west of Xian. This is the most important discovery to date of such inscriptions. The characters are small, the strokes extremely fine and the whole structure and arrangement compact, very similar to the style of Shang-dynasty oracle-bone inscriptions. Over a dozen individual characters have already been identified. This discovery indicates that the Chinese used a form of writing much earlier than the Shang dynasty, which was previously thought to be the period when writing in China began. It also suggests continuity from the basic symbols found on pots at Banpo and Jiangzhai, to these characters and then to Shang-dynasty oracle-bone inscriptions, recognized as the precursor of today's Chinese characters.

Another Longshan-culture site was recently discovered at Kangjiacun to the north-east of Xian, dating from 4,000 years ago. This site covers an area of 274,000 square yards, comprising 72 houses, 5 pottery kilns and 32 cellars. Many pieces of pottery, stone and jade tools were found here. This is the most complete site of the Longshan culture so far discovered in Shaanxi.

From Archaeology to Mythology – The Yellow Emperor

The discoveries from Banpo, Jiangzhai, Kexingzhuang and Kangjiacun give a general picture of the process of development in Shaanxi through the neolithic period, with the possible evolution from a matriarchal to a patriarchal society. This material evidence can be supplemented by oral traditions; a distorted reflection of primitive society is indeed found in Chinese legends and myths. Two well-known figures from these myths are Yan Di (the Fiery Emperor) and Huang Di (the Yellow Emperor). Legend has it that they both lived in the Wei River valley region. Yan Di's surname was Jiang and he is

known both as 'skilled farmer' and 'fiery mountain', suggesting that he was expert in the techniques of slash-and-burn cultivation. He is said to have entered the middle reaches of the Yellow River from the west and clashed with the Jiuli clan. The head of this clan, Chiyou, and his eighty brothers are all reputed to have been giants with skulls as hard as iron, sharp horns, four eyes, six hands and hair growing erect beside their ears. Their feet were like the hooves of an ox and they ate sand, iron and stones. Not surprisingly, Yan Di was defeated by Chiyou and had to ask for help from Huang Di. Huang Di, surnamed Ji and also called Xuanyuan, was the head of the Xiong clan. He fought Chiyou at Zhuolo (Hebei Province). At first Huang Di's troops suffered great losses as Chiyou blew a thick fog from his nostrils so that they could not find their way, but then Huang Di ordered the goddess of wind to blow a wooden figure on a cart so that its outstretched arm always pointed south, and with the use of this 'compass cart' he was able to lead his troops out of the fog. Finally, after various other incidents, Huang Di captured Chiyou and had him executed. After also defeating Yan Di at Banquan (east of Zhuolo County), he entered central China to become chief of an alliance of clans.

Huang Di is honoured as an ancestor of the Chinese nation and later generations have credited him with many inventions. In addition to the invention of the compass – one of the 'Four Inventions' that symbolize Chinese civilization (the other three being paper, printing and gunpowder) – the boat, chariot, written language, 'Heavenly Stems and Earthly Branches' system of year counting, the calendar and musical instruments are all, according to legend, inventions of this period. Huang Di's wife, Leizu, is also said to have taught people how to breed silkworms and acquire silk thread. Although most of these claims are fabulous, they may nevertheless indicate that this was a period of rapid development, in which new inventions were continually appearing and which also saw the development of a primitive form of the state. These events are purported to have taken place 4,000 to 5,000 years ago.

According to legend Huang Di lived for 111 years and was buried at Mt Qiao in Huangling County, Shaanxi Province. In the grounds of Xuanyuan Temple at the foot of this mountain is a huge cypress, alleged to have been planted by Huang Di. There is also a stele pavilion housing forty-seven inscribed tablets of past dynasties, the earliest being the 'Tablet to the Protection of a Forest' erected in the sixth Jiayou year of the Song emperor Ren Zong (AD 1061). Apart from two Yuan-dynasty tablets, the rest all date from the Ming and Qing dynasties.

Ancient cypresses cover the whole of the mountain and a tomb, purported to contain the effects of Huang Di, stands at the peak. In front of the tomb, which faces south, is a four-point sacrificial pavilion housing a tablet with the inscription: 'Tomb of Huang Di'. In front of this is an earth platform which, according to tradition, was built by the Han-dynasty emperor Wu to offer a sacrifice to his ancestor, Huang Di, after returning safely from an expedition to Shuofang in the north. It is also called 'The Celestial Platform of Emperor Wu'.

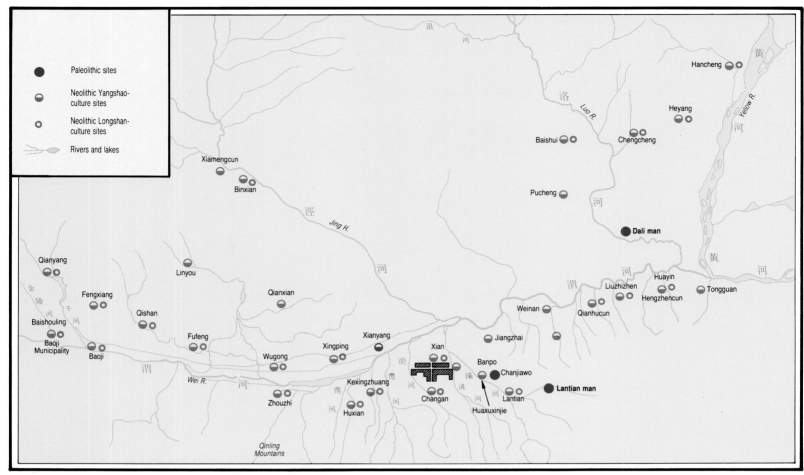

Legend:
- ● Paleolithic sites
- ◖ Neolithic Yangshao-culture sites
- ○ Neolithic Longshan-culture sites
- ⤙ Rivers and lakes

24. Map showing the sites of prehistoric remains in the land within the passes

25. Chanjiawo
Situated north of Xihu in Lantian County, this is where Lantian man was first found. A humanoid mandible was excavated from the steep slope of a ditch here in 1963.

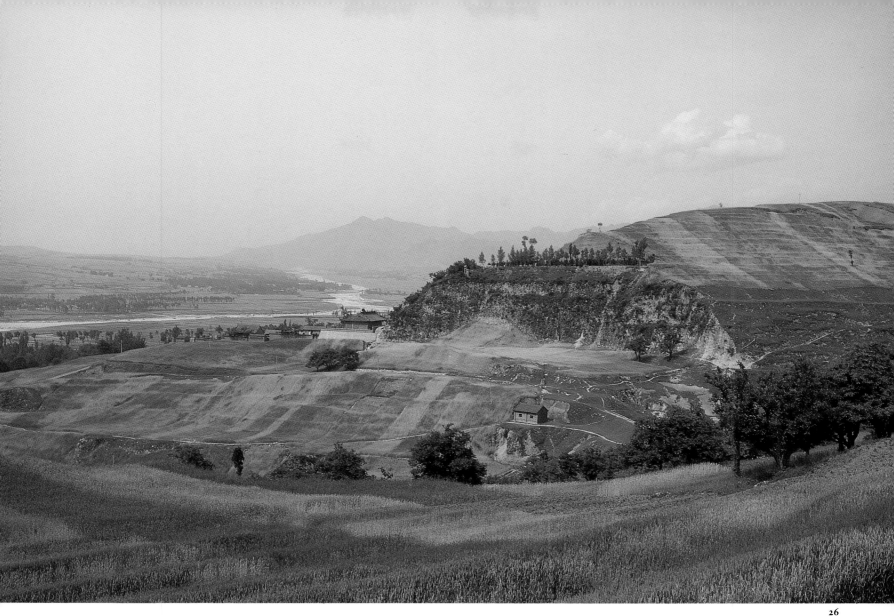

26. Gongwangling
About thirty miles east of
Chanjiawo this is where, in 1964, a
skullcap of Lantian man was
discovered. It has since been dated
to about 1 million years ago. At that
time the climate in this area is
thought to have been sub-tropical.

27. Skullcap of Lantian man
After the discovery of Peking man
at Zhoukoudian near Beijing,
Lantian man is one of the most
important finds to date of early man
in China. Lantian man belongs to
homo erectus. A complete lower jaw
along with a fragmented upper jaw,
skullcap and three teeth have been
found, probably from a woman.
The skullcap is extremely thick,
with a low, flat forehead, protruding
superciliary ridges and a wide, short
nose bone. The brain capacity is
780 ml, approximately 56 per cent of
modern man's.

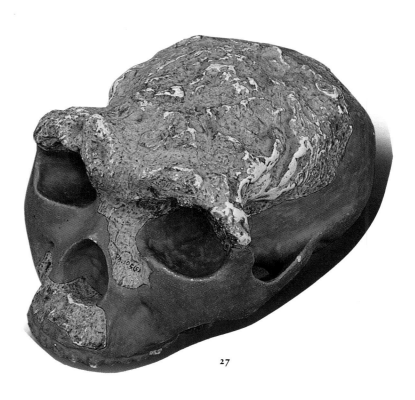

27

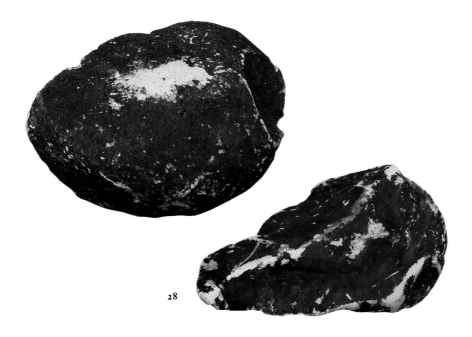

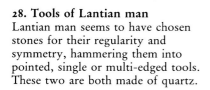

28

28. Tools of Lantian man
Lantian man seems to have chosen
stones for their regularity and
symmetry, hammering them into
pointed, single or multi-edged tools.
These two are both made of quartz.

29. Animal bones from Lantian
Bone fossils from fifty-two kinds of
animals were found at the Lantian
site. The fourteen from Chanjiawo
were mainly of forest animals, while
the thirty-eight from Gongwangling
comprise both grassland and forest
animals. These latter included some
from mammals that are now only
found in southern China, such as
the giant panda and the elephant,
suggesting that the climate at that
time was warmer and wetter and the
mountains densely forested.

30

46

29

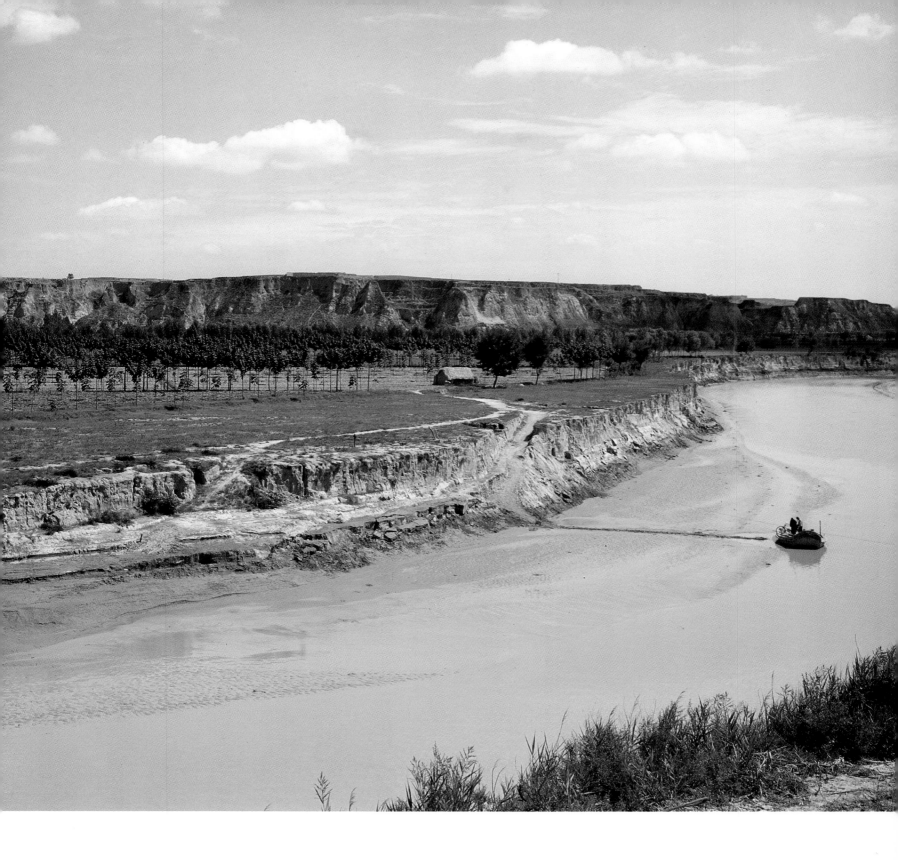

30. Area where Dali man was found
This site is near Duanjiacun in Dali County, north-east of Xian. About 200,000 years ago all traces of sub-tropical animals north of the Qinling Mountains disappeared and were replaced by northern Chinese animals, while grass seems to have been the main vegetation in the area. Dali man lived in the Wei River valley at this time.

31. Skullcap of Dali man
Dali man was the first complete fossil of an ancient man to be discovered in China. He was an early form of *homo sapiens*, having a larger skull, a higher top occipital bone, a less protruding mouth and a larger brain (1.12 ml) than Lantian man.

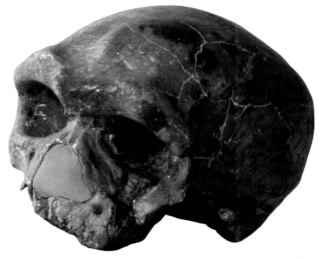

31

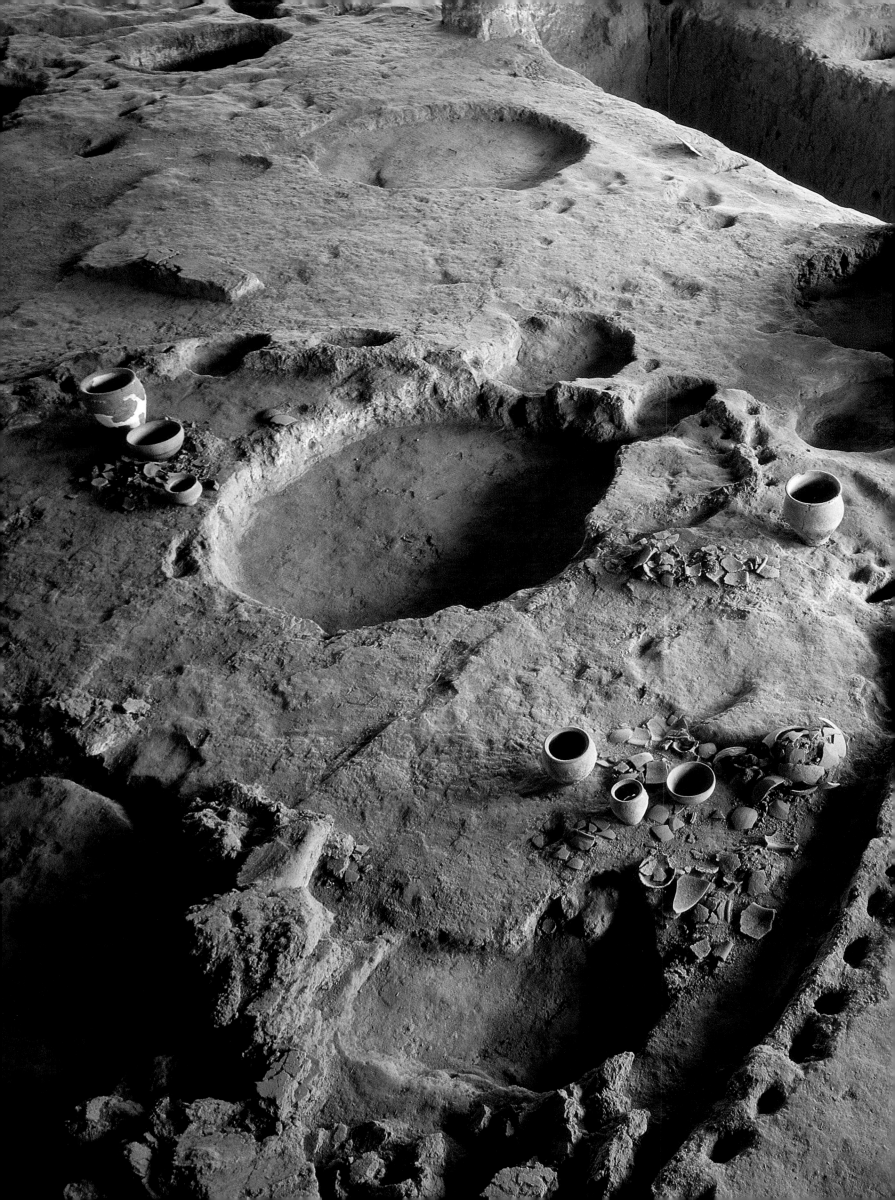

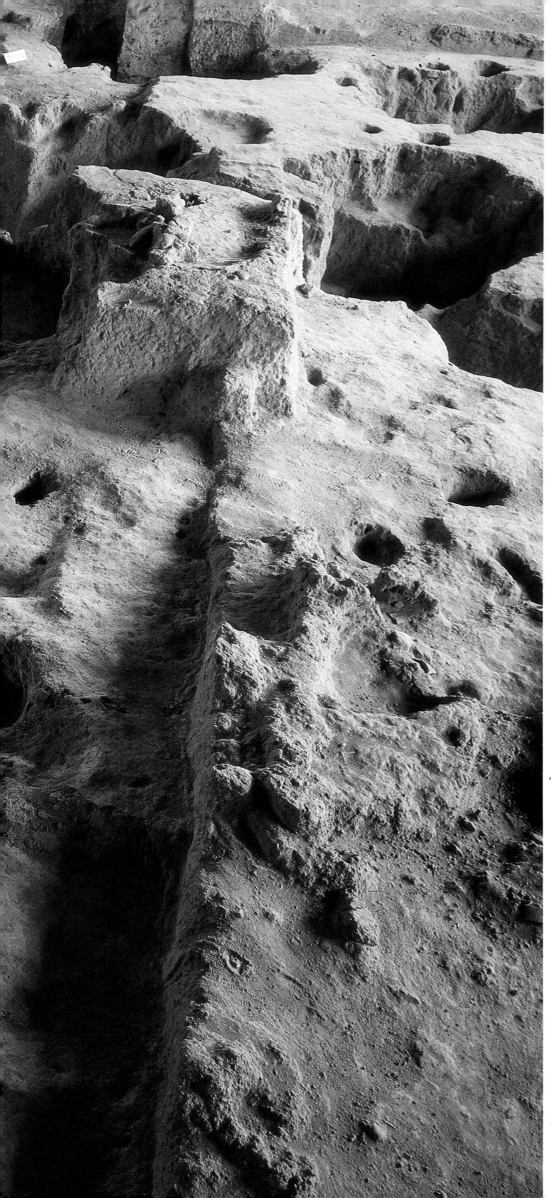

F: Houses H: Storage cellars K: Stoves

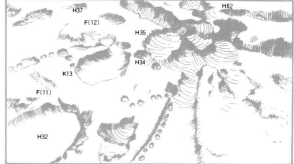

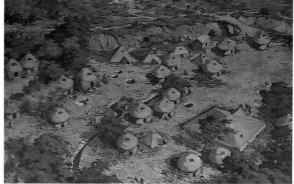

34

32. Remains of a neolithic settlement at Banpo

The Banpo remains are representative of the Yellow River valley Yangshao culture. This site, facing the Chan River and backing on to the Bailu Plateau, is the richest and most populous area east of Xian. In 1953 a large number of cultural remains were discovered here including traces of 45 houses, more than 200 storage cellars, 2 pigsties, 6 pottery kilns, 250 tombs (of which 73 were burial urns containing children) and numerous tool and artefact fragments. This extremely important find reveals much about the life of people in the neolithic age 6,000 to 7,000 years ago.

33. Plan of the remains shown in Plate 32

34. Reconstruction of Banpo Village

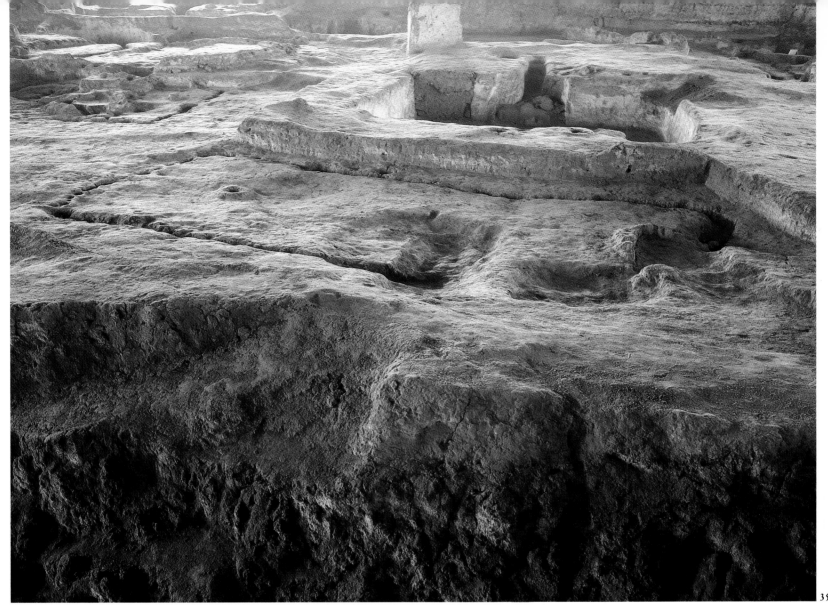

35. The large enclosing ditch and fence

Surrounding the village is a large ditch, 26 feet wide, 20 feet deep and over 980 feet in circumference. It is thought to have been used to defend the settlement against rival tribes and wild animals. Evidence of fencing was also found in two areas, one section 23 feet long and 9 feet wide and the other 19 feet long and 9 feet wide. This was probably used to contain the livestock.

36. Ruins of No. 1 House

No. 1 House is situated at the centre of the living area of the village. It is a semi-underground structure considerably larger than the other houses, with a floor space of 314 square yards and a door opening to the east. It is thought to have been a communal house where villagers met to discuss public matters and hold ritual ceremonies.

37. Reconstruction of No. 1 House

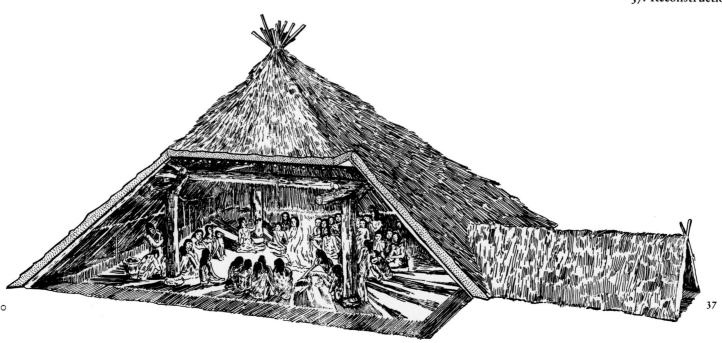

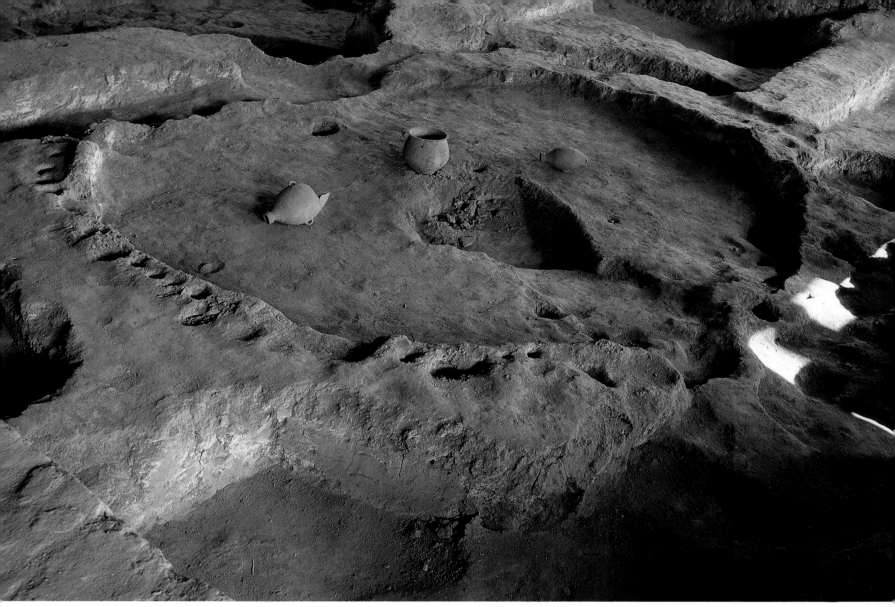

38. Remains of a round house
Traces of thirty-one round houses were found at Banpo. They were either built level with the ground or partly underground. Both types had a framework of wooden pillars covered on both sides with wattle and daub to form walls about eight inches thick. The pillars were arranged so closely that a house sixteen feet in diameter would need up to seventy pillars. Inside the house four to six pillars were used to support the roof. The doors of all the round houses opened to the south and each house had a hearth-pit in the middle. The threshold was always on a slightly lower level than the rest of the house.

39, 40. Reconstructions of round houses

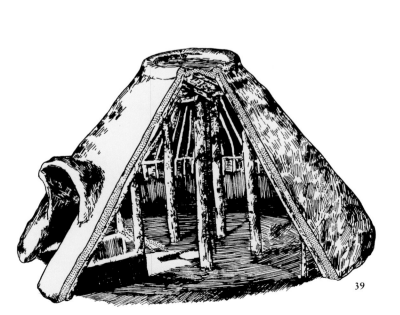

39

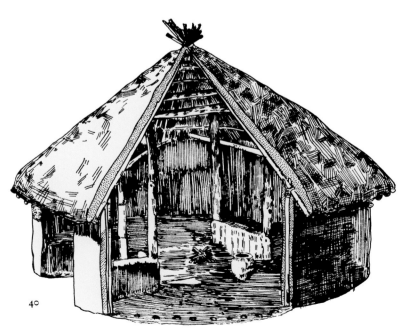

40

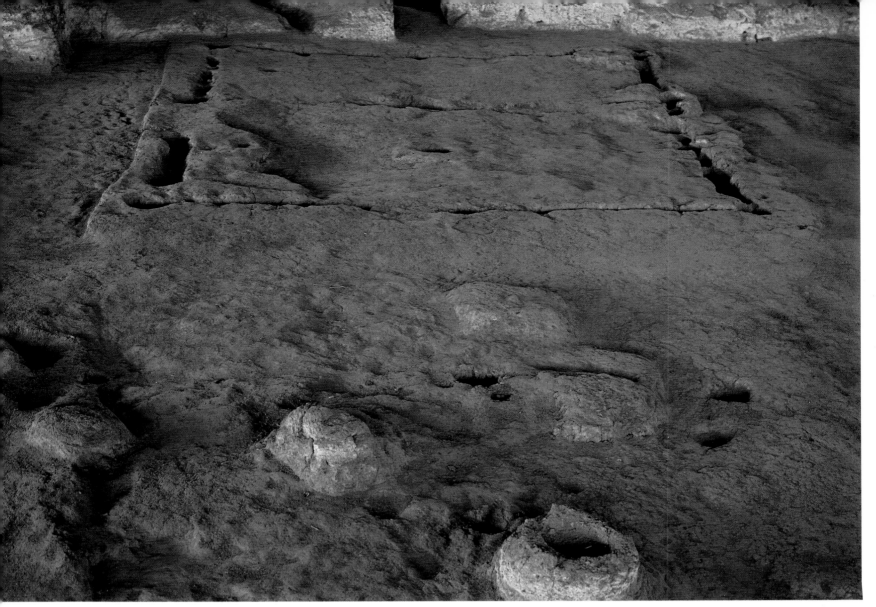

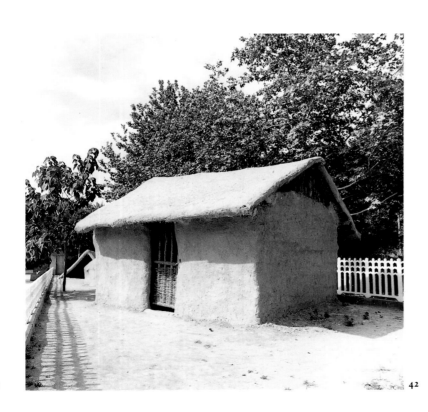

41. Remains of a square house
Remains of fifteen square and rectangular houses were found at Banpo. The average floor space was 40 square yards, but it could range from 20 to 60 square yards. Inside the houses are pillar bases made of rammed earth.

42. Reconstruction of a square house

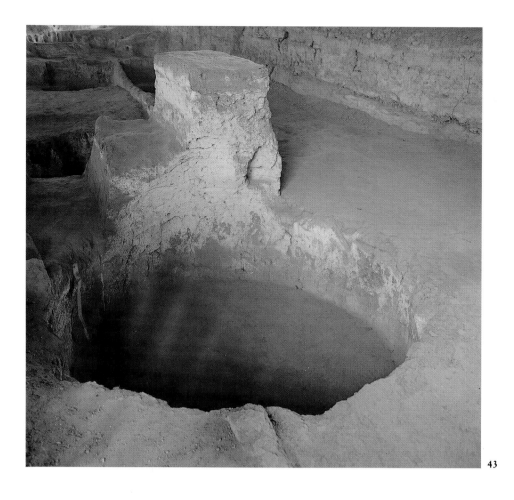

43. Bag-shaped storage pits

Grains of foxtail millet and seeds of brassica cabbage were both found in storage pits at Banpo, suggesting that Banpo man grew more than enough to meet his immediate needs. Storage pits are found both inside and outside the houses. They take three forms: like a bag (that is, with a small opening and a large bottom), an inverted wok or a square with rounded corners. The bag-shaped pit was the most common since it had the largest capacity in relation to the size of its mouth. In general these pits were about 5 feet deep, 3 feet in diameter at the mouth and 6 feet in diameter at the base.

44. Twin-stove hearth

Banpo man used the hearth for cooking, warmth and light. It was usually built inside the house, but this large one seems to have been for communal use, perhaps to keep a fire or to cook large animals. Having two connected stoves both economized on energy resources and provided an extra heat supply.

43

44

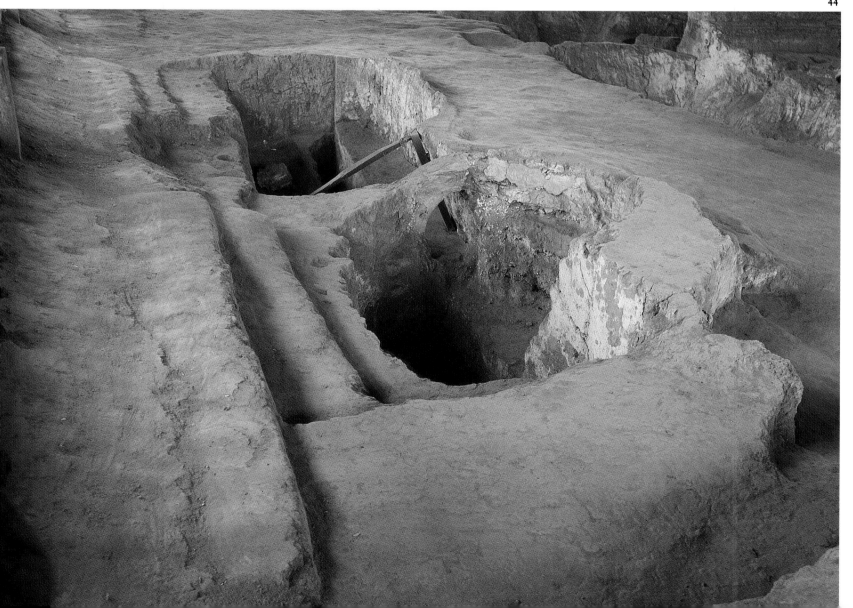

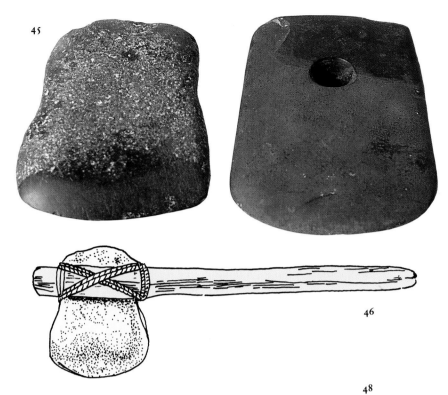

45

45. Stone axe with hole

The stone axes used by Banpo man were mainly ground smooth and some had holes used to secure them to their wooden handles. Two methods were used to make the holes: one was to grind a groove on each side of the axe and then dig out the stone at this point from both sides; the alternative was to drill a hole using a pointed wooden stick and an abrasive made from sand and water.

46. Sketch of a stone axe

46

47

48

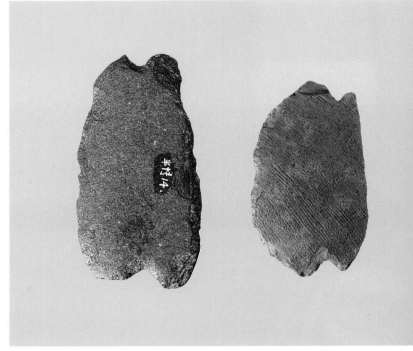

47. Stone balls

Stone balls were mainly used to weight nets in hunting, but may have also been decorations or children's toys.

48. Double-notched stone and pottery knives

The knife was one of the main tools of Banpo man. Both the top and bottom had cutting edges and a rope could be tied around the upper and lower notches for easy holding (as shown below).

49. A double-notched stone knife in use

49

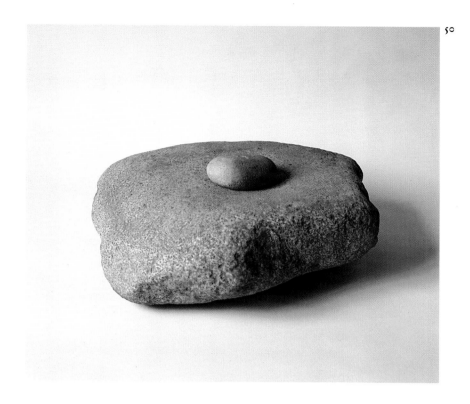

50. Stone mortar
This would probably have been used to hull and grind grain.

51. Ornamental stone and pottery rings

52. Bone needle and shuttles
These are tools used for sewing and weaving. They are delicately made with fine holes.

53. Animal-teeth ornaments
Banpo man wore many varieties of ornaments, such as rings, pearls and pendants made of pottery, stone, jade, bone, horn, teeth and shells.

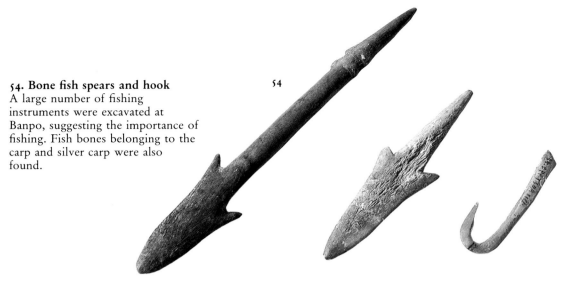

54. Bone fish spears and hook
A large number of fishing instruments were excavated at Banpo, suggesting the importance of fishing. Fish bones belonging to the carp and silver carp were also found.

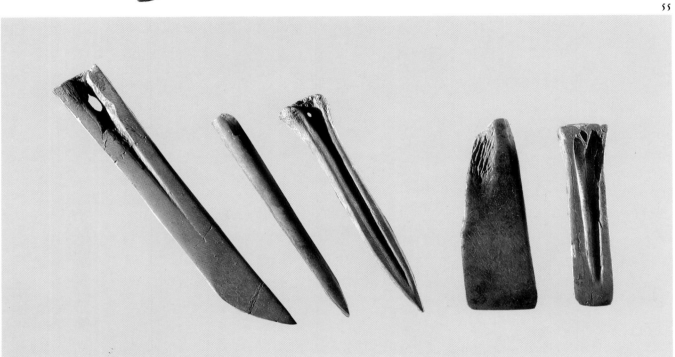

55. Bone knives and scrapers

56. Part of a dog's jawbone

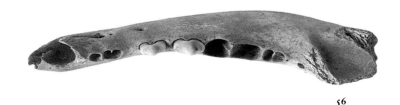

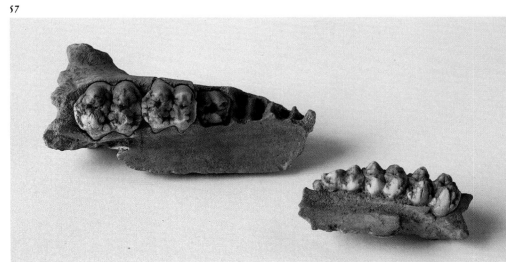

57. Fragments of a pig's jawbone
Banpo man kept both pigs and dogs, pigs probably being the main livestock animal. Most of the pig bones at this site are from piglets. Dogs were a meat source, but were probably also used in hunting and for guarding.

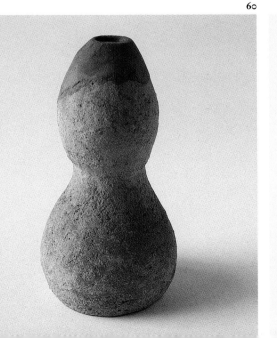

58. Snail shells
The snail was another food source for Banpo man.

59. Amphora
This amphora with a straight neck, bowed body and pointed bottom was used to draw and carry water. It could be lowered by ropes attached to the handles and when full of water would be easy to pour because of its high centre of gravity. It was made from spirals of clay. A large number of this type of water vessel were found at Banpo.

60. Gourd-shaped bottle
The invention of pottery heralds the start of neolithic culture and by the time of Banpo considerable development had occurred. Pottery vessels of many shapes were made in moulds or by coiling, although a turntable may have been used to finish the rims. The bottle shown here is modelled on a gourd and was probably used to carry water, although it could have had a purely decorative function.

61. Jar with relief pattern
The coloured pottery of Banpo and Jiangzhai can be more or less classified according to use: bowls, basins, jars, pots, cups and cooking vessels. The pottery vessels for everyday use were mainly plain red without any additional painted patterns, although some were decorated with relief, carved or impressed designs.

62. Duck-billed mouth jar
Banpo man had a variety of jars with different-shaped mouths for different functions, this type being useful for pouring water into other utensils. This kind of vessel was later developed into the ladle and *yi*, a wine container.

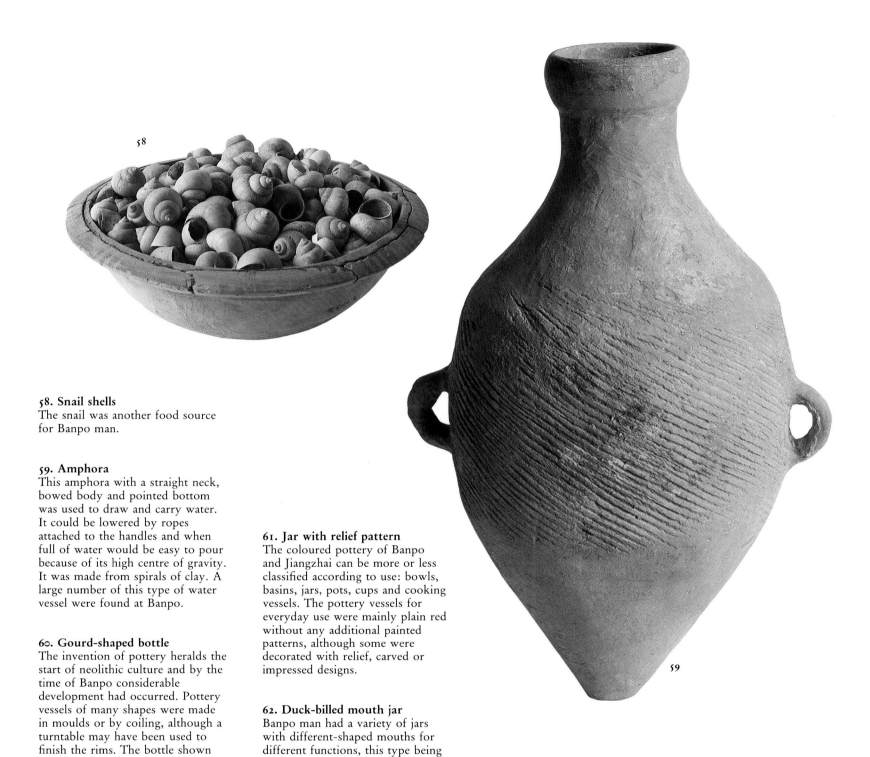

59

60

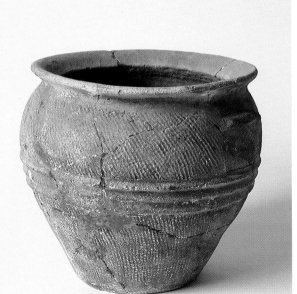

61

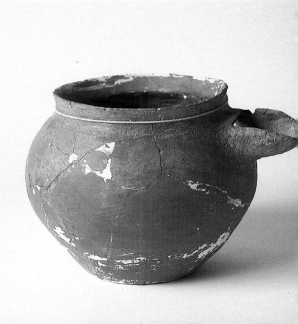

62

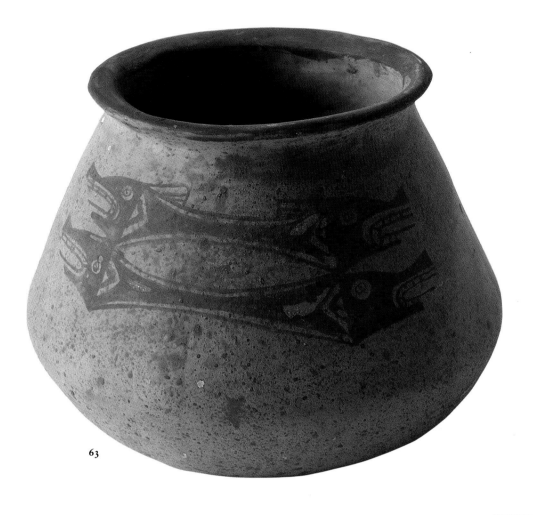

63

63. Jar with double-fish design
This double-fish design is the most common pattern on the painted pottery found at Banpo. The Banpo settlement was near a river and the existence of a large number of fishing implements, along with the prevalence of this design, suggests that fishing was an important activity.

64. Basin with net pattern
The pattern painted on this basin shows a net with even holes, resembling a modern-day fishing net.

65. Bottle with a zigzag pattern

66. Bowl with a triangle pattern
This type of pattern is thought to have been derived from the fish design and reflects the development of the abstract pattern by Banpo man.

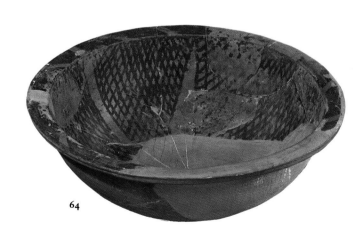

64

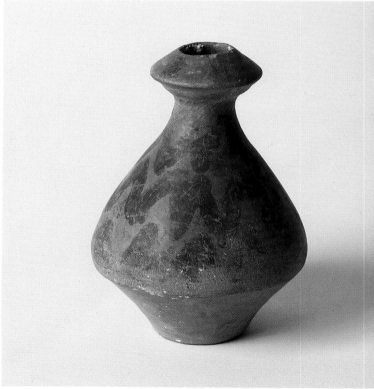

65

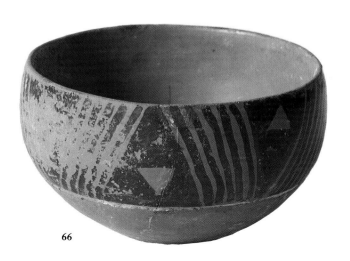

58

66

67. Jar with a pattern made by a fingernail

68. Jar with a pattern made by an awl
The decorations on Banpo pottery mainly derive from everyday life, the commonest being patterns made with fingernails or an awl, impressed patterns and animal designs. A pottery template with engraved patterns was sometimes used which, when pressed against the surface of a vessel, not only joined the cracks but left patterns on its surface.

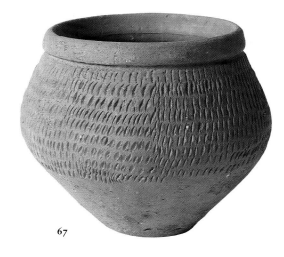

67

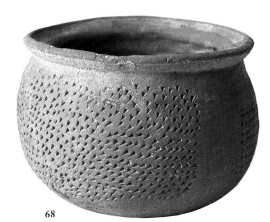

68

69. Pottery piece showing a regular pattern
This pattern of an equilateral triangle composed of holes, with eight holes to each side of the triangle, suggests that Banpo man had a simple concept of numbers.

70. Pottery pieces with inscribed symbols
Altogether 113 examples of inscribed symbols found on the outside edges of pottery shards have been excavated at Banpo. Previously the inscriptions on oracle bones from the Shang period, a thousand years later, were taken to be the first signs of writing in China, but it is now thought that symbols like these may represent a more primitive stage in the development of writing.

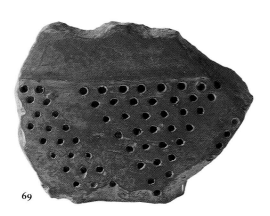

69

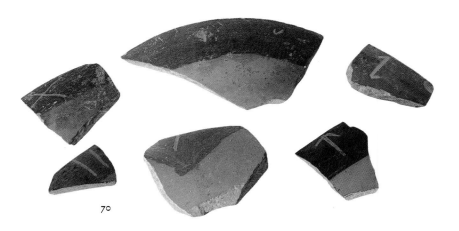

70

71

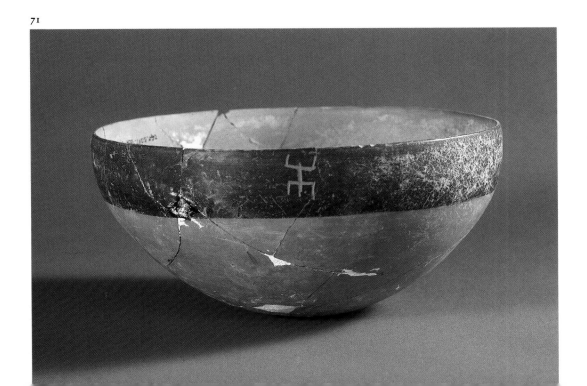

71. Bowl with a dark strip and an engraved symbol
This dark strip pattern is found mainly on round-bottomed bowls in red or black. This bowl has a black strip with a ' ⑪ ' symbol.

72

73

74

75. Pottery frog
This was found at the Yangshao-culture site of Jiangzhai in Lintong County and is the earliest clay frog found to date in China. It is interesting as an example of neolithic realistic art.

76. Eagle tripod
This was found at Quanhu Village, Huaxian County, in 1959. It is made of grey clay and was probably for everyday use.

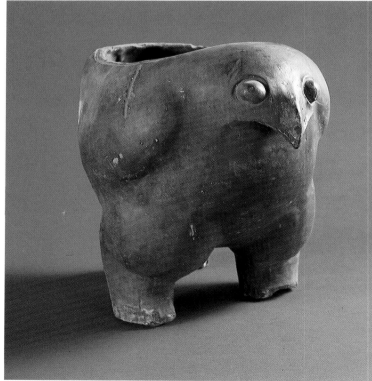

75

72. Pottery bird head
This was an ornament from the lid of a vessel.

73. Lid with an animal-shaped knob

74. Pottery model of a human head

76

77. Painting utensils

This ink-stone with lid, stone grinder and water cup was found at Jiangzhai. Although the ink-stone is damaged and worn, the round hollow in the centre still shows signs of coloured ink. The grinder is also very worn, indicating prolonged use. The cup is beautifully crafted out of a fine grey clay. These painting implements, dating from 6000 BP, are the earliest to be found in China.

78. Turquoise pendants

These pendants, found at Jiangzhai, are mainly rhombus-shaped, 6 to 12 inches long, with holes at the ends, presumably for a thread.

79. Jars with lids

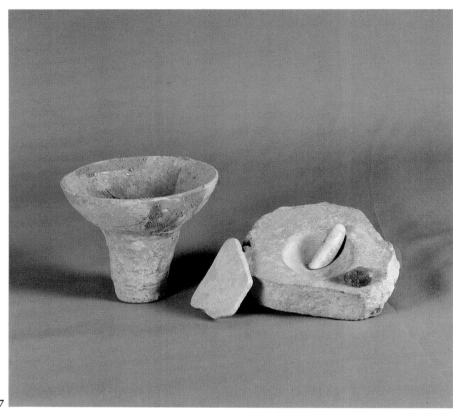

77

78

79

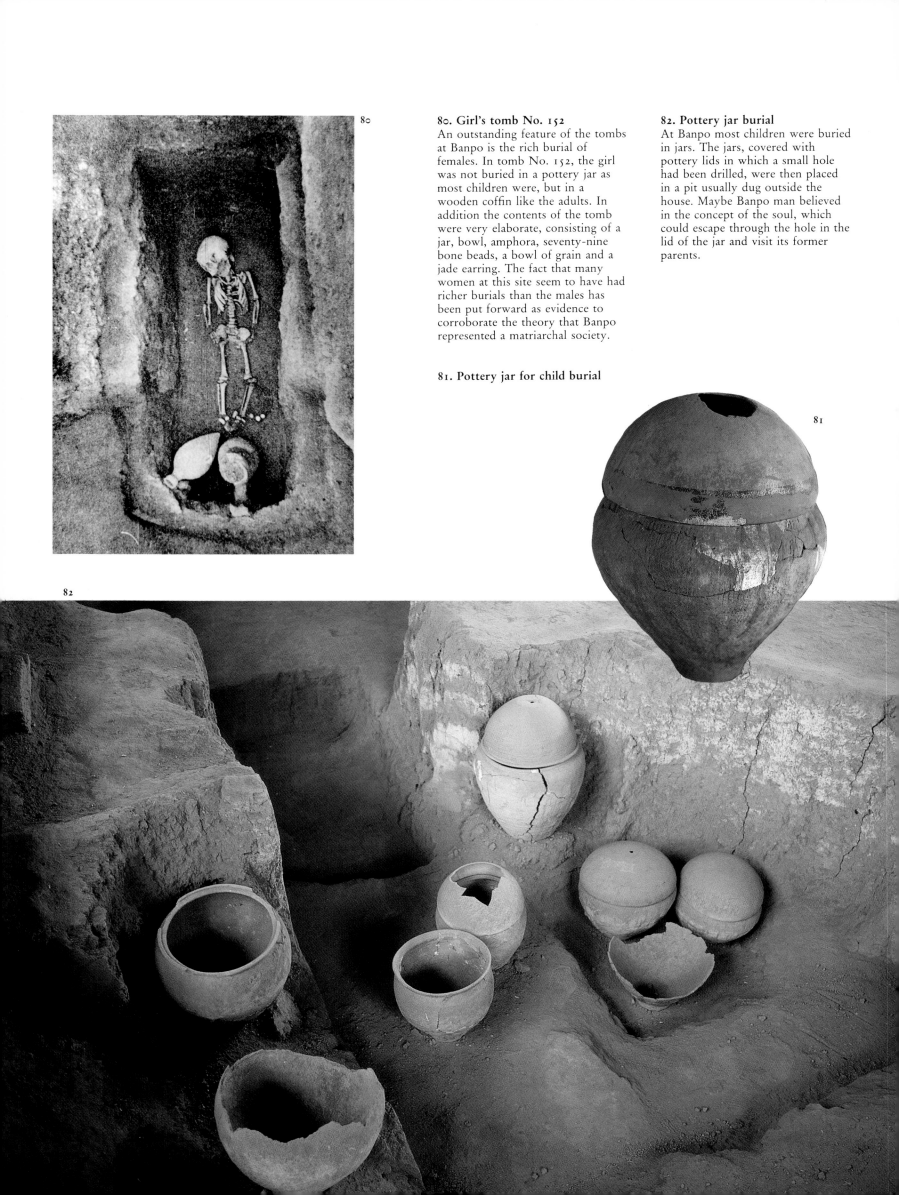

80. Girl's tomb No. 152
An outstanding feature of the tombs at Banpo is the rich burial of females. In tomb No. 152, the girl was not buried in a pottery jar as most children were, but in a wooden coffin like the adults. In addition the contents of the tomb were very elaborate, consisting of a jar, bowl, amphora, seventy-nine bone beads, a bowl of grain and a jade earring. The fact that many women at this site seem to have had richer burials than the males has been put forward as evidence to corroborate the theory that Banpo represented a matriarchal society.

81. Pottery jar for child burial

82. Pottery jar burial
At Banpo most children were buried in jars. The jars, covered with pottery lids in which a small hole had been drilled, were then placed in a pit usually dug outside the house. Maybe Banpo man believed in the concept of the soul, which could escape through the hole in the lid of the jar and visit its former parents.

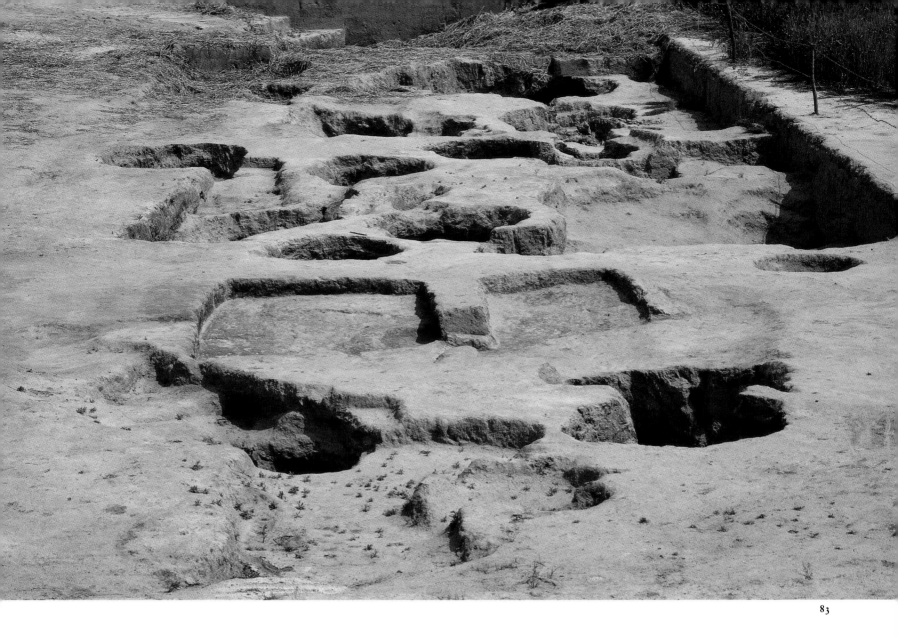

83. Ruins of houses at Kexingzhuang
These remains at Kexingzhuang, a Longshan-culture neolithic site, are on the west bank of the Feng River, west of Xian. There were ten houses at this site, all semi-underground and consisting of two rooms, without common walls but connected by passages.

84. Clay phallic images
These clay phallic images are common in the Longshan culture, but are first seen in the late Yangshao period. Studies suggest that these were used in worship; perhaps the precursor of the Shang and Zhou ceremony of ancestor worship in which the ancestral tablet, the symbol of the clan's ancestors, is also thought to be a phallic image. The discovery of such images suggests a patriarchal society.

84

85. *Gui*, a tripodal cooking vessel
This was found at Kexingzhuang. The *gui* was one of the main utensils of the neolithic Shaanxi Longshan culture. Its design, with three hollow legs, body and handle, was effective in transmitting the heat underneath the vessel to its contents.

86. Shell sickle
Tools made of shells were first found at sites dating from the Longshan culture. This shell sickle would have been used for harvesting crops and is hard and sharp yet still light in weight.

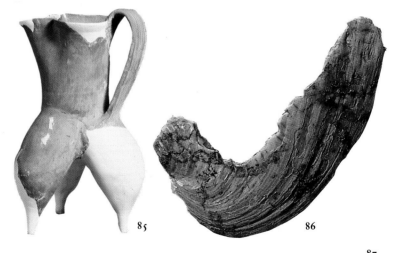

85 86

87

87. Inscription on bone
From 1985 to 1986 more than thirty pieces of inscribed bone were found at the later Longshan-culture site at Doumen, near Xian. The inscriptions are clear and more than ten characters can be distinguished. Specialists believe these are, to date, the earliest inscriptions on bones – used throughout the Shang dynasty as a means of divination – found in China and herald the dawning of Chinese civilization.

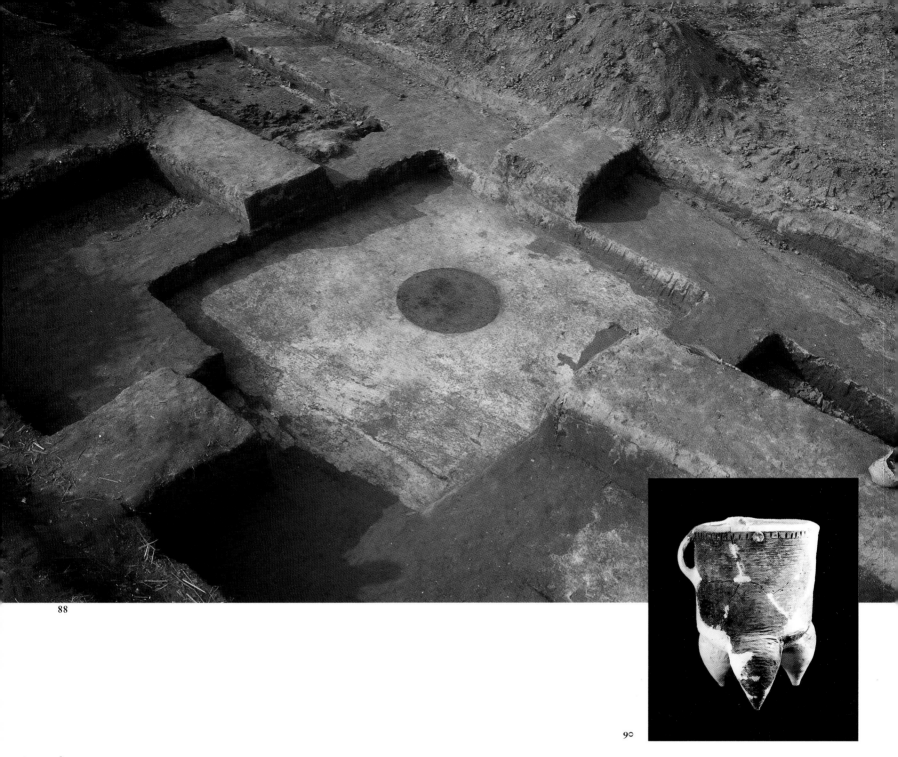

88

90

89

64

88, 89. Ruins at Kangjiacun
This site, in Lintong County near
Xian, has an area of over 2,700
square yards and belongs to the
neolithic Longshan culture. In 1982
over 30 houses, along with 21 lime
pits, 2 tombs and 2 pottery kilns,
were discovered in an area of 1,500
square yards. Stone axes, chisels,
rollers, knives, spinning-wheels,
bone awls, shell knives and other
everyday utensils were also found.

90. *Jia*, a tripodal cooking vessel
This *jia* was found at Kangjiacun.

91. Mt Qiao
Mt Qiao, about ninety miles north of Xian, is where, according to legend, the Yellow Emperor was buried. It is covered with ancient cypresses and the Ju River flows to the west.

92. Tomb of the personal effects of the Yellow Emperor
According to legend, the Yellow Emperor was the head of a powerful and united group of tribes on the north bank of the Wei River some 4,000 to 5,000 years ago. The tribe later moved east, asserting its control over the lower and middle reaches of the Yellow River. After a hundred years of rule the Yellow Emperor died on Mt Jing and ascended to heaven on the back of a dragon. The tomb on the summit of Mt Qiao is purported to contain his personal effects. In front of the tomb is a stele with the inscription, 'The Dragon Rider on Mount Qiao'.

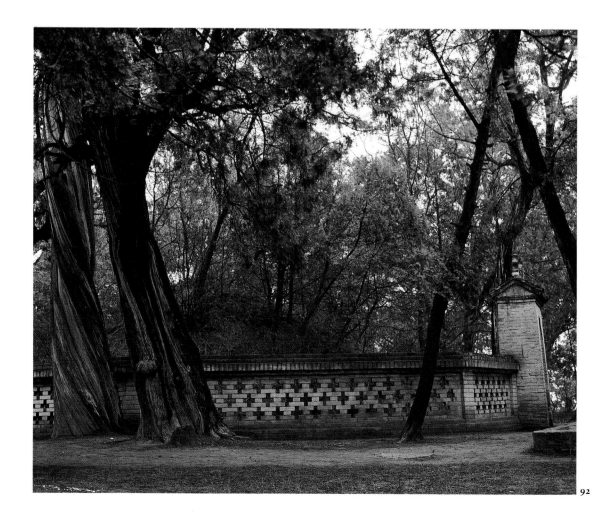

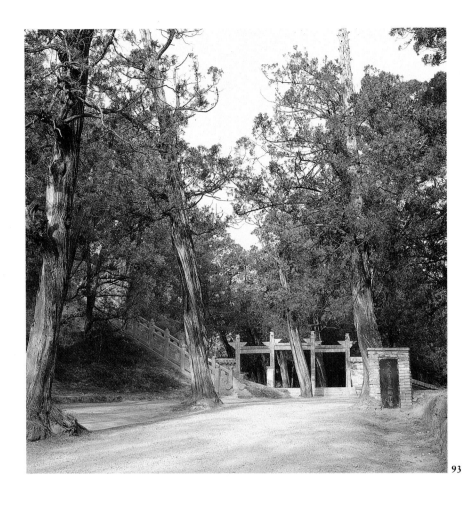

93. Dismounting stele
In ancient times it was part of the official protocol to dismount from horseback and remove armour before passing this stele, in order to show respect for the Yellow Emperor when visiting his tomb.

94. Xuanyuan cypress
Xuanyuan Temple at the foot of Mt Qiao contains many old cypresses, the oldest being about 62 feet high and 33 feet in circumference at the bottom. It is said that it was planted by the Yellow Emperor more than 4,000 years ago.

95. Celestial platform of the Han emperor Wu
This is a 65-foot-high earth platform opposite the tomb on Mt Qiao. Emperor Wu is said to have had it built so that he could offer sacrifices to his ancestor, the Yellow Emperor, after returning from travels to the north.

93

94

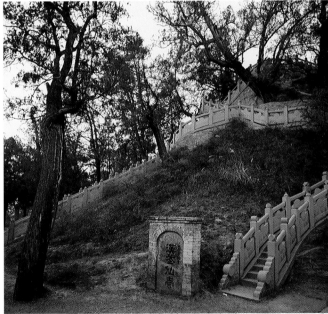

95

3.

From the Cities of Feng and Hao to Changan and Xian

The capitals established in the area around Xian were all outstanding examples of city design, planning and construction in their time. These cities, which became larger and more majestic with each dynasty, provide an unfolding spectacle of the development of civilization.

The Zhou Plateau and the Cities of Feng and Hao

The successive capitals of the Shang dynasty, the first Chinese dynasty to be supported by archaeological evidence, were all in Henan Province, and the move to Anyang, the site of the seventh and final capital, probably took place in about 1600 BC. Five hundred years later the Shang dynasty was destroyed by the state of Zhou, whose power lay in the region of the Wei River valley to the west. According to traditional sources, the Zhou peoples had originally lived in the mountains and plateaus along the Jing River in the western part of central Shaanxi Province. This was a demanding environment, as they were under constant threat of attack from the Shang people to the east, the Xunyu people to the north and other nomadic tribes. It is recorded that the Zhou led a semi-nomadic life, settling for a time in Tai (Wugong), then moving to Bin (Xunyi) before their leader, Gongfu Tanfu, finally led them to the Zhou Plateau (between Mt Qi and Fufeng). Here they settled, more secure from attack with Mt Qi to the north and the river to the south, and with an expanse of fertile land on the northern bank of the Wei River which was able to sustain agriculture. The building of the city, Qi, was supervised by specially appointed officials who followed a master plan. Documents record that the city had tall gates, with watchtowers for defence, and that there were palaces and an area where artisans lived and worked.

After several generations of able rulers, the Zhou state grew stronger and continued to develop its power in the east. In 1136 BC when King Wen destroyed the Shang aristocracy in the middle reaches of the Wei River he built the new city of Feng and moved his capital there. One year later he died and was succeeded by King Wu, who built the city of Hao to the east of Feng. The purpose of moving the capital was probably to expand eastwards in order to eliminate the Shang completely. Central Shaanxi Province had convenient transport lines so that the feudal lords and their troops could readily be summoned to the capital for battle. In addition, the Feng River ran between the cities, offering an abundant water supply, and there was fertile land all around. In less than twelve years the Zhou state had subdued the Shang and established the Western Zhou dynasty, keeping Feng and Hao as imperial capitals for 300 years.

Feng and Hao stood on opposite banks of the Feng River, sixteen miles apart. Hao, where the Zhou emperors lived, served as a political centre, while Feng consisted of the imperial ancestral temples and pleasure parks. The emperors often crossed the Feng River to offer sacrifices or holiday in Feng. These two cities with their different functions formed the first large-scale metropolitan area in Shaanxi. According to *Zhouli*, an ancient book concerning the Zhou dynasty, Hao was 4.5 miles square with three gates facing each direction. The Imperial Palace was at the centre, surrounded by the Hall of Administration, the Ancestral Temple, the market and the Temple to the Gods of Earth and Grain, all arranged symmetrically. In the later years of the Western Zhou the cities were invaded by the Quanrong people from the west and the next ruler, King Ping, was forced to move his capital east

to the region of Luoyang. This signalled the end of the period usually referred to as the Western Zhou and the start of the Eastern Zhou period. Feng and Hao were abandoned and it is recorded that they were soon in total ruin, with crops growing in the former Imperial Palace.

The exact sites of Feng and Hao have yet to be verified, but seven pits containing chariots, horses and other Zhou burial objects were discovered at Fengxi, and a concentration of Western Zhou relics and tombs was found in the area of Doumen in Changan County on the east bank of the Feng River. It can therefore be assumed that the sites of Feng and Hao are somewhere around these two areas.

In recent years large-scale ruins of Zhou palaces and ancestral temples have been excavated in Fengchicun in Qishan County and Zhaochencun in Fufeng County, the site of the previous capital, Qi. These have helped to compensate for the lack of actual material on the architecture of the Western Zhou palaces in Feng and Hao. These early Zhou palaces consisted of groups of buildings with screen walls, flat, pipe and eave roof-tiles and an underground pottery drainage system. Most had several front and rear courtyards and buildings arranged symmetrically to the east and west, indicating that the characteristics of ancient Chinese architecture had already taken shape 4,000 years ago: the mainly wooden framework and the well-proportioned and symmetrical plane layout, with the main buildings all on a central axis and the subsidiary buildings to either side.

Xianyang – Capital of the Qin

After King Ping of the Zhou had moved the capital east the Qin people from the Tianshui area in Gansu Province to the west rose in revolt and, following hard on his heels, entered the western part of Shaanxi Province, establishing their capital at Yong (Fengxiang County) in 677 BC. The Qin's first ambition was to conquer the whole of central Shaanxi and expand their territory to the banks of the Yellow River. It is reported that they first moved to Jingyang and then, in 383 BC, to Yueyang (Wutun in Lintong County east of Xian). Finally, Xianyang was chosen as capital in 350 BC, probably at the suggestion of the influential adviser Shang Yang.

Xianyang in the Qin dynasty was located over six miles to the east of the modern city, with Mt Liang to the north and the Wei River to the south. In ancient times the area south of a mountain and north of a river was called *yang* and Xianyang was thus named. At the heart of the land within the passes, it enjoyed almost impregnable natural defences and fertile land. In addition, the Qin controlled the ancient ferry pass on the Wei River which linked the roads running east and west across central Shaanxi. With Xianyang as their base they were able to launch successful attacks through Hangu Pass on the other six states (the Zhou by this time ruling in name only) and unify China in 221 BC. Xianyang then became the next great imperial capital to be located in this region.

During its 140-year history the city witnessed the formulation and application of a whole series of reforms, which effectively abolished the Zhou system of feudalism, replacing it with a bureaucracy paid for by taxes and corvée, which standardized weights and measures and reformed the Chinese script.

Yong, Yueyang and Xianyang, three capitals of Qin, have all been excavated in recent years. Xianyang itself was quite small, about 4 miles long by 2.5 miles wide, but it was linked with many palace sites in the area and it is

recorded that by the time of King Zhuang Xiang (250–247 BC) the palaces, houses, towers and roads of the city extended for over fifteen miles. Every time another state was conquered a palace was built near Xianyang, modelled on that of the conquered state. Not only did the styles of architecture come from all over China, but with the forced relocation of 120,000 wealthy and powerful families to the capital following the unification of China, Xianyang also had a large, heterogeneous population, with different customs and lifestyles.

The ruins of palace site No. 1, about ten miles east of modern Xianyang, probably comprise one of the major palace buildings in the Xianyang complex. Built in the Warring States period these buildings show signs of being renovated more than once in the time of the First Emperor. They form a multi-storeyed complex with raised galleries connecting the buildings, which were arranged along an axis. Care and attention were paid to all aspects of the design and the sophistication of this layout, along with the evidence we have of polychromic murals, interconnected cord-marked pottery water-pipes, decorated bricks, eave-tiles and bronze door-ring bases, suggests a high standard of architecture.

A study of the development of Xianyang during the Qin dynasty reveals the gradual move of the centre of the city to south of the Wei River. From 220 BC there was large-scale construction on the south bank. Xin Palace was built first as the core of a palace complex which later comprised Linguang Palace on Mt Li and Bei Palace on Beiling Plateau, all linked to the city by a large, stone-pillared bridge across the Wei. This layout was such that 'the Wei resembled the Milky Way, the bridge fording the earthly water in the south just like the Altair Star crosses the heavenly stream'. In 212 BC the construction of what was to be an even larger group of palaces began. Several years of labour by 720,000 workers resulted in the completion of the front palace only, the famous Afang Palace. According to historical records this was so large that 'the dais could seat 10,000 people and flags fifty-four feet high could be erected in the hall below'. With the addition of this building to the existing palaces, 'the road built in the Zhou became an inter-palace thoroughfare ... The palace complex covered an area over ninety miles in circumference with pleasure gardens, parks and side palaces linked by paths. The imperial road extended as far as Mt Li, twenty-five miles away. The peak of Mt Nan was the palace watchtower and Fanchuan Lake its pool.' It was a colossal project. Today there exists a rectangular, rammed-earth platform to the south-west of Sanqiao in the western suburbs of Xian, which is 3,280 feet by 1,640 feet and 23 to 26 feet high at the rear. Fragments of tiles dating from the Qin have been found on the platform.

Han Changan – Long Rule and Eternal Peace

After the Qin was defeated, Liu Bang and Xiang Yu contended for sovereignty in central China. Liu Bang first conquered central Shaanxi and, like the Zhou and the Qin before him, used it as a base to conquer the whole country. Xiang Yu, who had placed undue importance on the defence of Eastern Chu, was finally defeated but not before he had razed Xianyang to the ground. In 202 BC Liu Bang's advisers, Zhang Liang and Lou Jing, proposed that the Han capital be established in the land within the passes. Changan (eternal peace) was originally the name of a town opposite the Qin city of Xianyang, on the south bank of the Wei, and because Liu Bang 'wished his

descendants to live in eternal peace' he named his capital after this town. The basic construction was completed in four years, from 194 to 190 BC.

The city is situated about six miles north-west of modern Xian, on the Longshou Plateau, with the Zao River to the north, occupying an area of fourteen square miles. It thus enjoyed the same advantages as had the Zhou and Qin capitals, but without being under threat of flooding like the cities of Feng and Hao, and with more room to expand than Xianyang. The city was in fact developed from the resort palaces of the Qin, which were located to the south of the Wei River. It may be regarded, therefore, as a continuation and development of Xianyang. However, it seems to have been built according to rules purportedly laid down in the Zhou dynasty on the ideal city plan, and detailed in *Zhouli*, a book concerning Zhou ritual. This plan was used as a model for city builders of successive dynasties.

Although Changan was basically rectangular in shape, the north wall was restricted by the course of the river and the south wall by the palaces built before the city walls, so that they both twisted and turned. There were twelve gates altogether. Each had three gateways with roads passing through them. Each gateway was twenty feet wide, exactly four times the width of a carriage, and the middle one was reserved for the emperor. The eight avenues that formed a grid pattern were all the same width. They were each divided into three sections by two parallel drainage ditches. The central section, like the central gateway, was reserved for the emperor and was the widest, at about sixty-six feet. The outside lanes were all about forty feet wide and were used by everyone else. Chinese scholar trees, elms, pines and cypresses lined the avenues. The southern and central parts of the city were occupied by palaces while the residential areas, artisans' quarters and markets were in the northern part. In all there were 160 residential lanes, each lined with up to 200 houses, 'packed together with doorways side by side'. The city had nine markets, known collectively as the Eastern and Western Markets because of their respective positions to either side of one of the avenues. High watchtowers in the markets were established and managed by the local authorities, to monitor the trade and maintain public order.

The imperial palaces took up two-thirds of the area of the city. The famous 'Three Inner Palaces' were the Changle, Weiyang and Jianzhang Palaces. Changle Palace stood at the south-east corner of the city and its foundations remain today near Laomencun in Xibeige. In the early Han dynasty this was where the emperor administered to state affairs, and it later became the residential palace of the dowager empress.

Weiyang Palace was located to the south-west of the city and was built with the maxim, 'it is not beauty but majesty that matters', in mind. It was sited on a natural hill, thus symbolizing the supremacy of the emperor over the country. Throughout the Western Han dynasty it was the centre of political power, and grand ceremonies such as the emperor's ascension, birthday celebrations and funeral were all held there.

In 104 BC Emperor Wu built Jianzhang Palace just to the west of the city. From historical records it seems to have been a structure that fully embodied the mysterious and romantic trends in architecture that were developing in this prosperous period of the Western Han. It is recorded that the palace complex consisted of twenty-six

halls and was renowned for its 'thousand doors and million windows'. Several of its structures, including Shenming Platform (which housed a bronze statue of a celestial being with a dew-holding plate) and the wooden Jinggan Tower, were purported to be dozens of yards tall. Treasures and rare stones, tributes from foreign countries, were kept in Qihua Hall. To the north-west of the front hall was a large, man-made lake called Taiye, and the palace was thus described as a celestial island on the Zheng Sea, with the carved golden and stone fishes, dragons, rare birds and precious animals on the lake giving it the atmosphere of a Garden of Eden. In 1973 a huge stone sculpture of a fish was found to the north of this lake site, substantiating at least part of these records.

In addition to the Three Inner Palaces described above, the city accommodated the Bei, Gui and Mingguang Palaces. These, although smaller in scale, were all extremely beautiful, being painted in gold and inlaid with jade. Within the city elevated walkways linked the palaces, so that visits among members of the imperial family would not be witnessed by the common people.

Changan in the Sui and Tang Dynasties – A Brilliant New City

A city survived on the site of Han Changan for 800 years. Although it was destroyed by marauding armies many times in the chaotic period following the downfall of the Eastern Han dynasty, it was still the capital of the Former Zhao, Former Qin, Later Qin, Western Wei, Northern Zhou and early Sui dynasties. Only when the Sui emperor Wen reunified China in AD 581 was it finally abandoned as a city and turned into an imperial garden. A new capital, Daxing, was built. This became Changan in the Tang dynasty.

Geomancy and the rules for the ideal city were the two major factors in the siting and design of Daxing. The Chinese believed that by following these they would ensure a long and successful dynasty. The chief designer, Yu Wenkai, took the good points of Luoyang of the Northern Wei and Yedu of the Eastern Wei and Northern Qi and combined them with the topographical features of the area in an overall plan of the urban development of the vast area south of the Longshou Plateau. He ingeniously used the natural terracing of the plateau to site the buildings according to their importance. The imperial palace was therefore built on the 'most honourable' (that is, the highest) of the high ground, while government offices, important temples and officials' residences were placed on the other levels, all overlooking the rest of the city. The ordinary people lived on the low-lying and flat places. In terms of architectural style, the topographical features of the area were fully exploited so as to make the whole city multi-layered and solid. Ditches and lakes were dug in low-lying areas of the city to supply water.

These features of Daxing were maintained when it became the capital of the Tang, and there was constant renovation of the Sui buildings. The famous architect Yan Lide led the construction of new outer walls to contain the rapidly expanding city. They had a circumference of 40 miles, enclosing a rectangular area of 32 square miles, with the east–west side slightly longer than the north–south side. Most of the buildings faced south, at right angles to a central axis running along Changtianmen Street and Zhuquemen Street, which traversed the city from east to west. The Palace City, where the emperor lived and administered state affairs, was the centre of the

northern city, and the Imperial City, which housed the Imperial Ancestral Temple, the Temple of the Gods of Earth and Grain, the central government and military organizations, was located to the south of the Palace City. The rest of the city was all residential and commercial. It differed from Han Changan in that the residential areas occupied the greater part of the city and were entirely separate from the palaces and government offices. These residential areas were divided by eleven streets running from north to south and fourteen avenues running east to west, partitioning them in a chequerboard fashion into 109 units. Each unit was further divided by large and small intersecting streets into four blocks of sixteen small lots. Most houses were built around three sides of a courtyard with the fourth side open, but there were also small lanes in these lots containing houses built side by side, facing directly on to the lane. Every unit or ward was encircled by walls and gates. This type of enclosed unit was one of the unique features of Tang Changan.

Trade and commerce were concentrated in the East and West Markets, located to the south-east and south-west of the Imperial City, each occupying an area equal to two units. They were divided by streets into a grid of nine small blocks. The streets were 52 feet wide and 20-foot-wide shops opened in the small blocks facing on to the streets. There were more than 200 trades in each market, with buyers and sellers converging here, so that 'precious goods from the four corners of the land all accumulated in this place'. From the mid-Tang period, stores, snack-bars and handicraft shops could also be found in many of the residential wards and night markets also appeared, although the government had issued orders forbidding these. 'There was clamour and uproar both day and night and lights burned constantly.'

The population in Tang Changan exceeded 1 million. Administrative, military and police work was very strict and there were special organizations in charge of order on the streets, trading in the markets, weights and measures, the clergy and water-conservancy projects. A curfew was imposed and all the city and ward gates were opened and closed at fixed times. It was strictly forbidden for anyone to walk in the streets at night except from the 14th to 16th in the first lunar month during the Lantern Festival. Great attention was paid to the neatness of the city, with Chinese scholar trees, willows and elms shading the streets and elegant gardens with bamboo, shrubs and flowers to be found within the residential areas. In the areas outside the city, like Qujiang Lake and Huaqing Palace on Mt Li, man-made gardens and buildings were integrated with the natural landscape to create scenic spots of a unique style, the development of Chinese gardens and architecture reaching a peak at this time.

The Three Inner Palaces in the Tang Capital

There were three major palaces in Tang Changan. The West Inner Palace – Taiji Palace – took up half of the total area of the Palace City and was where the emperor lived. There was a large number of troops stationed at its north gate, Xuanwu Gate, to defend the palace. It was here that Li Shimin, the Tang emperor Taizong, launched the Xuanwumen coup to seize his father's throne. The south gate, Chengtian, was where the emperor received audiences. The street which ran east–west between this gate and the imperial city was 1,350 feet wide and was also an imperial square where grand state ceremonies, troop inspections and acceptances of surrenders were held. Taiji

Hall was the front hall of this palace and was where the emperor daily received his ministers and high officials. To the north of Taiji Hall was Liangyi Hall, which was the Inner Imperial Palace, where the emperor held discussions with trusted ministers. Further north were Ganlu, Yanjia and other halls, all lying on the same axis.

The East Inner Palace – Daming Palace – which was on the Longshou Plateau, was expanded in AD 662–3 by Emperor Gaozong on the plan of Emperor Gaozu's Yongan Palace. It was the largest of the three inner palaces and stood on the highest point, perfectly in keeping with and reflecting the unprecedented prosperity of the Tang period. It was both grand and beautiful. Hanyuan Hall, the front hall, was over 26 feet high. Three flights of steps about 250 feet long descended from its front entrance to the plateau. Looking up from the foot of the steps the hall was said to be so awe-inspiring that it resembled a heavenly palace amid the clouds. Another famous hall was Linde Hall where the emperor worshipped, held banquets for ministers and high officials and enjoyed displays of dancing, singing and music. Its front, middle and rear halls were all linked together; the middle hall was the main one and thus higher than the other two, and it was lit from the ceiling. A winding corridor connected the halls, with towers and pavilions on both sides. This novel structure, with three halls linked together as one, meant it could meet the varying needs of palace functions as effectively as the other palaces with their many separate halls. To the east was a scenic garden with Taiye Lake at its centre.

Xingqing Palace, located in the Xingqing ward in the eastern part of the city, was built by Emperor Xuanzong and was where he lived, administered state affairs and was entertained. It had a less formal layout than Taiji and Daming; there was no division into inner, middle and outer halls, the one main hall being used for all the different functions. Qinzheng Wuben Tower, Hua'e Xianghui Tower, Chanxiang Pavilion and Nanxun Hall were all buildings in this complex.

From Changan to Xian
The flourishing city of Changan was destroyed at the end of the Tang dynasty in peasant wars and conflicts between different warlords. In 904 the chief of the Tang imperial army, Han Jian, who was garrisoned at Changan, abandoned the Outer and Palace Cities and rebuilt the Imperial City. This was given a succession of names – Da'an, Jingzhao, Shaanxi, Anxi and Fengyuan – in the different periods from the Five Dynasties to the Yuan (907–1368). Despite the fact that it was never again the capital, it continued to play a major role in the defence of north-west China. Marco Polo wrote in his records that Changan of the Yuan was a bustling commercial and industrial city with abundant goods for sale and that the palace of Prince Anxi in the north-eastern part of the city was 'of such size and beauty that it could not be bettered'. However, in many aspects it was nothing in comparison to its former splendour.

After the founding of the Ming dynasty (1368) the name of the city was changed from Fengyuan into Xian. Emperor Taizu granted his second son Zhu the title of Prince Qin who Garrisoned Xian. To consolidate Ming's control over the north-west, it was rebuilt in 1374 at the same time as the Imperial City in Beijing. The rebuilt Xian was of the same size on its west and south sides as that of Fengyuan, while its other two sides were about a third as large again. It was 3.7 miles in circumference and encircled by high and strong walls on which towers were built. These walls were reinforced in 1568 and then renovated in 1642. By then the city's outlook and size were the same as today.

Present-day Xian still retains many aspects of its Ming past and is the most intact fortified city structure still existing in China. During the Qing dynasty (1644–1911), large numbers of Manchu moved to Xian, and the north-east corner of the city became a 'Manchu City', garrisoned by them. Xian was later turned into a military fort with the Palace of Prince Qin forming the Eight Banner Drill Ground where horses were trained and arms presented. Although the city's body – the moat, towers, walls and wall-top fortifications – was reconstructed and restored many times, its vital organs – industry, commerce and diversified construction – were neglected after this period and it was never to regain the glory of its past.

96

96. Zhou Plateau
This area is in the western part of the land within the passes, with Mt Qi to the north and the Wei River to the south. It has a warm, humid climate. Numerous artefacts and ruins dating from the Zhou dynasty have been found here, including the palace halls of the early and middle Western Zhou period, along with 15,000 inscribed bones and tortoise shells, 170 divination bones and a large number of bronze, jade and pottery objects.

97. Ruins of a Zhou-dynasty palace on the Zhou Plateau
Ruins of Zhou palaces have been found at two sites on the Zhou Plateau: Fengchu in Qishan County and Zhaoling in Fufeng County. This photograph shows the ruins at Fengchu, which date back to the early Western Zhou dynasty and cover an area of almost 30,000 square yards. All the buildings face south in a regular layout. The screen, gates, central courtyard, main hall and corridors lie on a central axis. On either side of this axis are front and rear halls and houses in enclosed compounds.

98. Plan of the Zhou ruins at Fengchu

97

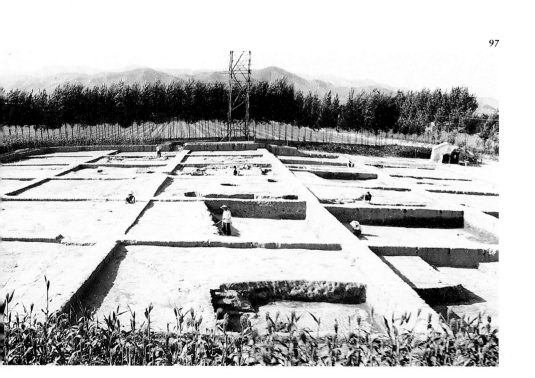

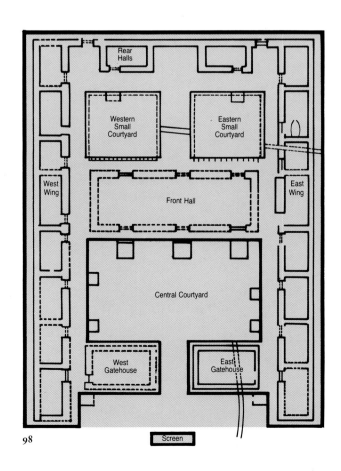

98

99. Feng River

The Feng River's source is at Mt Zhongnan and it joins the Yu and Hao Rivers at Xiangji Temple south of Xian before emptying into the Wei. Feng and Hao, capitals of the Western Zhou, were built on either bank of this river and the Qin and Eastern Han dynasty capitals, Xianyang and Changan, were also sited close to the confluence of the Feng and Wei. Kunming Lake, a resort lake in the Han and Tang dynasties, was replenished by the Feng.

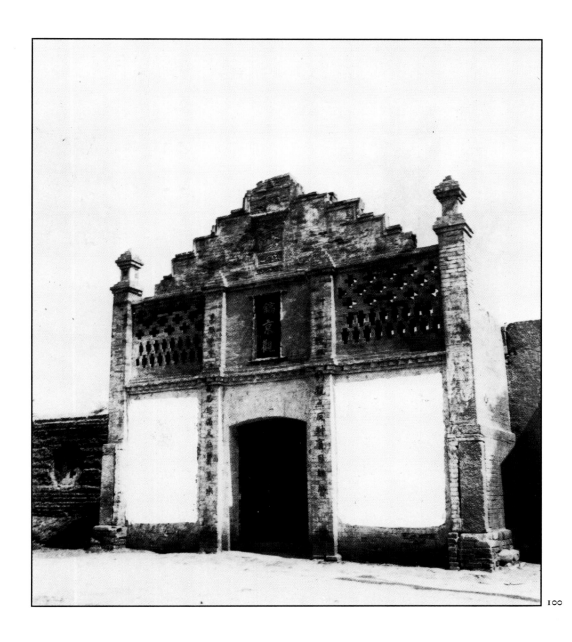

100

100. Front gatetower of Hao
The exact site of the ruins of the Western Zhou capital, Hao, has not yet been determined, but it is believed to be on the east bank of the Feng River. The gatetower shown here is in Fenghao Village, north-east of Doumen.

101. Map showing the Zhou and Qin dynasty capitals

102–104. Early Qin bronze building components
These three building components were found at the ruins of the early Qin city of Yong in the west of central Shaanxi Province. The city had the fertile land of Zhou Plateau to its east, the Wei and Ping Rivers to the south and west and Mt Ping to the north and was an important town in north-west China in ancient times. The state of Qin established its capital here in the later part of the Eastern Zhou and these finely cast building components found at the site indicate the high level of craftsmanship of the early Qin.

101

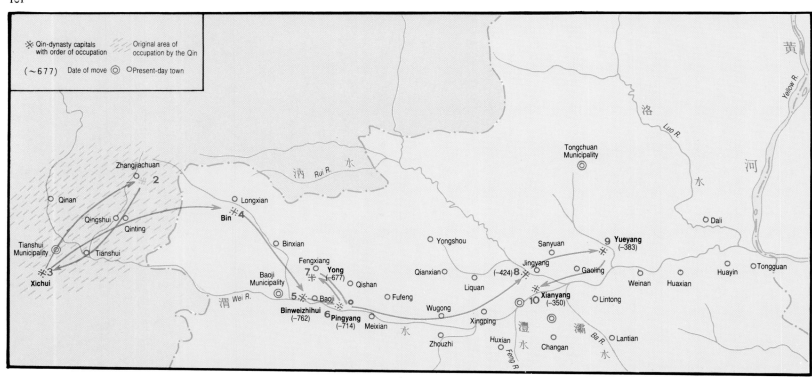

102

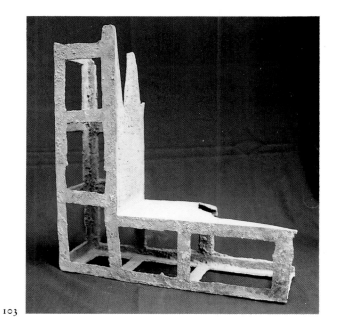

103

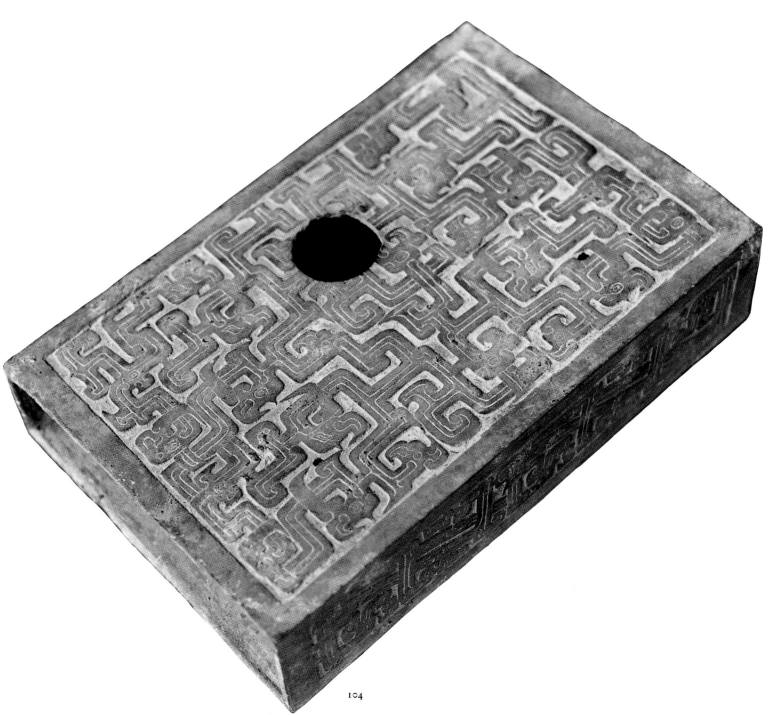

104

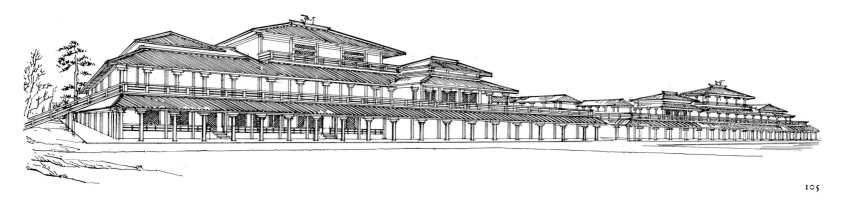

105. Reconstruction of the No. 1 Hall of Xianyang Palace

106. Ruins of No. 1 Hall of Xianyang Palace

Xianyang was built as the capital of the state of Qin in 350 BC and became the imperial capital in 221 BC when the First Emperor unified China. Xianyang Palace, which straddled the Wei River, was where the First Emperor lived. Later the course of the river changed, destroying the southern part of the palace. Many rammed-earth fortifications have been found in an area covering four miles from east to west and one mile from north to south. The platform shown in this plate, about 200 feet by 150 feet wide and 20 feet high, is a wooden and earth structure.

106

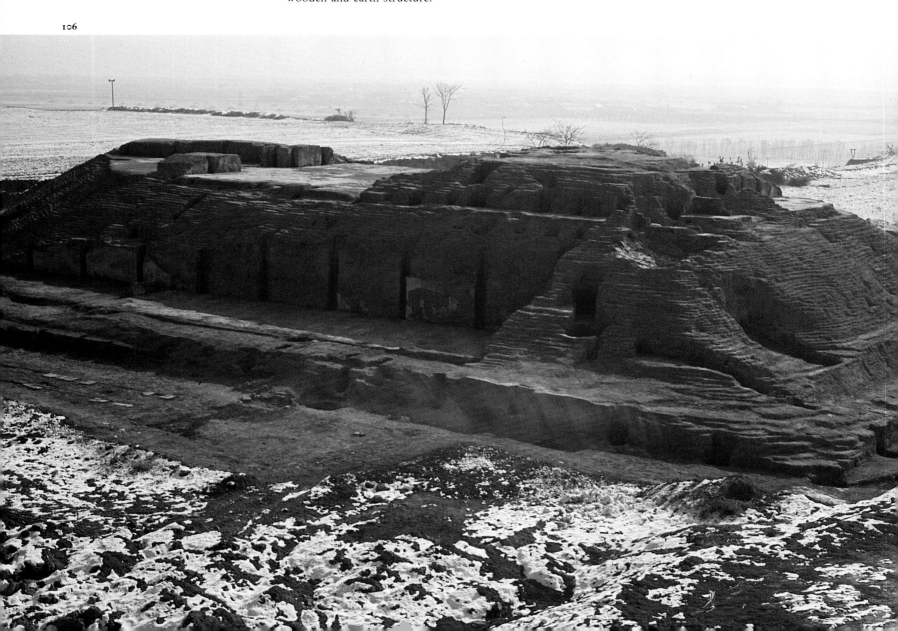

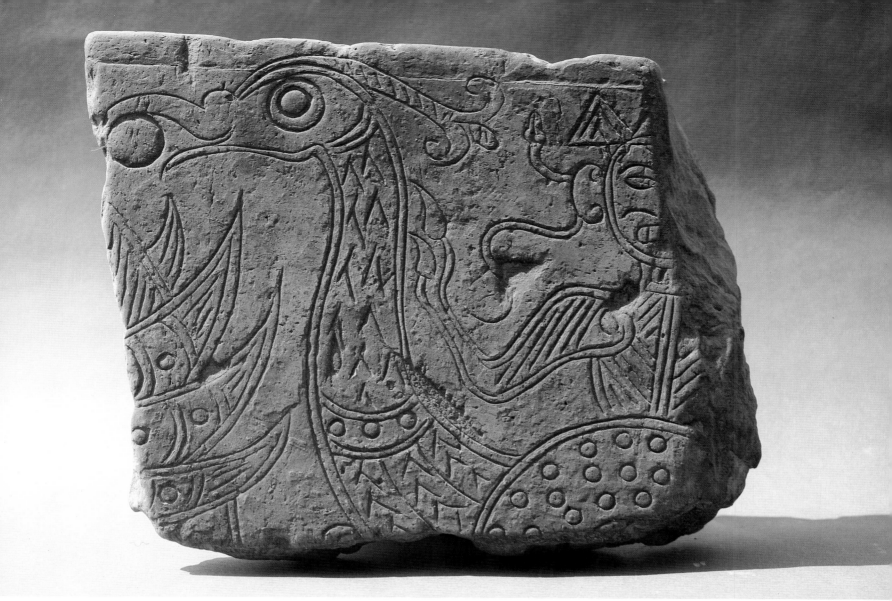

107

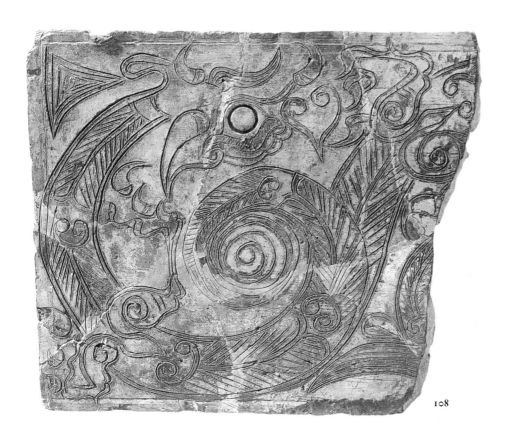

108

107. Brick with a phoenix pattern from Xianyang Palace
This type of hollow brick was used to build walls and tombs in ancient times, its hollowness helping to insulate against sound, damp and loss of heat. In general the surfaces of such bricks were carved with patterns of dragons or phoenix. Three types of phoenix pattern have been found: the standing phoenix, coiled phoenix and Water God Riding the Phoenix. This plate shows the coiled phoenix.

108. Brick with a dragon pattern from Xianyang Palace
The dragon patterns on such bricks were of two types: a single dragon and double dragons joined at head and tail. This plate shows the single-dragon design.

109. Section of Afang Palace

Afang Palace was the First Emperor's Imperial Palace, the equivalent of the Forbidden City in Beijing. According to records it was to extend from Mt Li in the east to Mt Zhongnan in the south, joining with Xianyang Palace in the north, a distance of over ninety miles. The Front Hall was the central building, measuring approximately 2,300 feet by 394 feet and several dozen feet high. To the front of the hall stood twelve bronze figures, each over 30 feet tall and weighing over 260,000 pounds. The remaining rammed-earth platform shown in this picture is 23 feet high, 4,265 feet from east to west and 1,312 feet from north to south, covering an area of over 5.5 million square feet.

109

110. Reconstruction of the Front Hall of Afang Palace

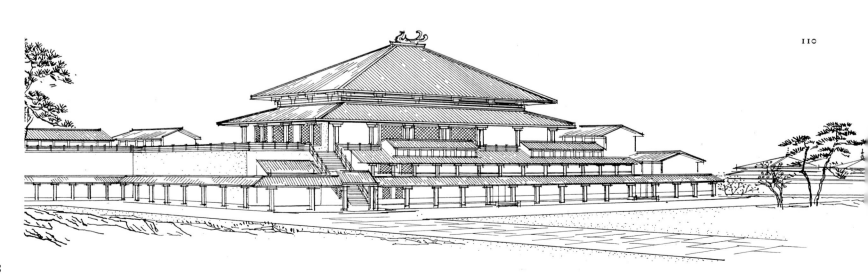

110

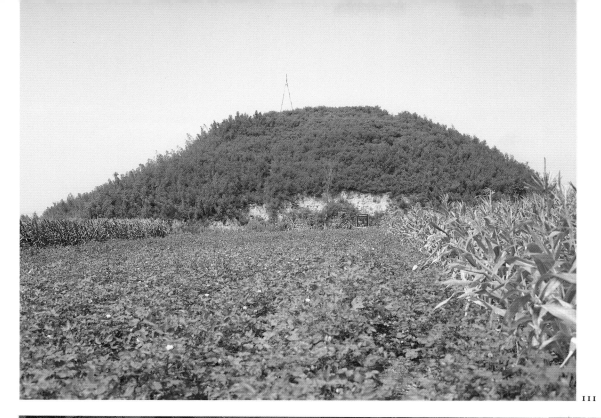

111

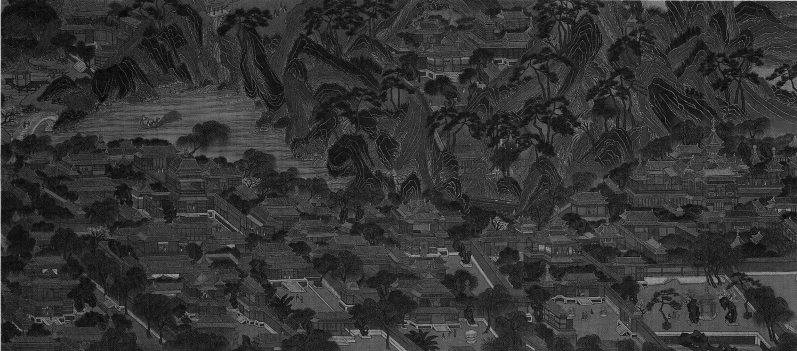

112

111. Ruins of Shangtian Platform
Shangtian Platform was one of the buildings in Afang Palace. The remaining earth platform is over 60 feet high, nearly 100 feet in circumference and covers an area of almost 900 square feet.

112. Ming-dynasty painting of Afang Palace

113. Qin-dynasty eave-tile with characters
The eave-tile was a unique structural component in ancient Chinese architecture, protecting the eaves and reinforcing the building. Both plain tiles and ones embellished with a design or with characters have been found. The tile shown in this picture was found at Afang Palace. It is 6.5 inches long and less than half an inch thick. The twelve characters cut in intaglio on its surface read: 'The Spirit descends from Heaven, so that the court will endure for 10,000 years, and there will be peace and tranquillity on earth below.' There are dragon patterns surrounding the characters and ten nipples between them and the characters. This pattern is unique among the eave-tiles found to date.

113

79

114

114. Valley of the scholars' execution

This valley is at the northern foot of Mt Li, six miles south-west of Lintong County. Following the advice of his Grand Councillor, the famous legalist Li Si, the First Emperor not only ordered the destruction of books 'to make the people ignorant' and so quell dissent, but also had 460 scholars buried alive in 212 BC for their views. This is the site of their execution.

115. Book Tower in the Zhang Liang Temple

Zhang Liang (d. 186 BC) is famous for helping Liu Bang, the future Han-dynasty emperor Gaozu, win power. He was also influential in persuading Gaozu to establish his capital at Changan and continued to be an important adviser to the emperor in the early years of the dynasty. This temple in Baxian County is where Zhang Liang is said to have gone to fast and cultivate his moral character. The Book Tower shown here is the highest building in the temple at 328 feet and is built of marble and Nanyang stone.

115

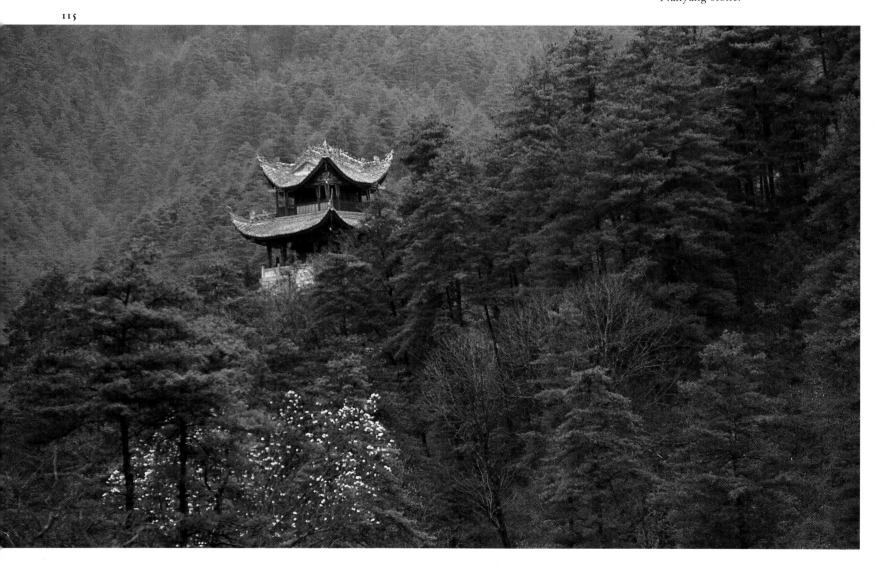

116. Plan of Changan in the Han dynasty

According to records, the Western Han capital, Changan, had eight avenues running east to west, nine streets from north to south, three palaces, nine large mansions, three temples, twelve gates, nine markets and sixteen bridges. When the city was completed it was three times the area of contemporaneous Rome and the centre of trade between north-west China and Sichuan (in the south-west), central China and, increasingly, the western regions.

117. Section of the city wall of Han-dynasty Changan

This broken section of the Han-dynasty capital is part of the remains of the city; it can be found about six miles north-west of Xian.

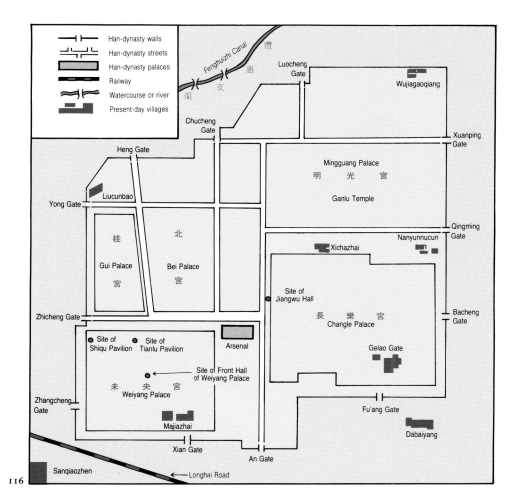

⊏⊐ ⊏⊐	Han-dynasty walls
⊣⊢ ⊣⊢	Han-dynasty streets
▬	Han-dynasty palaces
▬▬	Railway
∿∿	Watercourse or river
▄▄	Present-day villages

Fenghuizhi Canal 澧

惠 支 渠

Luocheng Gate

Wujiagaoqiang

Chucheng Gate

Xuanping Gate

Heng Gate

Mingguang Palace
明 光 宫

Ganlu Temple

Yong Gate

Liucunbao

桂 Gui Palace 宫

北 Bei Palace 宫

Qingming Gate

Xichazhai

Nanyunnucun

Site of Jiangwu Hall

Zhicheng Gate

长 乐 宫 Changle Palace

Bacheng Gate

Site of Shiqu Pavilion

Site of Tianlu Pavilion

Arsenal

Gelao Gate

未 央 宫 Weiyang Palace

Site of Front Hall of Weiyang Palace

Zhangcheng Gate

Majiazhai

Fu'ang Gate

Dabaiyang

Xian Gate

An Gate

Sanqiaozhen

← Longhai Road

116

117

81

118, 119. Han-dynasty pipe tiles

120–123. Han-dynasty eave-tiles with patterns of the four spirits. In Chinese mythology there are gods or spirits for each of the four points of the compass: the black dragon, white tiger, rosefinch and tortoise for east, west, south and north respectively. This designation is first used in the Eastern Zhou dynasty and had become widespread by the Han dynasty, as shown by the fact that all the palace buildings of this period had eave-tiles decorated with representations of the four spirits.

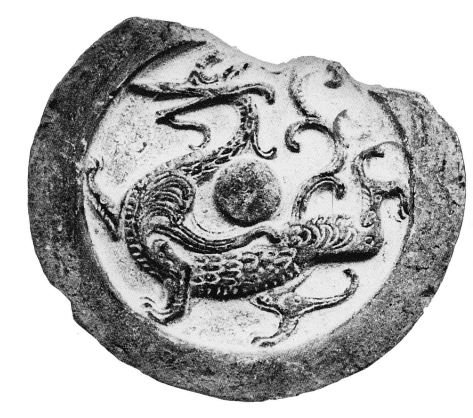

120. Black dragon patterned eave-tile

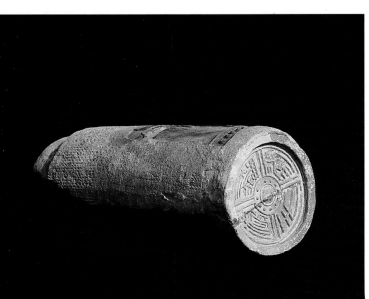

118

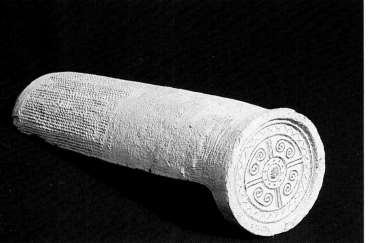

119

121. Tortoise patterned eave-tile

122. Rosefinch patterned eave-tile

123. White tiger patterned eave-tile

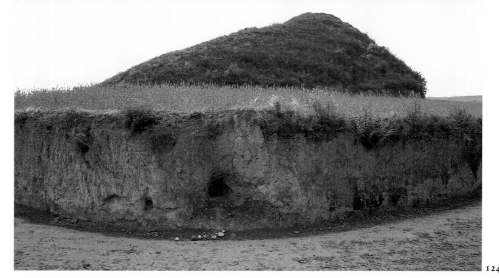

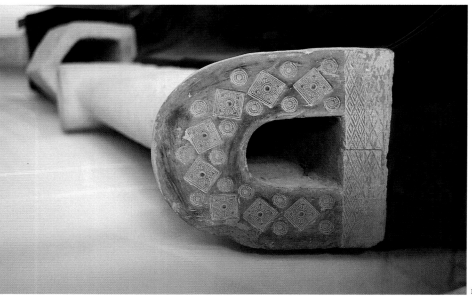

124. Ruins of Ganquan Palace
Situated in the north of Chunhua County, this was originally the Qin-dynasty Linguang Palace. It was extended during the reign of the Han emperor Wu and renamed Ganquan Palace. The palace complex, with a circumference of about twenty-eight miles, included the Gao, Chang, Ying and Zhu Halls, Tongtian Platform and other buildings and was second only to the Weiyang Palace in scale. The remaining foundations are in good condition and resemble an inverted basket. The underground pottery drainage pipes can be seen here.

125. Han-dynasty pottery drainage pipe

126. Ruins of Weiyang Palace
Weiyang Palace, the largest and most imposing of the Han palaces in Changan, was built in the reign of Emperor Gaozu (206–195 BC) under the supervision of his minister Xiao He. It occupied an area of about two square miles, or one-seventh of the total area of the city. In the Western Han and later dynasties it was used as the administration centre. The remaining foundation of the front hall is 650 by 330 feet wide and 33 feet tall at its highest point.

126

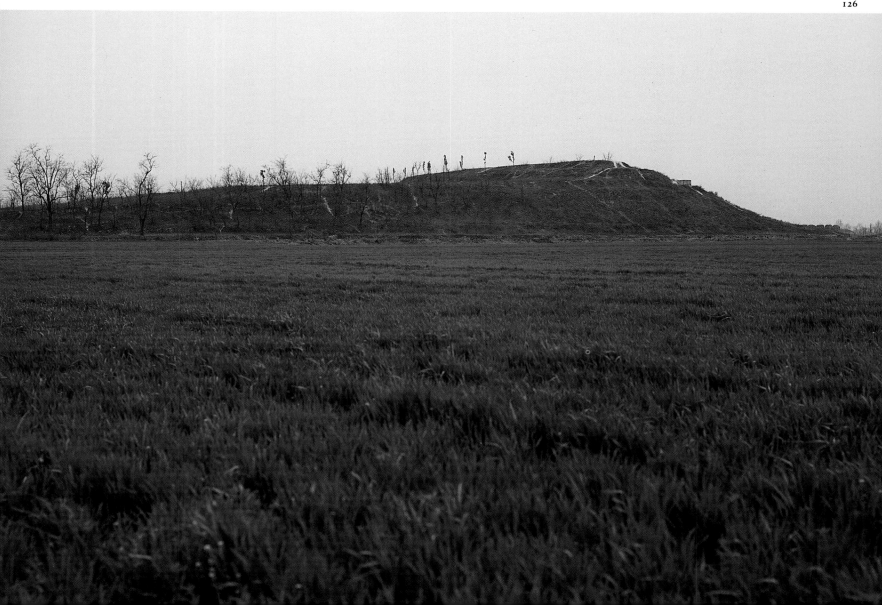

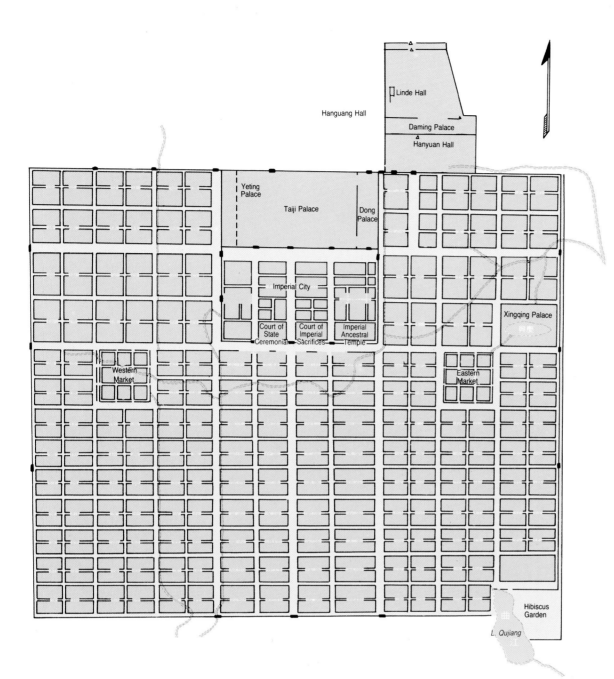

Linde Hall

Hanguang Hall

Daming Palace

Hanyuan Hall

Yeting Palace

Taiji Palace

Dong Palace

Imperial City

Court of State Ceremonial

Court of Imperial Sacrifices

Imperial Ancestral Temple

Xingqing Palace

Western Market

Eastern Market

Hibiscus Garden

L. Qujiang

127. Plan of Changan in the Tang dynasty

The Tang capital Changan was built on the site of the Sui capital Daxing. The city was divided into three main areas: the palaces in the north and north-east, the imperial city directly to their south and the outer city. The emperor lived in the palaces, the court officials conducted the administration of the country in the imperial city and the common people lived in the outer city. The outer city was made up of 109 wards arranged symmetrically between the eleven streets running from north to south and the fourteen avenues running east to west.

The city was approximately 6 miles by 5 miles, with a perimeter of over 22 miles and a total area of over 30 square miles, about seven times larger than that part of present-day Xian which is enclosed by walls. The main street alone was 500 feet wide. The city had a population of about 1 million, about one-third that of metropolitan Xian today. There were two markets, in the east and west, the latter thought to be the largest trading centre in the world at that time.

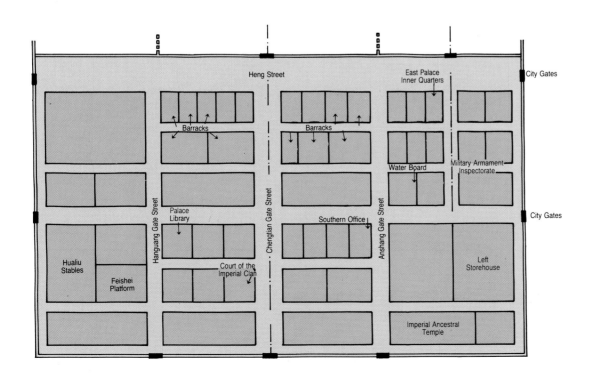

Heng Street

East Palace Inner Quarters

City Gates

Barracks

Barracks

Water Board

Military Armament Inspectorate

City Gates

Palace Library

Southern Office

Hanguang Gate Street

Chenglian Gate Street

Anshang Gate Street

Hualiu Stables

Feishei Platform

Court of the Imperial Clan

Left Storehouse

Imperial Ancestral Temple

128. Plan of the Tang-dynasty imperial city

129. Ruins of Mingde Gate

130. Reconstruction of Mingde Gate
Mingde Gate was the central gate in the southern wall of Tang-dynasty Changan and its ruins are located about three miles south of Xian. It was excavated in 1972 and revealed to be a tower-type structure with foundations 182 feet by 57 feet. It had five apertures, or gateways, each 16 feet wide. The central entrance was reserved for the emperor, the two inner ones for common people and the two outer ones for carts and horses.

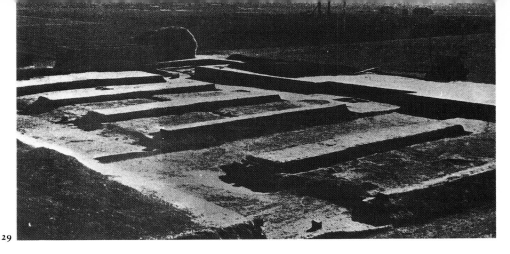

129

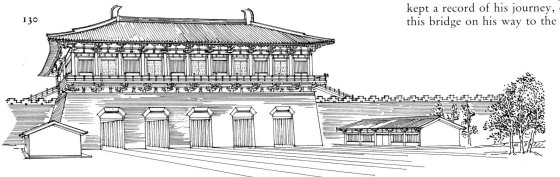

130

131. Ruins of the Tang-dynasty East Wei River Bridge
There were three famous bridges over the Wei River in the Tang dynasty. This one, as its name suggests, was the furthest east and lay on the road which went east from Changan, through the Hangu Pass to central China. The well-known Japanese monk, Ennin, who travelled to China in the Tang and kept a record of his journey, crossed this bridge on his way to the city.

From the archaeological remains it seems to have been about 980 feet long and 33 feet wide and was supported by wooden piers lashed together, with stones piled at their base on the side of the water flow.

132. *Gatetowers* – A mural in the tomb of Prince Yi De
Prince Yi De was the eldest son of the Tang emperor Taizong. He died in AD 701 and was buried at the Qian Mausoleum. The four gatetowers shown in this painting might either depict a part of the prince's palace or one of the city watchtowers, which afforded an excellent view.

131

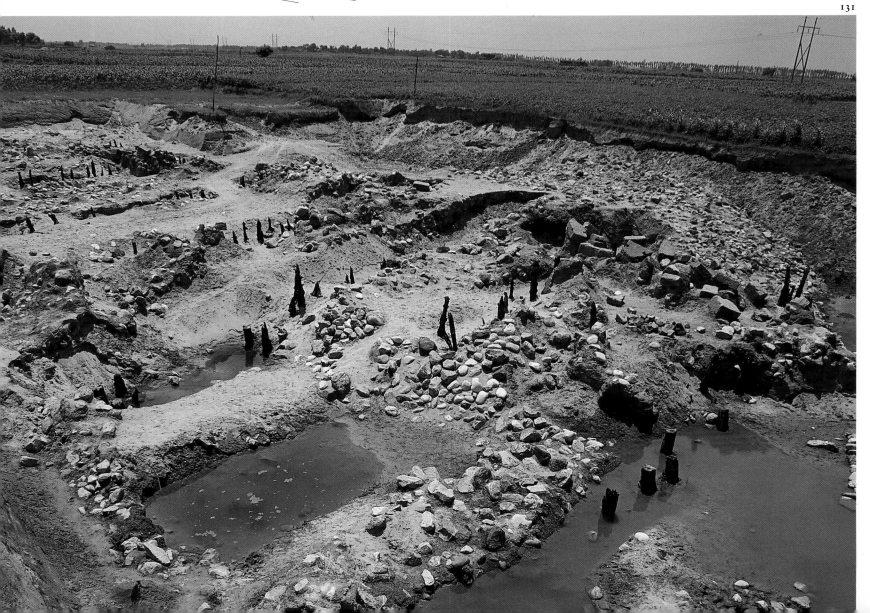

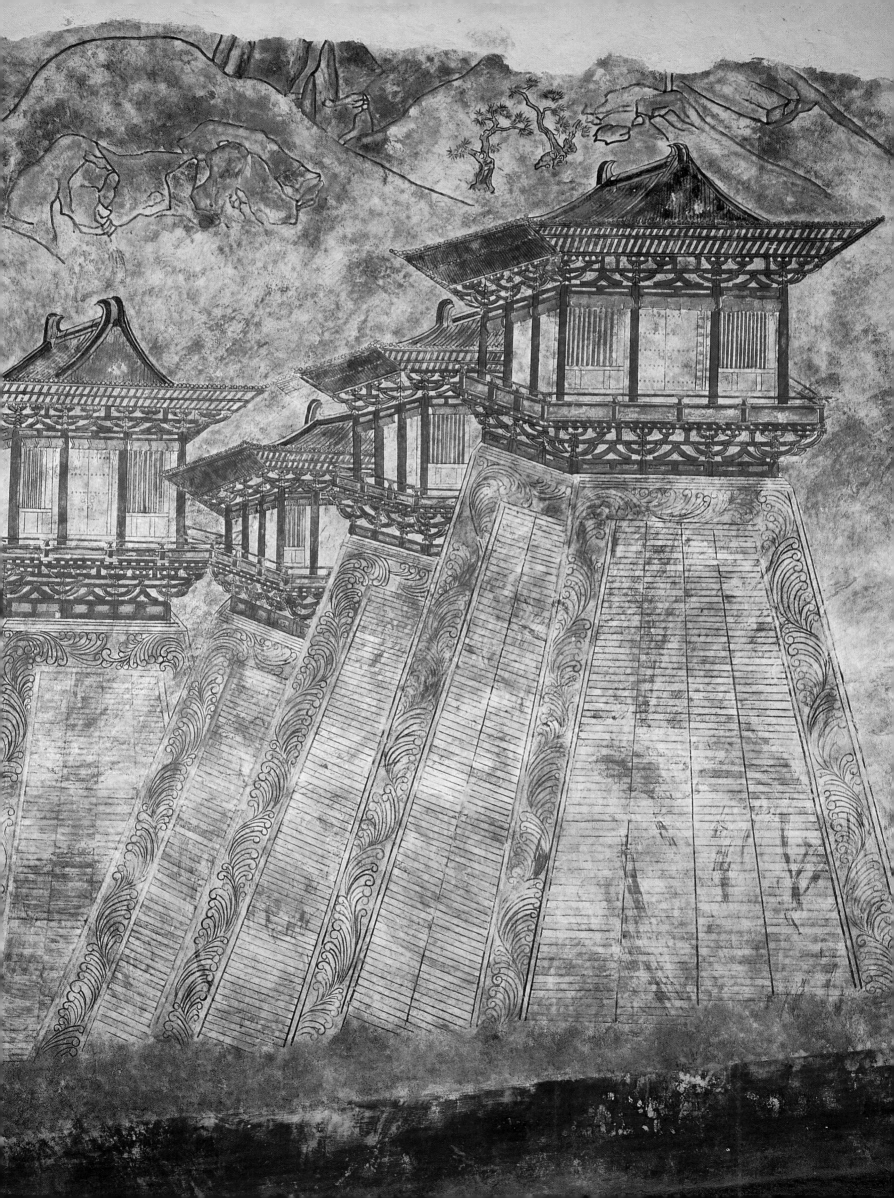

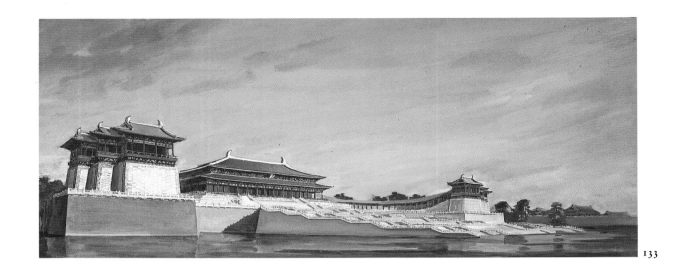

133

133. Reconstruction of Hanyuan Hall in Daming Palace
Hanyuan Hall in Daming Palace was built with specially selected Jingyang timbers from forests in south China. The two towers on the east and west sides of the hall were called Xiangluan and Qifeng, while the three parallel paths leading down from the main entrance were called the Dragon Tail Way.

134. Ruins of Hanyuan Hall
Daming Palace was the largest of the Three Inner Palaces located in the Tang capital Changan, and was built facing south on high ground in the north-west of the city. The main structures lying on a central axis were the Hanyuan, Xuanzheng, Zichan and Linde Halls, but there were over twenty other buildings. Hanyuan Hall was the front hall, where the emperor administered state affairs, held grand ceremonies, viewed the army and received foreign envoys. The remaining rammed-earth platform is 10 feet high and 249 by 140 feet wide.

135

136

137

Many artefacts have been found at
the site of Daming Palace, including
bricks, tiles, pottery implements and
tri-coloured glazed pottery. Shown
here are three bricks with beautiful
designs.

138. Broken tile with inscription
In ancient China the officials in
charge of overseeing the building of
the capital and the imperial palaces
were under the supervision of the
Ministry of Building. In order to
keep a check on the work of the
official and the artisans working for
him, their names were often
inscribed on the bricks and tiles
they made. Such bricks and tiles are
commonly seen from the Qin
through to the Tang dynasty. The
inscription on this tile reads, 'Made
by an Official Artisan'.

**139. Eave-tile with lotus design
from Daming Palace**

138

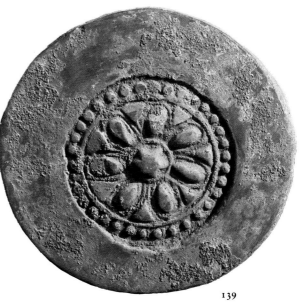

139

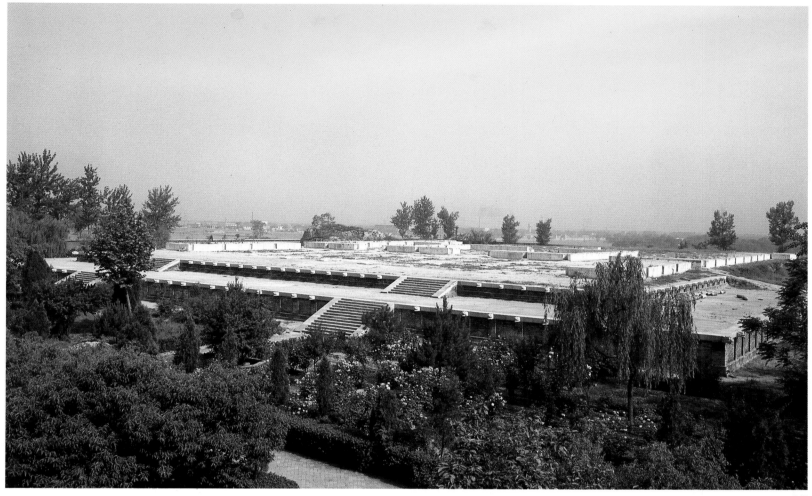

140. Ruins of Linde Hall

Linde Hall, one of the main buildings in Daming Palace, was built in AD 664 during the reign of Emperor Gaozong. It stands on high ground to the west of Lake Taiye in the northern part of the palace and close to Jiuxian Gate in the west wall, making it convenient for ministers and officials to come and go. The emperor held Buddhist rituals, received nobles and high officials, held grand ceremonies and met diplomatic envoys here.

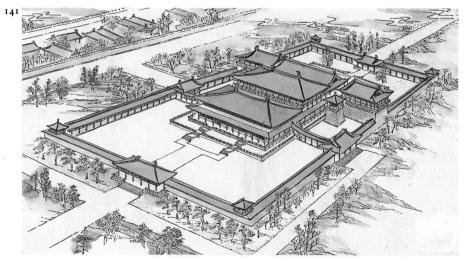

141. Reconstruction of Linde Hall

Linde Hall was 427 by 253 feet and consisted of three buildings, the front, middle and rear halls, which were also called the Three Halls of Religion.

142. Bathing pond in Linde Hall

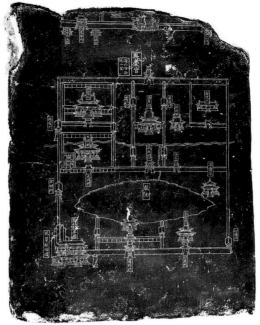

143

143. Plan of Xingqing Palace

Xingqing Palace was located in Xingqing Park in present-day Xian. It was originally the palace of the Tang emperor Xuanzong when he was crown prince, but it became his secondary palace after he ascended the throne. In the Kaiyuan period it was extended and renamed, being used for administration. Xuanzong and his concubine Lady Yang often stayed here because of its proximity to Qujiang Lake and the scenic area around. It comprised a palace area in the north with gardens to the south, the Dragon Pond in the gardens occupying an area of over 350,000 square yards.

144. Site of Qinzheng Wuben Tower, hall and house

These buildings were located in the south-western corner of Xingqing Palace.

144

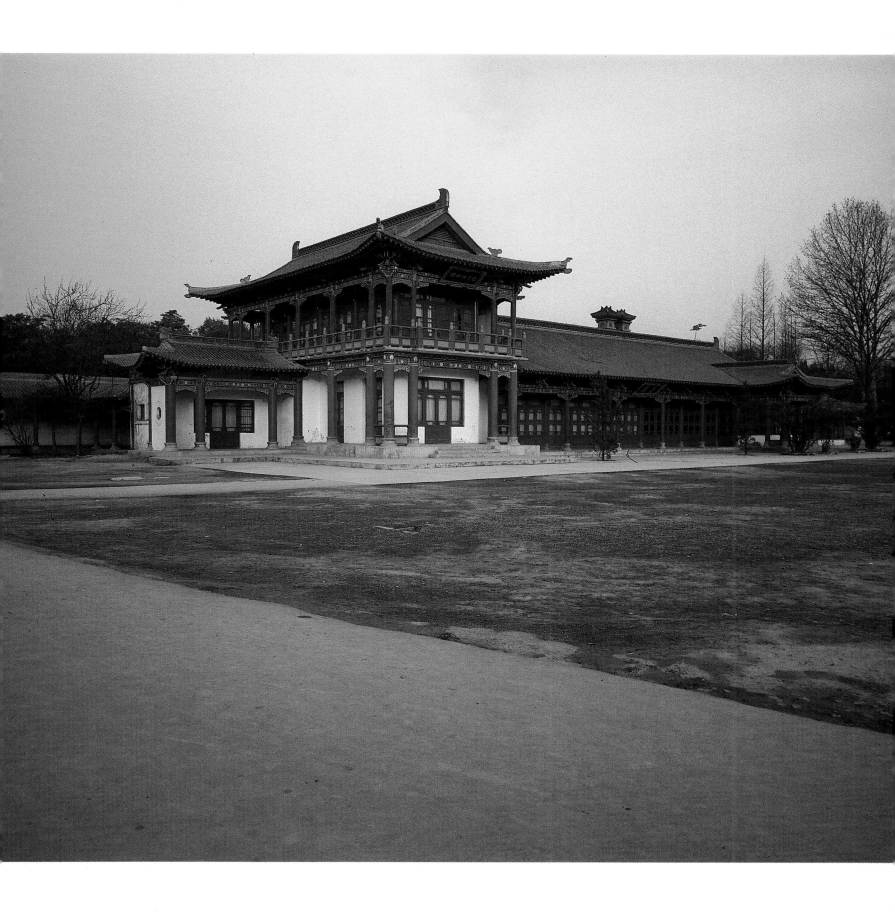

145. Hua'e Xianghui Tower
This part of Xingqing Palace was where the emperor announced amnesties, changed his reign-title and held other important events. The name, literally 'Mutual Brightness Like Petals and Calyx', refers to the close relationship Xuanzong enjoyed with his brothers.

93

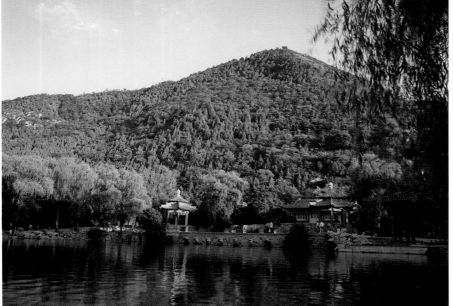

146

146. Huaqing Palace
Huaqing Palace stands at the northern foot of Mt Li and has natural hot springs in its grounds. Emperors of the Zhou, Qin, Han and Tang dynasties all built palace annexes here. The Tang emperor Xuanzong came here with his concubine Lady Yang and her sister every winter in the tenth month and stayed until the end of the year or the following spring. Many verses from Tang poems give vivid descriptions telling how the concubines would bathe in the hot pools on the cold days of early spring and how, from Changan, the mountain with the palace resembled embroidered green silk.

147. Part of Huaqing Palace

148. Remains of the bathing pool for imperial concubines
Huaqing Palace is famous for the hot springs which flow out of the ground at a temperature of 43°C. In 1982 ruins of the Tang-dynasty baths were discovered 33 feet north of the present-day springs. A large bathing pool at the ruins is now being excavated.

147

148

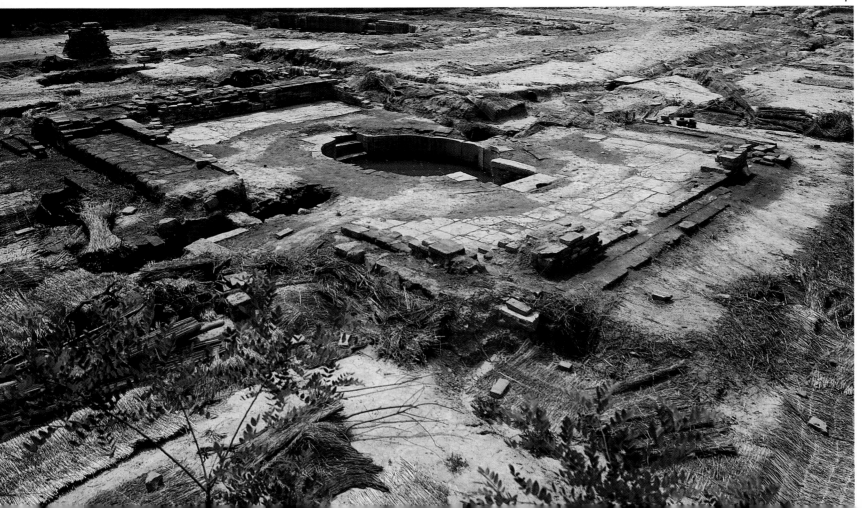

149

150

149. Restored well in Jiucheng Palace
This Tang-dynasty well was discovered in 1980. The square platform, 20 feet long, is made of square stone slabs and rectangular stone blocks. The mouth is round and 3 feet in diameter. Around the mouth are four stone pillar bases, 9 feet apart, 11 inches in diameter and each having a round hole in the centre.

150. Depiction of Jiucheng Palace
Jiucheng Palace was built in the Sui dynasty, when it was called Renshou Palace, but it was extended and renamed in 631 during the reign of the Tang emperor Taizong. The palace was divided into three areas: the park, armoury and temple. The picture shown here is a copy of the block-printed *Painting on Round Silk Fan of Jiucheng Palace* by the Tang-dynasty artist Li Sixun.

151. Plan showing location of the various capitals in the Xian area

152. The Ming-dynasty Drum and Bell Towers (*overleaf*)
The Drum Tower, shown in the foreground of this photograph, was built in AD 1380 during the reign of the Ming emperor Taizi and stands to the north of Xi Street in present-day Xian. In the fourteenth century the time was told by striking a bell in the morning and a drum in the evening. This tower contains a large drum and has a double roof with a grey brick foundation. The Bell Tower stands at the centre of modern Xian not far from the Drum Tower. It was first built in AD 1384 to the north of Xi Street, but was moved to its present location during the reign of Wanli. The 118-foot-high tower has a square base with an arched gate at the centre of each side, and a double roof.

Wei R.

河

渭

灞

滻

Qin capital
Xianyang

Han capital
Changan

Feng R.

河

滈

Hao

Feng

Ming,
Qing Site
of Xian

present-day
Xian

Sui city Daxing
Tang capital Changan

Chan R.

河

151

95

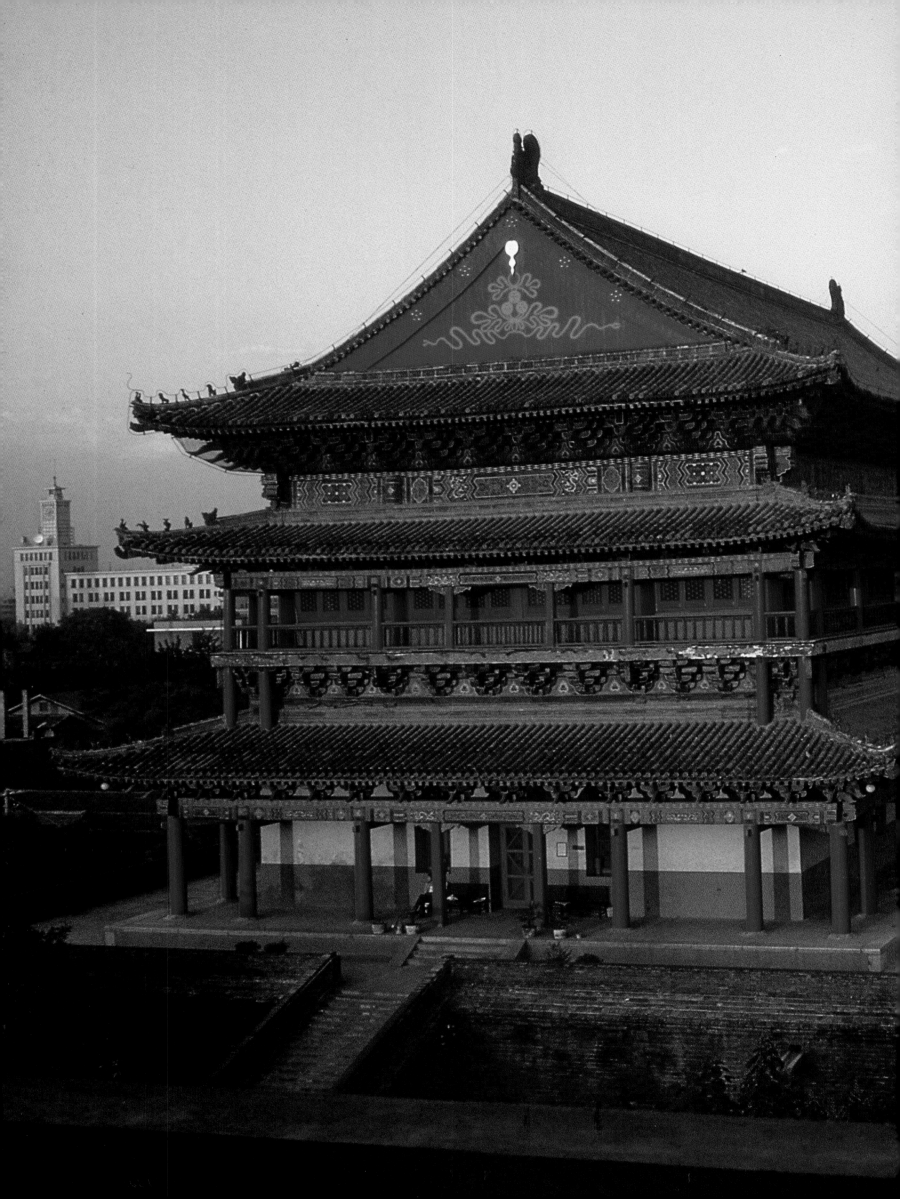

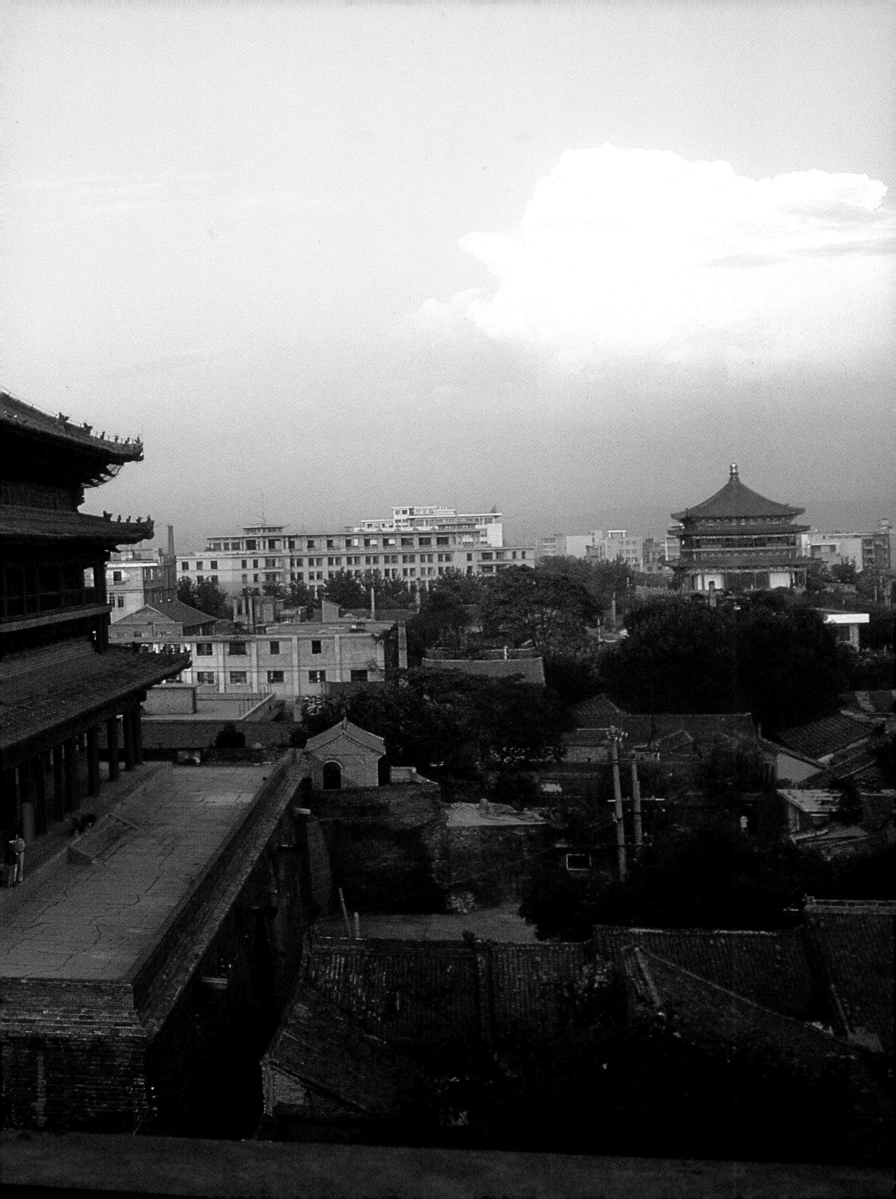

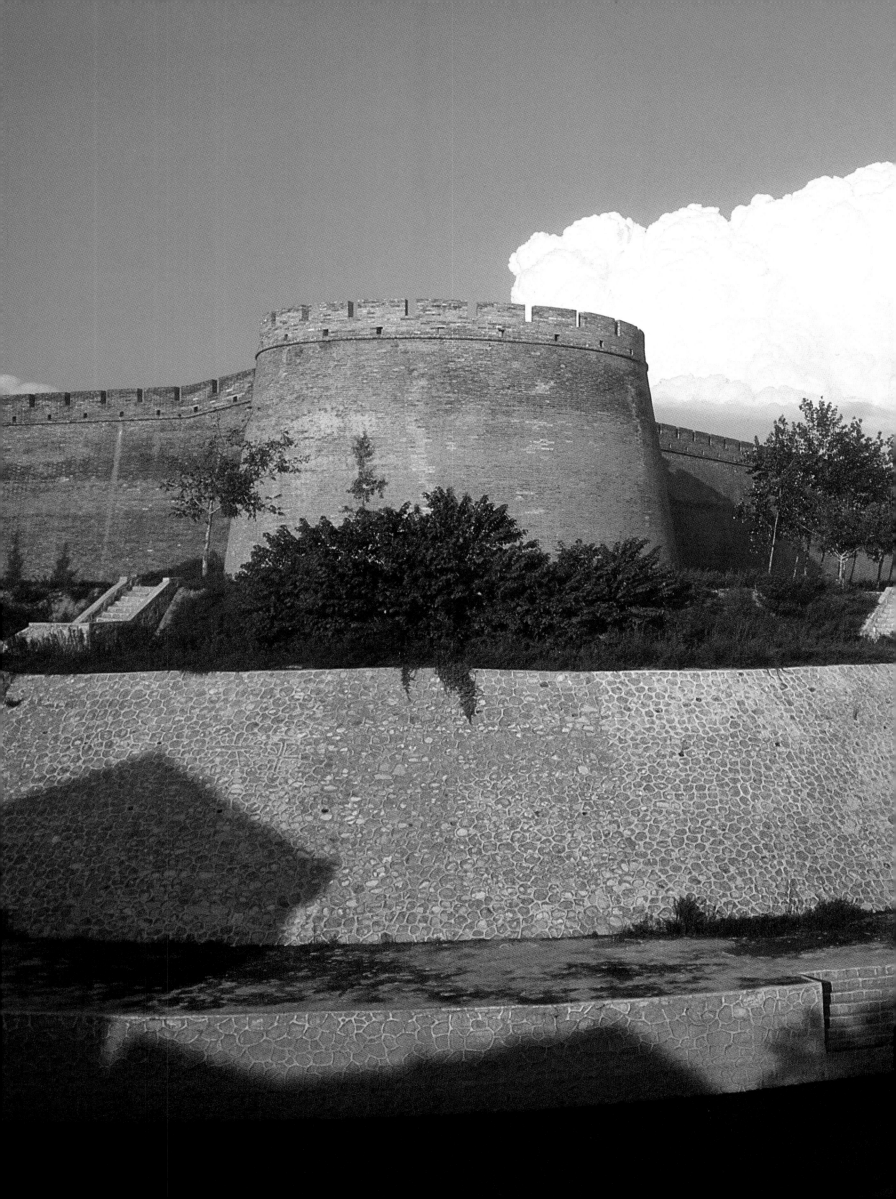

153. South-west corner of the Ming-dynasty city wall in Xian (*pp. 98–9*)
The present city wall in Xian was built during the Ming and is the most complete and largest among the extant city walls of the world. It is 7.5 miles long. When the Mongols established the Yuan dynasty they rebuilt the Tang walls with round corners, so that they resembled a Mongolian tent. In the Ming dynasty Prince Zhushuang extended the city by a third to the east and north and rebuilt all the corners except the south-west one, so that they were again square, in accordance with the Chinese custom. This south-west corner remains round.

154. The South Gate (*previous pages*)

155, 156. The West Gate (*opposite and below*)

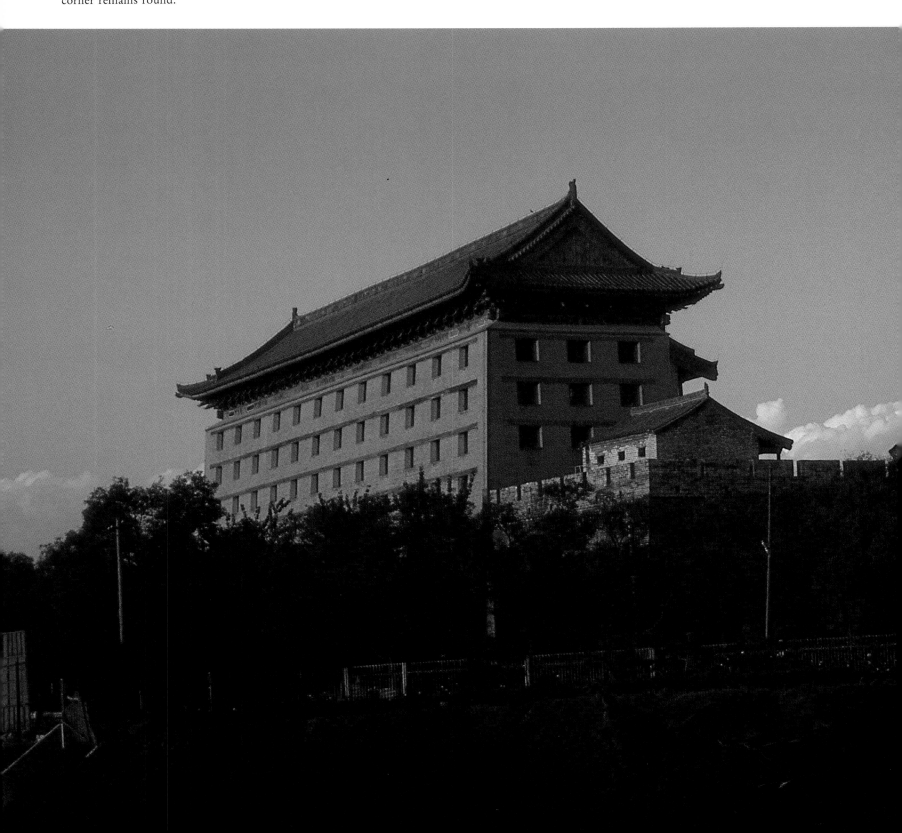

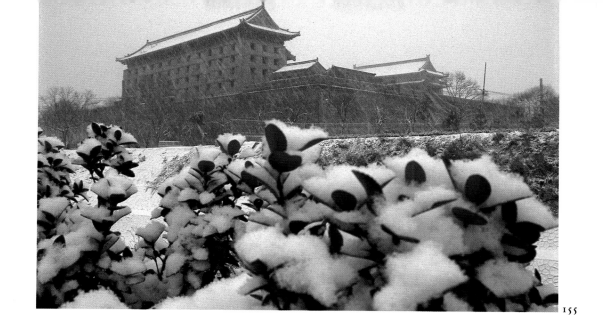

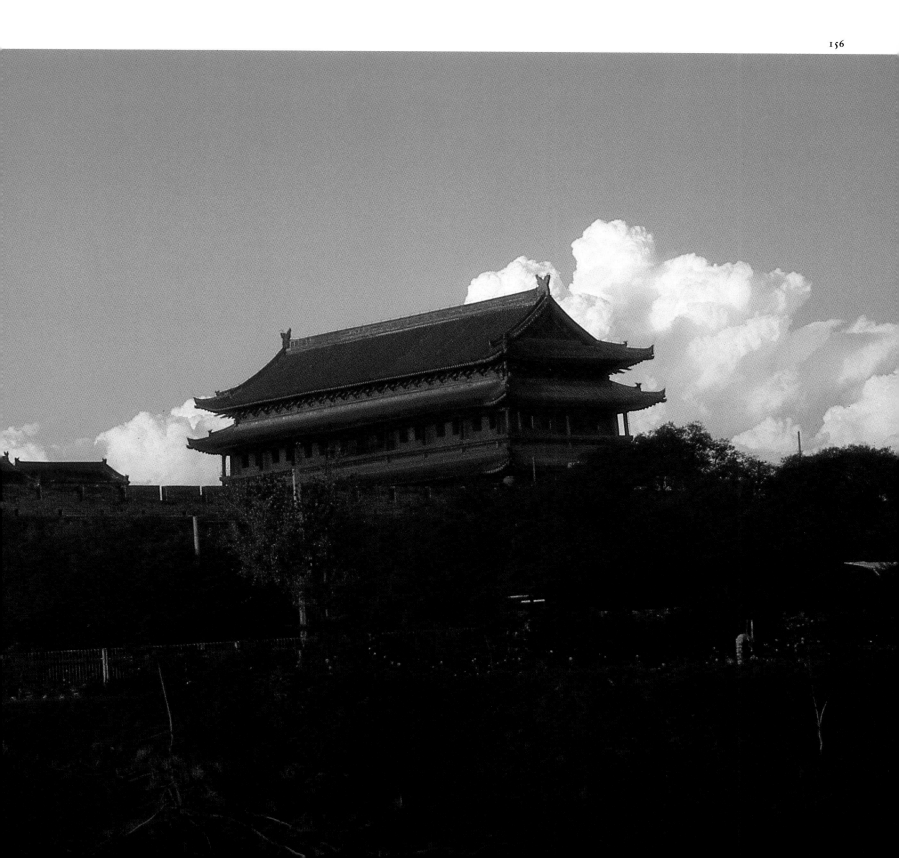

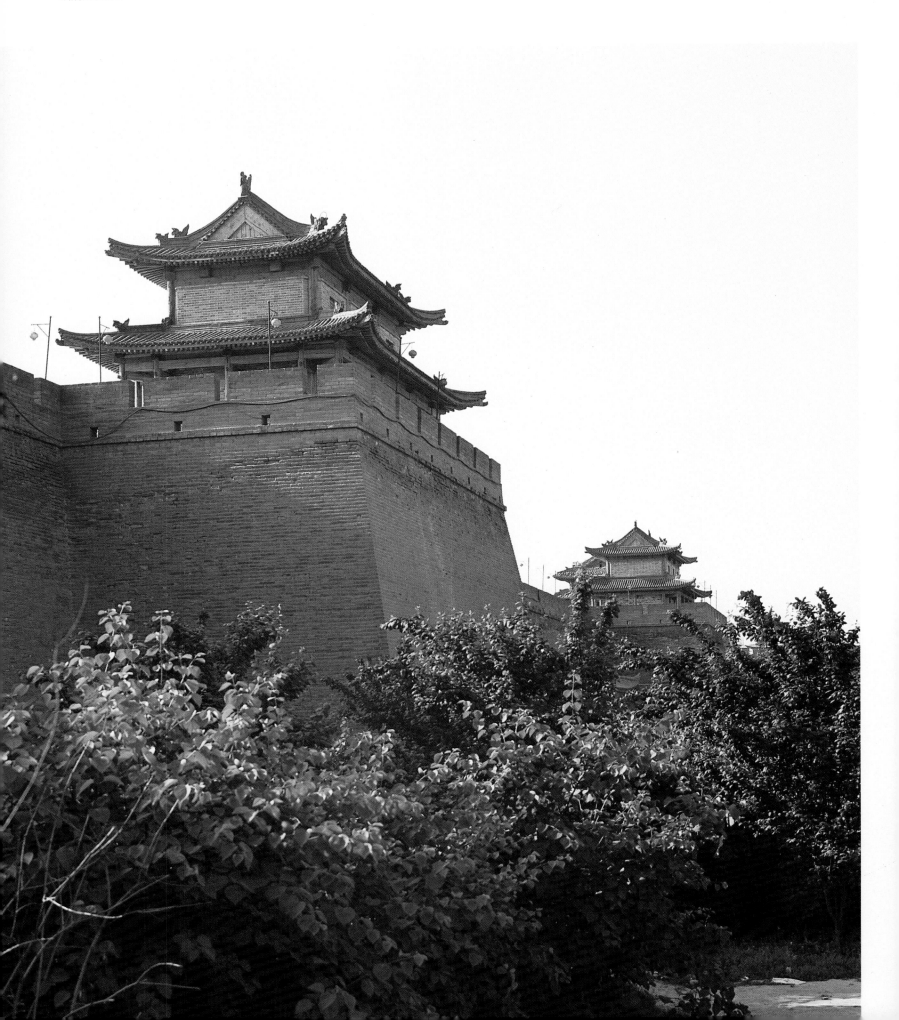

157. Watchtowers
There were ninety-eight defence
posts along the city walls of Xian in
the Ming dynasty, each with a
watchtower.

4.

The Heart of a Powerful Empire

The land within the passes was not only the political centre of China for a thousand years but also its military and economic headquarters – the heart of the empire.

The Water-crossed Land of Grain

Agriculture played a key role in the economy of ancient China and the land within the passes was, for a long period, the major grain-producing area. In the first history of China, *Shiji*, written by Sima Qian in the Han dynasty, it is recorded that: 'The land within the passes is a third of the country in terms of area and population, yet it produces almost two-thirds of the entire grain harvest.'

From the beginning, the development of civilization in this area was closely related to the development of agriculture: chipped and ground stone axes, adzes, spades and other farming tools are numerous among the findings from Banpo. More than 200 storage pits were also found along with grains. The cultivation of crops was always to play a more important role in this area than animal husbandry – although dogs and pigs were domesticated by this time – because of the lack of pasture land.

The Zhou people, who were settlers in this area, also relied on agriculture to provide a strong economic base from which to expand eastwards. This concern is reflected in their myths: the legendary ancestor of the Zhou was called Hou Ji, or Lord of Millet, and is credited with teaching his people how to cultivate grain at a place called Tai (in Wugong County, Shaanxi Province). Shrines to Hou Tu (Lord of the Earth) and Hou Ji were to be found in most villages throughout Chinese history. According to the official history of the Western Han dynasty, *Hanshu*, every generation after Hou Ji paid great attention to agriculture: 'Previously with Hou Ji at Tai, Gong Liu at Bin (Xunyi County, Shaanxi Province), Prince Tai at Qi (the Qishan), King Wen at Feng (in Sichuan Province) and King Wu at Hao, the Zhou people followed the example of their rulers and became skilled at sowing and reaping, devoting their energy to this basic industry'; as a poem from Bin says, 'agriculture and sericulture are essential for clothing and feeding the people.'

By this time soybean, foxtail and broomcorn millet, hemp, wheat and melon were being cultivated and there were many developments in irrigation, farming implements and techniques, also reflected in the legends from this period. One such legend relates how Yu the Great, by his water-conservancy projects, made barren land fertile. Irrigation was vital in the land within the passes; although the loess soil was extremely fertile when watered, the rainfall in this area was erratic and there were often long periods of drought. It is recorded that during the reign of King Xiao spring water was channelled through the fields and other irrigation projects, such as the digging of ponds to collect and store water, were initiated. Bao Pond, six miles north-west of Xian, is the most famous of these, built for the cities of Feng and Hao. *Zhouli* discusses the irrigation system at great length, indicating the seriousness with which it was taken.

The success of these developments is shown by the fact that, while at the start of the Zhou period most fields were left fallow at least once a year, by the Eastern Zhou there was widespread double cropping. Legend relates that the grandson of Hou Ji invented the ox-drawn plough, but it seems more likely that it was invented in the Eastern Zhou period, although a primitive ploughshare may have been used as far back as neolithic times. This period also

saw the invention of the iron ploughshare and more sophisticated ploughs which would turn the soil to produce a deep furrow; however, it is probable that light ploughs continued to be used in the land within the passes because of the problems of erosion of the fine loess soil. The use of green manure and other fertilizers and the implementation of large-scale irrigation projects all contributed to the increased grain production during this period.

The Qin people also lived in this area. During the reign of Duke Xiao (361–338 BC), Shang Yang, a famous legalist who believed in government by punishment and reward, was employed to implement political reform. He destroyed the Zhou system of feudalism, thereby abolishing many of the aristocrats' privileges, permitting private ownership of land, providing incentives for farming and rewarding efficiency. This seems to have been very effective; when Xun Zi, a philosopher broadly of the Confucian tradition, visited the capital, Xianyang, he praised the state of Qin for its productivity, wealth and law-abiding, diligent officials. One of the major projects of the Qin was the Zheng Guo Canal, connecting the Jing and Luo Rivers, a distance of over ninety miles. The canal is named after a water-conservancy expert sent to Qin by the state of Han. Han believed that the building of the canal would expend all of Qin's resources and thus prevent their eastward expansion; in fact, the canal probably had the opposite effect, as it not only improved communications but also made great tracts of land suitable for agriculture, the additional grain output supporting the soldiers who finally conquered Han and the other states.

At the very beginning of the Han dynasty a policy of supporting agriculture was officially adopted as the 'first and foremost way to govern the country'. Notable in the implementation of this policy was Emperor Wu, who supported the construction of irrigation projects, the popularization of new implements and the system of having both civilians and the military work on land reclamation in remote areas so that grain output was increased further.

During his reign a canal was dug between Changan and the Yellow River to facilitate the transportation of handicrafts and agricultural products from areas east of the Hangu Pass and south of the Yangtse River to the capital. Meanwhile, the areas on either side of the canal benefited from irrigation. In 111 BC, on the advice of Ni Kuan, canals built in the Qin, including the Zheng Guo Canal, were rebuilt and new canals dug, bringing more areas under irrigation. Soon after, under the supervision of an official called Bai Gong, the Bai Canal was dug from Gukou, the head of the Zheng Guo Canal, conducting water from the Jing River south-east to join the Wei River north of Lintong County. A contemporary folk song reflects the benefit these canals brought to the farmers of the region: 'The canal makes it easy to irrigate and enrich the land so crops can be grown to feed the capital's population of thousands.'

Apart from these projects, during Emperor Wu's reign the three-leg drill harrow and crop rotation to maintain the land's fertility were invented by Zhao Guo, and their application raised labour efficiency and increased output. During the reign of Emperor Chang, Fan Shengzhi wrote over ten articles on agriculture discussing in detail issues relating to crop yield, the farming calendar, identification of soil, the application of manure, selection of seed,

sowing and coping with drought. His works were the fruit of the agricultural development from neolithic times, but especially since the Eastern Zhou and they, in turn, paved the way for future developments. In the Han-dynasty official history, *Hanshu*, it is recorded that: 'During the reign of Emperor Wu there was so much wealth in the capital that coins corroded before they could be counted and grain rotted before it could be eaten.' Pottery models of barns, storage jars, wells, granaries and other objects have been found in most of the Han-dynasty tombs in the area around Xian, some bearing inscriptions such as 'millet store' and 'wheat jar', vividly reflecting the fact that agriculture continued to be fundamental to Chinese life.

The land within the passes continued to be the centre of the empire in Sui and Tang times. Because of the demands from the officials and armies based in the capital it was necessary to raise grain production in the region, although by this time grain was also being imported from the east, which enjoyed a more favourable climate and allowed diversified production. New techniques and implements were invented while different fruit and vegetables were introduced from other regions. In the early years of the dynasty the Sui system was followed, whereby every farmer worked on an equal area of land. This practice had in fact first been introduced during the Northern Wei dynasty (AD 386–534), but relied on a much older tradition which stated that in the Zhou dynasty the land used to be divided on the 'well-field system' (the character for 'well' in Chinese resembling a grid of nine squares), whereby each farmer would work his own individual plot of land (the eight outer squares) and, in addition, work on another plot with seven other farmers (the central square) for the feudal lord. Although no proof has yet been obtained that such a system existed, it is clear that this system was always regarded as an ideal by the Chinese of later generations, who sought a 'golden age' in their past.

Craftsmen and Workmanship

An ancient Chinese legend describes how Shen Nong, a mythical ancestor of the Chinese people, was both a farmer and a potter. Like many legends, it reflects the actual historical development, in which pottery emerged at about the same time as the cultivation of crops. At Banpo many fine painted pottery wares were produced that must have had some special function. Ceramics continued to play a central role throughout the neolithic

cultures of China and must have influenced the bronze wares that supplanted them as the ritual vessels in the Shang and Zhou dynasties.

The bronze wares of the Shang dynasty, which was based east of the land within the passes, were made by a complex method of casting in which ceramic piece-moulds were used. Such a method was possible because of the sophistication of ceramic manufacture developed during the neolithic period. High-quality ceramics continued to be made in large numbers and these and the bronze wares suggest a highly organized society, with division of labour and considerable supervision. This picture is reflected in accounts of the capital Hao, of the succeeding Zhou dynasty, which record a clear division of labour between craftsmen specializing in different trades, known as the 'hundred workers'.

Bronze wares during the Western Zhou show some continuity with the Shang bronzes but rapidly developed their own distinctive style. The complex forms and elaborate designs of the late Shang bronzes became progressively simplified throughout the Western Zhou. Their most prominent characteristic are the long paragraphs of inscriptions often found on their surface; the longest inscription on a Shang-dynasty bronze is less than fifty characters, whereas a large tripodal vessel manufactured during the reign of King Kang of the Zhou has an inscription of 291 characters. Inner and outer moulds used for decorating the bronze parts of harnesses for horses and carts have been excavated from early Zhou sites at Zhangjiabo and Kexingzhuang in Changan County, along with pottery casting moulds. A large number of bronze slags and cakes were found at Cheng-jiacun in Fufeng County. From these relics it is possible to infer that by the Zhou the complicated techniques of foundering, mould making, smelting and casting had already been mastered.

Jade, bone and ivory carvings, lacquer wares and other handicrafts have also been discovered in Western Zhou tombs near Xian. Among the findings from a tomb in Baoji County were jade silkworms about one inch long and traces of mineral yellow, vermilion and brown silk fabrics. These findings corroborate historical documents recording the great variety of textiles available in the Western Zhou period and the existence of the advanced technology to produce them. They also reflect that, at a very early period, the Chinese people knew how to raise silkworms and spin and weave silk thread; a tradition which legend says dates back to the wife of the Yellow Emperor but which may actually go back further, since broken silkworm cocoons have been found at Longshan-culture sites dating from the neolithic period. In the Zhou dynasty sericulture was carried out by civilian women who were supervised by special officials appointed by the court.

The Qin greatly developed metal-smelting techniques, concentrating particularly on the iron industry. According to the *Hanshu*, 'the salt and iron industries in the Qin dynasty were twenty times more advanced than in ancient times.' However, the Qin dynasty was short-lived and their expertise was mainly manifested in the production of weapons and articles of war. The two bronze chariots and horses excavated west of the tomb of the First Emperor in Lintong County reflect the superb techniques of Qin craftsmen in metal processing and assembly.

In the Han dynasty the further developments in techniques of metal smelting are manifested in the highly

sophisticated ploughs and other agricultural implements from this period as well as in weapons of war. There are many examples in contemporary sources of families becoming rich through iron smelting, and such families may have employed as many as a thousand people. However, economic pressures gradually forced the substitution of earthenware models for bronze and jade wares, prevalent in tombs from the Zhou period. Economic reasons probably also accounted for the rapid development in ceramic, lacquer and silk production, as none of these used particularly valuable raw materials.

Silk weaving was one of the major industries of the Han dynasty. Many technical improvements were made and the variety of silk produced was greatly increased. Mulberry trees were grown in the imperial palace gardens in Changan to feed the silkworms which were raised in specially designed houses. According to a book on the geography of the capital the Weiyang Palace had east and west weaving rooms where silk garments were made exclusively for the imperial family. It is also recorded that skilled textile workers from throughout the country often went to Changan to pass on their techniques. When the 'wife of Chen Baoguang of Julu' (in Hebei Province) went to Changan at the invitation of the wife of a famous general, she used a new style of loom with 120 string-pulling heddles which, in sixty days, could weave a bolt of fashionable *jin* silk with a grape design or *ling* silk with a scattered-flower pattern.

Paper has played an important role in the spread of culture in many civilizations but it was first invented in China. Formerly it was believed that Cai Lun (d. AD 121) was its inventor, but in 1957 the discovery at Baqiao, east of Xian, of small scraps of hemp paper dating from the early years of the Western Han (206–24 BC) have pushed the date of its invention back two to three hundred years.

In Tang-dynasty Changan numerous varieties of Chinese silk, ceramics, gold, silver, lacquer and bamboo wares could be found for sale in the markets, alongside glassware from India. The famous tri-coloured glazed pottery was a new creation of this period; camels, horses, human figures and representations of articles of daily use were glazed in yellow, green and white. Articles inlaid with gold and silver were also a Tang-dynasty innovation.

Silk textiles accounted for a larger proportion of the handicraft industry than any other product. There were numerous cottage industries as well as a weaving and dyeing mill in the Tang Imperial Palace itself which recruited over 300 skilled weavers from all over the country. These people were called *qiaoer* or master workers. In addition there were eighty-three *ling* silk weavers and forty-two *qiaoer* working in the inner court and 150 *ling* weavers working for the side courts. Historical documents record that the daughter of Emperor Zhongzong had a skirt woven with birds' feathers which was a different colour when viewed from the top and from the side, and revealed patterns of many hundreds of birds. The designs, colours and varieties of silks produced at this time were extremely rich; from the area to the south-east of the Yangtse River alone over twenty varieties of silk were produced. Bai Juyi, a famous Tang poet, compared silk designs with the masterpieces of painting in their execution, depiction and use of colours.

Invincible Capital with an Impenetrable Defence
From the first unification of China by the Qin dynasty in 221 BC, the Chinese had to retain a strong military force,

not only to defend the country against attack by surrounding tribes, but also to suppress revolt from within. In times of peace there would be a consolidation of national defence and military forces would be reinforced in preparation for the next, inevitable defensive.

Largely on the basis of the solid economic strength of his state, the First Emperor was able to defeat his six rival states and unify China in 221 BC. His territory then extended to the east and south-east of the land within the passes and a more efficient communication network was necessary if he was to assert his control over this vast area; not only to disseminate court decrees to the provinces but also to ensure the efficient deployment of troops. The Qin therefore commenced the construction of a road network radiating outwards from the capital in the second year after unification. One of these roads led eastwards to Yan and Qi (Hebei and Shandong Provinces) and one south to Wu and Chu (Jiangsu, Zhejiang, Hunan and Hubei Provinces). They were each about 300 feet wide, with pine trees planted every 110 yards along both sides. In 212 BC the emperor ordered General Meng Tian to build a road from the Ganquan Mountains, north-west of Xianyang, north over the Ziwu Peak to reach the foot of the Great Wall at Jiuyang (near Baotou in Inner Mongolia Autonomous Region). This was used to transport troops and supplies in the Qin's defensive against the Xiongnu tribes (Huns) of the north.

Long walls for defence against other Chinese states and northern tribes had been built during the Warring States period by the states of Qi, Chu, Yan, Han, Zhao, Wei and Qin. Traces of the Wei's early contribution to the Great Wall still exist in Hancheng, Huayin, Dali and other counties in the land within the passes. After the unification of China the First Emperor instructed General Meng Tian to connect and repair the northern walls built by Yan, Zhao and Qin – a project that culminated in the Great Wall, stretching from Lintao (Minxian County, Gansu Province) in the west to the coast of Liaoning Province in the east. The wall was built with bricks, rammed earth and stones, or by cutting away mountain slopes to form cliffs. This gigantic project must have involved huge resources and organization, as well as considerable engineering and construction skills. It has been suggested that the First Emperor, by initiating this vast project, not only hoped to solve the problem of the Xiongnu but also to provide employment for the labour force made idle by the end of the war and the abolition of serfdom.

Thousands of workers were conscripted, many of them dying on the project. The suffering this must have brought to countless people is reflected in the legend of Meng Jiangnu. Her husband was conscripted to work on the wall and never returned. Meng Jiangnu managed to travel to the wall and obtain his bones with the help of the gods, but she could not afford to give them a decent burial. However, she happened to be seen by the First Emperor who was on a tour of inspection and agreed to become his concubine, despite her hatred of him, if he first gave her husband a state funeral on the shores of the sea. When the ceremony was over she leapt into the sea to join her husband in death.

It was not only the common people who suffered: General Meng Tian was forced to commit suicide after the death of the First Emperor because of the terrible loss of life the project inflicted, although in his suicide note he confessed to a different crime: 'I have disturbed the earth

over more than 10,000 li (3,000 miles) and must have cut through the veins of the earth. This is my crime.' Despite this, the wall was successful, helping to contain the Xiongnu invasions for a long period during the Qin and Han dynasties.

According to the *Shiji*, a history of China written in the Han dynasty: 'The Qin army consisted of more than 1 million armour-clad soldiers, 1,000 chariots and 10,000 cavalry.' It also claims that the Qin army had the help of numerous brave soldiers who fought without helmets or armour but, 'with swords in hand, charged against the enemy troops and defeated them with their gallantry and anger', and that 'the horses of the Qin army sped towards the front lines covering over seven yards in one stride'. The terracotta warriors and horses and the weapons excavated from near the tomb of the First Emperor in Lintong County corroborate these accounts and also reflect the sophisticated technology available to the handicraft industry in this period.

The Han dynasty strengthened its army in order to protect against 'attack from outside and revolt from within', a recognized malady of an ailing dynasty. Han forces were divided into two branches; the local and the capital troops, the latter consisting of the northern and southern armies. The southern army was responsible for safeguarding the royal palace, while the northern army defended the capital as a whole. Later, two more armies, the Qimen and the Yulin, were established under the direct control of the emperor in order to strengthen the palace garrison forces.

The Ganquan Mountains to the north-west of Changan (in Chunhua County) were an important base of the Qin and Han armies in their resistance against the Xiongnu. The Linguang Palace was built there by the First Emperor and connected by road to the foot of the Yin Mountains in the north. In 177 BC when the Xiongnu forces invaded areas south of the Yellow River, the Han-dynasty emperor Wen went personally to the Linguang Palace to command his forces. After the Han victory he went to Gaonu (Ansai County, Shaanxi Province) along this road on a tour of inspection. Towards the end of his reign the Xiongnu attacked again, and, according to the *Hanshu*, 'when the Xiongnu cavalrymen reached Juzhu (the Juzhu or Yanmen Mountains in north-west Daixian County, Shaanxi Province), beacon fires were lit all the way to Ganquan and Changan for months on end'. (Under the reign of the Han emperor Wu, the Linguang Palace was expanded and renamed the Ganquan Palace.)

Beacon fires were an important alarm system in ancient warfare. In the Western Zhou beacon towers were constructed all the way from Xianyang to the Li Mountains so that military information could be promptly relayed to the capital. The Han dynasty used the same system. Tang laws, however, specified that at the first hour after darkness fell a fire, called the safety fire, was to be lit at every beacon tower. According to the biography of An Lushan (a foreign general who rebelled and captured Changan in AD 755), on the night of his revolt, 'the safety fire could not be seen and Emperor Xuanzong was greatly alarmed'. The next day the emperor fled to Sichuan taking his favourite concubine, Lady Yang, and others with him.

At the beginning of the Tang dynasty the armed forces were divided into military prefectures comprised of soldier-farmers. Each of the 634 prefectures had between 800 and 1,200 farmer-soldiers; 261 of these prefectures were in the land within the passes, which commanded a combined force of 260,000 men, in keeping with the policy of positioning troops heavily in key areas.

Communications were obviously very important for commerce and military affairs. The area of Changan, as the site of the capital for much of Chinese history before the Tang, was the hub of a communications network started in the Western Zhou dynasty with the construction of a military road called the Zhou Passage, running east and described in an early text as 'as smooth as a whetstone and as straight as an arrow'. Several roads were built during the Qin dynasty and there was further development in the Han and Tang dynasties on the basis of this earlier construction, with two roads leading east on the north and south sides of the Wei River. The road on the south passed through the Tong and Hangu Passes to enter the Central China Plain, while the one to the north ran to the bank of the Yellow River at Chaoyi, in Dali County, and continued eastwards, linking with other roads leading to all parts of north and east China. The close relationship between the states of Qin and Jin in ancient times was principally dependent on this north road. The Wuguan or Lanwu Road was constructed between Changan and Henan and Hubei Provinces, starting from the east of the capital and passing along the Qinling Mountains and through Lantian and Wuguan. Another road ran west along the northern bank of the Wei River and split into two at Chancang (Baoji City, Shaanxi Province). From here one branch, called the Chancang or Old Road, ran south across the Wei River and the Qinling Mountains and through Hanzhong to Sichuan. The other branch continued west through the Dasan Pass to the Hexi Corridor in Gansu Province; this was the main branch of the Silk Road which connected China with the western regions and Asia. Another road connecting the Changan area with Sichuan Province was the Baoxie Road, whose northern end was in the valley south-west of Meixian and southern end in the Baogu valley, north of Hedongdian in Hanzhong. The road south leading directly from Changan to Hanzhong was called the Ziwu Road because it was constructed on the basis of the Qin-dynasty road across the Ziwu Peak; this peak is still referred to as Old Road Peak by local people today.

Although after the Tang dynasty Changan was never again the capital of China it continued to occupy a key position in China's military affairs, communication network and commercial trade and so remained an important city. The founding emperor of the Ming dynasty, Zhu Yuanzhong, once remarked: 'Of all the places in the empire, the land within the passes is of the greatest strategic importance.' Xian, today a key city in north-west China, continues in this tradition.

158. Memorial platform to Hou Ji

This platform, located outside the east gate of Wugong, is where according to legend the ancestor of the Zhou, Hou Ji, taught the people how to grow and harvest crops. It is said that he loved to plant trees, hemp, beans and wheat while he was young, and was thus skilled at farming by the time he reached adulthood. Yao, a mythical emperor, hired him to train people in his skills and there were bumper harvests thereafter. In recognition of his services he was granted the land of Tai and given the honorary title Hou Ji – Lord of Millet. His descendants are said to have built this brick platform to commemorate his contributions.

159. Stone rubbing of a double ox-drawn plough

Ox-drawn ploughs and iron farming implements were in extensive use by the Han dynasty. Because of the relatively high cost of oxen, poorer farmers may have formed ploughing partnerships, owning one ox between them and helping in the ploughing of each other's land. This picture shows two oxen drawing a plough that is guided by a single man. Although ploughs that turned the earth to produce deep furrows had already been invented, it is probable that shallow ploughing continued to be practised in central Shaanxi because it made the fine loess soil less vulnerable to erosion.

160. Iron shovel

Iron tools first emerged during the Spring and Autumn period and were in widespread use by the Western Han dynasty.

161. Iron pick

162. Iron ploughshare

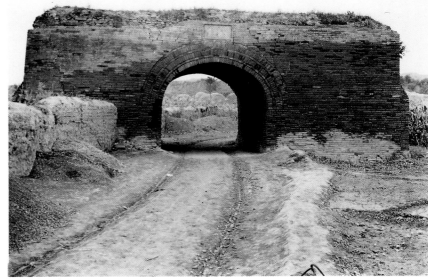

158

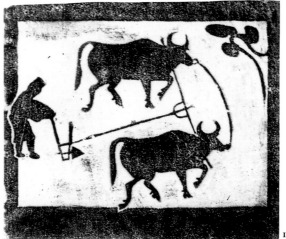

159

161

162

110

160

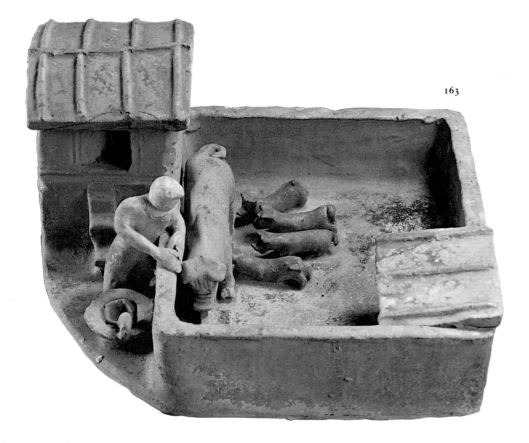

163

163. Green-glazed pottery model of a pigsty
Animal husbandry is evident in the neolithic remains found at Banpo, where pigs, chickens and dogs were raised. During the Qin and Han dynasties much progress was made in improving stock breeds and in the techniques of raising animals. This green-glazed pottery pigsty, six inches high, was discovered in 1961 in a Han-dynasty tomb in Qianxian County.

164. Jade pig

165. Green-glazed pottery dog

166. Pottery storage jar

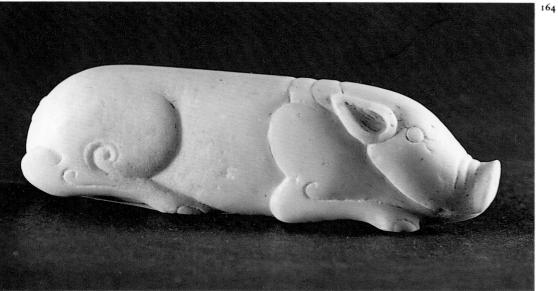

164

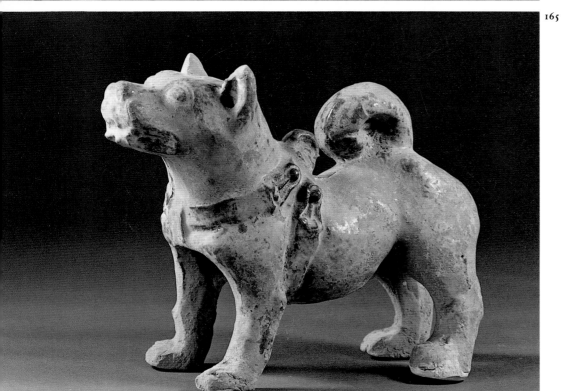

165

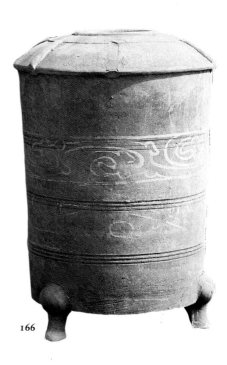

166

167 (top); 168 (above)

167. Remains of the Zheng Guo Canal

The remains of this canal are on the northern bank of the Jing River, north-west of Jingyang County. Before the state of Qin conquered China another state, Han, became concerned about their increasing power. When Qin asked for advice on water conservancy Han sent Zheng Guo, a specialist, to tell them to dig a canal connecting the Jing and Luo Rivers in the hope that this massive project would ruin them economically and thus halt their eastward expansion. Qin accepted the suggestion and recruited thousands of labourers to dig a canal from Gukou (in Liquan County), channelling water from the Jing River past Zhongshan to the Luo River in the east, a distance of over ninety miles. It brought under irrigation vast tracts of saline–alkali land and transformed them into fertile farmland. Instead of ruining Qin the construction of the canal increased grain production, strengthening the economy and enabling Qin to launch successful attacks against the six rival states. The Zheng Guo Canal continued to be one of the major reasons for the key role of the land within the passes during the following 1,000 years.

168. End of Longshou Canal

Longshou (Dragon's Head) Canal was constructed during the reign of the Han emperor Wu in order to collect water from the Luo River to irrigate the land east of Linjin (Dali County) and Chongquan (southeast of Pucheng). As the Gaoyan Mountains (now called the Tielin Mountains) traversed this area, the canal had to be tunnelled through them. At first the canal passed through a cutting but the risk of the mountain slope collapsing into the canal caused a change in technique. Wells were dug and then connected horizontally underground by means of tunnels. This method was later imitated in Xinjiang in the west of China and in such countries as Iran and the USSR. Dinosaur fossils found while these tunnels were being dug gave the canal its name. This photograph shows Donqutou (East Canal-Head) Village on the right and Xiqutou (West Canal-Head) Village to the left.

169

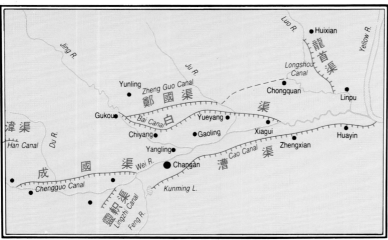

169. Map of the Tang-dynasty water system in the land within the passes

In the Tang dynasty the area surrounding the capital, Changan, was criss-crossed by rivers and canals and dotted with lakes. The Zheng Guo and Bai Canals were to the north of the city, the Han, Chengguo and Lingzhi Canals to the west, the Cao Canal ran south of the city and the Longshou Canal was to the north-east. Apart from the 'Eight Rivers of Changan' there were many lakes, including Kunming Lake, the source of the Cao Canal. The water resources provided by these canals, rivers and lakes helped compensate for erratic rainfall and were also important as a transport network, adding to the prosperity of the Tang dynasty.

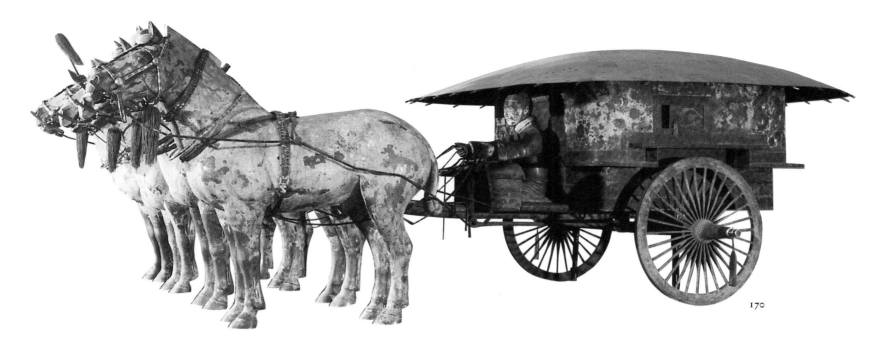

170

170. Bronze chariot
Two chariots have been excavated
west of the tomb of the First
Emperor. The one shown here is
made of bronze, weighs 2,736
pounds and has 3,462 parts. It is
about half life-size.

**171. Detail of a horse pulling the
bronze chariot**

172. Four-god wine-warming stove
This is made of bronze, with an
open top, a flat base and horse-hoof
feet. The stove walls are cast with
the gods of the four directions. A
long bow-shaped handle with a flat
round end sticks out from the
central section, while the edge of the
stove mouth has four knobs
supporting a shallow bronze vessel.
This delicate and finely executed
wine-warming stove dates back to
the Western Han dynasty.

173. Iron gear wheel
Iron gear wheels were first found in
the Han dynasty and precipitated an
unprecedented progress in the
development of many kinds of
machinery, as the wheel could be
used to change direction and start
and stop machines. This picture
shows a Han-dynasty iron gear
wheel found in the eastern suburbs
of Xian.

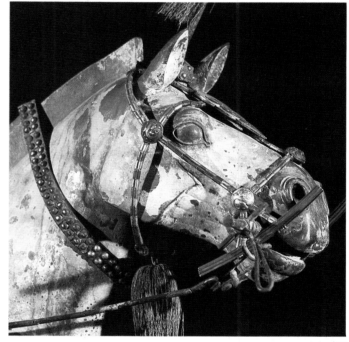

171

172

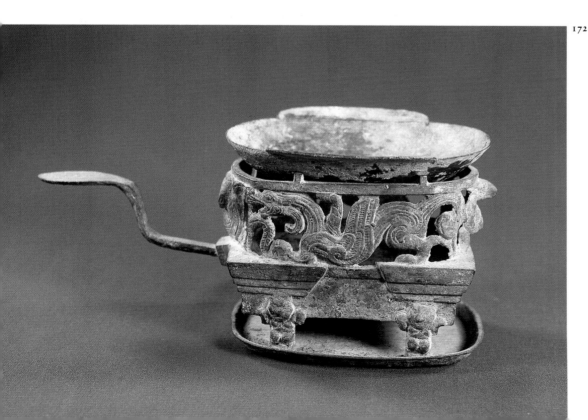

173

113

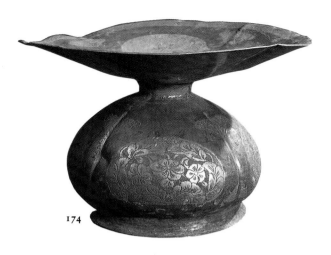

174

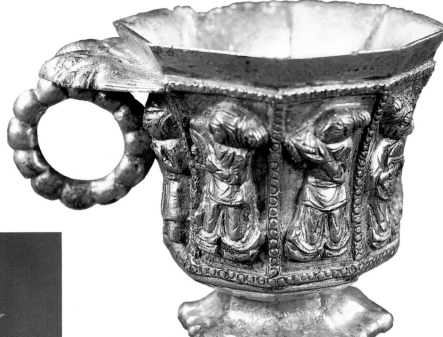

175

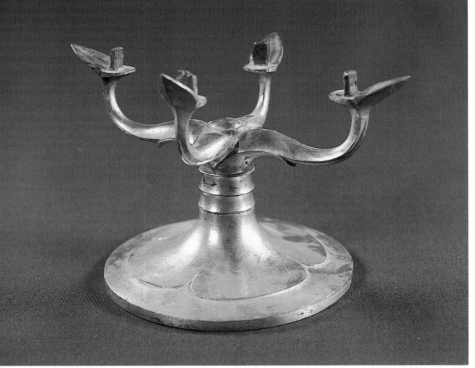

176

177. Qin-dynasty weight
This bronze weight is inscribed on all sides. One side bears the relief characters Gaonu, the name of a county in present-day Yanchuang County. The other sides bear two paragraphs, one being a decree issued by the First Emperor in 221 BC and the other a decree of the following emperor in the first year of his reign, 209 BC. The decrees relate to the standardization of weights and measures introduced by the First Emperor in his own state of Qin before he had unified the country, and then extended throughout the empire after 221 BC.

174. Gilded silver container

175. Octagonal gold cup with relief pattern of musicians
This was found in the southern suburbs of Xian and is 2.5 inches high. On the top of the handle are relief patterns of two old men's heads with deep-set eyes, high noses and long beards – probably representing foreigners. With its exquisite design and fine workmanship it is one of the best pieces among the extant gold and silver wares of the Tang dynasty.

176. Gilded stand for wine cup
This gilded bronze stand was used by Han-dynasty noblemen to support their wine cups. It has a wide, trumpet-shaped base, while the upper part resembles a persimmon stalk. The stem is round with thread patterns. The design is very unusual and the workmanship superb.

177

178. Qin-dynasty measure
The short empty shaft of this bronze measure was designed to hold a wooden rod. Both sides are inscribed with a decree of the First Emperor while the top bears a decree from the second emperor.

178

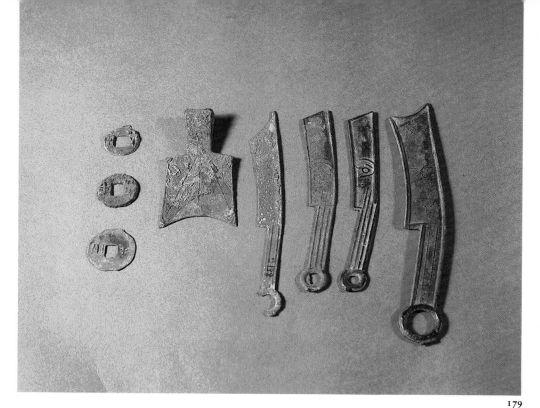

179

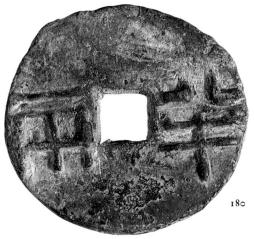

180

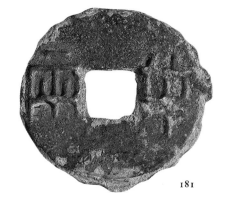

181

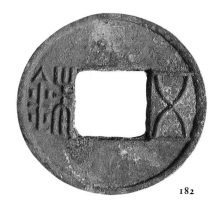

182

179. Pre-Qin money
During the Eastern Zhou period each of the many states had their own currency. The picture shows three sorts of coins – round, shovel-shaped and knife-shaped – that were among the most extensively circulated tender of that period.

180. Half-liang Qin-dynasty coin
A liang was a Qin unit of weight made up of twenty-four zhu and equivalent to slightly less than two ounces. This coin, weighing twelve zhu, or half a liang, was originally the currency of the state of Qin and, after Qin had defeated the other states, it became the standard currency throughout China. Successive dynasties up to the Qing all modelled their own currencies after Qin coins, because of their simplicity and convenience.

181. Half-liang Han-dynasty coin
The Han cast its own half-liang coins which were smaller than those of the preceding Qin dynasty. In addition they cast coins weighing two-thirds and one-third the weight, eight zhu and four zhu respectively.

182. Five-zhu Han-dynasty coin
This weight of coin was first cast in 126 BC during the reign of Emperor Wu, and then in six dynasties of the Wei and Jin period following the Han. It was generally about one inch in diameter and weighed five zhu. It was the coin used for the longest period of time in ancient China.

183. Han-dynasty pottery coin mould
Moulds for casting coins were usually made of bronze or pottery.

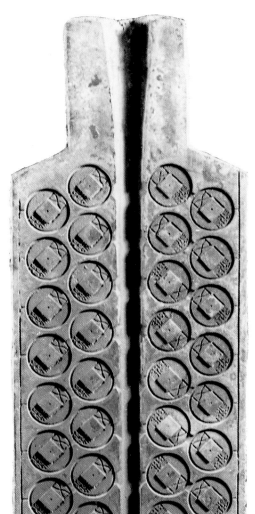

183

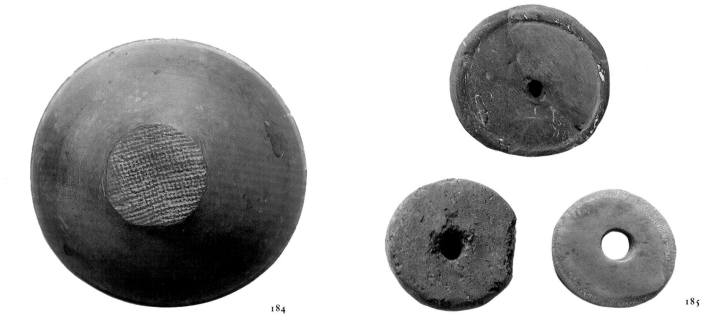

184

185

184. Pottery jar with impressed pattern

185. Spindle wheels
These wheels, used in spinning for textile weaving, were found at the neolithic site at Banpo.

186. Gilded silkworm
This silkworm was found in 1985 in Shiquan County. It is 2.2 inches long, with a nine-jointed body. Its head is raised as if it were spinning silk. Shiquan County being a major producer, the silk industry prospered during the Han dynasty, and gilding techniques were also developed. This silkworm has been cast in bronze and then gilded. It is the only one of its kind.

187. *Picking Mulberry Leaves* – a **brick painting**

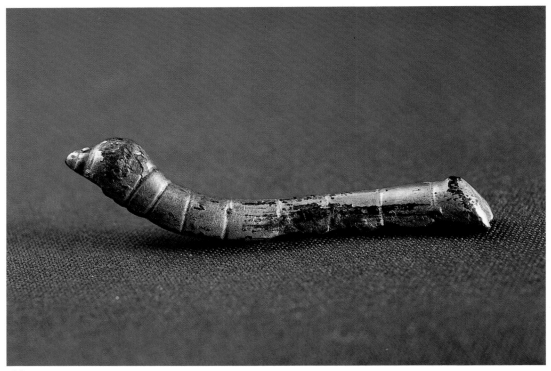

186

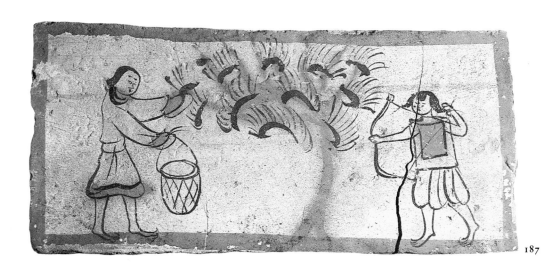

187

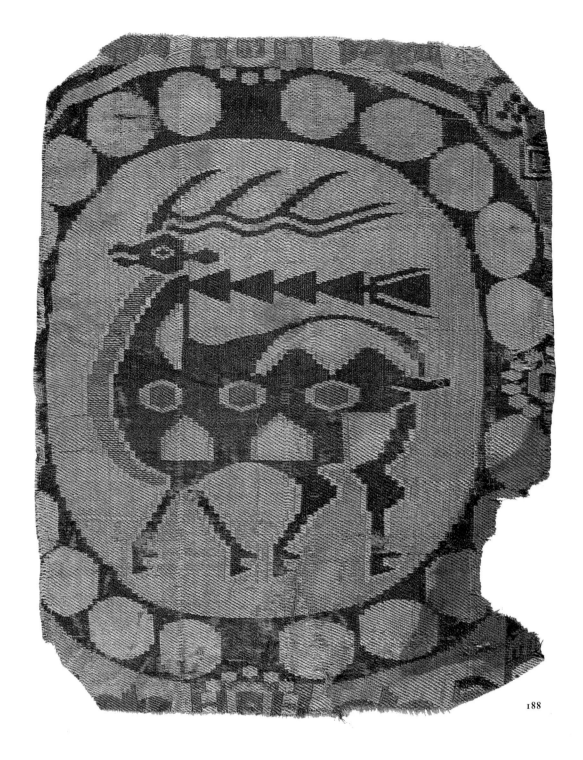

188

188. Tang *jin* with linked pearl and deer design
This piece of silk was found in a Tang tomb in the northern area of Astana in Xinjiang Province. It measures 8.6 by 8 inches and has a yellow *juan* silk rim bordering a piece of *jin* silk with a design of linked pearls surrounding a deer walking proudly along, head held high. The Chinese word for 'deer' is a homophone for 'official salary', hence the deer is often used to symbolize good fortune, or the attaining of an official post.

189. Hemp paper
This paper was discovered in a Western Han tomb in Baqiao, near Xian, in 1957 and is the earliest example of paper discovered to date in the world.

189

190. Part of the wall of the state of Wei
This section of what was later to become the Great Wall was built by the state of Wei to protect itself from invasions by neighbouring states and nomadic tribes in the north. It was started in 252 BC and extended for over ninety miles from Huaxian, through Chengbeicun and on in a circuitous fashion to the bank of the Yellow River. Watchtowers and defence posts were built along its length and guarded by strong forces. The picture shows part of a relatively well-preserved section which runs for twelve miles between Changnancun in the east (nine miles south of Hancheng) and Chenghoucun in the west. It is about 16 feet high, 26 feet wide and made of layers of rammed earth each about 3 inches thick.

191, 192. Warning beacon
This tower, built on a peak south-west of Mt Li in Lintong County, was used to alert the feudal lords in the surrounding area of impending attack and so summon them to the capital.

191

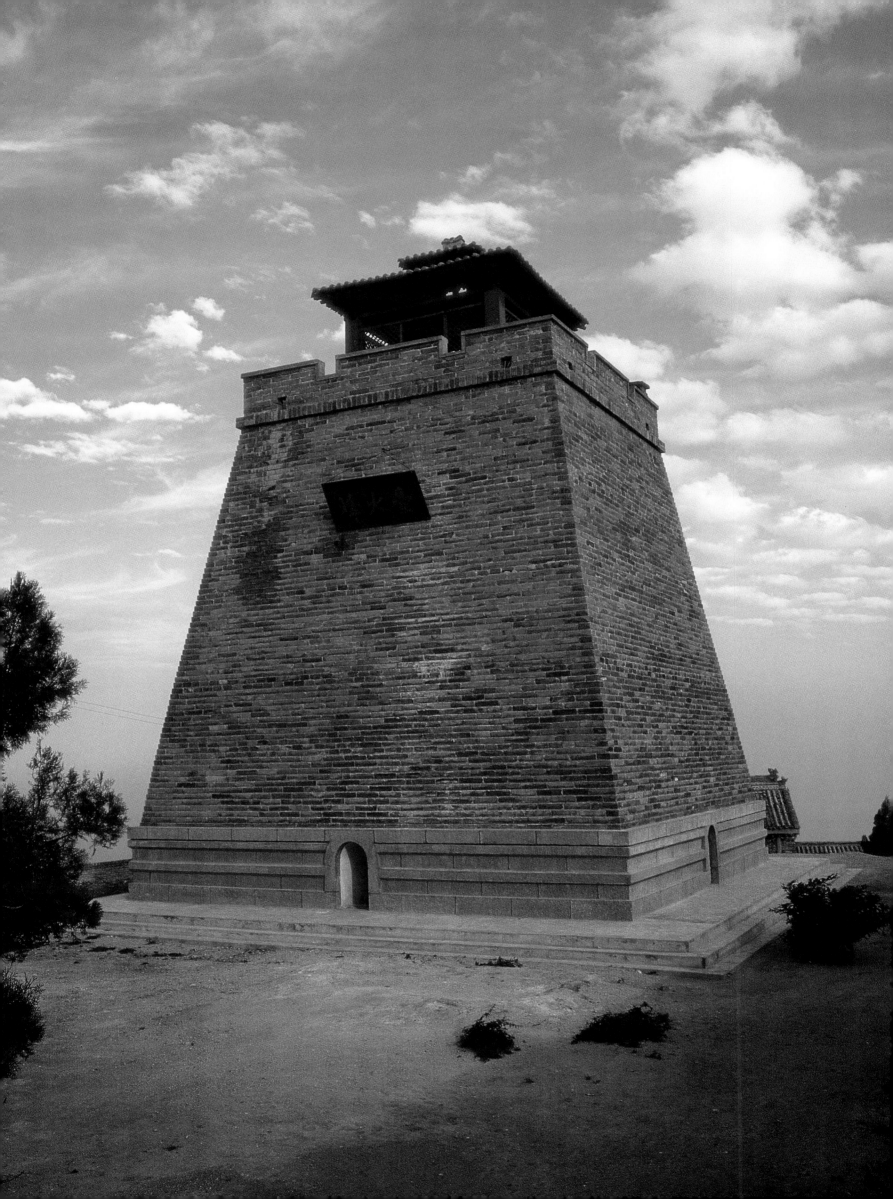

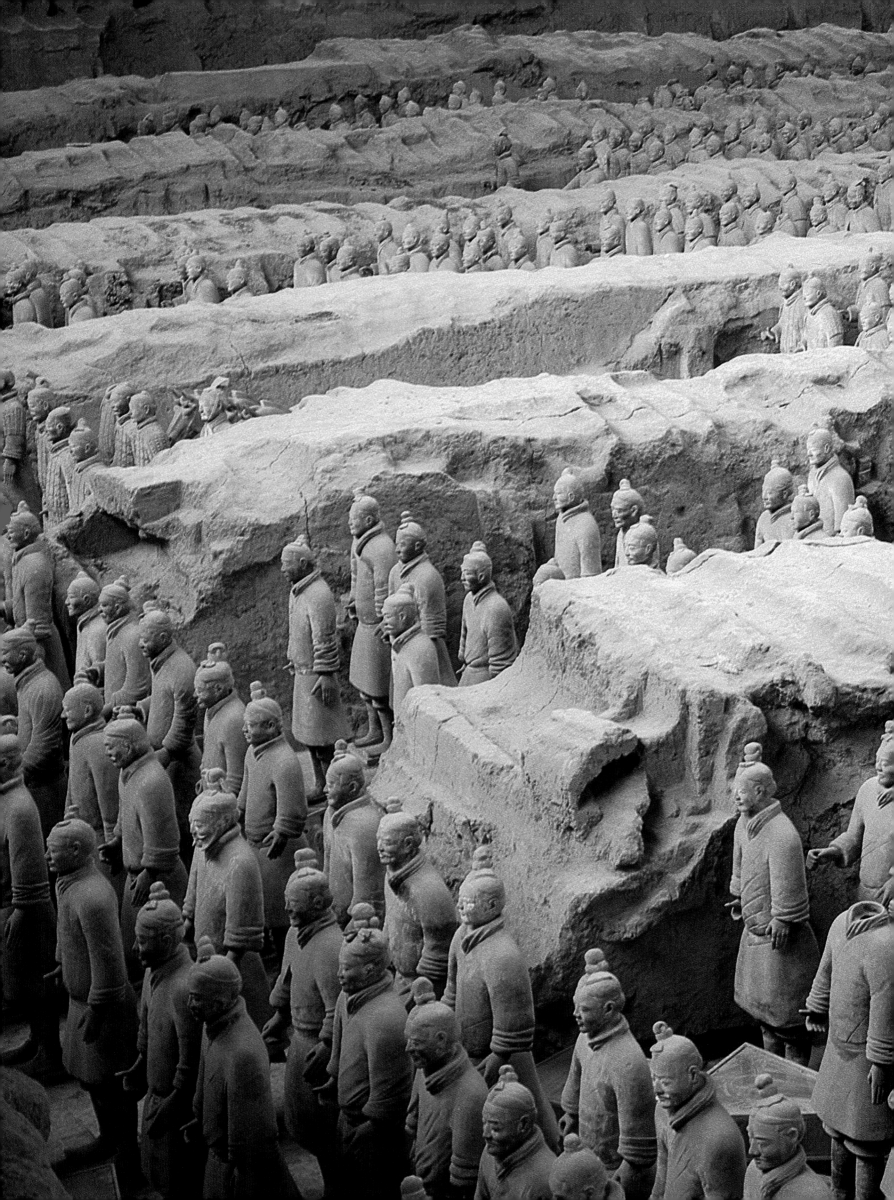

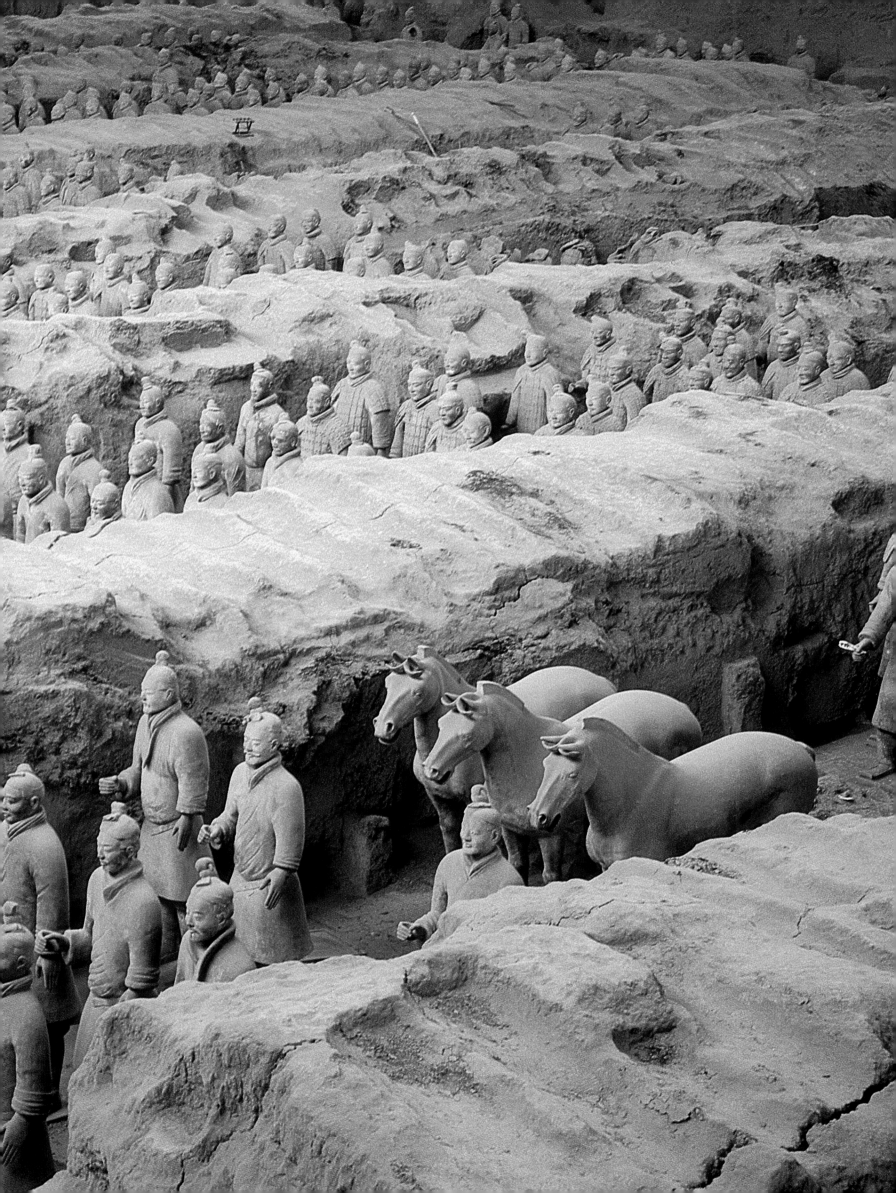

193. Terracotta army of the First Emperor of China – Pit No. 1
(*previous pages*)
The discovery of this terracotta army to the west of the mausoleum of the First Emperor of China excited the world. Pit No. 1, shown here, covers 27,950 square yards and contains 6,000 life-sized terracotta warriors and horses arranged in military formation, ready for battle. The three front rows of 64 warriors all face east and act as a vanguard. They are followed by 38 columns. The chariots and infantry form the main body of the army and there are rows of soldiers on both sides and at the rear representing the flank and rear guards. These well-organized warriors must surely reflect the force and discipline of the Qin army, which defeated the other six states at the end of the Warring States period.

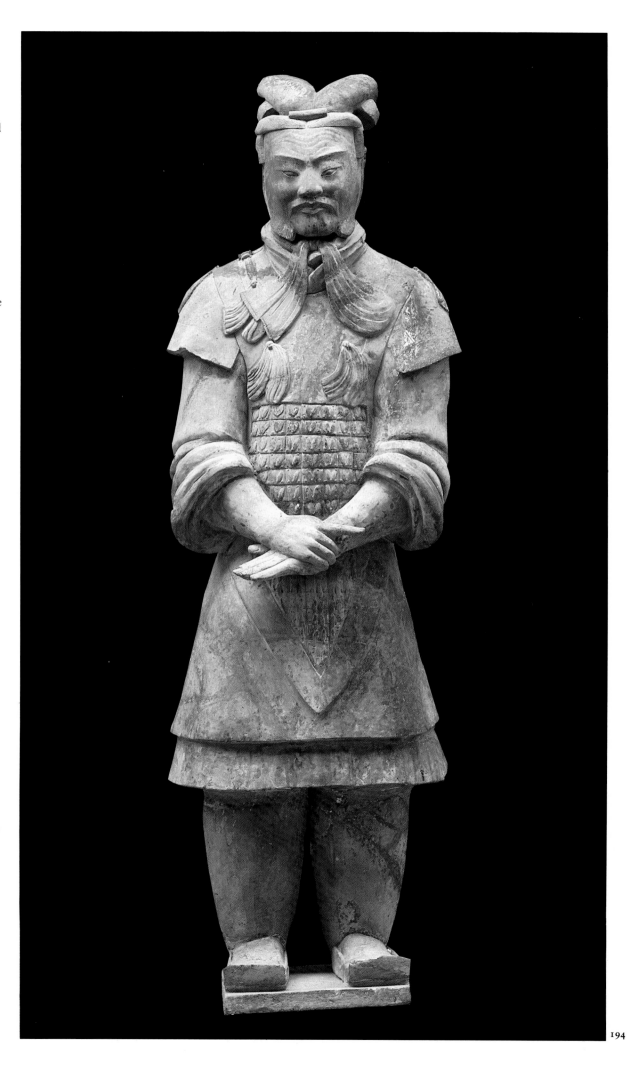

194. Army general
This Qin general wears armour with a fish-scale pattern over a long jacket and trousers which narrow at the ankle. His shoes have square toes that curl up. His sleeves are rolled up and his hands are crossed in front of him as if he were leaning on a sword. He is 6 feet 5 inches tall and was found commanding the crossbow force.

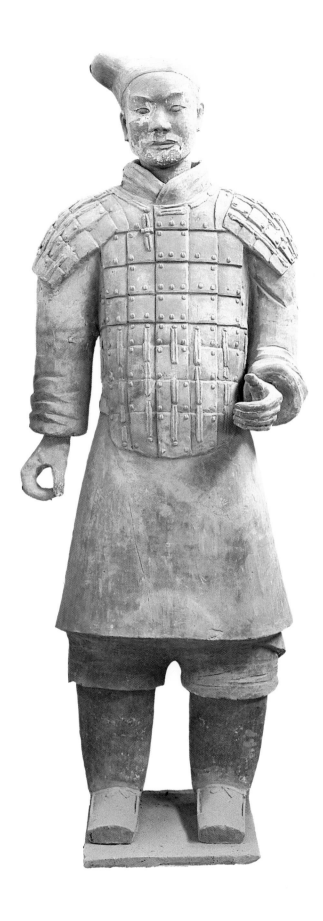

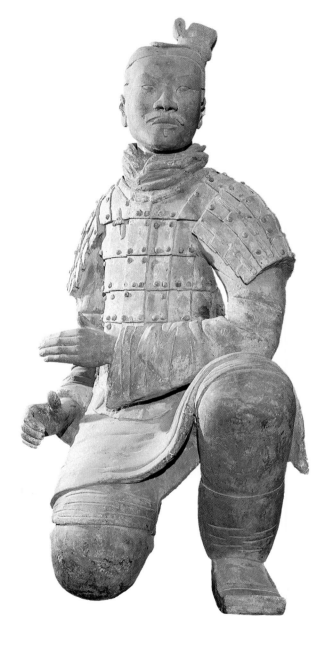

195. Soldier
This figure is 5 feet 11 inches tall
and wears a short brown jacket,
armour and short boots. The
soldiers were in various postures as
if holding spears, swords or
crossbows.

196. Kneeling archer
This warrior also wears armour and
is shown kneeling on one knee,
drawing a crossbow.

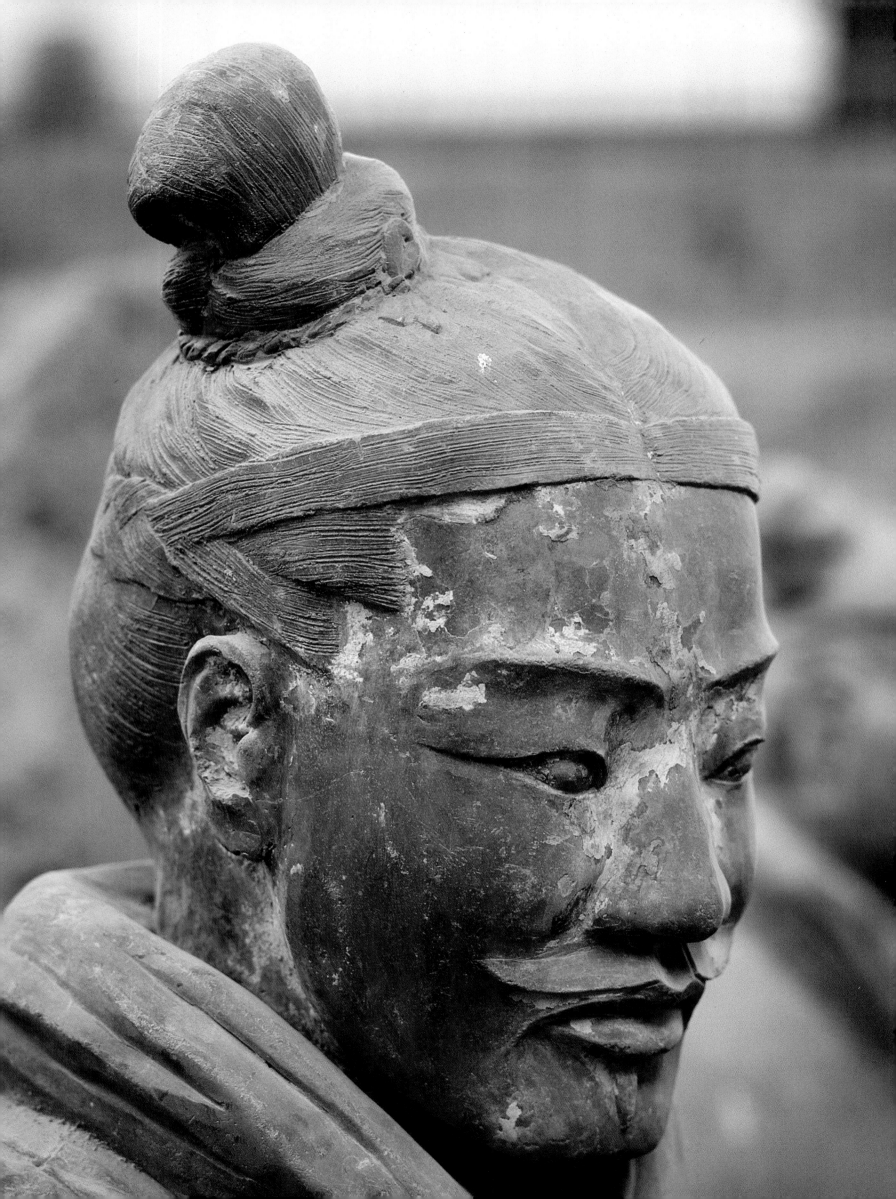

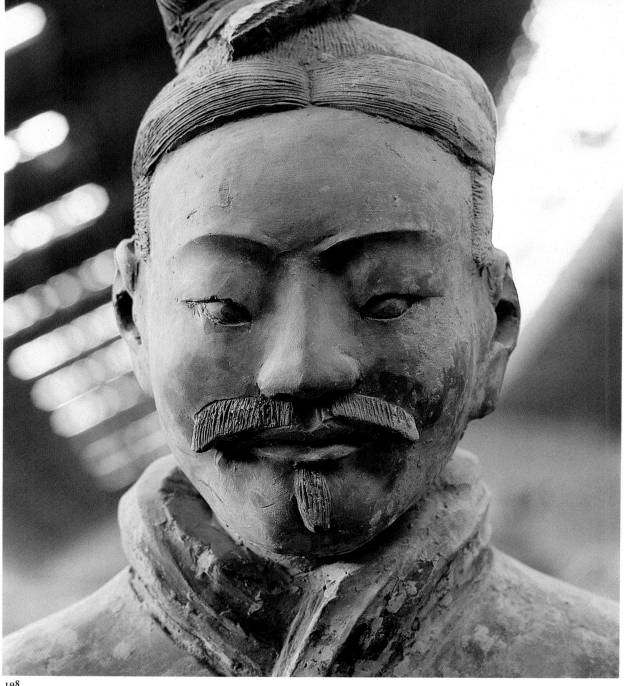

198

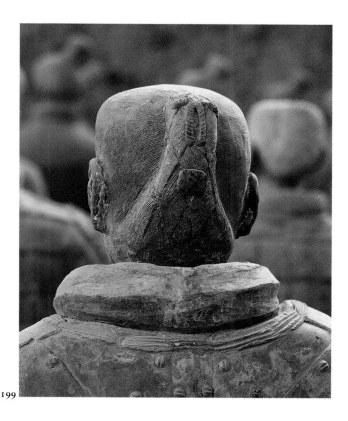

197–199. Details of soldiers' heads
The soldiers comprising this terracotta army had many different hairstyles, all extremely detailed. Plates 197 and 198 show two different soldiers, both with top-knots, while the soldier in 199 has pigtails tied at the ends with bows and rolled up and fixed at the back of his head by a hairpin, which can be seen under the ribbons.

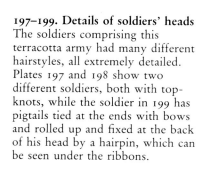

197

199

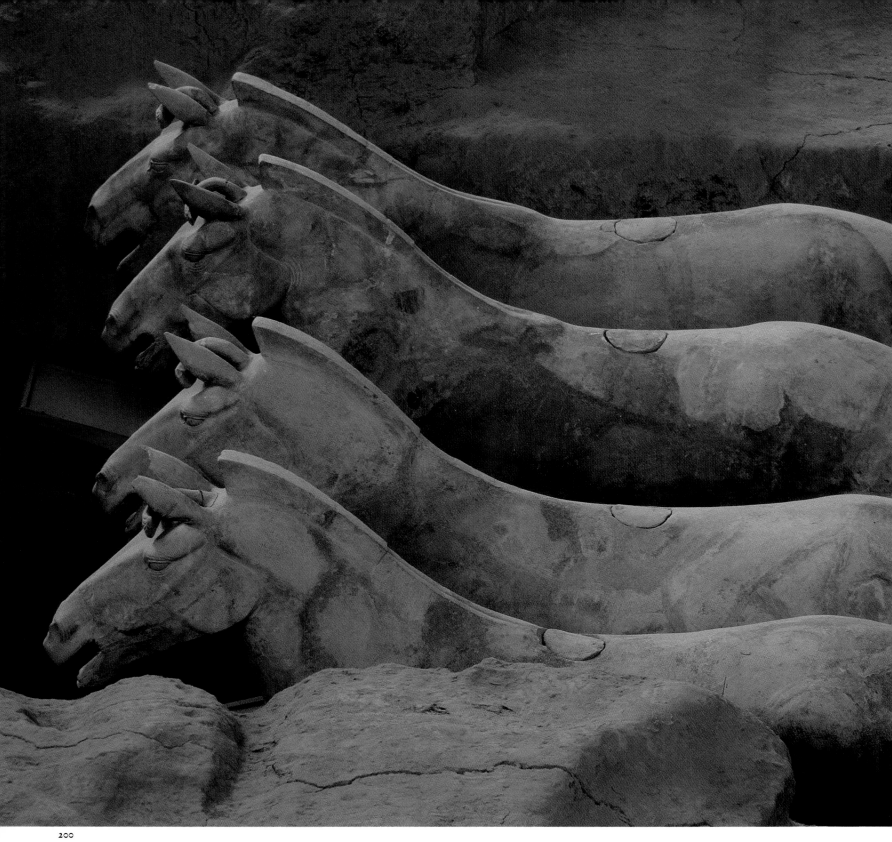

200

201

200. Four-horse chariot

126 201. Detail of a soldier

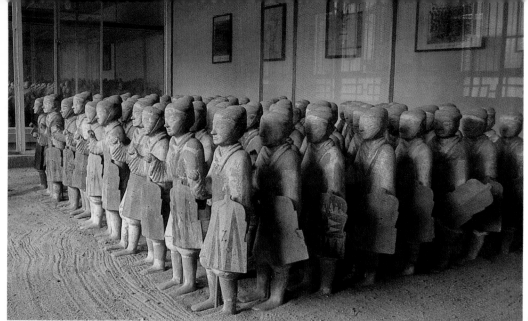

202

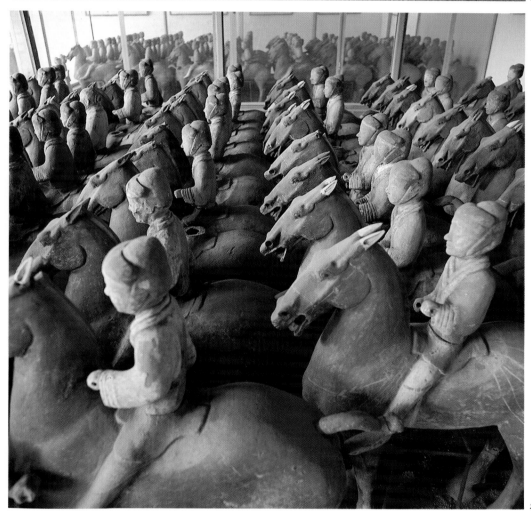

203

202, 203. Pottery figures of infantry and cavalry regiments from Yangjiawan
These two pottery regiments, one infantry and one cavalry, were found at the tomb of Zhou Yafu, an attendant tomb at the Chang Mausoleum of the Han-dynasty emperor Gaozu, in Yangjiawa, Xianyang County. There are about 3,000 pieces in total.

204

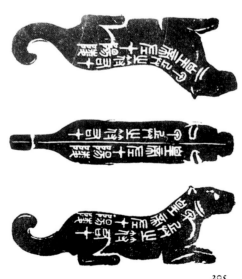

205

206

204. The Du tally
This is a Qin-dynasty military tally used to ensure the authenticity of military documents. One half of the tally was kept by the emperor and the other by the military commander. The inscription reads: 'The right part of this tally is kept by the emperor and the left part is at Du. Whoever commands a force of over fifty men must first obtain authority.' Du was south of the Qin capital Xianyang.

205. Rubbing showing the inscriptions on the Yangling tally
The Du tally was issued before the unification of China by the Qin, while this one was issued after the founding of the empire. It reads: 'A military tally, the right part of which is kept by the emperor and the left part at Yangling.'

206. Bronze sheath
This sheath, discovered among the Qin-dynasty terracotta army, would have been placed at the end of the handle of a spear or halberd; fragments of the wooden handle still remain.

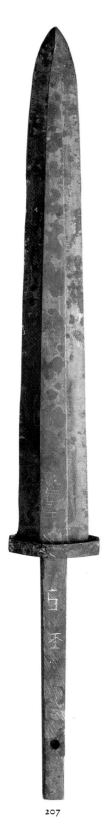

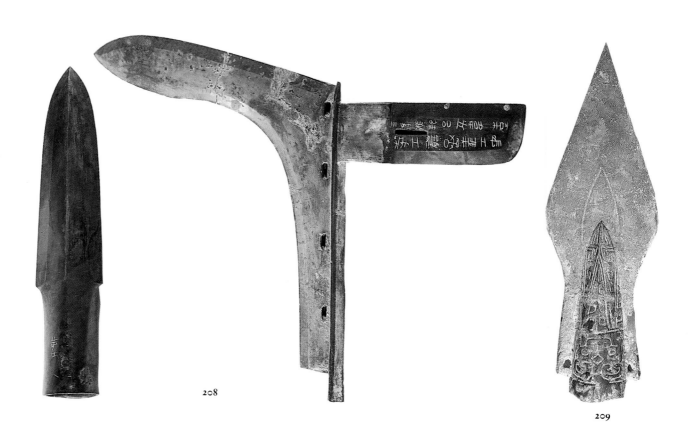

208

209

207. Bronze sword
This was found with the Qin-dynasty terracotta army. It is three feet long and made of an alloy consisting mainly of tin and lead, but also containing thirteen other metals. It has been chromized to prevent rusting, and has an oxidized layer ten microns thick on its surface, which makes it still shiny today.

208. Halberd
The halberd was a combination of a dagger-axe and a spear. It could be used in a variety of ways and was a very popular weapon. 'The halberd-holding masses' and the 'ten thousand long halberds' were both synonyms in ancient times for an army. A Qin-dynasty halberd was almost ten feet long.

209. Spear with a dragon design
Spears were common in ancient China, being among the first weapons of war. Stone spears are first seen in the paleolithic period. This metal spear with a stylized dragon design dates back to the Western Zhou.

210. Arrowheads
These arrowheads were found with the Qin-dynasty terracotta soldiers. The lead content of their tips is 7.71 per cent, making them very effective and showing the sophistication of metallurgy at the time.

207

210

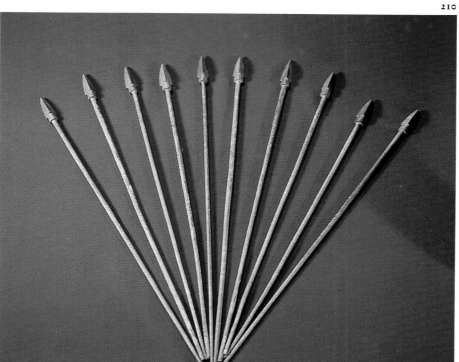

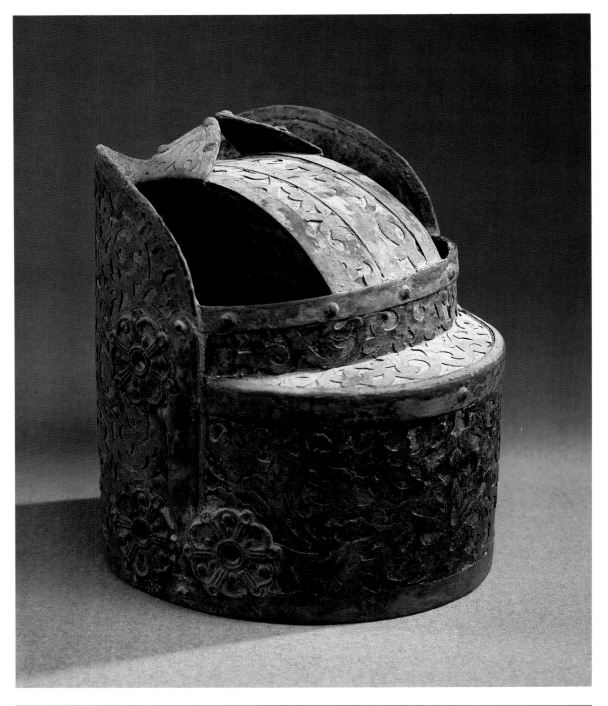

211. Helmet from the tomb of Li Ji

Li Ji was originally called Xu Maogong but was made Duke of Yin and awarded the surname Li, that of the imperial family, for his achievements during the reign of the Tang-dynasty emperor Gaozong. After his death he was buried in an attendant tomb at the imperial mausoleum, but this was destroyed when his grandson, Xu Jingye, rebelled against Empress Wu Zetian. His honour was restored by a later emperor and he was reburied with official garments, a helmet and sword. This helmet is the only Tang headgear so far discovered.

212. Li Ji's sword

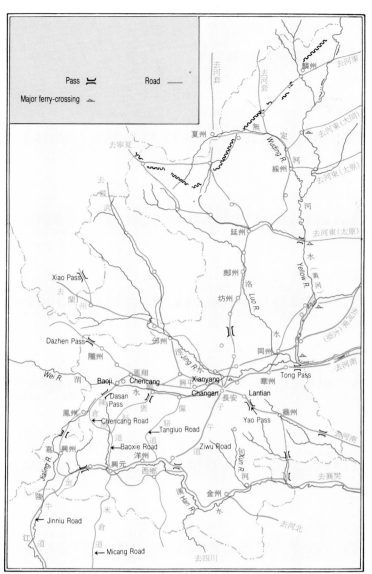

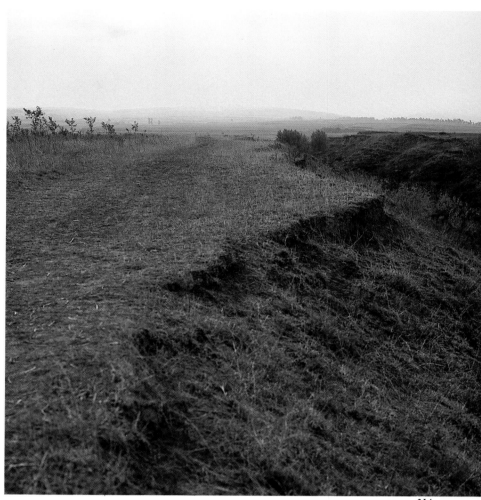

213. Map showing transportation routes in the Qin dynasty

214. The Qin-dynasty Zhi Road
This section of the road was near Linguang Palace and led to the Ganquan Mountains via Ziwu Peak.

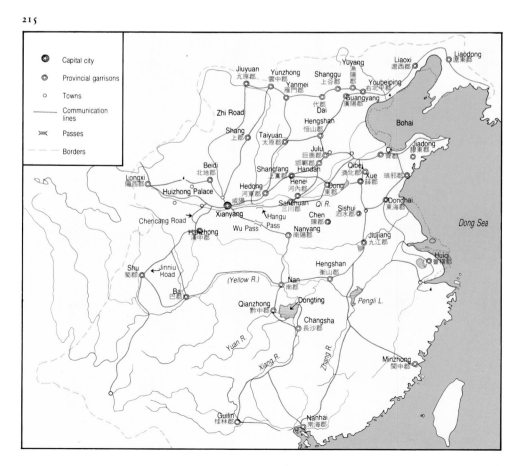

215. Map showing transportation routes in the Han and Tang dynasties

216. Site of the Ziwu Plank Road

The construction of this road began in the Qin and was carried on by the Han dynasty. The road started south of Changan and ran 261 miles to Hanzhong in south Shaanxi. The northern end, called Zikou, was nineteen miles south of Xian, and the southern end, Wukou, fifty miles east of Yangxian County. The road followed a valley with steep cliffs. Wooden sleepers were inserted into holes drilled into the cliff-face. These supported the planks that gave the road its name. The road was frequently the focus of military contention.

217. Xinhongxia Road

This was part of Chencang Road, which linked Baoji with Sichuan Province in the south-east, passing through Hanzhong. Liu Bang, the founder of the Han dynasty, was purportedly a labourer engaged to build this road who, after being held up by inclement weather on his way to report for duty at the capital, realized he would be executed for being late and so rebelled.

216

217

5.
Changan

The Thoroughfare Between China and the West: From Legend to Reality

From the Han dynasty onwards the world-famous Silk Road linked Changan in China, via Xinjiang in the western regions to central, south and east Asia, where it joined with roads leading to Europe. It was not, however, the silk trade that initiated links between China and her western neighbours: these links have a much longer history.

According to legend, Chinese influence in the pre-historic period had already reached the areas of Kunlun, Xiji and Xihai; that is the Qinghai–Tibet Plateau, part of South-east Asia. A popular story tells how, in the tenth century BC, King Mu of the Western Zhou set off from the capital Hao in a chariot drawn by eight horses, on a journey to present-day Pakistan. During the trip he was said to have passed through the areas today known as Henan, Shaanxi, Inner Mongolia, Ningxia, Gansu, Qinghai and Xinjiang, and to have met the Queen Mother of the West, a famous mythical figure, at Mt Yanzi.

In the west there are stories that suggest that, during the sixth and seventh centuries BC, Greeks had already travelled to the 'capital of the Silk Country'. The famous Tang-dynasty Buddhist monk, Xuan Zang, while on his travels to India to collect scriptures, heard a legend concerning the ruins of a place called Princess Castle at Taxkorgan (in Xinjiang Province). The legend told how, in the third century BC, a Persian king sent an envoy to China to bring back a Chinese princess whom he was to marry. On their journey back they built this castle on top of a mountain. There is also a record of a delegation of eighteen Indians, led by a monk, being received by the Qin emperor in the capital Xianyang in 218 BC.

After the unification of China by the Qin the city of Xianyang, located in the heart of the land within the passes, became the country's political, economic and military centre, and hence the hub of communications throughout the empire. The Qin encouraged the bartering of silk for oxen, horses and other materials with regions in the north-west, and contacts were established with India, Arabia and other civilizations to China's west via Shuchuan and Yongchang (Sichuan Province and

Baoshan County in Yunan Province). The Sanskrit words *Cina* and *Chinas* and the Arabic words *Cyn* or *Sin* are all transliterations of the Chinese word *Qin*. In ancient India people also called China the 'Land of Qin'.

Towards the end of the Qin dynasty, the Xiongnu – nomadic people who lived on the steppes to the north of China – took control of areas west of the Yellow River, thereby severing China from the roads leading west. In about 138 BC, Zhang Qian, under order from the Han emperor Wu, set off from Changan to try to negotiate an alliance with another people, the Dayuezhi in Bactria, in order to mount a converging attack on the Xiongnu (the Xiongnu are said to have killed the king of the Dayuezhi and used his skull as a drinking vessel). He encountered many difficulties passing through the Xiongnu-held territory, being captured on both the outward and return journeys, but he nevertheless successfully traversed the Gobi desert and the Congling Mountains to reach Dayuan, Kangju and Dayuezhi. He finally returned to Changan in 126 BC; his mission having opened up further contacts between China and Asia. Its significance was recorded in the *Shiji* as 'an unprecedented undertaking', and scholars in more recent times have described it as 'the discovery of a new land'. In 119 BC the Han dynasty mounted a successful attack against the Xiongnu and Zhang Qian was again called upon to serve as an envoy on diplomatic missions to countries in the west.

The Birth and Development of the Silk Road

Zhang Qian's 'unprecedented undertaking' is usually regarded as the opening of the Silk Road, making Changan of the Western Han dynasty both the heart of the Chinese empire and the eastern terminus of a major trade thoroughfare. Chinese merchants started from here on their trade missions to central and west Asia, Persia and India, while merchants from these countries also came to Changan.

The Silk Road was extremely long and arduous, but Chinese governments from the Han dynasty onwards devoted considerable effort to its management. When the capital was moved to Luoyang in the Eastern Han, Changan became a prefecture but retained its role as the major distribution centre for east–west trade. The Silk Road continued to be used throughout the turmoils and muddled warfare of the Northern and Southern dynasties period following the fall of the Han, as can be seen from the fact that in AD 397 Fa Xian, a prominent Chinese monk, travelled along it on his way to the Buddhist states of the west and in AD 401 Kumarajiva, an Indian monk, arrived in Changan to translate Buddhist scriptures.

Soon after the founding of the Tang dynasty (AD 618) the Tang army defeated the Tujie people, powerful enemies in the north, and subdued other tribes in the west. A protector-general's office was established for maintaining peace and order in the western regions, which resulted in a period of flourishing trade along the Silk Road and brought great prosperity to the areas it passed through. A Song-dynasty source recorded that from Changan's 'Kaiyuan Gate (the west gate of the city) to the borders of the Tang empire in the west, houses lined the route and mulberry and hemp trees provided shade'. In Xinjiang Province the Silk Road branched into three routes; in addition to the northern and southern routes which went south of the Tian Mountains and had been opened before and during the Han dynasty respectively, a new branch was opened which went north of the

mountains and led directly to Suiye, the westernmost town under the jurisdiction of the protector-general's office (today Tokmak, in the Republic of Kirghiz in the USSR).

Exotic Products from Many Lands

The main characteristic of Changan was its cosmopolitanism; the diversity of culture was shown by the wide range of foreign goods available and the large number of foreigners. In the Western Han, Zhang Qian and others brought back seeds of grapes, walnuts, broad beans, sesame, pomegranates, cucumbers, garlic, lucerne lettuce and alfalfa, which were first cultivated near Changan. Following this, envoys and merchants from the west brought in fine horses, perfume, ivory, hawksbill turtles, asbestos cloth, ostrich eggs and several rare birds and animals. Two breeds of horse, the Xiji breed from Wusun (the Ili River basin region) and the Tian from Dawan were especially appreciated; Han emperors composed poems in admiration of their beauty and special pastures were set aside for breeding from them, resulting in a dramatically improved strain of Chinese horse. During the Sui and Tang dynasties, pearls, lions, Persian horses and ostriches all found their way to Changan.

Not only was there a flourishing commercial trade in the Sui and Tang periods between China and the other lands, but the Tang court maintained diplomatic contact with numerous countries and regions. Kings and emperors, officials, scholars, monks, merchants and even ordinary people from all these places visited Changan, one of the largest and most splendid cities of its time. Special institutions, such as the Honglu Temple, were established to attend to foreign visitors, and a protocol department received them, provided interpreters and looked after daily necessities; travellers were even provided with travel expenses for their return journeys. Successive Tang emperors granted frequent audiences to visiting envoys. It is recorded that Empress Wu Zetian gave an audience in the Linde Hall of the Daming Palace to Makone Awata, an envoy from Japan. Xuanzong received Japanese envoys several times in the Xingqing Palace and at a leaving banquet personally composed farewell verses. He also held grand state banquets in Hanyuan Hall in the Daming Palace to welcome diplomatic envoys from Arabia, Korea and Japan.

The growth of foreign trade resulted in the development of markets – special areas reserved for commercial transactions – in Changan. During the Han dynasty there were nine markets in the city – six in the west and three in the east, each about 260 feet square. The markets were well stocked with a wide range of goods as transportation was convenient; the markets were all close to junctions of the east and west avenues which led directly to the start of the Silk Road.

Commerce also flourished in the Tang capital where two markets were the centre of activity. Not only were these markets much larger than those in the Han capital but they were better organized, with trading following regular hours. Of the two, the Western Market was closer to the junction with the Silk Road and also bordered the Yongan and Cao Canals. Its convenient location helped to attract large numbers of merchants and businessmen. Garment stores, gold and silver dealers, herbalists, saddlers, shops selling weights, grain and silk as well as numerous restaurants, pawnshops and banks could all be found there.

By the Tang period there were fewer restrictions placed on foreign merchants, and they came to Changan in such numbers that they were able to travel in large groups, lessening the risks of attack on the Silk Road. They would meet at Kaiyuan Gate in the west of the city with their camels loaded with fine silks and other commodities, in preparation for the long journey home. But not all the foreign merchants immediately returned home; there are also records of foreigners living and trading in Changan. The art of the period reflects a familiarity with foreigners: some of the tri-coloured glazed-pottery figures depict foreigners leading horses or camels, and many of the household utensils of the time also feature designs portraying foreigners, while evidence remaining in Changan of the burgeoning trade with other countries includes the existence of Roman, Persian and Japanese coins, and goods from abroad dating from the Tang.

Foreign Residents in Changan

Although there were foreigners living in Changan from the Han and Wei dynasties, it wasn't until the Tang that the city's residents could truly be called cosmopolitan. The first major influx of foreigners was in AD 630, when the Eastern Turks were defeated by the forces of the Tang emperor Taizong and, as a consequence, 10,000 Turkish families moved to Changan to live. From this time on rulers of neighbouring countries often sent their children to live in Changan as a pledge of their loyalty. During the reign of Gaozong, an area called Helong was captured by the Tibetans and the road to the west was cut off, leaving many foreign visitors stranded in Changan. Some remained even after the road was reopened, taking wives and buying land and property. As an indication of the number of foreigners resident in the city it is recorded that, during the reign of Dezong, 4,000 foreigners followed the official procedures to become subjects of the Tang dynasty. In the time of Suzong, 150,000 Chinese residents, originally from Sufang, Anxi, Xinjiang and Arabia, were enlisted as soldiers to recapture the two capital cities from the An Lushan rebels. During the reign of Daizong it is recorded that there were often over 1,000 Uighur people in the city.

These foreigners who made Changan their home not only brought new blood to the Chinese nation but made lasting contributions in political and economic spheres. King Peroz of Persia, accompanied by his son Prince Nyas, came to Changan to request help from the Chinese court after his Sassanid dynasty was defeated by the Dashi. The father and son were appointed Right and Left Generals of the Tang's defence forces; a model of the king is to be found among the sixty-one stone statues representing envoys that stand in front of the tomb of the Tang emperor and empress Gaozong and Wu Zetian. Another famous Persian to hold high office in the Tang government was Li Yuanling. He was originally called An, but after performing outstandingly in the suppression of two attacks – the Tibetans' incursion into the Hexi corridor and the rebellion of Zhu Zi – he was rewarded by Emperor Dezong with the imperial surname, Li. He held the positions of Left Minister, Viceroy, Commander of the Zhengguo Army and Prefectural Governor in Huazhou (Huaxian County, near Xian), where a monument still stands to commemorate him. Then there was Mi Jifen, so called by the Chinese because he came from the state of Mi (south-east of Samarkand in the USSR). He also served as general, holding the post of Left

Commander among others, and died in Changan in AD 805. His grave has recently been discovered in the western suburbs of Xian.

Foreign traders came from many countries in Central Asia, but mainly from Persia and Dashi, to do business in the major cities of China, some staying permanently. Usually they were jewellers, or ran food stores and wine shops, but the most successful operated banks and even conducted business on behalf of the emperor: agalloch eaglewood was specially imported for the construction of the royal palaces; grape wine and flax-oil cake were delicacies of the western regions favoured in Changan.

Cultural Exchanges

During the Tang dynasty the introduction and assimilation of foreign cultures enriched the indigenous Chinese culture in Changan. According to a book on the arts written in AD 894 it was possible to recognize dances introduced from the western regions. Emperor Xuanzong, who was alleged to be a good composer of music, adapted a western opera, *The Brahman's Song*, to become the *Song of Beautiful Clothes*. He also arranged a dance of the same name which was performed in the palace and which has since been taken as representative of a Tang dance style. A folk dance from the western regions known as *sumozhe* (also called *luntuo*, or the water-sprinkling dance) was also prevalent in Changan and other cities in China. The lion dance, now such an integral part of many Chinese festivals, was introduced to China by Xiliang performers.

The imperial court music of the Sui and Tang dynasties also absorbed foreign elements, and music from India and Korea could be heard in Changan at this time. The court musicians would use a combination of traditional Chinese instruments and foreign instruments; the Jie drum (named after the Jie tribe), for instance, remains one of the main instruments in a Chinese traditional music ensemble. Not only were many of the instruments foreign, but some of the most famous musicians and singers at court and elsewhere came from west and central Asia.

With this penetration of western influence in the east, some of the higher-class women in Changan began to adopt foreign hair-styles and dress fashions, reflected in murals, stone carvings and tri-coloured glazed-pottery figures found around Changan. Moreover, Chinese women are sometimes shown on horseback, another custom from the western regions.

Although it is impossible to list all the ways in which foreign culture influenced China in this period, it is clear from the above examples that many aspects of Chinese life were enriched. Of course, there are also numerous examples of Chinese influence on other cultures in this period. Besides silk, China exported lacquerware, bamboo products, steel, gold and silver utensils, steel-making and well-drilling technology and advanced farming techniques. Kabul in Afghanistan has a collection of lacquerware fragments dating from the Han dynasty in China. Pliny (AD 23–79) praised Chinese iron and steel products, saying that they were outstandingly fine. The ancient Indians called iron and steel 'products from China', peaches 'fruits of the Han' and pears 'Han princes'. They also used the phrase 'Land of Qin' as a prefix to such words as lead, copper and camphor. At the same time as Buddhism travelled east to China, portraits of Lao Zi and copies of the Daoist classic ascribed to him, *Daodeching*, travelled west, finding their way to India. In AD 751

techniques for weaving Chinese silk, for painting, for gold and silver beating and, notably, for paper-making were introduced to Arabia by captured soldiers, and in this way spread to Europe. In Arabic the expression for nitre is 'Chinese snow'. Innumerable other such examples could be cited to show the impact Chinese civilization and culture had on the development of other civilizations to her west.

Exchanges between China and her eastern neighbours deserve special mention. Historical records show that the First Emperor of China sent a Chinese necromancer, Xu Fu, as leader of a group of young people across the East China Sea in search of the elixir of life. They never returned, but there are Japanese legends that describe the place where they are said to have landed and which also claim that Xu Fu's descendants are still living in Japan. Many bronze mirrors dating from the Han dynasty have been discovered in ancient tombs in Japan, but the most valuable finding to date is the gold seal of the Japanese king, issued by the Chinese Han dynasty. Whatever the exact date of the first contact, by the Tang there were numerous exchanges: nineteen diplomatic missions from Japan consisting of 200 people in the beginning and up to 600 people by the time of the later missions. There were many Japanese students resident in Changan, some of them spending twenty or thirty years pursuing their studies. When they finally returned to Japan they made significant contributions to the development of Japanese culture. The Japanese emperor Kōtoku, in launching the Taika Reforms in the seventh century, was assisted by Kuromaro Takamuku and other returned students. At this time many of Japan's basic structures, notably the legal system and the government, were profoundly influenced by the Tang; the current political system in Japan, consisting of a central government with two chief offices and eight ministries, was established on the basis of the Tang system of three ministries and six departments.

During the course of the frequent economic and cultural exchanges between China and Japan, skills such as water-wheel making, metal smelting, ceramics and silk weaving were passed on to Japan. When students and monks returned to Japan they took with them large quantities of ancient Chinese books, classical works, calligraphy and paintings, Buddhist scriptures, figurines, portraits, traditional medicines, architectural techniques, music, dances, poetry and fine arts. Kukai and Makibi Kibono were two scholars who took back the Chinese script and from it developed Japan's own written syllabary. On the other hand, amber, agate, pearls, silk, hemp and other cloth were imported to China from Japan.

The Tang dynasty also maintained close links with the Kingdom of Silla on the Korean Peninsula. In AD 663, Emperor Gaozong appointed Kim Bok Min, Prince of Silla, as governor of Jilin Prefecture after Kim had unified his kingdom. The government of Silla consisted of a prime minister, a deputy prime minister, an agricultural minister, a minister of supplies and various other officials, and was obviously influenced by the Tang system.

Tang garments, silks and gold and silver inlaid articles were transported to Silla in great quantities while the export trade to China from Silla exceeded that of any other country. Students from Silla arrived continuously in Changan; the largest recorded group consisting of 105 students. Many of them passed the Chinese imperial examinations and some remained as officials in China. Because Silla absorbed so much of the Chinese political system and culture she prospered and was praised by Xuanzong as 'a land of gentlemen, extremely cultivated and in many ways like China'. He selected learned officials to go to Silla as diplomatic envoys.

Tang-dynasty Changan, certainly the largest and most splendid city in the East, acted as a model for cities throughout the world: the ancient capital cities of Japan such as Nara and Kyoto were constructed in the architectural style of Changan, as were Pyongyang and Seoul in Silla – at one time Seoul was called Changan, while the Korean name for it now is 'Han City'.

From the Han dynasty to the Tang, Changan and the Chinese culture it represented both influenced and were influenced by the diverse cultures of the many countries that had contact with China. This influence permeated all aspects of everyday life and culture, enriching the civilizations of both the east and the west.

218. Tomb of Zhang Qian

Zhang Qian, buried in his home town in Chenggu County, was the first envoy in Chinese history to visit the western regions and thus form the initial link between China and her western neighbours. He has been praised as a pioneer by historians throughout the ages.

219. Stone carving in front of Zhang Qian's tomb

In front of Zhang Qian's tomb are two stone animals, each carved from one lump of stone. Both are damaged, missing their heads and legs.

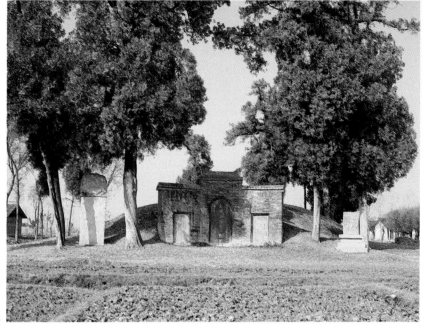

218

219

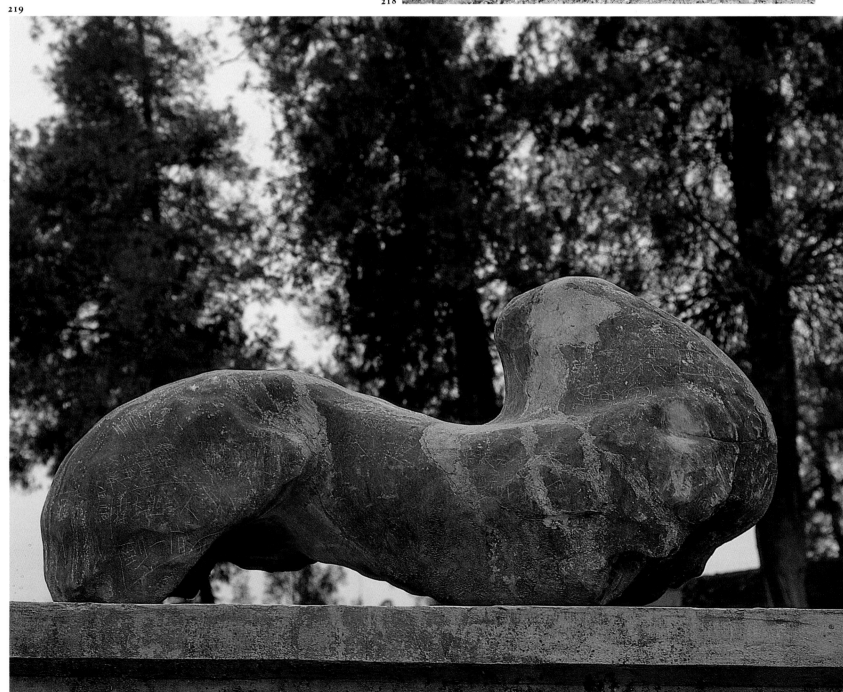

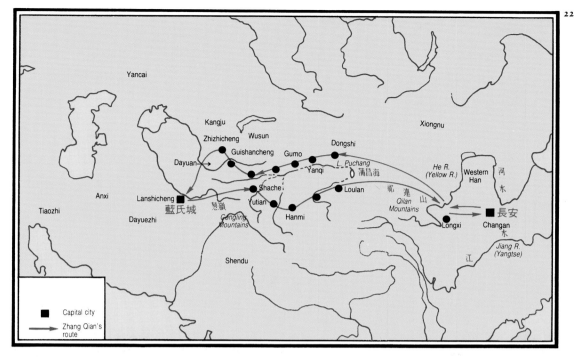

Map labels: Yancai, Kangju, Zhizhicheng, Wusun, Xiongnu, Dongshi, Guishancheng, Gumo, Dayuan, Yanqi, *Puchang*, 蒲昌海, He R. (Yellow R.), Western Han, 河水, Anxi, Shache, Qilian Mountains, 祁連山, Lanshicheng, Yutian, Loulan, Hanmi, 藍氏城, 長安, Tiaozhi, Congling Mountains, 葱嶺, Dayuezhi, Longxi, Changan, 水, Shendu, Jiang R. (Yangtse), 江

■ Capital city

→ Zhang Qian's route

220. Map showing Zhang Qian's route to the western regions

221. *Merchants from the Western Regions* – a mural at Dunhuang
Dunhuang, a town in Xinjiang Province that formerly stood on the Silk Road, is famous for the nearby Mogao Caves, carved and painted with murals from the Northern Wei dynasty onwards by Buddhists passing along the road. This mural depicts foreign merchants with high-bridged noses, deep-set eyes and curly moustaches.

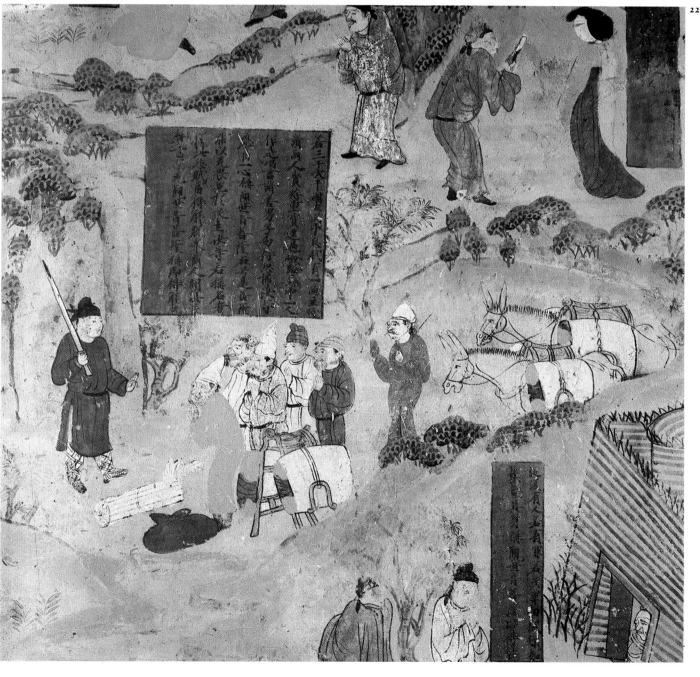

222

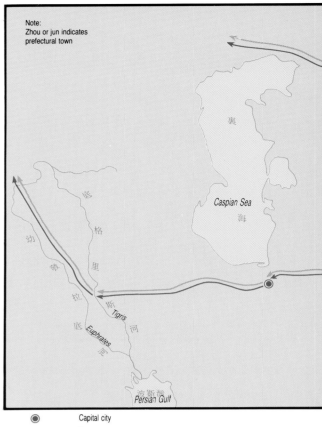

裏

Caspian Sea
海

幼
發
拉
底
河

底
格
里
斯
河

Tigris

Euphrates

波斯灣
Persian Gulf

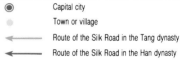

⊙ Capital city

○ Town or village

← Route of the Silk Road in the Tang dynasty

← Route of the Silk Road in the Han dynasty

222. Part of the Silk Road near Binxian

The Silk Road was an economic and cultural link between China and her western neighbours. It started at Changan in the east, branching out into two routes, which merged again on reaching Gansu Province. The northern route passed through Xingping, Wugong and Qishan, and the southern route through Qianxian, Yongshou, Binxian and Changwu. The road then crossed the Takmalakan Desert before splitting again into two routes (three by the Tang dynasty) which went either side of the Tarim Basin to the far west of China. This section of the Silk Road is near the Great Buddha Temple in Binxian.

223. Han-dynasty beacon tower on the Silk Road

223

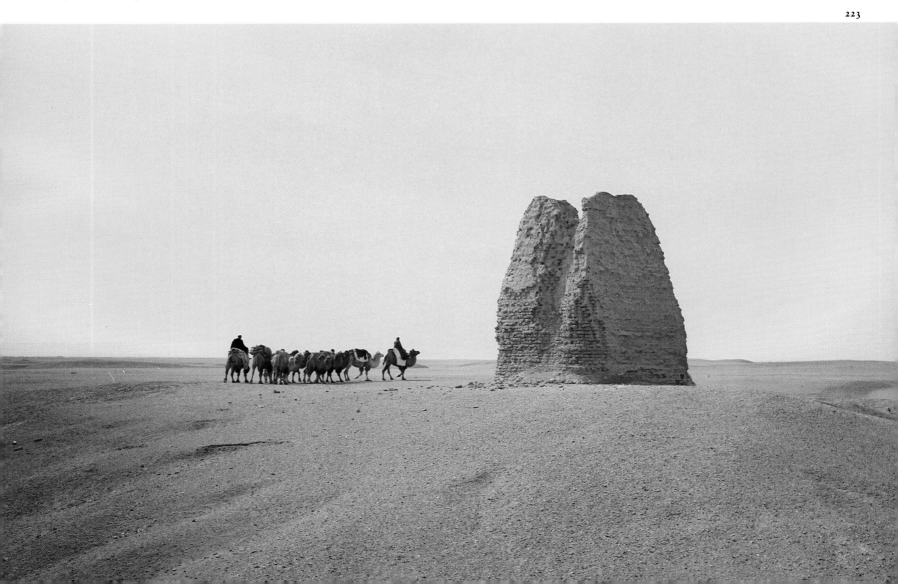

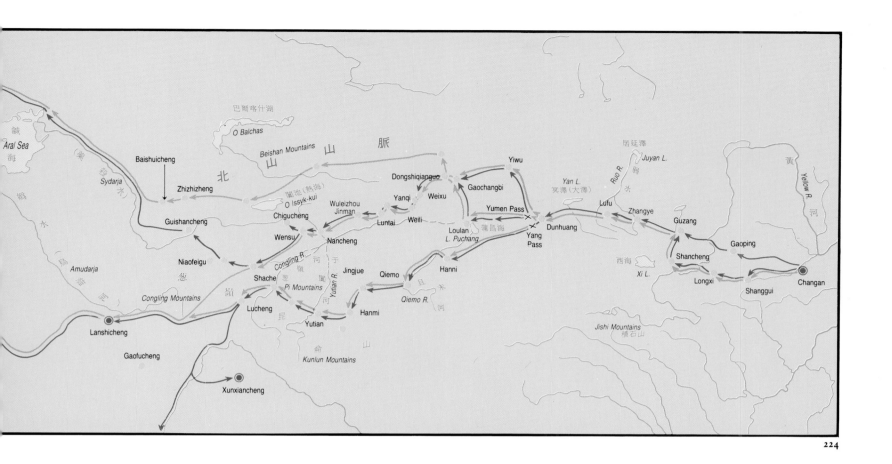

224

224. Map showing the Silk Road in the Han and Tang dynasties

225

225. Longevity and good fortune *jin* from the Eastern Han dynasty
This piece of silk *jin* was found in the ruins of the ancient town of Niya in Minfeng County, Xinjiang Province. It is a five-coloured warp *jin* with a design of clouds and *ruyi*, symbolizing good fortune and often found on textiles. *Ruyi* literally means, 'as one desires'.

226. Remnant of Han-dynasty hemp
This was found in the ruins of the Han-dynasty Great Wall.

227. Flower-patterned *jin* from the Tang dynasty
This was found at Asitana in Xinjiang Province. The colouring is plain, unlike the more usual brightly patterned *jins* of this period, but the design is typical of the Tang dynasty.

227

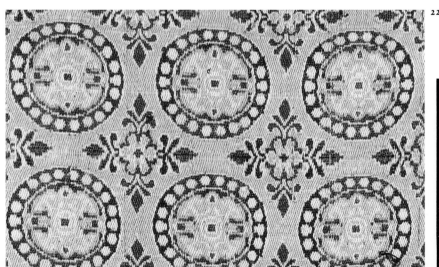

226

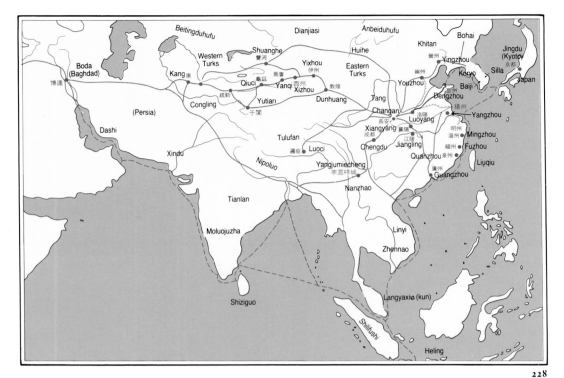

228

228. Map showing the road network in Asia in the Tang dynasty

229. *Receiving Foreign Envoys* – a mural from the tomb of Prince Zhang Huai

Prince Zhang Huai was the second son of the Tang emperor Gaozong. This painting is one of over fifty murals found on the passageway of his tomb. It depicts three foreign visitors being entertained by court officials while waiting to be received by the prince.

It is recorded that numerous countries and regions had diplomatic relations with the Tang court and there are frequent reports of visits to Changan by foreign envoys, ambassadors and other visitors. The three figures on the left side of the mural are Tang officials from the protocol department, while the others are the envoys from the Eastern Roman Empire, Korea or Japan and north-eastern China minority peoples.

230. *The Imperial Sedan Chair*

This painting, showing the Tang emperor Taizong meeting Ludongzan, an envoy who accompanied Princess Wen Chong to Tibet to marry King Songsan Gambo in AD 641, was painted by Yan Liben, a famous Tang-dynasty artist.

229

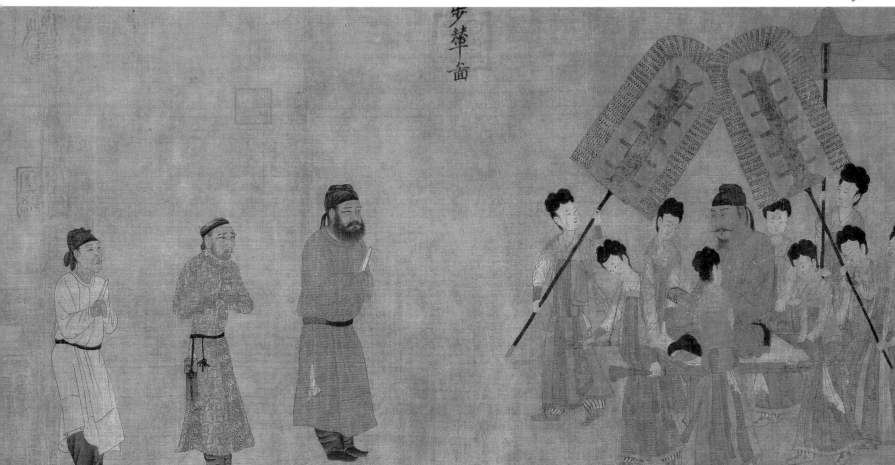

230

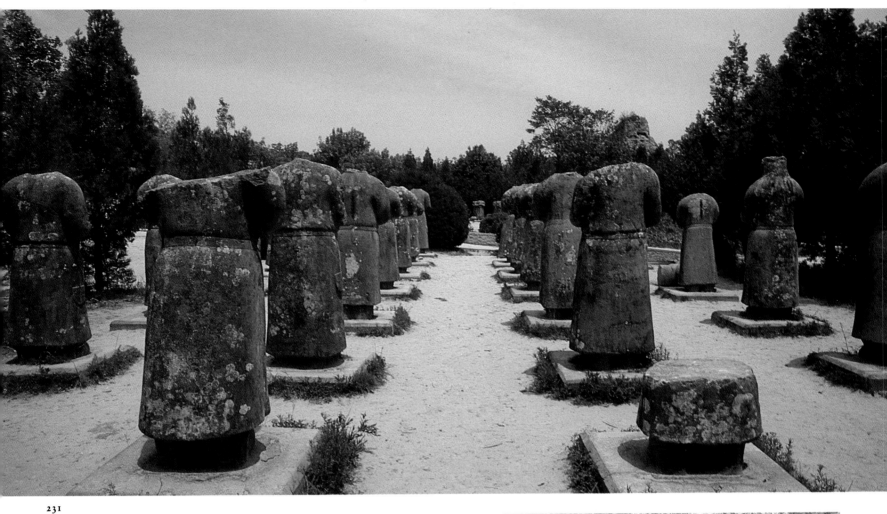

231

231. The sixty-one guests
These statues standing with hands
clasped together, in front of the
stone lions at the mausoleum of
Emperor Gaozong and Empress Wu
Zetian, represent foreign envoys and
officials who attended the emperor's
memorial service. They were made
on the order of the empress, to
commemorate the power and
influence of the Tang dynasty. Most
of them are dressed in the western
style, with their shirt collars turned
out and their gowns tied at the
waist.

**232. Inscription, reading: 'Situole,
King of Mujuhan'**
The nationalities, names and
positions of the sixty-one guests
shown in Plate 231 were carved on
the back of each statue. This is one
of the few inscriptions that can still
be deciphered.

232

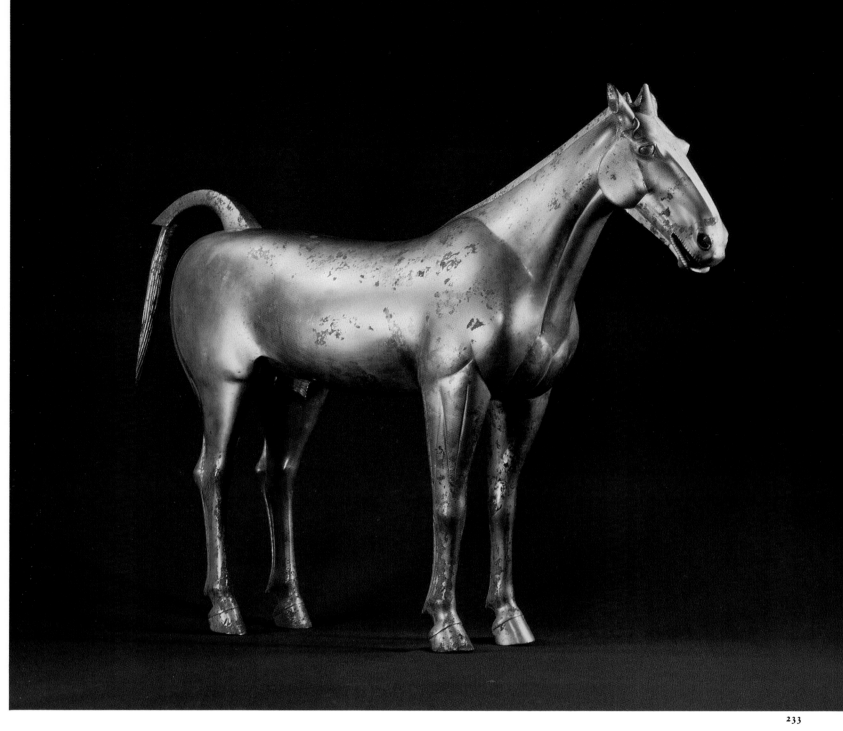

233

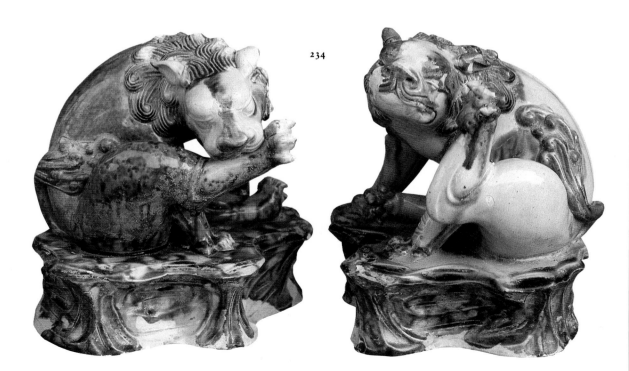

234

233. Gilded bronze horse
This beautifully crafted and realistic horse was found in Xingping County in 1981.

234. Tri-coloured glazed pottery lions
Horses and camels are the most common tri-coloured glazed pottery animals, while lions are very rare. This pair, one licking its paw and the other scratching itself, are both vividly portrayed and beautifully glazed, ranking among the finest examples of the genre.

235. Tri-coloured glazed camel with musicians
This is another fine example of Tang-dynasty tri-coloured glazed pottery ware. The musicians sitting on the back of the camel are playing reed pipes, a flute and two kinds of stringed instruments, resembling a lute and clappers.

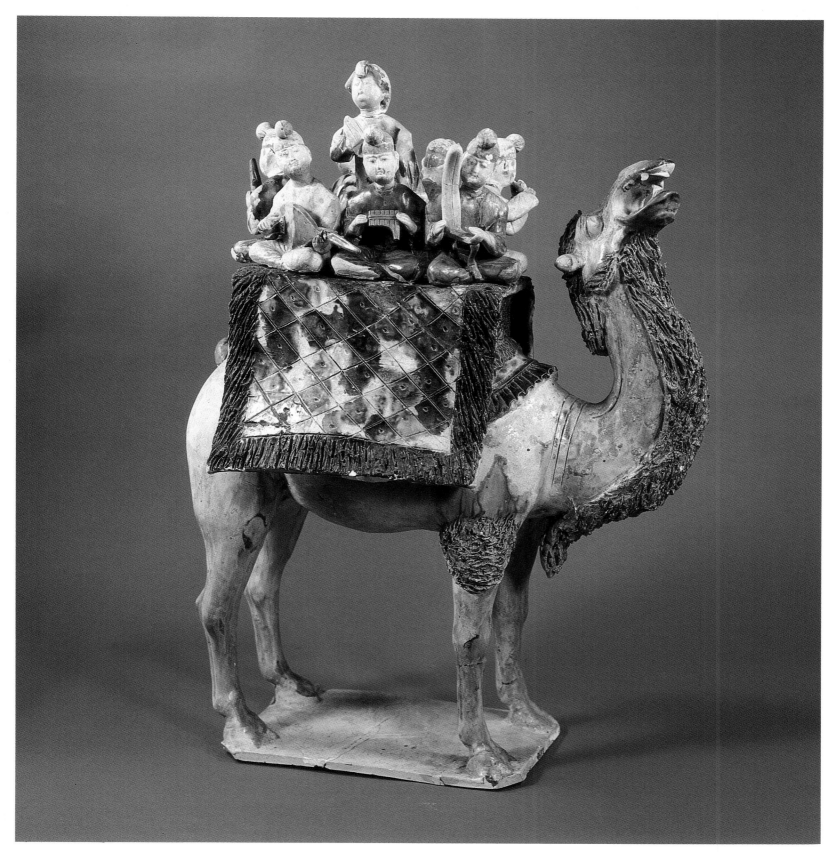

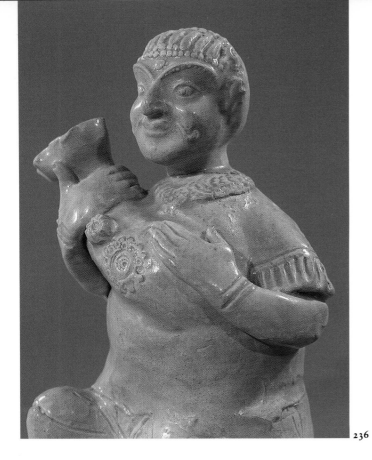

236

236. White porcelain figurine
The curly hair, deep-set eyes and high-bridged nose of this figure show that he is a foreigner, or one of the ethnic peoples who lived on the fringes of China. He wears a short shirt with ribbed collar and cuffs and is clutching a fish-shaped vase in both hands. This is a unique example of white porcelain of the early Tang dynasty.

237. Foreign merchant leading a camel
Camels were an indispensable means of transportation on the Silk Road and as such highly valued. This camel is loaded with bundles of silk to be carried back to the west for sale, and the appearance of the man suggests he is also from a foreign land.

238. Porcelain figure of a foreigner

237

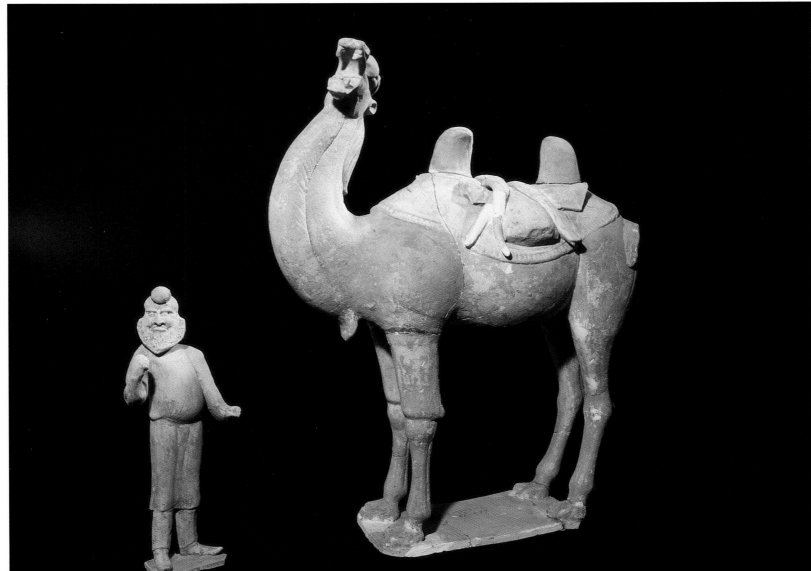

146

238 ▷

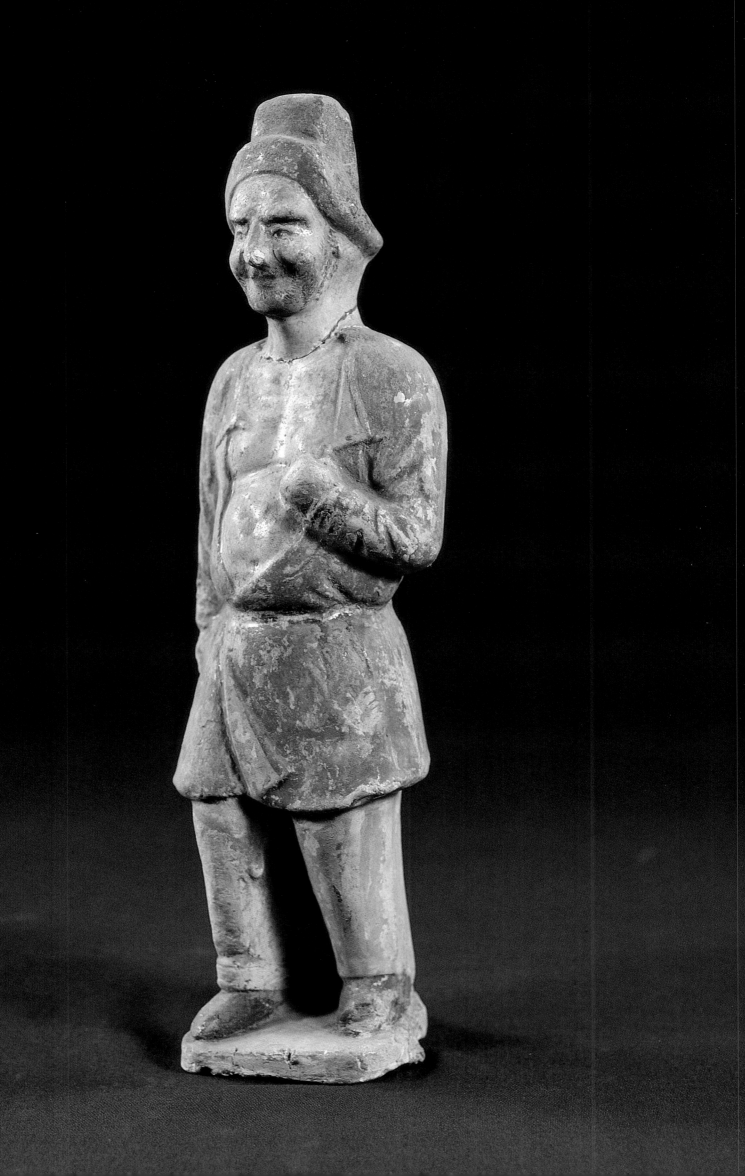

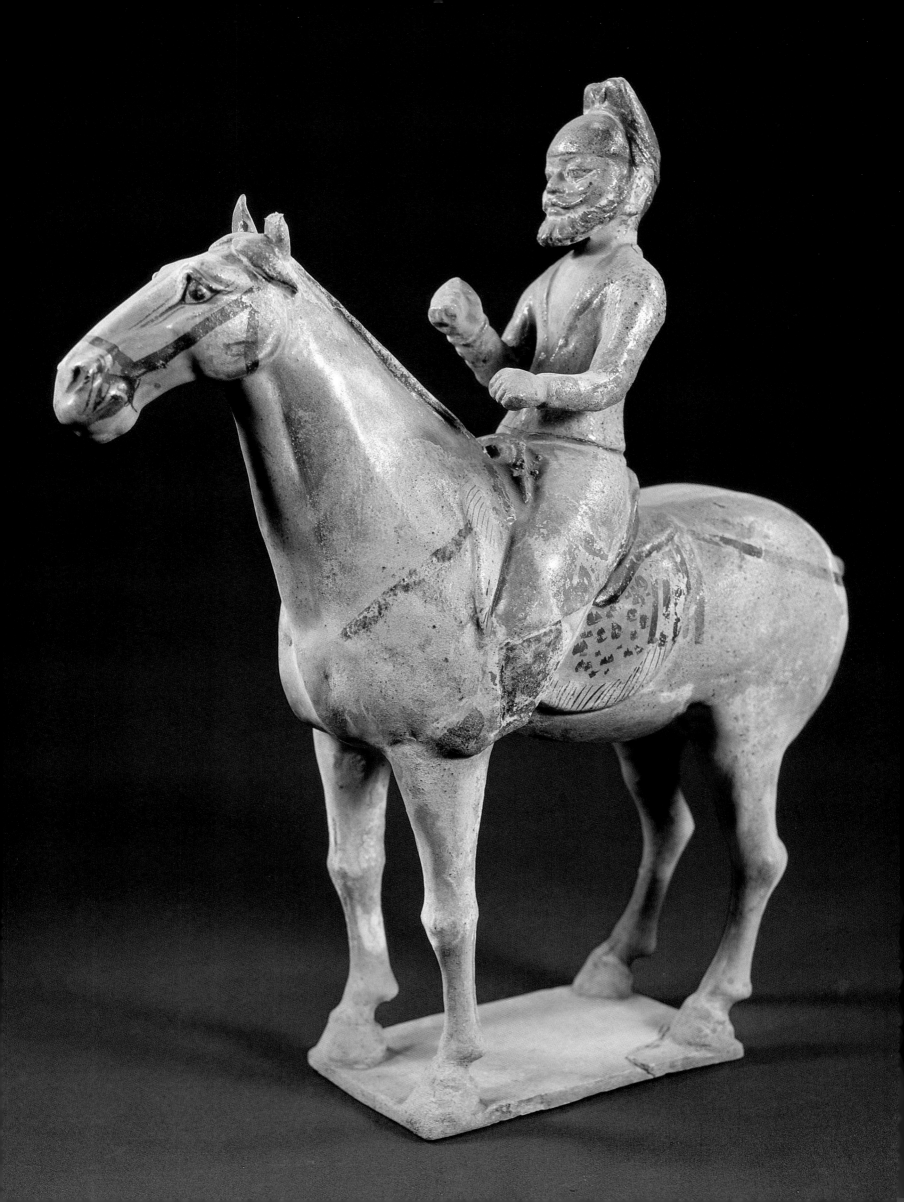

241

239. Foreigner on horseback
Many of the foreigners who visited
Changan during the Tang dynasty
enjoyed riding, and this figure
probably depicts an everyday sight
for the residents of Changan at that
time.

**240, 241. Porcelain figures of
Africans**
These two figures, about ten inches
tall, were discovered in a Tang-
dynasty tomb in the southern
suburbs of Xian. China traded
porcelain for ivory and spices from
Africa during the Tang.

242. Pottery figurine
This figure has large eyes, heavy eyebrows, a high-bridged nose, full red lips and dark curly hair, all the attributes of a foreigner. He is wearing only a red band and shorts and standing as if pulling a horse or drawing a bow.

243. Pottery head of a foreigner
This was discovered in the Tang-dynasty tomb of Princess Yongtai.

244. Pottery head of a foreigner
This probably represents a merchant from the Persian Gulf; the lively eyes, neatly trimmed beard and serene but shrewd smile all suggest that it was modelled from life. It was found in the tomb of Princess Yongtai.

245. Painted pottery figurine in foreign dress
Although the features of this figure seem to be those of a Chinese person, he is wearing foreign clothes. His arms are drawn back and hands held tight, as if clutching something.

242

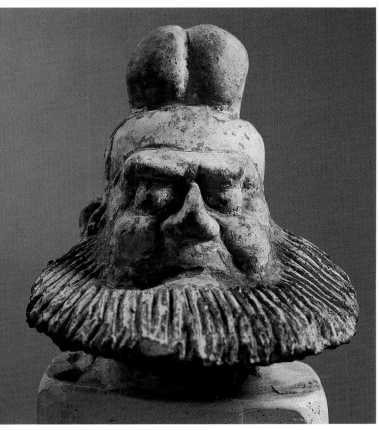

243

244

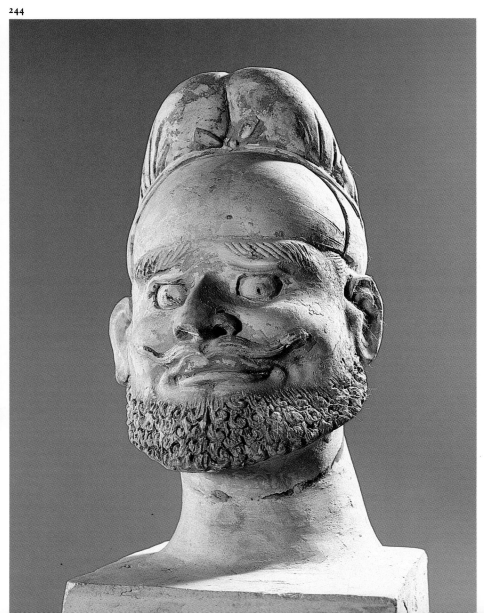

245

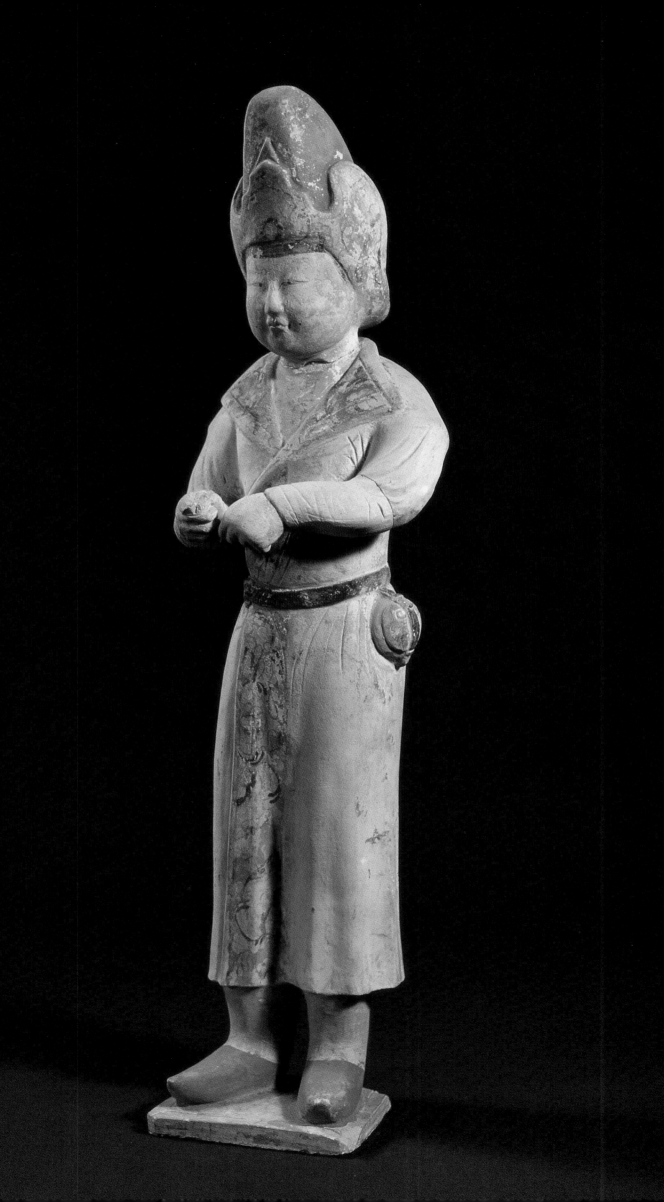

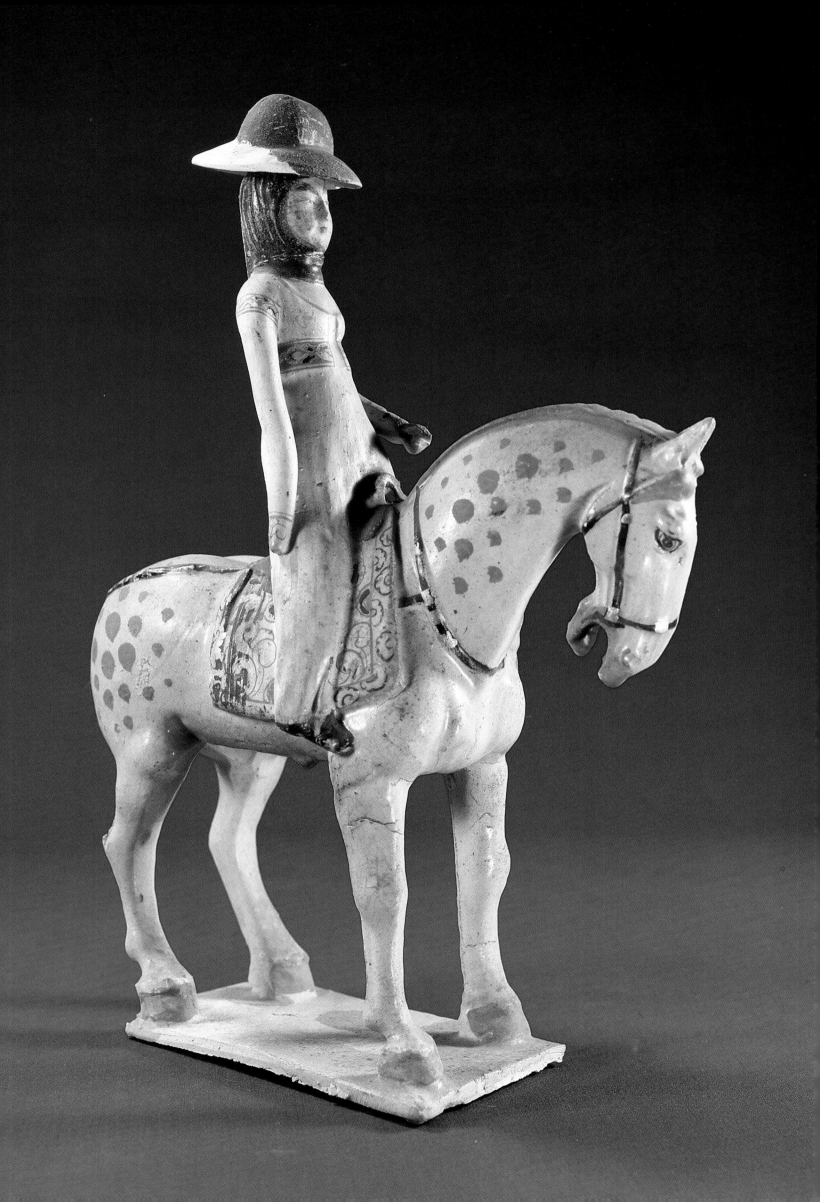

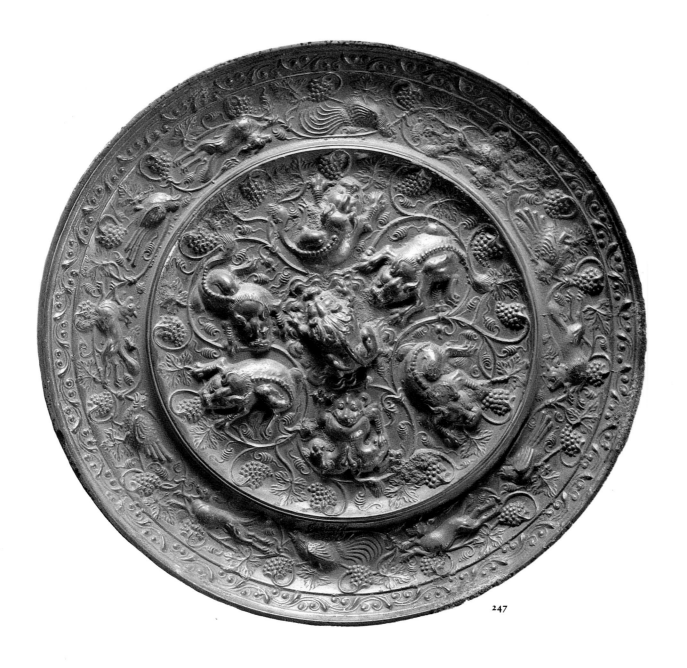

247

246. Coloured pottery figure on horseback
This woman on horseback wears a wide-brimmed hat, a white blouse with tight sleeves, a white tunic with a red floral design, a striped skirt and black shoes.

247, 248. Mirrors with sea-creatures and vine patterns
Bronze mirrors were everyday articles in ancient China, the oldest dating back to the late years of the neolithic period. By the Tang dynasty finely made mirrors were numerous. This one has a pattern of sea-creatures (popularly seen as auspicious animals) and vines with bunches of grapes. Grapes were at that time a special product of the western regions.

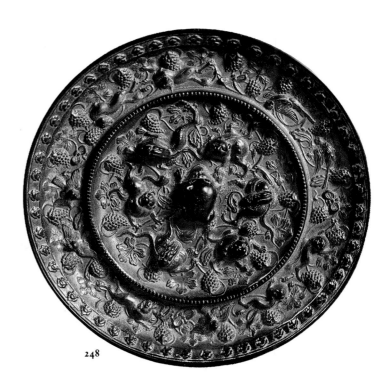

248

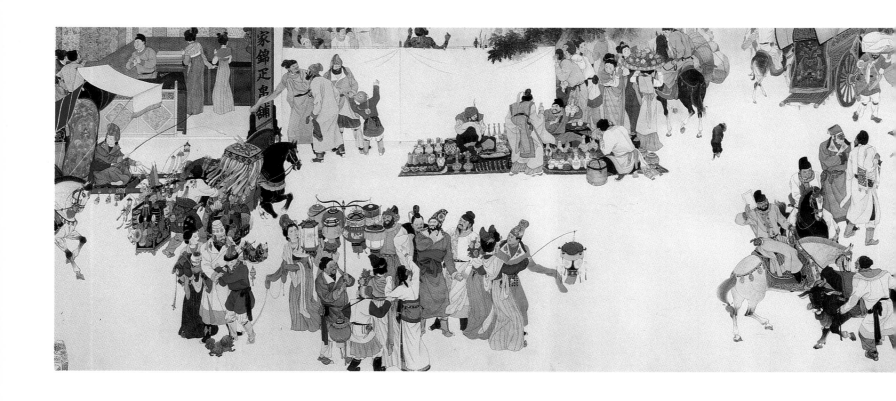

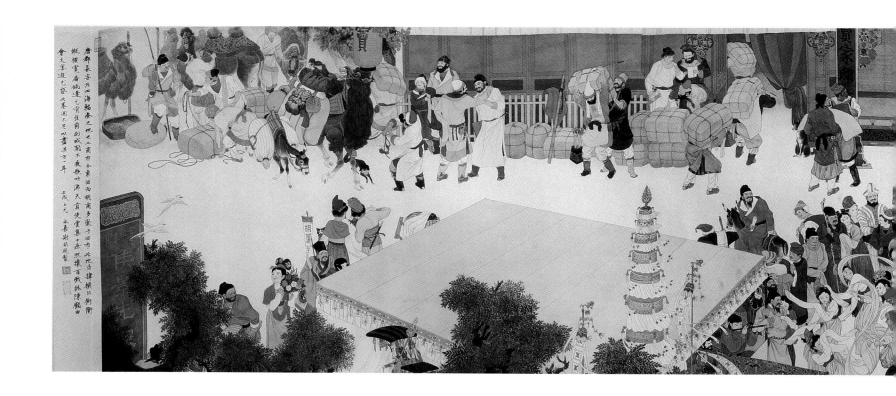

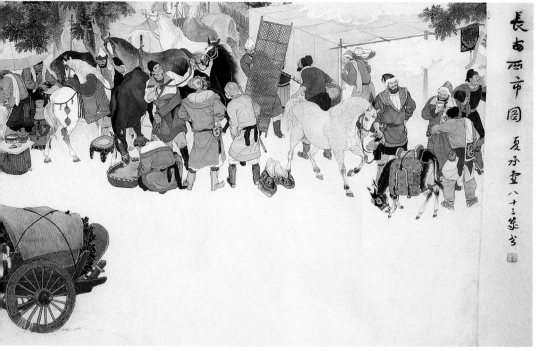

長安西市圖 夏承燾八十三叟書

249, 250. Painting of the Western Market in Changan
There were two markets in the Tang-dynasty capital, Changan, the one depicted here being to the south-west of the imperial palace. It consisted of two main streets lined with more than 200 different types of shops; it was where most of the foreign traders conducted their business. This painting is by a modern artist from Xian, Xie Zhenou.

249

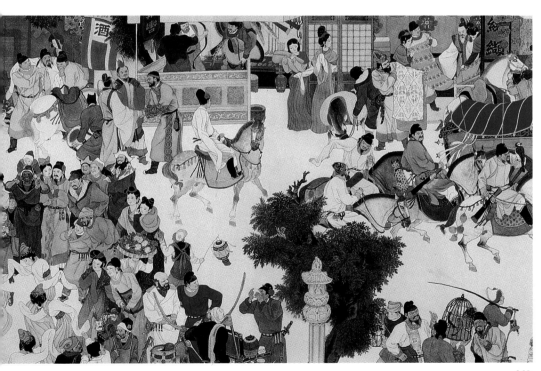

250

251. Agate ox-head cup
This cup is made in a shape typical of central Asia, indicating the existence of artistic exchanges between China and the west.

252. Lead coin with Greek letters
This coin shows a circle made from imperfectly copied Greek letters. The other side has a pattern of interlaced hydra.

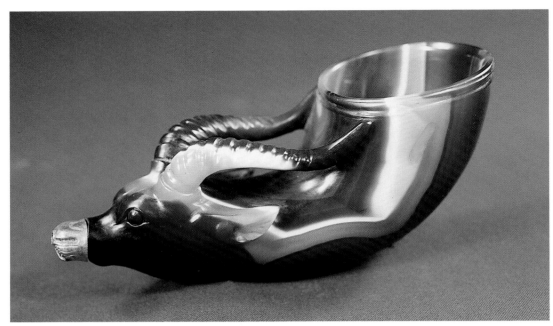

251

252

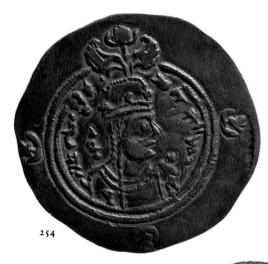

254

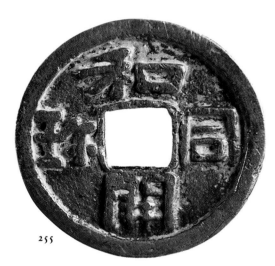

255

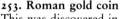
253

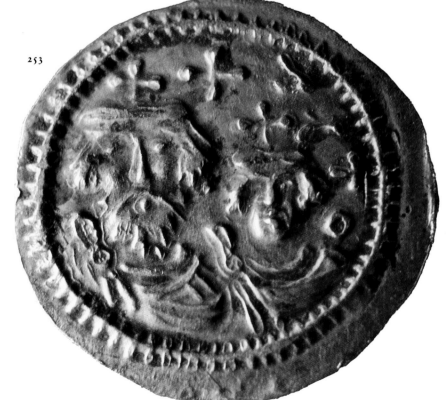

253. Roman gold coin
This was discovered in a Tang-dynasty storage pit in Hejiacun near Xian in 1970. It was probably brought to China by merchants from the Eastern Roman Empire.

254. Persian silver coin
This coin was cast during the reign of King Chosroes II (591–628) of the Sassanid kingdom. It has a portrait of the king on the obverse and a Persian inscription on the reverse.

255. Japanese silver coin
Five coins of the Nara dynasty in Japan, resembling Chinese coins of the Tang dynasty, were found near Xian in 1970. Such coins were given to the Tang emperor by visiting Japanese as a token of goodwill.

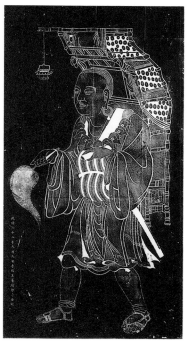

256

256. Xuan Zang carrying Buddhist scriptures

In AD 627 Xuan Zang, a Buddhist monk, set off from Changan without official permission to travel to India in search of Buddhist scriptures. It was nineteen years before he returned and wrote *Records of Western Travels*. He spent the rest of his life translating the scriptures he had brought back. This rubbing is from a stone carving kept at the Greater Wild Goose Pagoda Temple south of Xian, and shows him with a backpack full of rolled-up scriptures.

257. Map showing the route taken by Xuan Zang

258. Tablet bearing Buddhist sutra in Chinese and Nepalese

257

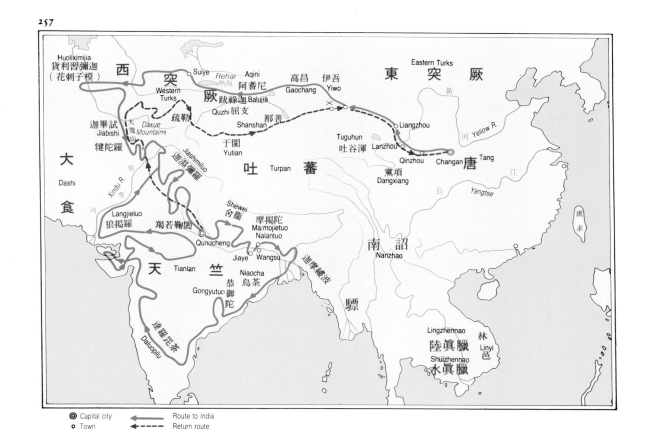

| ◎ Capital city | → Route to India |
| ○ Town | ◄--- Return route |

258

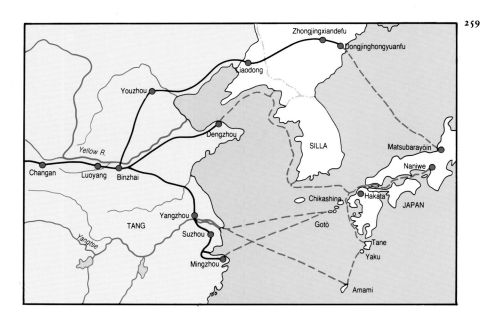

259

260

259. Map showing routes taken by Japanese ships visiting China
During a period of 264 years, from the reign of the Tang emperor Taizong to Zhaozong's reign, Japan sent nineteen delegations to China, consisting of over 200 people – an indication of the close relationship between the two countries at this time.

261

260. Imprint from the seal of a Japanese envoy to China

261. Seal of a Japanese king issued by the Chinese in the Han dynasty
This gold seal was found in 1784 in Fukukoda County, Kyūshu, Japan. According to the official history of the Eastern Han period, Japanese envoys visited China in AD 57 to pay tribute to the Han court and were granted a gold seal by Emperor Guangwu. This is probably the seal mentioned and its discovery thus corroborates the earliest Chinese written record of contact between the two countries.

262. Imprint from the Japanese king's seal

262

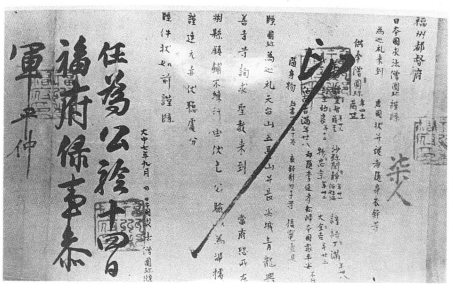

263

264

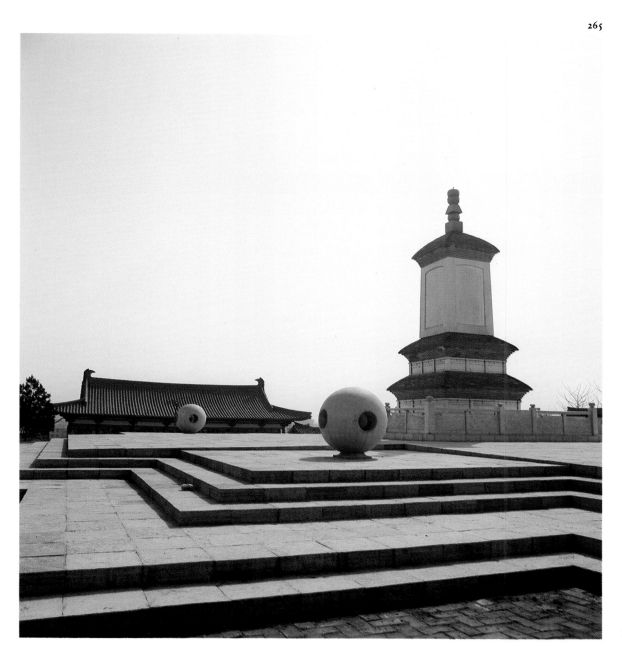

263. Enchin's travel permit
Most of the Japanese visitors to China were either students or monks in quest of Buddhist learning. Enchin was a monk who arrived in China in AD 838. After returning to Japan he and Yuan Ren established the two major schools of the Tiantai sect. Shown here is the travel permit issued by the Fuzhou provincial government giving permission for Enchin and six others to travel to Changan to study Buddhism.

264. Monument to Nakamaro Abe
Nakamaro Abe was only sixteen when in AD 717 he set out for China as a member of the ninth Japanese delegation to China. He remained in China taking the imperial examinations and doing so well that the Tang emperor Xuanzong bestowed on him the Buddhist name Chao Heng. After this he held various official posts until his death in Changan at the age of seventy. This monument in his memory was erected in 1979 in Xingqing Park, Xian.

265. Kūkai's memorial hall
Kūkai ranks among the greatest of the Japanese monks sent to China in the Tang dynasty, studying at Heilong Temple before returning to Japan in 806. He belonged to the Esoteric sect of Buddhism and eventually became the master of the Eastern Esoteric school, or Shingon sect. The memorial hall shown here was built in 1981 next to Heilong Temple.

266

266. Monument to Makibi Kibi
Makibi Kibi was a Japanese student
who lived in China for nineteen
years before returning with a large
quantity of Chinese books on
ceremonial rites, meteorology and
music. This monument to him
stands next to the city wall in Xian.

**267. Carved portrait of Makibi
Kibi**

267

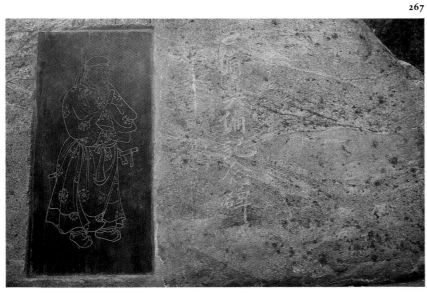

6.

The Imperial Tombs

Chinese emperors of successive dynasties expended considerable resources in building their own tombs and ensuring the protection of existing imperial tombs; memorial services and sacrifices to the ancestors were an established part of state affairs. The system of tomb construction was guided by the principle that the emperor should live after death as he had done before; one consequence of this is seen in the tombs' structure and design, which were generally the same as those of the Imperial Palace. Nevertheless, the imperial tombs were at the mercy of economic and political developments and were often modified during the course of their construction.

Over seventy imperial tombs and more than 1,000 attendant tombs containing the remains of members of the royal families and the nobility, along with civil and military officials, are spread across the Wei River valley. They date from the Western Zhou, Qin, Western Han and Tang dynasties. Despite natural deterioration and damage caused by tomb robbers, the gradual excavation of these sites over the past few decades has yielded an enormous number of historical images and artefacts, making these underground palaces an even more convincing testimony of history than the palace ruins above ground.

Tombs of the Zhou-dynasty Kings

According to legend, King Wen (founder of the Zhou), King Wu and Duke Ji Dan were all buried at a place called Bi (south-west of Xian). At that time it was the custom to bury nobles in their clan cemetery, each member of the clan in a place prescribed by ritual. The differences in rank between the occupants of different tombs were indicated below ground, by the number of outer coffins and quantity of funeral objects; there was no mound above the ground to indicate the size or status of the tomb.

From 1957 several pits containing chariots and horses were discovered at Zhangjiapo and other places on the west bank of the Feng River. Both the chariots and horses had bronze livery and decoration. Studies have revealed that these pits were attendant tombs of the Western Zhou nobility; the tombs of the kings must have contained even more exquisite artefacts.

In the *Shiji* it is recorded that the state of Qin buried twenty of its rulers at Yong (south of Fengxiang, Shaanxi Province). After nearly a decade of study, archaeologists have discovered a group of eight Qin mausoleums in this region, containing twenty-five large graves. Mausoleum No. 1 occupies an area of over 39,000 square yards, while the largest grave is almost 10,000 square yards. All the graves are on an east–west axis, and most have two ramps. Six human sacrificial victims were found in the largest grave in mausoleum No. 1. In front of these mausoleums are twenty-one pits of various sizes containing chariots and horses. The cemetery is protected by a multi-layered defence trench that is over six miles long. Architectural ruins were found above some of the tombs, although most of them did not have earthen mounds.

The decade from 1976 to 1986 saw the excavation at this site of tomb No. 1 of a Qin duke. Its dipper-shaped pit is almost as deep as an eight-storeyed building, with a base as large as two basketball grounds. The huge square wooden coffin chamber, 14 feet high and covering an area of over 170 square yards, was enclosed by a protective carbon layer 10 feet thick. The coffin chamber is divided into a 'palace at the front, living-quarters in the rear'

arrangement, so imitating the palace of the ruler. The tomb pit yielded over 180 graves with the remains of humans and animals and around a thousand artefacts, reflecting the sophistication of economic production, science, technology, culture and art in China over 2,500 years.

Mausoleum of the First Emperor of China

Archaeological studies to date conclude that the mausoleum of the First Emperor of China, despite being the earliest, is also the largest of China's imperial mausoleums. The First Emperor reigned for thirty-seven years, and the construction of his mausoleum took thirty-six. It is recorded that over 700,000 labourers worked on the project, a reflection of the prosperity and power of the Qin dynasty. The tomb, on Mt Li, was originally enclosed by two long and narrow walls. The outer wall was 7,129 by 3,196 feet and had a watchtower at each corner, while the inner wall was 2,247 by 1,896 feet. Both walls had a gate on each side with a tower built on top. The living-quarters and recreational halls were in the northern half of the area enclosed by the walls, while the grave was in the southern part. The grave mound was built with rammed earth with a circumference of 4,593 feet, and it rose in three wave-like tiers to a height of 394 feet. *Hanshu* records that: 'King Hui, King Wen, King Wu, King Zhao and King Yanxiang of the state of Qin all had large tombs, yet these were nothing in comparison to the awe inspiring and magnificent mausoleum of the First Emperor.'

Although the tomb mound and surrounding area have been investigated, archaeologists have not yet excavated the tomb chamber, but there is a detailed account of the tomb and its contents in Han historical sources. This relates how the tomb was dug so deep that underground water was reached. The outer coffin, encased in copper, was placed in a chamber made to represent the earth and the heavens: on the floor were mountains and valleys, and mercury, representing the water in the rivers and lakes, was kept constantly flowing by mechanical devices; the sun, moon and stars were painted on the ceiling. Candles made of slow-burning fish-oil lit the chamber, and crossbows were installed, ready to fire on anyone who dared to break into the tomb. In structure and design it was a replica of the Qin-dynasty royal palace in Xianyang.

The history also records how, four years after the burial of the First Emperor, when the country was in turmoil, one of the rebel leaders, Xiang Yu, entered the land within the passes and set fire to everything connected with the Qin dynasty. Although it is not clear whether he destroyed the tomb, there is evidence of a fire having engulfed the pits containing the emperor's terracotta army. The mound above the tomb today stands at 250 feet.

Since 1974 three underground, rectangular-shaped pits containing full-size terracotta tomb figures of soldiers and horses have been discovered to the north of the avenue leading to the east gate of the mausoleum. The figures all face east, indicating that they are a garrison for the emperor in his afterlife. This massive army consists of infantry, archers, crossbowmen, charioteers, cavalry and a command centre, arranged in tight battle formation. It would have been an army like this that swept through the Hangu Pass on its way to defeat the other six states and unify China. In 1980 two bronze chariots pulled by bronze horses were unearthed just west of the tomb.

While the terracotta army awes the visitor by its scale, it is the elegance, luxuriousness and superb craftsmanship that make the horses and chariots so outstanding.

The continual discovery of new cultural artefacts has aroused unprecedented public interest and enthusiasm for this tomb, the terracotta army alone being ranked as one of the wonders of the world and a unique military museum.

The Western Han Imperial Tombs of Xianyang

Of the eleven emperors of the Western Han dynasty, Emperor Wen was buried at Baling, south-east of Changan, and Emperor Xuan was buried at Duling, also south-east of Changan, while the other nine were all buried near Xianyang. The tombs that wind along the plateaus north of the Wei River for twenty-four miles include many attendant tombs of relatives and friends. The site was ideally located: with mountains to the north and a river to the south it fulfilled the geomancers' requirements; and the deep, dry layer of soil on the plateau made it easy to excavate large, imposing tombs.

The arrangement of the Han tombs followed the Qin system, placed on an east–west axis, but one distinguishing feature was the large number of attendant tombs: the mausoleum of Emperor Gaozu has seventy attendant tombs, while that of Emperor Jing has thirty-four. All the attendant tombs are located to the north or north-east of the emperors' tomb, symbolizing the Chinese concept that the south-west was the superior position. Apart from the mausoleum of Emperor Wen, the imperial mausoleums of the Han dynasty all have high, rectangular or square mounds. According to historical records, empresses were usually buried in the same mausoleum as the emperor, but in separate graves, either in the east or north-west sections of the mausoleum. The Western Han system stipulated that each emperor's tomb should cover an area of 115 acres and be 132 feet high, but in reality the tombs are slightly higher than this, the difference in height between them reflecting the appraisal made of the emperor in his lifetime. Of course, the emperors' tombs always had to be higher than those of the attendants' tombs.

None of the nine imperial mausoleums has yet been excavated, but from studies of the ruins above ground it is clear that the mound was surrounded by a large square enclosure with a gate in each side. Inside the enclosure were houses for the tomb attendants and ritual sleeping- and living-quarters, originally complete with all the emperor's daily necessities, including palace maids. It is recorded that they worked just as they had when serving the live emperor, bringing sacrificial food four times a day. Twenty-five memorial services were held every year in the temples built just outside the tomb enclosure. In addition, once a month the emperor's robes and crown, which were kept in the sleeping-quarters, were taken to the temple as part of a very grand ceremony. Some mausoleums had recreational and pleasure sections, such as the Hall of White Cranes, the Horse Riding Hall and the West Garden in the tomb of Emperor Wu. Whenever an imperial tomb was built, a residential district was established under direct control of the central government and wealthy provincial families were ordered to move to this area. With this relocation, the population of the tomb area rapidly increased and it became important both economically and politically. Moreover, it acted as a defence buffer, controlling the western routes into the

capital. The practice of relocating wealthy and powerful families had first been practised under the Qin dynasty when the old Zhou system of feudalism was abolished, but during the confusion following the downfall of the Qin, many families had taken the opportunity to return to their country estates.

The Mao Mausoleum – Tomb of Emperor Wu

Of all the Western Han imperial tombs, the Mao mausoleum of Emperor Wu is the most outstanding. It is advantageously sited at the south-westernmost part of the tomb area and, at 150 feet, is unusually high, which has to be taken as a token of the respect felt towards Emperor Wu and his achievements. According to a rough estimate, if the earth of the tomb mound were used to build a wall, a metre in height and width, it would go round the city of Xian eight times.

The Western Han system allowed the emperor to spend one-third of the country's annual tax income on the construction of his own tomb – the 'longevity mausoleum' – from the second year of his reign. Emperor Wu's reign covered a period of fifty-three years, in which the country was strong and prosperous. It is recorded that so many treasures were sent for storage in his mausoleum that there was no space left when he actually died. In the Western Jin dynasty 'decaying silk was piled up high and there were pearls and jade in abundance', even though by then the tomb had been robbed several times. Today the ruins of the north, east and west gates of the inner wall can still be seen and, although the tomb itself has not been excavated, over 200 rare objects have been found in the area, including a bronze rhinoceros-shaped wine cup, jade door decorations, a gilded bronze horse, a gilded silver incense burner, a cornered porcelain water container, gilded animal heads and bronze mirrors.

The best known of the attendant tombs at this site are those of Wei Qing, Huo Qubing, Lady Li, Jin Ridi and Huo Guang. They were generals, favoured concubines and meritorious ministers to whom the emperor felt closest in his life. Huo Qubing's is the most impressive of these tombs, standing only 547 yards from the mausoleum. Huo Qubing (140–117 BC) emerged as an outstanding general in the campaigns against the northern Xiongnu tribes, winning outright victories in all of the six battles he fought. The emperor was very upset at his early death and had this tomb built for him in such a shape as to resemble Mt Qilian, one of the battlegrounds where he had fought. Workmen quarried stone from Mt Qilian itself and carved huge oxen, horses, tigers and strange animals to be placed in front of the tomb. The form of these animals followed the natural shape of the stone, features being indicated with a minimum of carving, thus creating statues with a wild, primitive majesty that is representative of Han sculpture.

The Zhao Mausoleum – Largest of the Tang-dynasty Imperial Tombs

Of the eighteen emperors who are buried at the foot of the Bei Mountains in the northern part of the land within the passes – an area that is even higher than that occupied by the Western Han mausoleums – the Xian Mausoleum of Emperor Gaozu, the Zhuang Mausoleum of Emperor Jingzong, the Duan Mausoleum of Emperor Wuzong and the Jing Mausoleum of Emperor Xizong are on flat land at the foot of the mountains, while the other fourteen were constructed in scooped-out hollows half-way up isolated

hills. This exploitation of natural hills is a particular feature of Tang-dynasty burials. The Tang mausoleums that meander along the plain from Qian County in the west to Pucheng County in the east echo the series of Han mausoleums that spread from north to south on the Xianyang Plain.

The Tang tombs were built with the coffin chambers at their centres. Square palaces were constructed above and planted with many trees. The walls had corner watch-towers, a gate in each direction with two towers and a pair of stone lions in front. On both sides of the sacred path leading to the southern gate stood ornamental pillars, statues of relatives, stone animals such as horses and stone figures representing the participants at the ceremony at which hundreds of civil and military officials had an audience with the emperor in Changan. There was also a large garden. The front halls of the palace were used for memorial services, while a daily service was held in the rear halls.

Emperor Taizong is said to be the first emperor to build his tomb against a mountain (although the Ba tomb of the Han-dynasty emperor Wen was built on a natural hill). It took thirteen years to complete this meticulously executed project in the Jiujun Mountains, Quan County. The tomb is said to have been designed by the brothers Yan Lide and Yan Libe, well-known craftsmen and painters. According to historical records it was built by chiselling 820 feet into the mountain rock; five stone gates were then erected in the passage leading to a central coffin chamber with east and west side chambers. Inside the side chambers were many stone containers in which pre-Tang books, rare scrolls of calligraphy and paintings were stored. Above the palace was a pleasure hall for the emperor's soul and a memorial hall was constructed nearby for later generations to offer sacrifices. There were once 378 houses at the foot of the mountain and fourteen stone statues at the northern gate representing foreign kings. The famous stone carvings of the 'six steeds of Zhao tomb' stood on the east and west, and outside of the south gate were huge and beautiful carvings of figures and animals.

As the Tang dynasty followed the tradition of the Han in building attendant tombs, the foot of the Jiujun Mountain is also the home of approximately 300 tombs of meritorious ministers and close relatives of the imperial family, occupying a total area of over 20,000 hectares. In height the tombs of meritorious officials such as Wei Zheng, Li Jing and Li Ji were only slightly lower than those of the three princesses (children of the emperor and his first wife, the empress) but higher than those of children by his concubines. Li Jing's tomb is shaped like Mt Yin (in the west of Inner Mongolia) and Mt Ji (south-west of Xining, Qinghai Province) forming a taper-shaped mound with two rectangular side sections. Li Ji's tomb was also fashioned on several mountains, making three taper-shaped mounds placed at the points of a triangle. Among the other attendant tombs were those of non-Han Chinese generals such as Zhongwei Chigong, Ashisher and Qibaili, reflecting the cosmopolitanism of Tang society; this mausoleum could be taken as a symbol of the unified prosperity and political enlightenment of this period.

The Qian Mausoleum – Joint Burial Place for Emperor Gaozong and Empress Wu Zetian

The Qian Mausoleum is located to the north-west of Xian on Mt Liang in Qianxian. It is the joint burial place of the

third Tang emperor, Gaozong, and Empress Wu Zetian, the only ruling empress in Chinese history. Mt Liang has three peaks, the tallest being the northern peak where the tomb is located. The southern peaks are quite low and face each other east to west; towers have been built on their summits so that they resemble a woman's breasts, and hence are nicknamed 'Nipple Hills'. The towers are imposing and a unique feature among the eighteen Tang tombs north of the Wei River. The local people used to call the tomb peak, 'Aunt Hill', implying that the nephews of Wu Zetian only cared about the burial of their aunt, not bothering about that of the emperor. Other records state that there are dark stone chambers inside the tomb and the gates leading to them were sealed using molten metal. Recent surveys indicate that the tomb's passage is about 4 metres wide and 65 metres long, blocked with rectangular stone slabs which were fastened together horizontally by iron strips, then vertically reinforced by cast iron. Earth was used to ensure a close join between the stone slabs and the surrounding mountain earth.

The scale of the whole mausoleum is vast, the main structures being arranged on the northern peak of Mt Liang and the yellow loess platforms surrounding it. It was originally encircled by two walls, the inner enclosing an area of 4.7 million square yards. Each of the four gates was guarded by a pair of stone lions, while the north gate was further protected by one pair of stone horses and the west gate by three pairs. There is a 20-foot-high tablet outside the south gate bearing a eulogy to the emperor in the handwriting of Li Xian, but purportedly drafted by the empress. Opposite is a matching tablet without an inscription. One suggestion to explain this is that the empress was so confident of her achievements during her life that she felt they would speak for themselves after her death. To the north were sixty-one stone statues of which sixty incomplete ones still exist. They all have close-fitting clothes, turned-out collars and broad belts, and portray the foreign envoys and representatives of foreign rulers who attended the emperor's funeral service.

Historical documents record that there are numerous attendant tombs in the vicinity. Of the seventeen lying to the south-east five have been officially opened: those of Princess Yong Tai, Xue Yuanchao, Li Jinxing, Prince Zhang Huai and Prince Yi De. They are similar in structure, with enclosing walls and decorations of ornamental pillars on the front of the tombs, along with stone statues of people and animals. Each consists of an entrance, hallway, a passage leading to the coffin chamber, front and rear chambers and shafts leading down to either side of the passage containing various objects. A large number of artefacts were found, despite the fact that all the tombs had previously been robbed. Notable among the finds are the murals on the walls of the tombs of Princess Yong Tai and the two princes, which depict lively scenes: polo games, hunting and other activities of imperial life. The portrayal of the human characters is expressive and lifelike, and it also reflects the architecture, lifestyle, ceremonies and dress of the time.

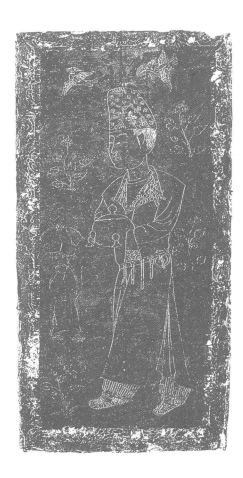

268. Fenxi chariot pit
Between 1956 and 1958
archaeologists working on a large
Western Zhou-dynasty tomb at
Genggao discovered seven chariot
pits of which Pit No. 2 was the best
preserved. Two chariots, one pulled
by two horses and the other by four
horses, were found in this pit. The
occupant of the tomb must have
been a high-ranking official.

**269. Tomb of a Qin-dynasty duke
– Tomb No. 1**
This tomb is in the ruins of Yong, a
city of the Qin state, three miles
south of the Yong River. It took
from 1976 to 1986 to complete the
excavation, being the largest tomb
excavated in China in this century.
The sides of the tomb are 984 feet
long, it is 79 feet deep and covers an
area of over 10,000 square yards.
Over a thousand artefacts were
found in the tomb along with
drainage ditches, water pipes, pillars
and the remains of human slaves,
while traces of buildings can be seen
above ground. Studies suggest that
this is the tomb of the great-
grandson of Duke Mu (577–537 BC).

268

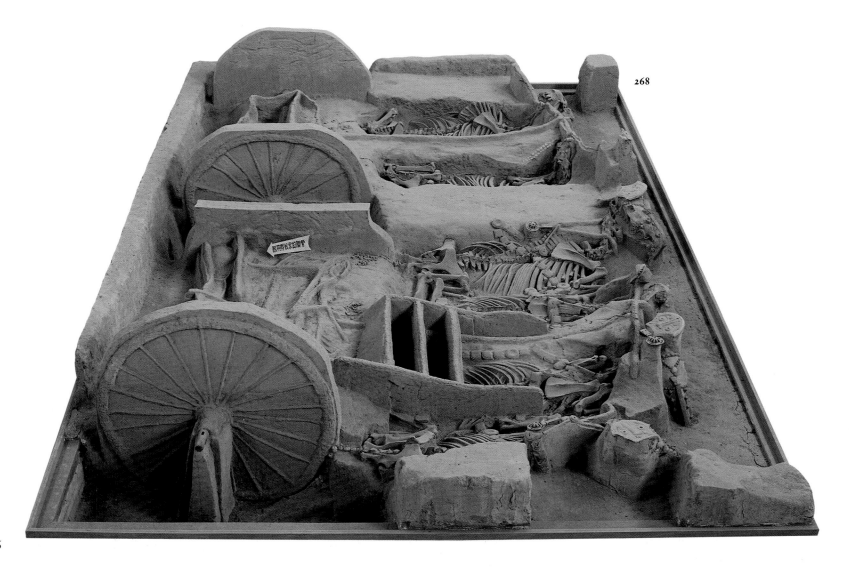

270. Jade tablet

271. Jade fish
These were both among the artefacts found in Tomb No. 1 of a Qin-dynasty duke. Jade tablets were used by noblemen for ceremonial occasions such as audiences with the king, memorial services to the ancestors, sacrifices to the gods and funerals, but it is also thought that they could simply be decorative.

272. Gold animals
These were found in Majiacun near the tomb of a Qin-dynasty duke.

273. Tunnel dug into Tomb No. 1 by robbers
This tomb had been extensively robbed, over 270 tunnels being found when excavations started. The tunnel shown here leads to the side chamber of the tomb and is less than three feet square.

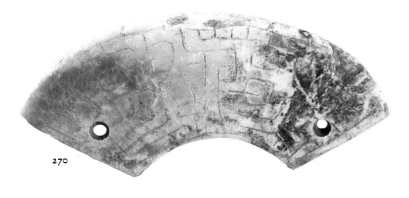

270

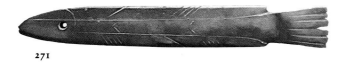

271

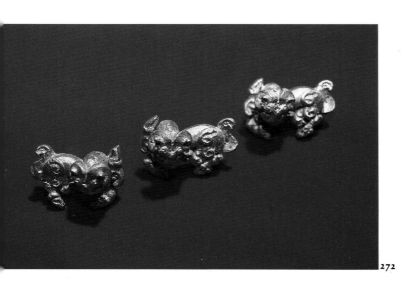

272

273

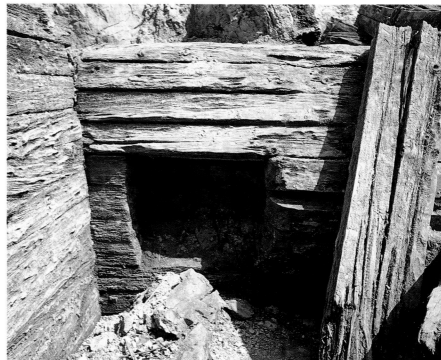

274. Mausoleum of the First Emperor

According to historical records, construction of this tomb, which lies three miles east of Lintong, began in 247 BC, when the future emperor of China became king of Qin. After the unification of China in 221 BC he is reported to have expanded the project, enlisting more than 700,000 labourers. The work continued after his death and was not even complete at the end of the Qin dynasty.

The first official history of China, *Shiji*, describes the tomb as being so deep that it was below the level of the water table. The outer coffin was made of copper, and mechanical devices were set up to keep the mercury on the floor of the tomb – representing the water in rivers and lakes – permanently moving. The ceiling was painted with the moon and stars and the whole tomb was lit by fish-oil lamps. So that these secrets would remain hidden, the builders were sealed inside and there were also crossbows hidden in the passages, set to fire automatically if the tomb was disturbed. It is also recorded that all those palace maids with no children were buried as well. People have doubted the accuracy of this description for years and until the tomb is excavated the account will remain unverified; however, preliminary excavations of recent years have tended to confirm the general description.

The mausoleum is ideally located following Chinese geomantic traditions, with Mt Li to the south and Wei River to the north. The mount was originally almost 400 feet high, but has been eroded over the past 2,000 years.

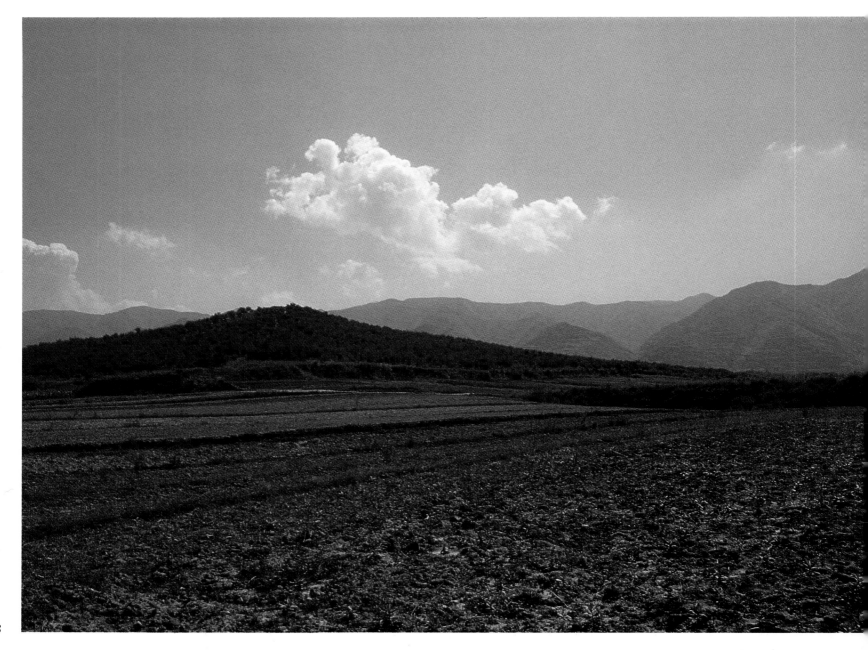

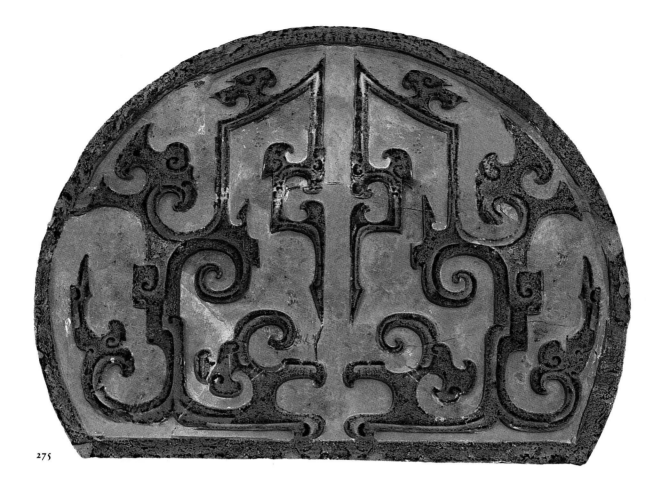

275

275. Tile-end with stylized dragon patterns
This tile-end, found near the First Emperor's tomb, is the largest of its kind found in China to date and so is called 'the king of tile-ends'. It measures 19 by 24 inches and would have been used on the gable of a building, as decoration.

276. Map showing position of the mausoleum of the First Emperor
The layout of the mausoleum of the First Emperor was a copy of the Imperial Palace in the capital Xianyang. The outer wall was 6,890 feet by 3,195 feet and the inner wall 4,445 feet by 2,231 feet. The coffin was placed to the west of centre since west was the direction that symbolized a happy life in the afterworld. The inner wall had three gates, a wide road led from the eastern one through the single, eastern gate of the outer wall and slightly northwards to the pits containing the terracotta army which guarded the tomb against the six rival states to the east.

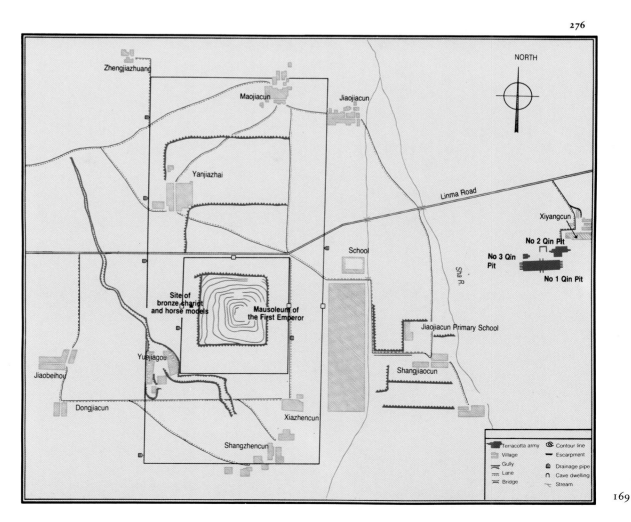

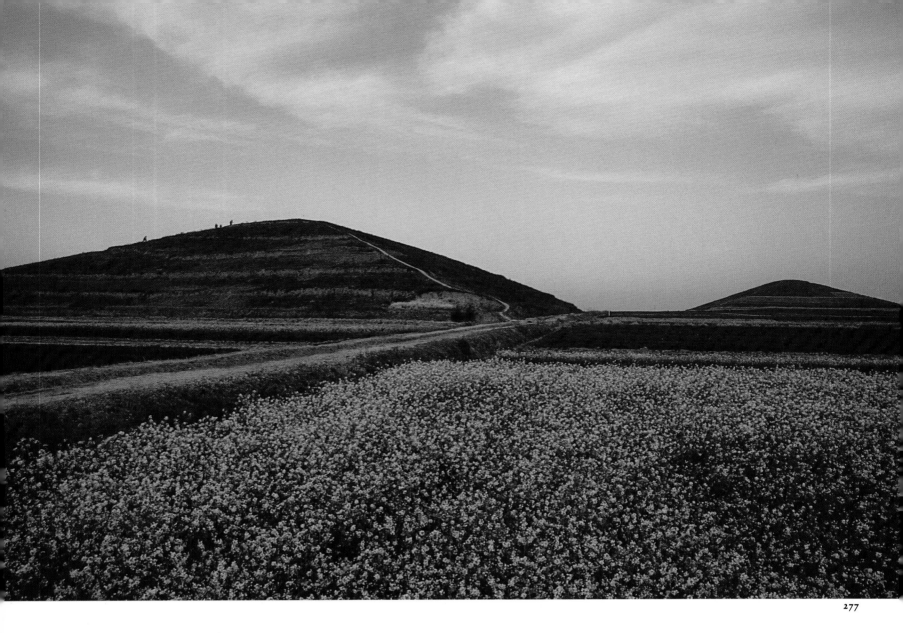

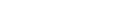

277

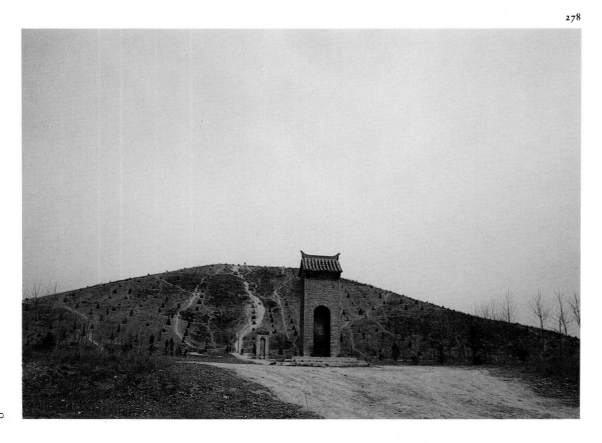

278

277. The Chang Mausoleum of the Han-dynasty emperor Gaozu
The Chang Mausoleum, also called Mt Chang, is a pyramid-shaped hill near Xianyang. There are four other emperors buried in this area, at the An, Yang, Mao and Ping Mausoleums.

278. The Mao Mausoleum of the Han-dynasty emperor Wu
This is the largest of all the Western Han-dynasty tombs and is said to have once been guarded by over 5,000 troops. It took fifty-three years to build, longer than any of the others. There are many attendant tombs at this site, including that of the emperor's favourite concubine, Lady Li, and two generals, Wei Qing and Huo Qubing. Over 270,000 people lived in the residential area designated to this tomb, many of them rich and powerful families who were moved there after its completion, although it is recorded that the area became so prosperous and highly regarded that even nobles and officials from Changan wanted to move there.

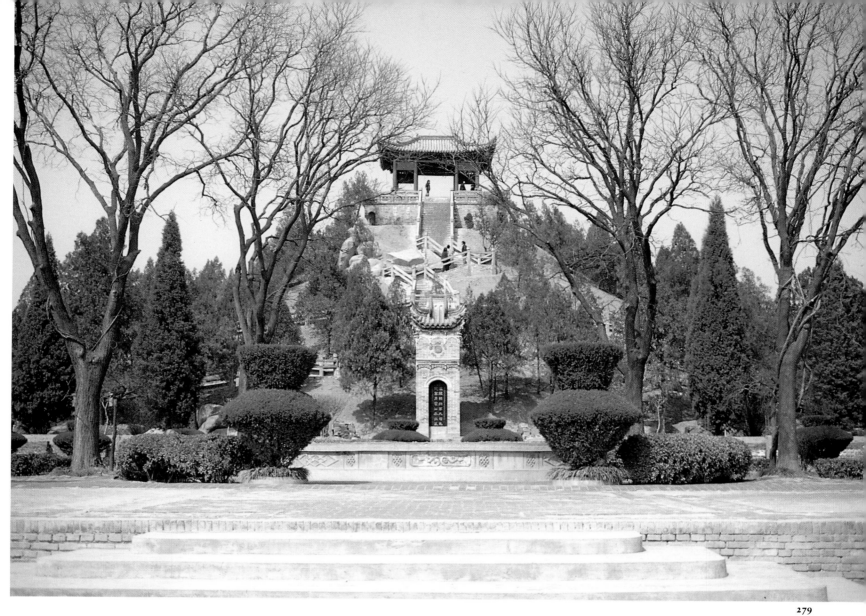

279

279. Tomb of Huo Qubing
Huo Qubing, a famous general of the Western Han dynasty, led six successful expeditions against the nomadic Xiongnu (Huns) to the north, before dying prematurely at the age of twenty-four. In recognition of his services Emperor Wu ordered that he be buried in an attendant tomb at the emperor's own mausoleum. The general's tomb was built to resemble the Qilian Mountains, as this was one of his battlegrounds.

280. The Wei Mausoleum of the Han-dynasty emperor Yuan

280

171

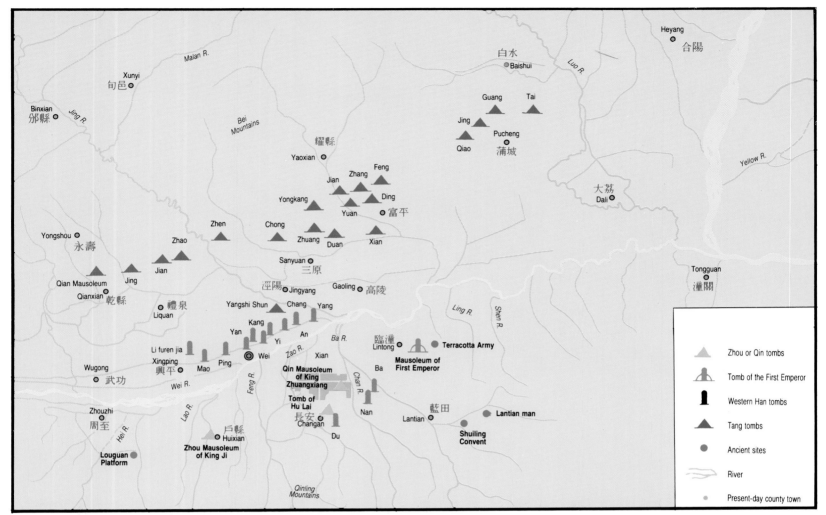

281

172

282

282

281. Map showing the locations of the imperial tombs of the Zhou, Qin, Western Han and Tang dynasties

282. Stone pillar and animal at the Yongkang Mausoleum of the Tang-dynasty emperor Taizu
This mausoleum is located in Sanyuan County, and stone carvings of animals, humans and ornamental pillars can still be found south of the tomb.

283. The Xian Mausoleum of the Tang-dynasty emperor Gaozu
This tomb, of the founder of the Tang dynasty, is also in Sanyuan County and is renowned for the beautiful tigers, rhinoceros and other stone animals lining the Spirit Walk leading to the tomb. There are twenty-three attendant tombs of princes, relatives and civil and military officials.

283

284

284. Ornamental pillar at the Xian Mausoleum

A pair of ornamental pillars stood in front of every palace, mausoleum and city gate in ancient China and, because of their original function as a place for the subjects to memorialize the emperor, these pillars served to symbolize the emperor's willingness to listen to his subjects. The ones at the Xian Mausoleum are octagonal and carved with grass and leaf patterns. Each pillar base had a design of a coiled dragon, while a lion stood on the top. They are typical of early Tang stone carvings, still showing some characteristics of carving from the Northern and Southern dynasties period.

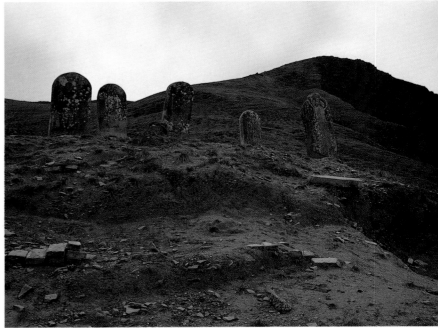

285

286

285. The Zhao Mausoleum of the Tang-dynasty emperor Taizong
This is said to be the first imperial tomb to be built into the side of an existing mountain rather than lying below a man-made mountain, establishing a precedent which later emperors followed. The coffin chamber was fashioned out of the rock of the southern slopes of the Jiujun Mountains.

286. The sacrificial altar at the Zhao Mausoleum
Apart from the underground chamber which contained the coffin, there were two buildings above ground at the Zhao Mausoleum: a hall for worship in the south and a sacrificial altar in the north. The ruins of the altar are all that remain today.

287

288

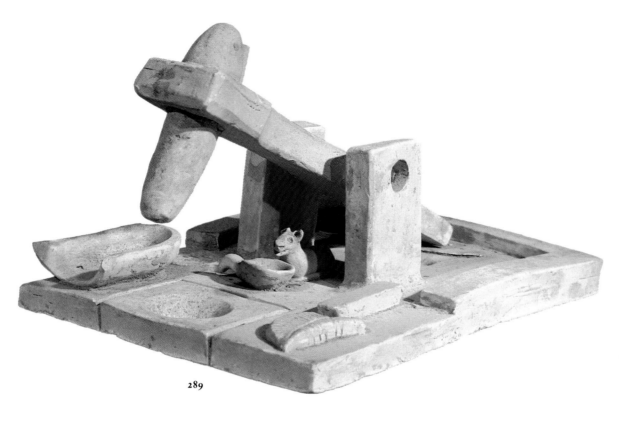

289

287. Pottery pig: burial object at the Zhao Mausoleum

288. Pottery dog: burial object at the Zhao Mausoleum

289. Pottery mortar and pestle: burial objects at the Zhao Mausoleum

290. Painted pottery fireplace and figure: burial objects at the Zhao Mausoleum

290

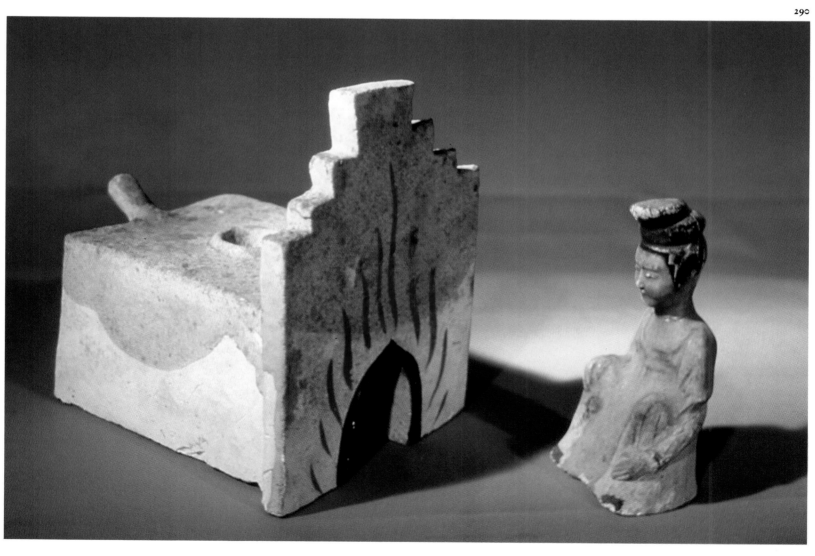

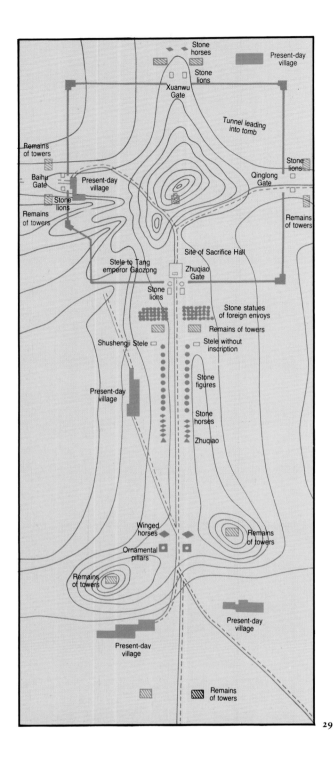

292. The Qian Mausoleum of Emperor Gaozong and Empress Wu Zetian

The Qian Mausoleum is on Mt Liang, 3,437 feet above sea-level and four miles north of Qianxian. The character Qian indicates 'heaven', so the Tang emperor chose this as a name for his tomb, to indicate his supreme position. The tombs of the emperor and empress have not yet been fully excavated, but preliminary studies suggest that they have not been robbed.

292

293. The Watchtowers at the Qian Mausoleum (overleaf)

Mt Liang has three peaks; the tomb was built on the highest, northern peak while the two southern ones formed a natural gateway and were each crowned with a watchtower. The ruins of the watchtowers can still be seen today.

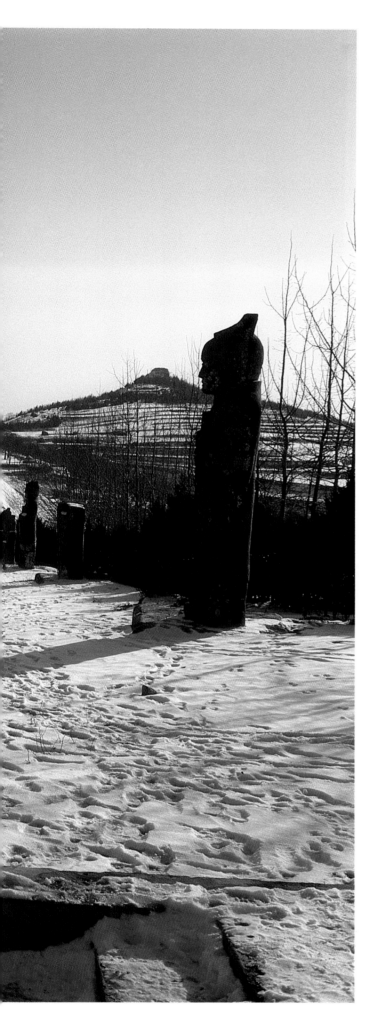

294. Stone lions at the Qian Mausoleum

The stone carvings are all that remain of the structures above ground at the Qian Mausoleum. This pair of stone lions stand either side of the southern gate and face south. In front of them to the east are the sixty-one statues representing foreign envoys.

295. The uninscribed stele at the Qian Mausoleum

This twenty-one-foot-high stele which stands to the east outside the southern gate of the Qian Mausoleum was fashioned from one piece of stone. The top is carved with eight interlocked dragons and there are flying dragons on the sides. The matching stele standing to the west of the gate has a long inscription praising the emperor. It has been suggested that this stele, which should have praised the empress, was ordered to be left blank on her instructions, because she felt her deeds went beyond words. Inscriptions were added in the Song and Jin dynasties, but these are now too worn to decipher.

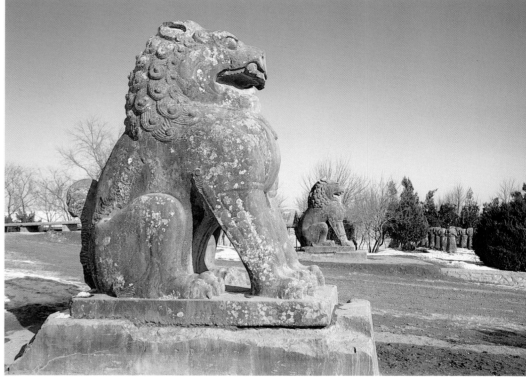

294

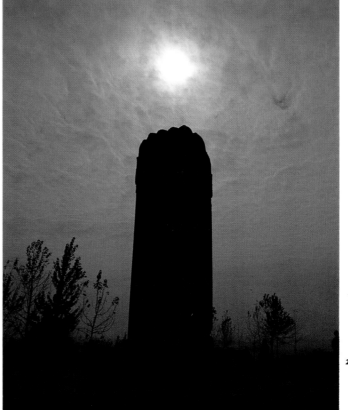

295

179

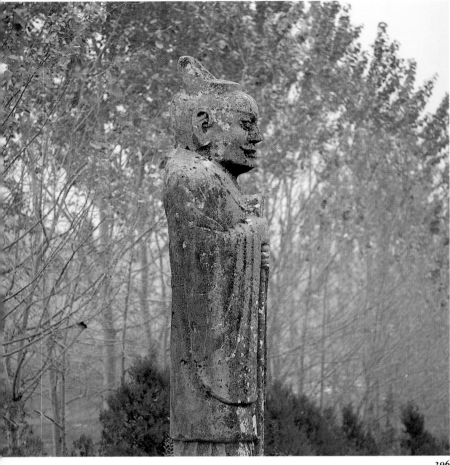

296. Stone carving of a giant at the Qian Mausoleum
Weng Zhong was the name of a legendary giant in the Qin dynasty, and the First Emperor had golden statues of him cast so that Weng Zhong later became a synonym for the large bronze or stone figures guarding the entrances to tombs. There are ten pairs of 13-foot 6-inch statues placed along the sacred path leading to the Qian Mausoleum, all wearing helmets, belts, loose-sleeved robes, with their hands in front of their chests holding swords.

297. Winged horse at the Qian Mausoleum
This is one of a pair of sturdy winged stone horses that stands on the sacred path to the Qian Mausoleum. The cloud designs on the wings are very finely carved.

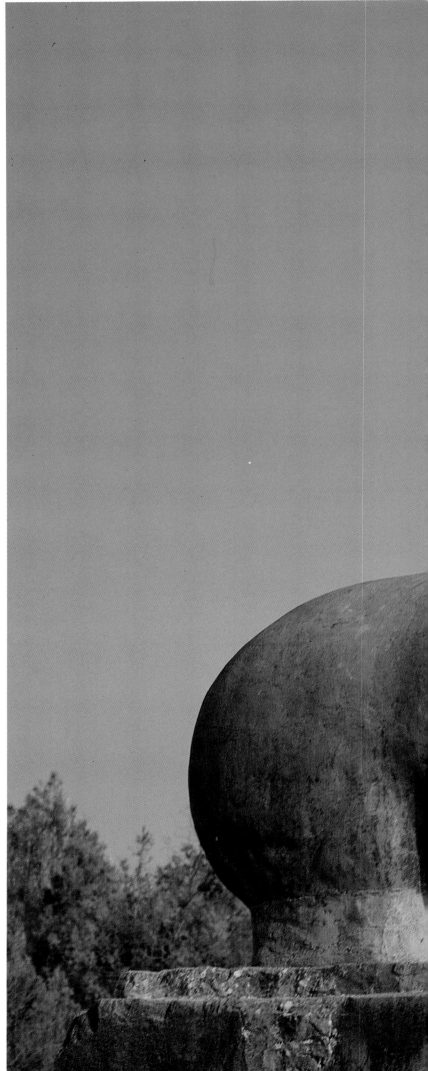

297

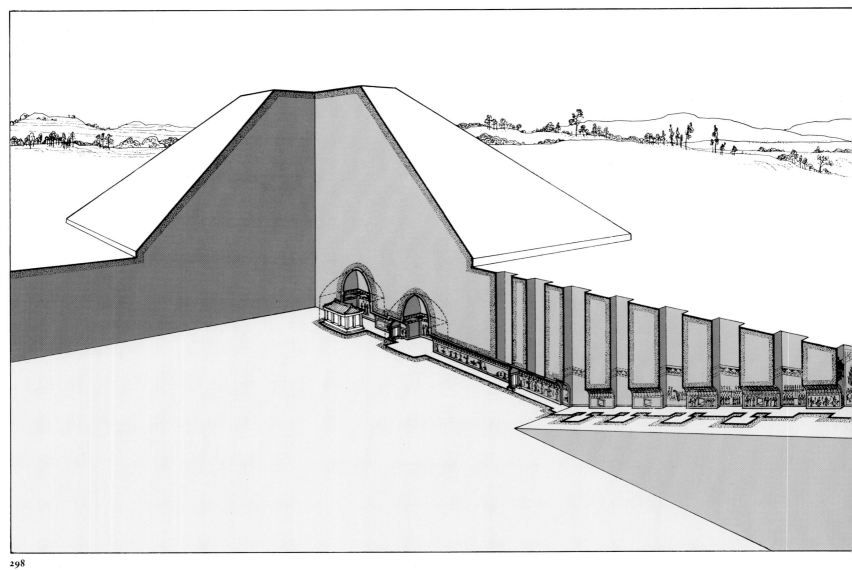

298

299

298. Plan showing a section of the tomb of Prince Yi De
This is one of the attendant tombs at the Qian Mausoleum. The tomb is 331 feet long and 59 feet deep, with 6 side chambers, 7 shafts and 8 niches. It occupies a total area of 784 square yards and has numerous murals painted on the walls of the passageway. The stone gate of the coffin chamber and the stone coffin itself are carved with beautiful designs.

299. Passage leading to the coffin chamber in Prince Zhang Huai's tomb
This is another attendant tomb at the Qian Mausoleum and also comprises a sloping passage with shafts, side chambers and niches, being 233 feet long from the beginning of the passage to the rear chamber. When the tomb was opened a large number of tri-coloured glazed pottery ware and wall murals were discovered.

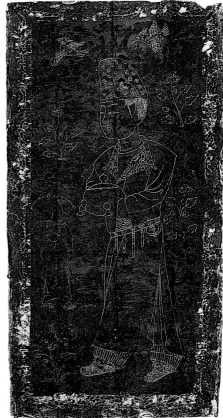

300. Epitaph of Princess Yong Tai
Princess Yong Tai was the seventh daughter of the Tang emperor Zhongzong. She is buried in an attendant tomb at the Qian Mausoleum. The plate shows a tablet which bears an inscription to her memory.

301. Carving on the outer stone coffin in Princess Yong Tai's tomb
This is one of the carvings depicting a female figure found on the outer stone coffin of Princess Yong Tai. The palace maid depicted here is wearing a flower-patterned, western-style robe with a turned-out collar.

302. Painted pottery cavalryman
Prince Yi De, who died at nineteen, was buried in an attendant tomb at the Qian Mausoleum. This pottery cavalryman in full military uniform on a horse with a gilded face was found in his tomb.

301

300

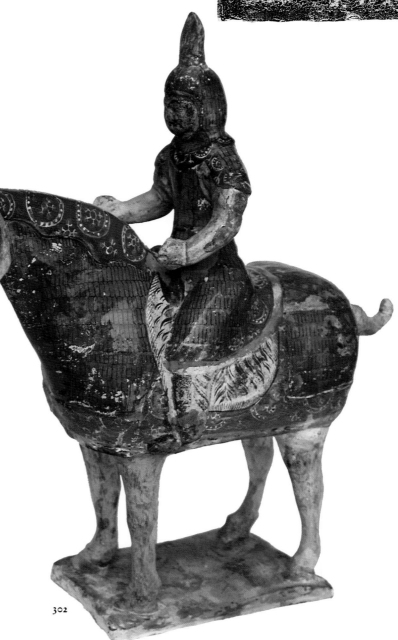

302

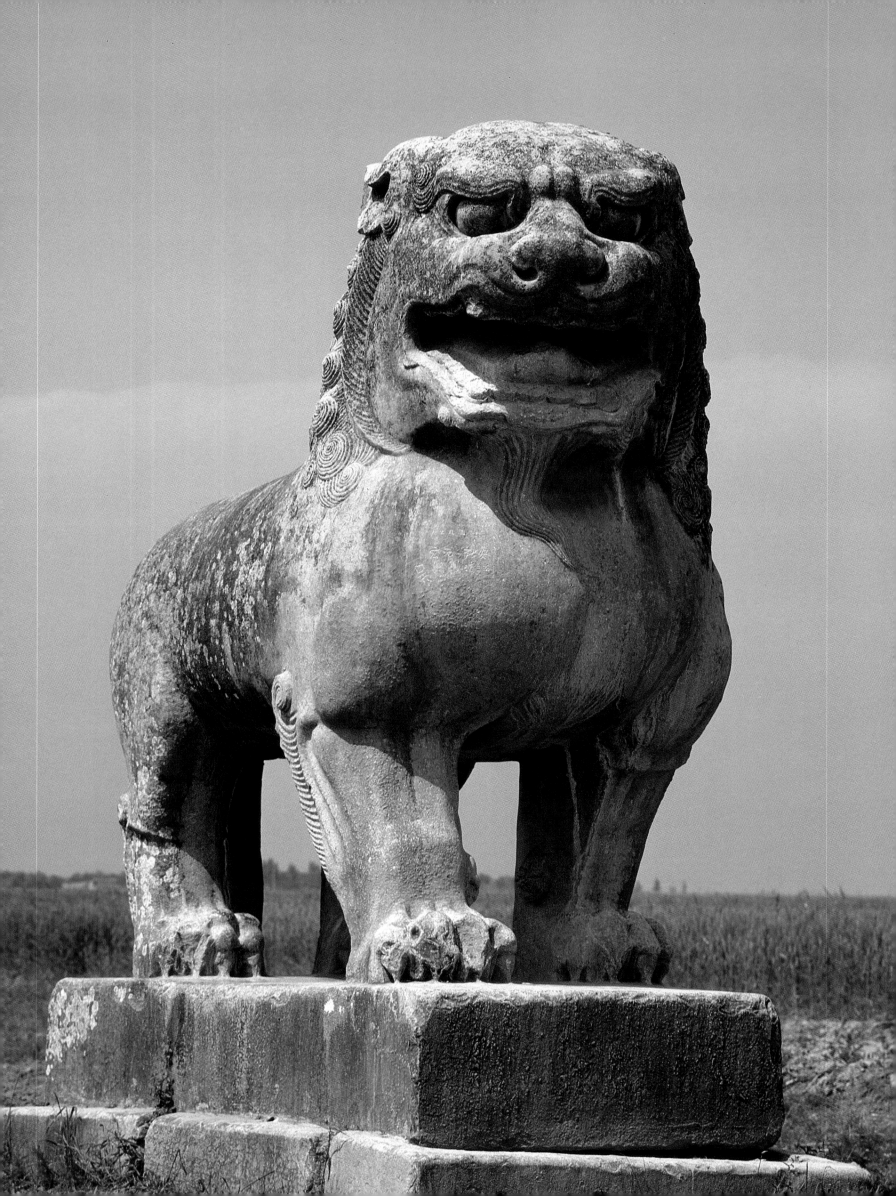

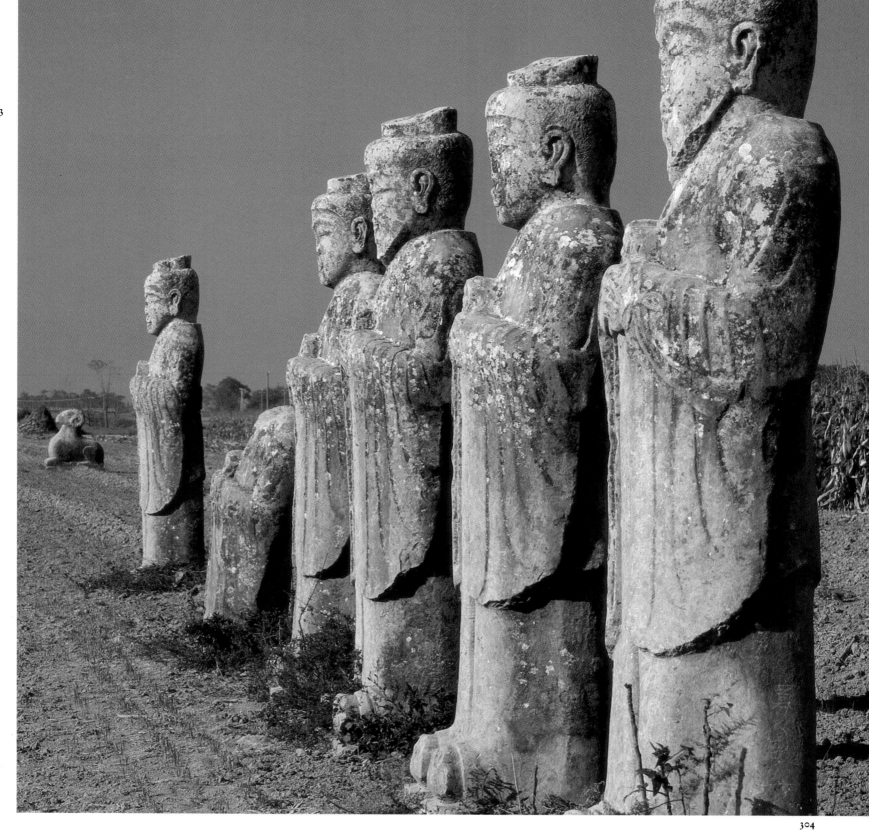

304

305

303. Stone lion at the Shun Mausoleum

The Shun Mausoleum was built by Empress Wu Zetian for her mother. All the stone carvings found at this tomb are extremely large: this lion is over thirteen feet high.

304. Stone figures at the Shun Mausoleum

It was customary for there to be ten pairs of carved stone human figures standing opposite each other along the sacred path leading to the tomb. These figures, which represent officials attending to the emperor, were in official dress with court hats and swords.

305. Stone winged horse at the Shun Mausoleum

According to Chinese mythology winged horses symbolize good luck and prosperity. They are also loyal and brave and were placed in front of tombs to guard them.

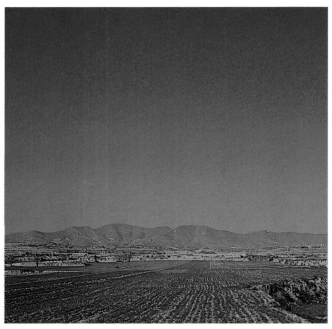

306. The Qiao Mausoleum of the Tang-dynasty emperor Ruizong
The Qiao Mausoleum is located in the Feng Mountains, nine miles north-west of Pucheng. The stone carvings lining the sacred path remain intact, making this one of the most important of the Tang imperial tombs.

307. Ostrich at the Qiao Mausoleum
The ostrich, lion and camel, all animals foreign to China, made their way to Changan in the Tang dynasty as a consequence of increasing cultural and economic links with countries to the west. The fact that the ostrich had by this time been accepted by the Chinese as an animal suitable to guard an imperial tomb reflects the complete assimilation of things foreign into Chinese culture at this time.

306

307

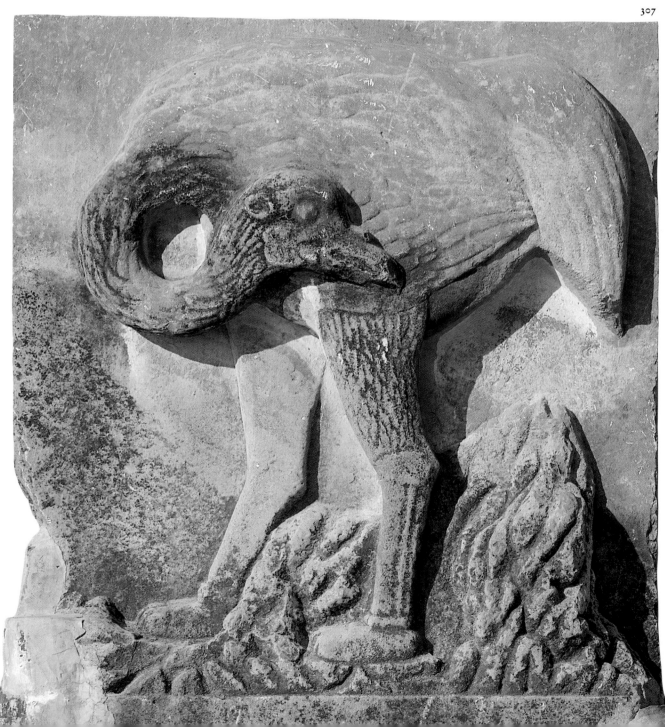

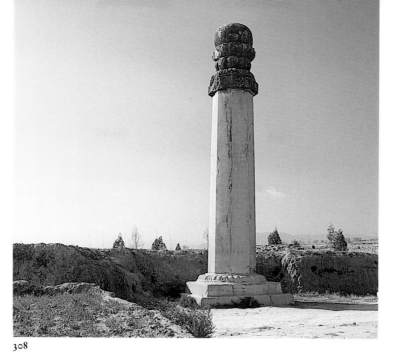

308. Ornamental pillar at the Qiao Mausoleum

309. Ornamental pillar (*detail of Plate 308*)
This design, with its precise style and fine detail, is typical of Tang-dynasty drawings.

308

309

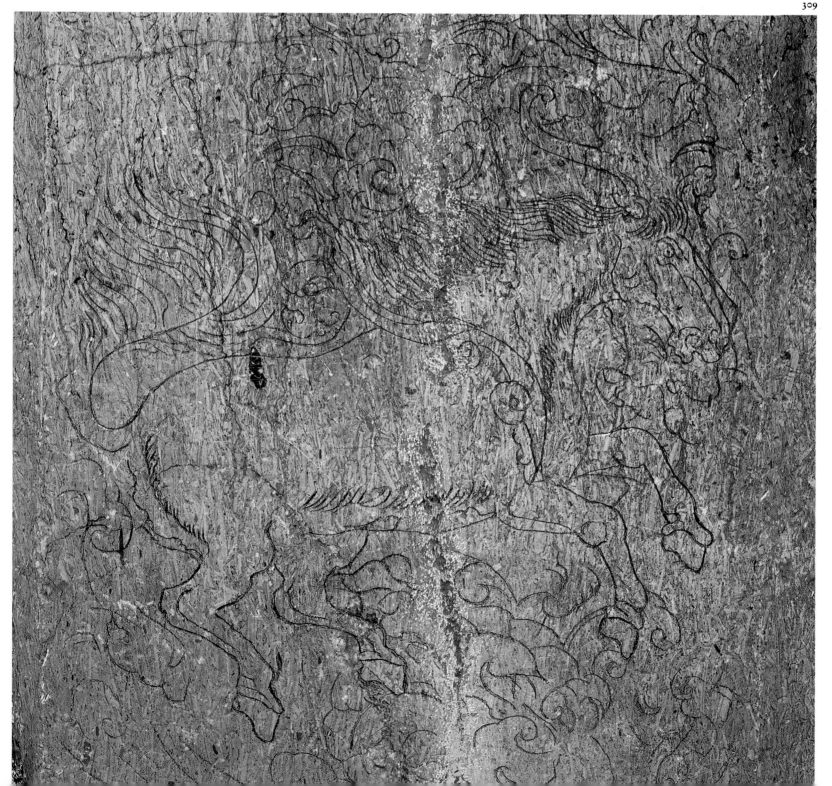

187

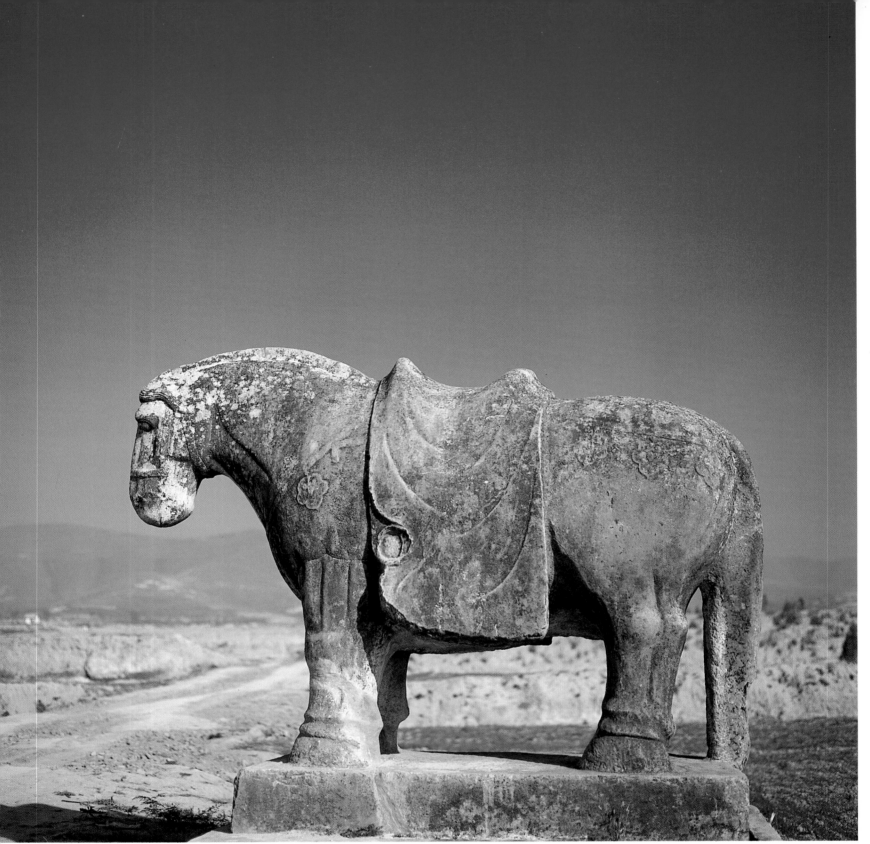

310

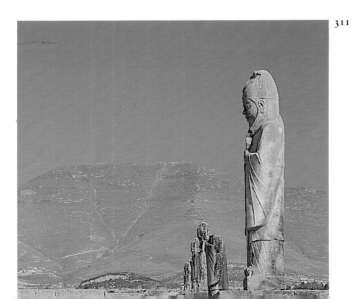

311

310. Stone horse at the Qiao Mausoleum

Five pairs of stone horses were always found along the sacred path leading to imperial tombs of the Tang dynasty. The horses at the Qiao Mausoleum are sturdy and realistic.

311, 312. Stone figures at the Qiao Mausoleum

These stone figures, fifteen feet high, together with those at the Qian Mausoleum, constitute the finest examples of Tang-dynasty tomb sculpture.

312

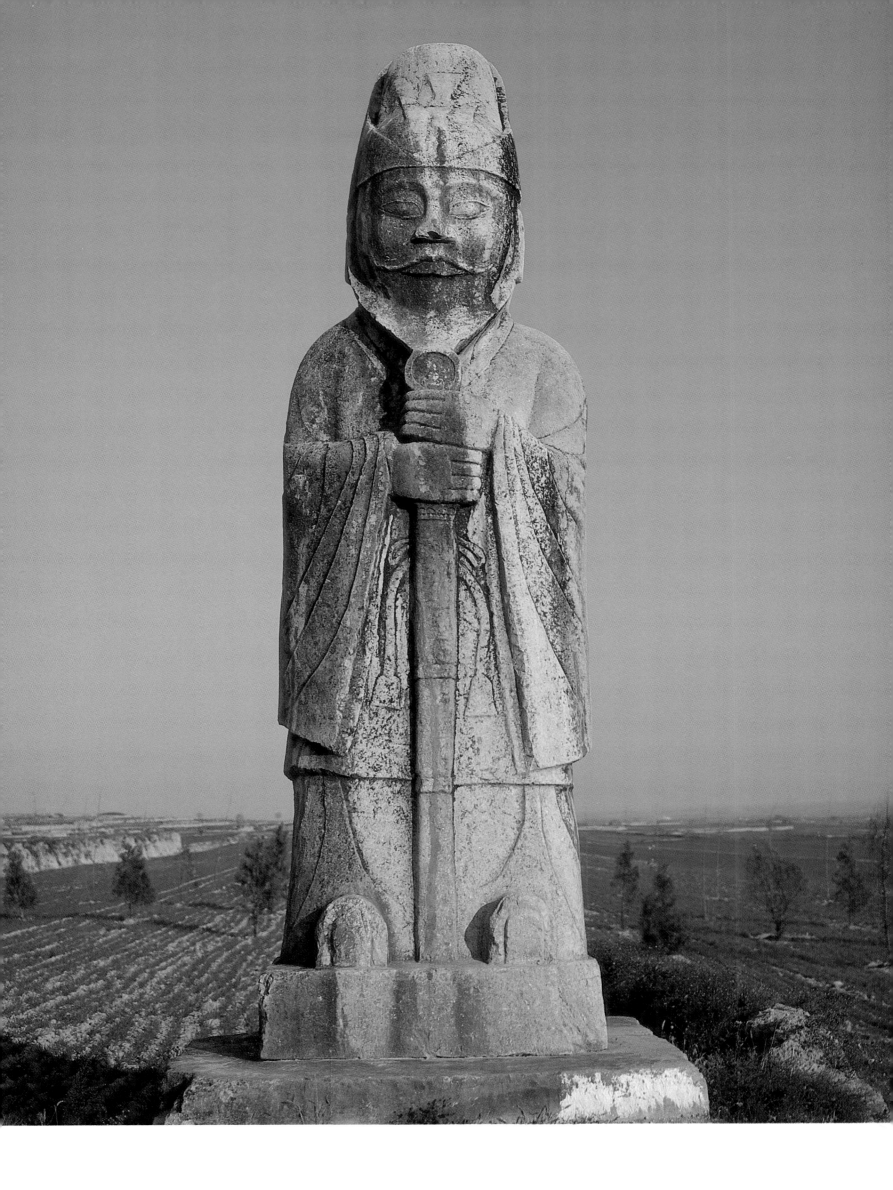

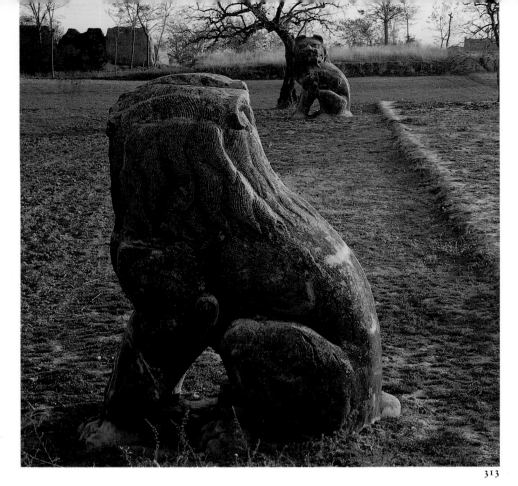

313

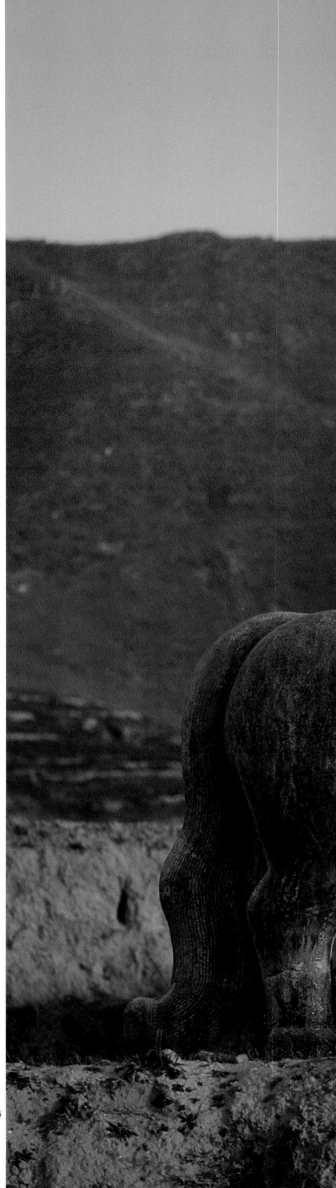

313. Stone lions at the Qiao Mausoleum

The fierceness and power of the lion made it an ideal guardian of the imperial tombs, even though it was an animal, like the ostrich, introduced from the west. The lions at the Qiao Mausoleum, with their heads turned towards each other, are the only identical pair of lions at the Tang-dynasty imperial tombs.

314. Stone winged horse at the Tai Mausoleum

The Tai Mausoleum, the tomb of the Tang-dynasty emperor Xuanzong, is in the Jinsu Mountains, nine miles north-east of Pucheng County. This horse has cloud-pattern wings and is also standing on clouds.

314

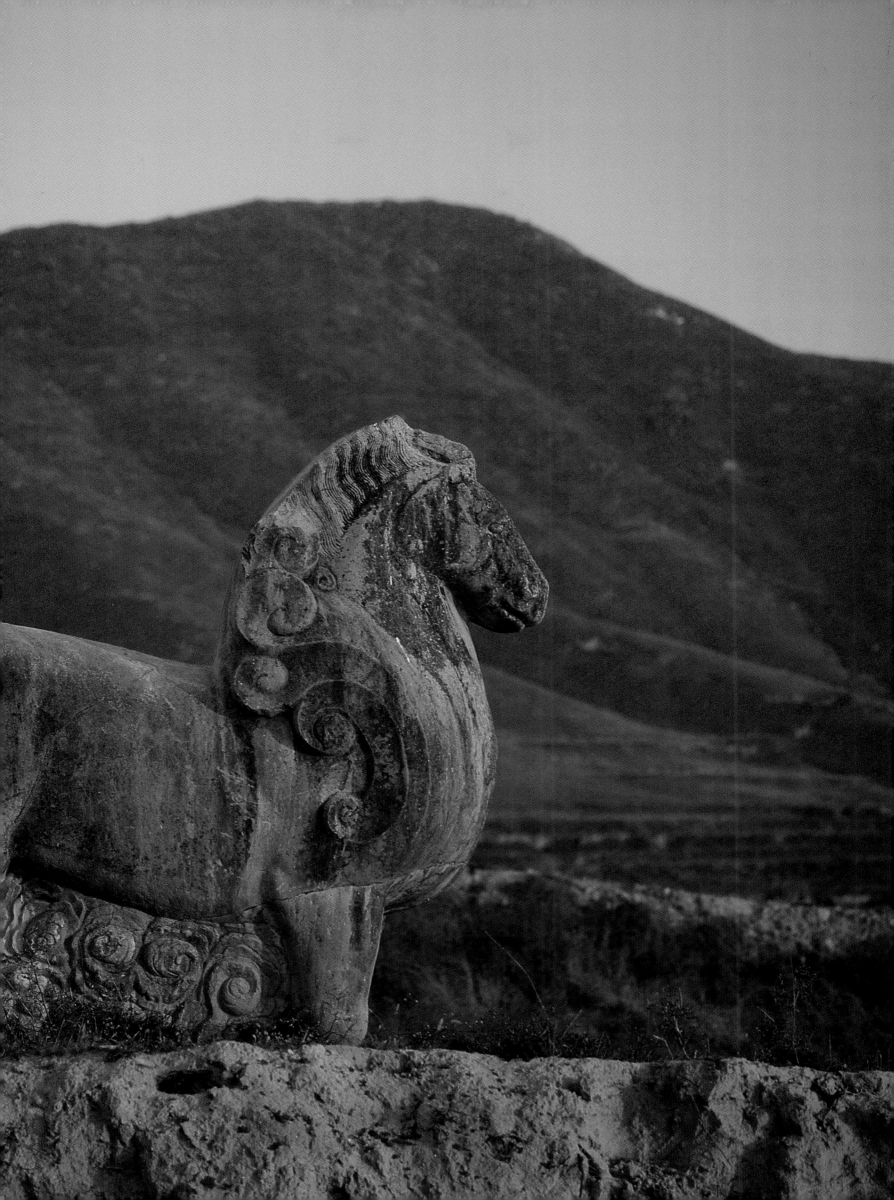

315. Tomb of Lady Yang

Yang Yuhuan was the favourite concubine of the Tang emperor Xuanzong, and she has usually been blamed by historians for the An Lushan rebellion which toppled the Tang dynasty, its leaders gaining control of the country for several years. It was said that Lady Yang and her family gained too much power at court. When Xuanzong fled the capital for Sichuan his soldiers forced him to hang Lady Yang *en route*. She was thirty-eight. After the rebellion was put down the emperor secretly had her tomb moved to another site. It is difficult to say whether the tomb shown here, at Maweipo, Xingping County, is the original tomb or the later one.

316. Stone animals at the Jing Mausoleum

The picture shows the horses lined up along the Spirit Road to the Jing Mausoleum of the Tang emperor Xianzong, in the Feng Mountains, north-west of Pucheng County.

315

316

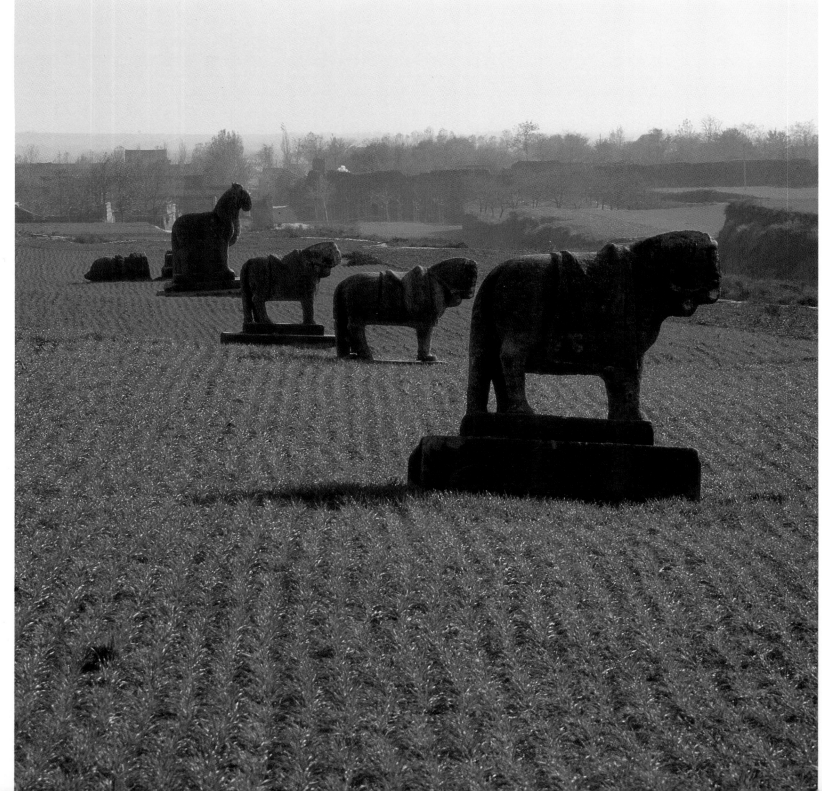

7.

The Development
of Religion

Primitive Religions

Primitive religious beliefs were probably held by the people of the neolithic Yangshao culture living in the area of central Shaanxi Province six or seven thousand years ago. At Banpo these beliefs can be sensed in the burials; graves were laid out in a rectilinear fashion, equidistant from each other, with the heads of their occupants all pointing west. Possibly the fish and frog motifs on the pottery represented totemic ancestors – fish and frog motifs found in Shaanxi folk art today retain vestiges of a former religious role. Totems were deified ancestors, symbols of family groups as well as their guardian spirits. It has also been postulated that other traditional ceremonies, such as the celebration of the goddess Nu Wa's birthday, directly relate to the worship of maternal ancestors in remote antiquity. The discovery of pottery phalluses and cracked bones at a later neolithic Yangshao-culture site at Keshengcun indicates a change to a worship of paternal ancestors and the beginnings of divination using oracle bones.

By the time of the Shang dynasty, ancestor worship and the concept of a supreme being – who was also the first ancestor of the Shang people – were well developed. This first ancestor, Shang Di, had ultimate control over the natural and the human world and presided over a range of nature divinities. Closely linked with ancestor worship and court ritual in general was divination using animal bones or tortoise shells; a heated point was applied to a bone or shell and the resulting cracks gave the answer to the question inscribed on their surface. However, this was the religion of the rulers of the Shang; very little is known about the deities of the peasantry at this time.

In the twelfth century BC the Shang dynasty was taken over by the Zhou, who located their capital in the land within the passes. The Zhou people belonged to a different clan and had their own ancestor, Hou Ji, but they did not replace Shang Di with their own clan ancestor; instead they invented a new concept, heaven, and described the authority of the kings as 'ordained by heaven' (*tian ming*). The king was divinely sanctioned to rule because he had virtue (another concept which appears for the first time in the Zhou); however – and this has been a vital part of the whole concept of power in China – he would be divested of his authority if he lost this virtue. During the Western Zhou, Shang Di ceased to be thought of as an ancestor of the Shang and was regarded solely as a god, while Hou Ji was worshipped as an ancestor but not as a god. Sacrifices to heaven and Shang Di and worship of the Zhou ancestors, exclusive rights of the Zhou royal house, were conducted in temples and shrines built in the city of Feng, across the Feng River from the other, administrative and residential capital Hao. It is also recorded that the Zhou ruler made periodic sacrifices to famous mountains and rivers to reaffirm his domination over the land.

The peasantry of China probably worshipped local nature deities, although there seems to have been a shrine to the Lord of the Earth (Hou Tu) and the Lord of the Grain (Hou Ji) in every village throughout Chinese history.

Divination was held to be extremely important; before King Wu set out on a punitive expedition against the last king of the Shang, and before Duke Zhou sent forces to suppress the rebellious princes, they both turned to divination, hoping that divine 'permission' for their campaigns would help to unify their armies and inspire a fighting morale. One of the ancient classic texts in the Chinese Confucian tradition is the *Yi Jing*, which contains rules of interpretation of hexagrams: a form of divination prevalent during the Zhou which involved the arrangement of yarrow stalks into figures composed of six continuous or broken lines. It is claimed that the predecessor of the founder of the Zhou dynasty composed a considerable portion of the commentary of this text and that it was used as a manual of divination by the Zhou court (hence it is also known as *Zhou Yi*). While there is now a general consensus among scholars that some of the text dates from Qin or Han times, it is also agreed that it does relate to Zhou practices. As one of the classics, this text was influential throughout the succeeding dynasties, moulding much of the ritual life at the court.

The decline in the power of the Zhou king in the latter half of the dynasty resulted in total severance of any lingering identification between the ancestors and the gods. The Zhou gradually became rulers in name only, as the actual power passed between rulers of rival states, known as hegemons, until even this system collapsed, leading to a period known appropriately as the age of the Warring States. The rulers of each state, previously politically subordinate clans, competed for dominance and the concept of *tian ming* achieved a real significance as the link between the Zhou clan and the authority of the gods was increasingly brought into question.

The Eastern Zhou period witnessed the emergence of the 'hundred schools of thought'. These many systems of thought included both Confucianism, which by the Han was an integral part of Chinese thought and institutions, and Daoism (as exemplified in Zhuangzi and Laozi), which gave rise to a philosophy followed by disillusioned intellectuals and a religion followed by both emperors and peasants. This period and the Qin and the Han dynasties following it also saw the increasing influence of necromancers and shamans both at court and among the populace. They were active in witchcraft, religion, astronomy and geography, making predictions about nature and society using mystical tenets and preaching volubly on the techniques of immortality – a theory associated with Daoism. The Han-dynasty emperor Wu had a 550-foot-high Sacred Terrace built in Jianzhang Palace where 100 of the most senior Daoist priests were assigned to pay tribute to heaven. He also had Taiye Lake dug to symbolize the Immortal Isle in the East Sea.

From these examples it is apparent that there was already considerable diversity in religious beliefs and practices at court by the time of the Han dynasty, in contrast to the strict ritual ceremonies of the Shang and Zhou. This diversity and popularization of religion must have also been seen among the people. It is postulated that the shamanistic tradition originated among the people of the state of Chu, on the borders of southern China, and this was to be just one of many influences from outside China that would affect the traditional philosophies and religions over the following centuries: Buddhism is the most well-known example.

The Introduction of Buddhism

Buddhism was probably introduced to China during the Eastern Han dynasty. According to legend the first Buddhist temple, Baima (White Horse) Temple, was built in Luoyang (capital of the Eastern Han) in AD 67, when the emissaries sent by Emperor Ming to Dayuezhi, a state in western Xinjiang, returned with icons of the Buddha and scriptures. Another legend records the huge crowds of people kneeling in tribute and burning incense by the roadside west of the former capital Changan when the scriptures arrived there, so filling the place that the procession was delayed for three days. Afterwards it is said that the people built the Qingfan Temple where the crowds had gathered and this would have presumably been even older than the Baima Temple. Recently the site of another Eastern Han temple, Famen Temple, in north Fufeng County in the western part of central Shaanxi Province has been excavated, revealing an underground palace containing four objects alleged to be Sakyamuni's (the Buddha) finger bones; the temple is also called the Pagoda of the True Relics. These 'true relics', along with a large number of Tang-dynasty artefacts – gold and silver vessels, coloured glazed pots, pearls, jade, lacquer and bamboo wares, fragments of woven silk and a kind of porcelain used at the palace and mentioned in historical sources but examples of which were previously thought not to have existed for over a thousand years – were also discovered.

By the second century AD both Hinayana and Mahayana texts were being translated in Luoyang. In the third century more Buddhists arrived in China, including one of central Asian descent. However, it was during the period of turmoil following the downfall of the Han dynasty that Buddhism began to spread rapidly throughout China. One of the most important figures of this time was a monk called Dao An (312–85) who may be regarded as the founding father of Chinese Buddhism. He worked first in Xianyang, but then moved to Changan under the patronage of Fu Jian, an emperor of the Former Qin dynasty. Unlike previous translators, he made an attempt to understand Buddhist concepts on their own terms, rather than equate them with Chinese concepts. He also produced a catalogue of all existing translations of Buddhist texts, which contained 600 titles.

The next great figure was a central Asian nobleman called Kumarajiva (c.344–409). He had been detained for several years in Wuwei (Liangzhou) by the Early Qin, during which time Dao An had persuaded Fu Jian to send an expeditionary force, 70,000 strong, to bring him back. They failed, but Kumarajiva nevertheless finally arrived in Changan in AD 401, when Yao Xing, emperor of Later Qin, conquered Wuwei. This period saw the growth, development and assimilation of Buddhism and was a period of intense activity as far as translating was concerned, Kumarajiva alone having translated well over 400 volumes while in Changan. A contemporary poet spoke of tens of thousands of people travelling from afar to see Kumarajiva and his 3,000 disciples working together on translations of scriptures and how, when the translation project was completed, Kumarajiva gave a series of lectures attended by 5,000 Buddhist monks and priests.

Two years prior to Kumarajiva's arrival in Changan a Chinese monk named Fa Xian had set out to the west in search of Buddhist scripture. He spent fourteen years learning Sanskrit and collecting Buddhist classics. Although he was almost certainly not the first Chinese pilgrim to travel to India, he was the first to leave an account of his travels.

The Journey to the West, a famous Ming-dynasty Chinese novel which relates the adventures of a monk, a monkey and two other travel companions on their way to the west in search of Buddhist scriptures, is based on the account of the Tang-dynasty monk Xuan Zang. He travelled for a total of nineteen years across India and returned amid much praise in AD 645 (despite the fact that he had set out without official permission). He brought back 657 volumes of Sanskrit scriptures and devoted the rest of his life to the translation and elucidation of these, becoming the most prolific and competent of the translators. He was based at Dacien Temple in Changan. The other famous pilgrim monk of the early Tang period was Yi Jing, who set out by sea in AD 671 during the reign of Emperor Gaozong and returned in AD 695 during the reign of the Empress Wu Zetian. He brought back 400 volumes of scriptures and expository materials. He went first to Luoyang, then to the Dajianfu Temple in Changan, where he taught and translated. Daxingshan Temple was the third great translation centre in Changan and was where the Asian monk, Amoghavarta, worked on tantric Buddhist texts from AD 756 onwards.

Buddhism during the Tang

Buddhism, now firmly established as a major religion in China, flourished during the Tang. This is manifested in the abundance of monasteries; the eighty-one monasteries and twenty-eight convents in Changan were unsurpassed throughout the whole of China in terms of their quality and scale. They were built following the basic principles of Chinese architecture: rows of buildings, courtyards, gates and passages on a central axis, with subsidiary buildings on either side. The largest in Changan had over ten courtyards. Most of them had tall pagodas inside surrounded by trees, bamboo and vegetable plots. Several were huge places

financed by members of the ruling house or high-ranking officials; for example, Dacien (Great Benevolence) Temple (in the south of Xian today) has eleven courtyards, buildings with almost 2,000 cubicles and living quarters for 300 monks. It was erected under the orders of Crown Prince Li Zhi (Emperor Gaozong) in memory of his mother, Empress Wende. After Xuan Zang returned from India, Emperor Taizong appointed him head priest and established a special translation office there. The magnificent Dayan (Greater Wild Goose) Pagoda in the temple was designed by, and built under the supervision of, the monk himself.

Dajianfu Temple was built in a residence donated by Emperor Taizong's daughter, Princess Xiang Chang, and covered an area of twenty-five acres. Its pagoda, a fifteen-storey structure built by Emperor Zhongzong, is still over 140 feet high, although only thirteen storeys remain. Daxingshan Temple was erected in the early years of the Sui dynasty and covered a huge area. Zhangjing Temple, built outside the East Gate with an enormous sum of money from Emperor Daizong and named after his mother, had forty-eight courtyards and over 4,000 cubicles in its buildings.

The emperor's support of Buddhism had repercussions both in Changan itself and throughout the country. The court sent officials out to welcome Xuan Zang on his return in AD 645 and crowds gathered to watch. The emperor himself officiated at the welcome ceremony and when later the monk moved his residence from Hongfu Temple to Dacien Temple the court held another grand ceremony, the procession preceded by 1,000 chariots with colourful banners and followed by over 300 canopies, 200 embroidered portraits of the Buddha and a dazzling array of gold and silver images. Monks from all the temples in the city followed behind burning incense, strewing flowers and chanting sutras, accompanied by palace guards riding in chariots. Emperor Taizong, the empress, concubines and the crown prince burned incense and watched the procession from the top of one of the gatetowers, as hundreds of thousands of Changan's residents lined the street. When Xuan Zang died in AD 664, Emperor Gaozong suspended court audiences as a sign of mourning. Xuan Zang was first buried at Bailu Hill but his remains were then moved to Shaoling Hill south of the city because of the proximity of Bailu Hill to Hanyuan Hill, where the emperor sometimes held court; it is recorded that the emperor could not restrain his grief at the sight of the tomb. During the reign of Suzong a memorial pagoda was erected which the emperor named Xingjiao, 'to promote the teaching', and this gave rise to a temple of the same name, which is now famous among Buddhists throughout the world.

The Tang also saw the emergence of many different sects of Buddhism. Although many of the early texts translated into Chinese belonged to the Hinayana (Lesser Vehicle) school of Buddhism, the Mahayana (Greater Vehicle) school soon became dominant, the Chinese probably finding its doctrine that salvation was open to everyone more palatable than the Hinayana view that it was only open to those who joined the monastic order. The Faxiang (Dharmalaksana) sect founded by Xuan Zang was popular for several decades due to its promotion by Xuan Zang

and his disciples and, even more so, because of the patronage of the imperial house. In the early years of the Tang dynasty the monk Shan Dao founded the Pure Land (Sukhavati) sect which became popular not only because of Emperor Taizong's support but because it taught that the reading of scriptures was sufficient to attain enlightenment. After Shan Dao's death his disciples erected a memorial pagoda in Xiangji Temple which was purported to have a circumference of 1,300 feet and be thirteen storeys high. It attracted large numbers of Buddhists as well as high-ranking officials from afar; Empress Wu Zetian herself visited it many times with her son Emperor Zhongzong, to pray and give alms.

To seek power and influence the Buddhist sects became increasingly involved in palace politics. While teaching Buddhist classics in the imperial palace the monk Fa Zang of the Huayan sect gained Empress Wu Zetian's special favour by saying that it had been ordained that she would become 'Son of Heaven of the Great Zhou' as an incarnation of Maitreya, the future Buddha, and replace the Tang. When Wu Zetian did gain the throne and establish her own short-lived dynasty she showed her favour by having large numbers of monasteries built, and Fa Zang was recorded as a third-rank court official. During the reigns of Zhongzong and Ruizong, Fa Zang officiated at the Buddhist initiation and was appointed as an imperial tutor; five Huayan Temples were also built as a special favour to the monk. After his death he was awarded the posthumous title of President of the Board of Sacrificial Rites. A third-generation disciple of his, Chengguan, was also appointed imperial tutor by Dezong and was venerated as a Professor-Monk with the titles State Protecting Master and Head Monk under Heaven. The succeeding emperors, Xianzong, Muzong, Jingzong and Wenzong, all conferred on him the title of State Teacher.

Monks of the Mi sect (Esoteric Buddhism or Tantrism), many of them Indians, were invited several times into the imperial palace to pray for rain. During the An Lushan rebellion they were again invited to chant sutras to beg for the Buddha's protection. After the rebellion was quelled the monk Amoghavajra was appointed Grand Minister and given a ducal title.

The Widespread Influence of Buddhism in City Life
With the emperors' promotion of Buddhism more and more officials and scholars also became supporters: Wang Wei, Wang Jin, Yuan Zai and Du Hongjian being outstanding representatives. Wang Wei, a Tang-dynasty poet, became a vegetarian in his later years and wore simple clothing despite his status. While in the capital he entertained learned monks every day, engaging in the practice of *xuantan* (mysterious conversation) with them. After retiring from court he burned incense and sat alone, chanting scriptures. His poems are full of Buddhist allusions and he was spoken of as the Buddhist poet, ranking with Du Fu and Li Bai in fame. On his deathbed he wrote to friends exhorting them to believe in Buddhism and indicating his desire to donate his manor house at Wangchuan for use as a temple. Wang Jin, Wang Wei's brother, later became prime minister. He also donated his country house after the death of his wife, naming it Baoying Temple. He persuaded Emperor Daizong to spend a huge sum of money to establish halls for religious ceremonies in the Imperial Palace and also to build shrines and temples all over the city of Changan.

Buddhist monks were adept in propagating their religion through art and literature. For example, they adapted Buddhist scriptures into prose and verse stories which were then chanted in public places and illustrated with paintings, a practice known as *su jiang* – popular preaching. This attracted large audiences. These stories are probably a precursor to the development of drama in later dynasties. Eminent *su jiang* monks in Changan included Hai An and Ti Xu in the west of the city and Wen Xu in the east. It is said that Wen Xu's voice was so sweet and touching that illiterate

men and women flocked to the temple to listen to him and musicians tried to imitate him.

Many artists of the Tang also used their skills to promote Buddhism; for example, inscribing steles for temples and to famous monks, carving images of Buddha and painting murals, thereby drawing even more believers and visitors to the temples. The artist Wu Daozi painted over 300 murals for monasteries in Changan and Luoyang. His painting depicting the underworld drew enormous crowds and it was said that some butchers were so scared by it that they vowed never to wield a cleaver again.

Buddhist fanaticism in Changan reached its zenith when Emperors Xianzong and Yizong sent for the Buddha's finger bones from Famen Temple. On both occasions it is recorded that people flocked into the streets. When the 'true relics' were returned people turned out in their thousands to bid farewell to the bones. Old men congratulated each other, saying that it was a once-in-a-lifetime opportunity and they all prostrated themselves in tributes filled with tears and excitement.

The spread of Buddhism enabled the monasteries to come into possession of vast tracts of land, making them as rich as many secular landlords. According to a Tang law on land ownership, each monk was allowed five acres of land, each nun just over three acres and, apart from this, each monastery its own 'permanent land'. During Xianzong's reign it was stipulated that a monastery with a hundred monks or more could have no more than 115 acres of 'permanent land', and that one with fewer than fifty monks no more than eighty-two acres. In other words, with the addition of the individual monk's land, a monastery of a hundred monks could possess anything up to 615 acres of land. In fact, the amount was often much more, since the monastery could, by dint of its political and economic strength, buy or appropriate land or accept land donated by officials. As monks were exempt from taxation, many people became monks to evade paying taxes. By the reign of Daizong (763–79) in the Changan area 'most of the fertile land belonged to the monasteries and nunneries and the officials were powerless to do anything' (*Jiu Tangshu*, one of the official histories of the Tang). This situation posed a major threat to the national economy and people's livelihood and also incurred the hatred of the landlord class, as they saw their wealth and power threatened. These tensions erupted during the Huichang period (841–6) of the reign of Wuzong.

The Development of Daoism
Daoism, which claims a tradition back to the *Laozi* and *Zhuangzi*, texts of the Zhou dynasty, encompasses a whole range of beliefs and practices in its broadest definition, including a philosophy of life, a popular religion, alchemy, immortality cults and breathing exercises, but the definition many religious Daoists sought to propagate was a much narrower one, distinct from popular cults and involving the worship of anthropomorphic powers that somehow represented the ultimate *dao*. Religious Daoism appeared in a rudimentary form in the Eastern Han period, but by the Northern and Southern dynasties it had absorbed Confucian and Buddhist ideas and was widely propagated.

Louguan Terrace at the foot of Mt Zhangnan in Zhouzhi County near Xian was believed to be the place where Laozi, the accepted founder of Daoism, wrote *Laozi* (or *Daodejing*) and where the First Emperor and Emperor Wu of the Han paid tribute to celestial beings and built shrines in their memory. During the Yuankang period (AD 291–9) the Jin-dynasty emperor Hui had thousands of trees planted in this place and 300 families were moved there on his orders to protect them. Soon after his accession the Sui emperor Wen ordered major structural repairs.

The Tang ruling house had the same surname as Laozi, and thus claimed descent from him in order to add legitimacy to their rule. In 621, Emperor Gaozu, founder of the dynasty, went to Louguan

Terrace to pay tribute to the founder of Daoism, his ancestor. Between 618 and 625 he had the terrace completely rebuilt and renamed it Zongsheng (Sage Worship) Palace. Within the palace complex was Shoujing (Teaching the Scriptures) Tower and Laozi Temple. Gaozong conferred on Laozi the posthumous title of Supreme Emperor of the Profound Heaven. On the pretext that he had dreamt of meeting Laozi, Emperor Xuanzong had the philosopher's portrait painted for worship throughout the country.

Because of respect for Daoism, Tang laws stipulated that local officials were not authorized to punish Daoist priests or nuns who had committed a crime. Changan alone had thirty Daoist monasteries and six convents and there were temples to Laozi in Changan, Luoyang and all the prefectural towns. Two of Emperor Ruizong's daughters, Jin Xian and Yu Zhen, were initiated into Daoist religious life and had temples built in their names. During the reign of Emperor Xuanzong, Daoist classics became part of the syllabus of the imperial civil examinations and many Daoist priests gained the favour of the emperor.

Daoism as a religion was popular both among the people and with the intelligentsia in the Tang. The poet Li Bai styled himself as *Zhe Xian Ren* (immortal banished from heaven), and the essayist Han Yu died of elixir poisoning. Sun Simiao, a celebrated pharmacologist venerated by later generations as 'King of Medicine', was also a Daoist devotee. Competing with Buddhism for followers, the Daoists adopted the method of preaching on the streets (*su jiang*) and also allowed women to preach. It is recorded that 'Buddhist monasteries were empty, but horses and carts jammed the streets and listeners filled the Daoist temples to overflowing so that latecomers could not find seats or any place where they could listen'.

The exchange of ideas between these two religions continued throughout the Northern and Southern dynasties and the Tang, resulting in many similarities between them. The Chan (Zen) sect, a product of Chinese Buddhism, gained special favour among scholars, while Tantrism gradually became identified with Daoism. Confucianism had long been associated with the system of government and an accepted ideology of bureaucrats and officials. So, despite the conflicts in court between Buddhist and Daoist priests and Confucian officials, many of the literati of the period were eclectic in their beliefs and venerated all three systems at once. One example is that of the famous scholar Liu Zongyuan, who described himself as a 'travelling companion of Laozi, Confucius and Sakyamuni'.

The land within the passes continued to be an important centre of Daoism after the Tang. During the Song dynasty Louguan Terrace was renamed yet again as Shuntian Xingguo (Follow Heaven and Exalt the Country) Temple. In the early period of the Yuan dynasty it was rebuilt to cover an area of 2.3 square miles, with fifty halls and pavilions and 200 priests, being renamed Zongsheng Palace. In the Southern Song dynasty the Quanzhen (Complete Truth) sect of Daoism (which incorporated certain Confucian and Buddhist tenets) was established in this area. In their western expedition the Mongols enlisted the cooperation of the Quanzhen sect, and the Daoist priest Qiu Chuji, at Genghis Khan's order, visited central Asia and Persia. Daoism therefore won the favour of the Yuan-dynasty emperors, who conferred on Wang Zhe, founder of the Quanzhen sect, the posthumous title of Master Chongyang, and renamed his ancestral temple Chongyang Wanshou Palace. This palace, with its pavilioned buildings containing over 5,000 monks' cells and its thousands of priests, became the mecca for Chinese Daoists in the Yuan and was protected by 3,500 government troops.

The Many Religions of Changan
A number of religions, apart from Buddhism, were introduced to China from the west along the Silk Road.

Zoroastrianism, called xianjiao (religion of the god of fire), probably spread to China during the Northern Wei dynasty, but it gained popularity in Changan during the Tang, as more believers came from central Asia. A government office established to oversee Zoroastrian affairs appointed an official to manage each of the five Zoroastrian temples in the city. Relics recently excavated in Xian include an epitaph for the deceased wife of a man named Su Liang and another for the deceased chief of Mi (an ancient state located in the area of Uzbekistan), both of which relate to Zoroastrianism.

The practice of Manichaeanism, another religion from central Asia, was authorized in China in AD 694 during Empress Wu Zetian's reign. In 732 the Tang court issued an edict forbidding the Han Chinese people from following this religion, but other nationalities were allowed to continue their worship. In 786, on the strength of the influence of the Uighur people (Turks who lived in Xinjiang and Gansu Provinces), the Manichaeans secured imperial permission to build the Dayunguangming Temple in Changan, but the religion began to decline in popularity with the fall of the Uighurs in Wuzong's reign.

Nestorianism had been a branch of Christianity before it gained popularity in Persia. In AD 635 a Nestorian monk from Persia, known to the Chinese as Aluoben, built a temple at Yiningfang in Changan and initiated twenty-one monks. By Xuanzong's reign there were several Nestorian temples in Changan, Luoyang and various prefectures. A bilingual Tang stele in Syriac and Chinese was found in 1625 and is now in the Stele Forest Museum in Xian. It describes the spread of this religion and the support it won from the emperors; Nestorian monks from Persia even held official posts during the reign of Suzong.

Islam, still an important religion in China today, was probably introduced by Arabic merchants and naturalized soldiers following the Arab expansion westwards from the middle of the seventh century. However, they were not allowed to preach among the native population and it remains to be seen whether there were mosques in Changan in the Tang; the Grand Mosque on Huajue Lane in Xian today was built in the Song, then rebuilt first in the Yuan and later in the Ming, when it attained its present form; the mosque on Daxue Lane, purportedly first built in the Yuan dynasty, is somewhat similar to the Grand Mosque in style. The prayer halls, pavilions, pulpits and Imam halls in both mosques are laid out in accordance with Islamic rules; there are no graven images and the shrines all face Mecca. The resident Hui people, traditionally Muslims, have followed this religion for generations and attend the mosque regularly.

Lamanism, or Tibetan Buddhism, is prevalent mainly in Tibet and Inner Mongolia. The Guangren Temple in the north-west corner of Xian, the only lamasery in the city, was built in 1705 during the reign of the Qing emperor, Kang Xi, for lamas from north-west China to stay and perform religious services while *en route* to Beijing.

The openness of several of the Chinese dynasties to foreign religions encouraged all kinds of religious developments in China. The protracted mutual exchange between these various faiths enriched and expanded the spiritual world of Changan.

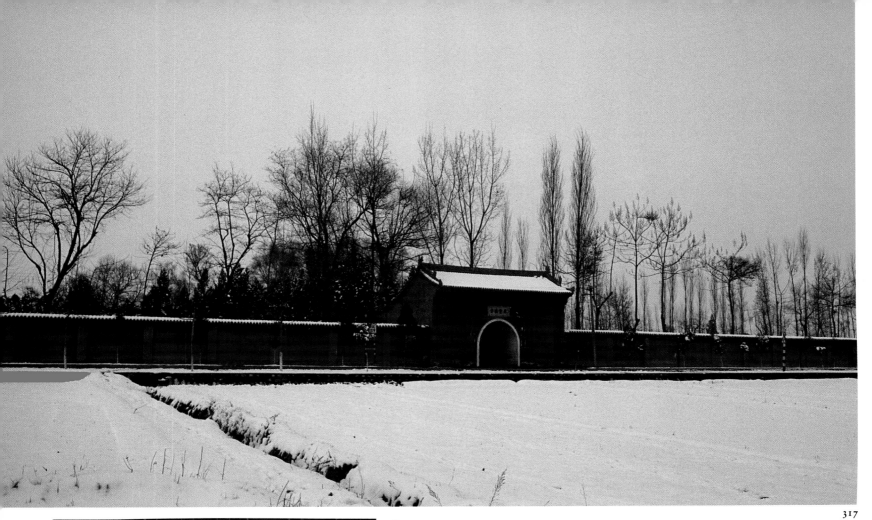

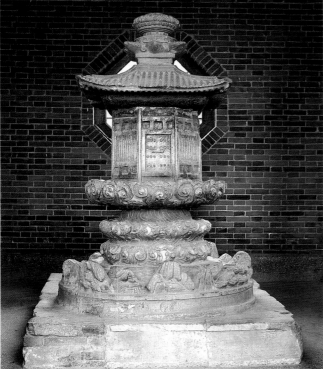

317. Caotang Temple

Located at the northern foothills of Guifeng Mountain, Caotang Temple was built on the site of the Xiaoyao Gardens of the Later Qin dynasty. After the Indian monk Kumarajiva came to China he lived there, translating the Buddhist scriptures and teaching the classics to 5,000 monks and priests from all parts of China.

318. Kumarajiva Stupa

Kumarajiva arrived in China in AD 401, following the repeated requests of emperors of the Later Qin dynasty. He translated ninety-seven scriptures, some of which consisted of over 400 volumes – the first large quantity of foreign work translated into Chinese. After he died in 413 he was buried in an octagonal, twelve-layer marble stupa, eight feet high. The stupa, covered with relief carvings of clouds and vines, rests on a pedestal representing Mt Sumera.

319. Yanwu Well in Caotang Temple

The name of this well, Yanwu, means 'misty' and according to legend it was so called because a mist would rise every autumn and winter morning and drift towards Changan, making the well one of the eight scenic wonders of the land within the passes.

320. Famen Temple Pagoda

Famen Temple, in Fufeng County, is famous for housing true relics of the Buddha. It was founded in the Eastern Han dynasty as Asoka Temple, renamed Chengshi Shrine in the Sui and was given its present name in the Tang. From the Northern Wei through to the Sui and Tang it was a holy place to visit. The pagoda in the temple was originally a four-tier wooden structure, but this collapsed in the Ming and was rebuilt into a thirteen-tier octagonal pagoda made of brick. In 1981 torrential rain destroyed the west half of the pagoda. When it was being reconstructed in 1987 an underground chamber was discovered, the largest of its kind ever found. The artefacts in it were buried in 874, during the Tang dynasty, and include four objects, alleged to be finger bones, the 'true relics' of the Buddha, objects for the reception and send-off of these relics, 121 gold and silver articles, 17 glazed vessels, 16 porcelain objects, 12 stone artefacts, 19 lacquer, wooden and miscellaneous pieces, 400 pieces of jewellery and a large quantity of silk. Most of the gold and silver articles were donated by the Tang emperors Yizong and Xizong. This discovery is the most important archaeological find after Banpo and the terracotta army. Six of the artefacts found in the palace are pictured overleaf.

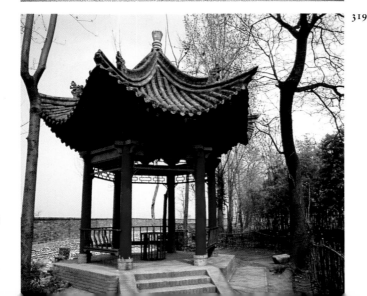

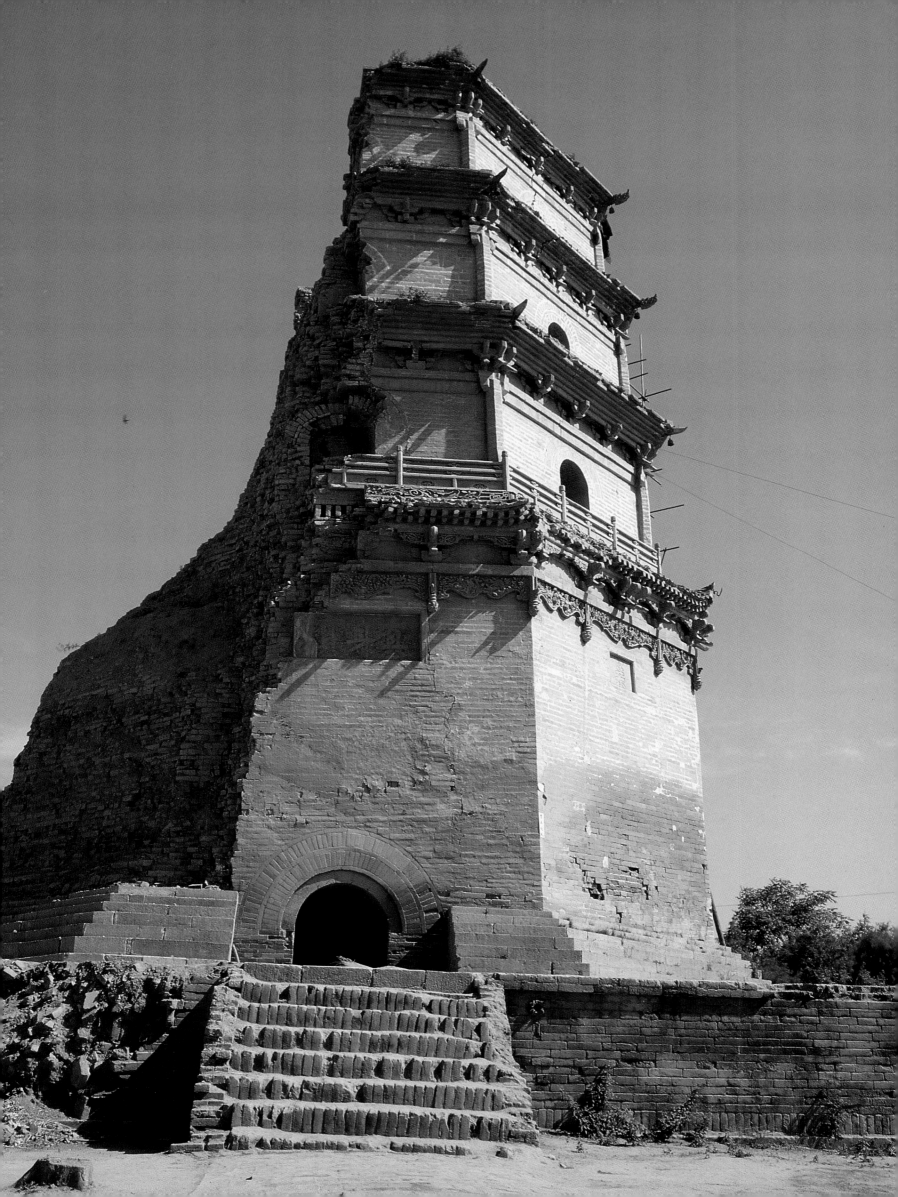

321

321. Cushion cover embroidered with gold thread on red silk gauze with a flower design

322. Pale yellow glass vase

323. Octagonal *mise* glazed vase
In historical records a certain sort of glazed porcelain is mentioned which was: 'blue as the sky, bright as a mirror, thin as paper and resonant as glass', and was for the exclusive use of the imperial household. This has been called *mise*, or 'secret' porcelain because no examples of it had been found. However, this vase and other pieces discovered at Famen Temple are now thought to be *mise* porcelain.

324. Gilded five-legged silver incense-burner

325. Painted stupa

326. Gilded silver tortoise box

322

323

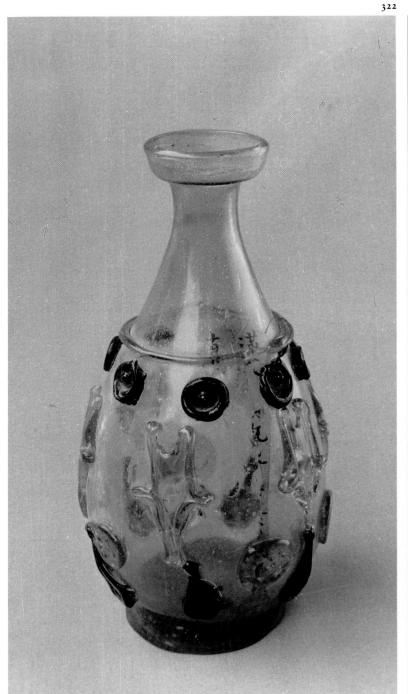

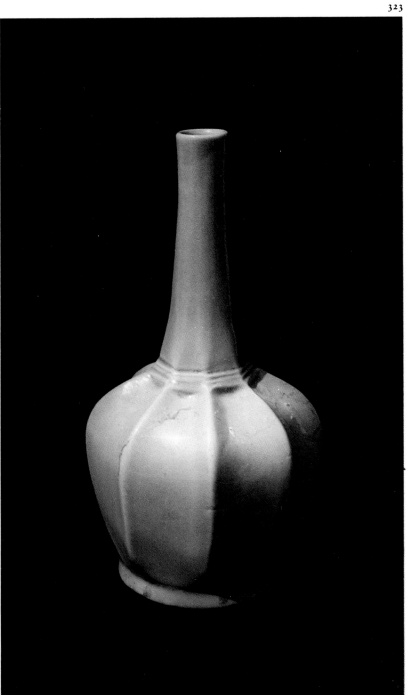

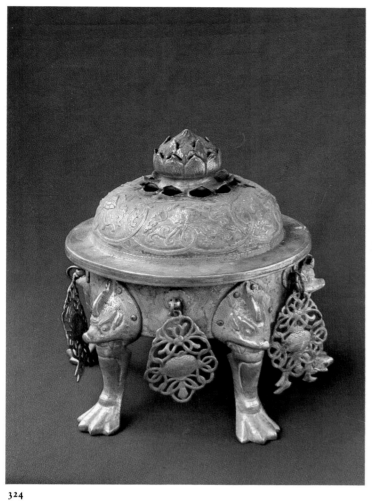

324

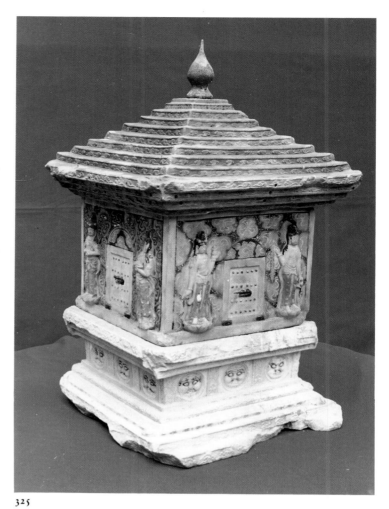

325

326

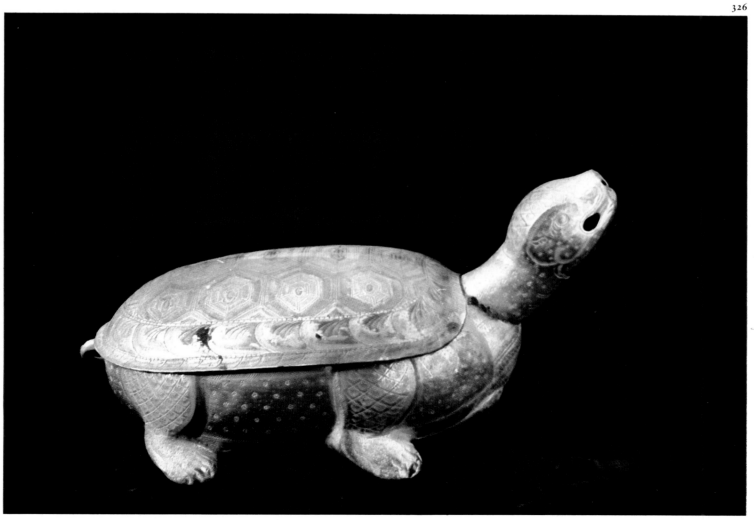

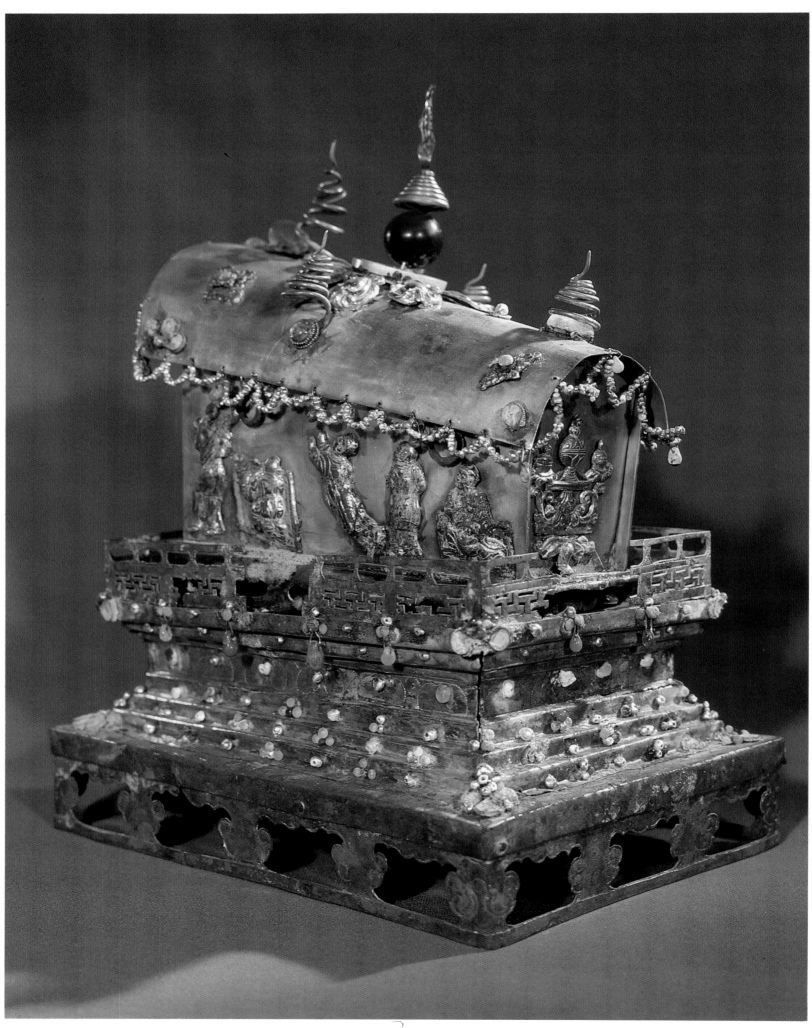

327

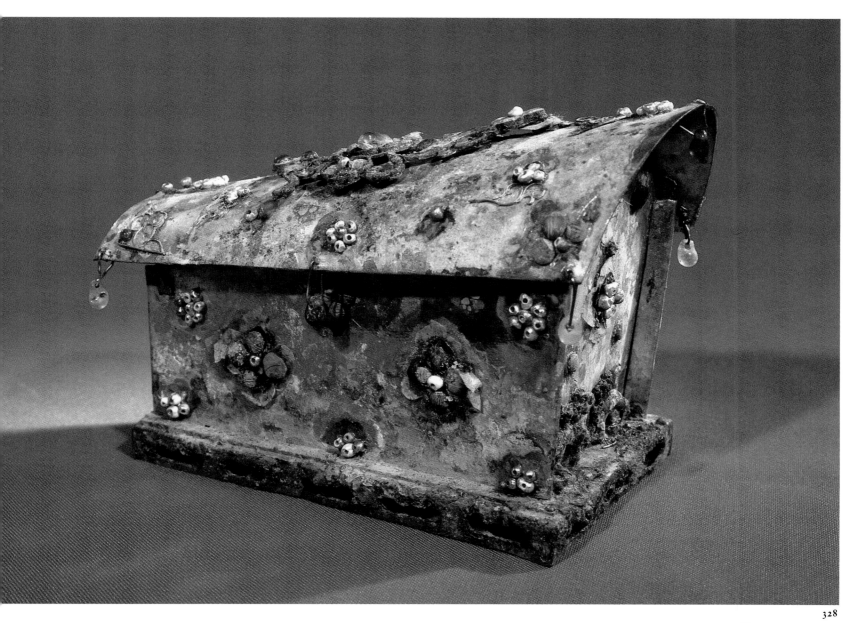

328

327. Silver outer coffin from Qingshan Temple

In 1985 a set of coffins containing Buddhist relics and 120 artefacts were found at the site of Tang-dynasty Qingshan Temple, 2.5 miles north-east of the First Emperor's mausoleum. The silver outer coffin and gold inner coffin reflect the sophisticated artistry of the high Tang period.

328. Gold inner coffin from Qingshan Temple

This pure gold coffin, 5.5 by 4 inches, with a rectangular stand and an arc-shaped cover, is decorated on all sides with gold-plated rosettes, pearl-like flowers and other motifs.

329. Ornaments from the gold coffin

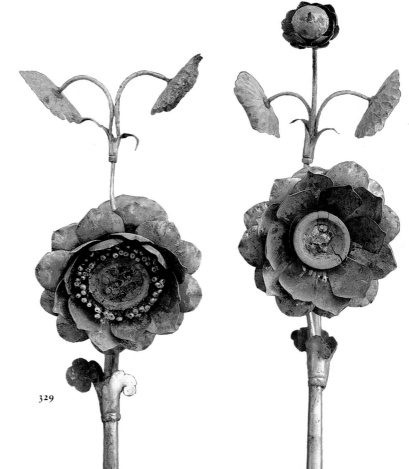

329

203

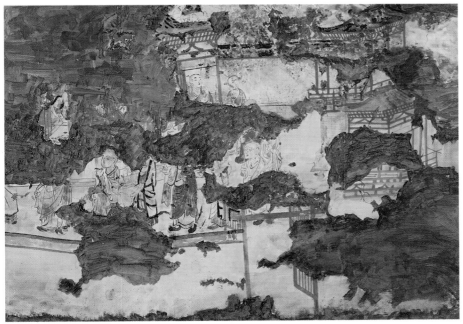

330

**330. *Buddhist Monks and Priests
– a mural in Li Shou's Tomb***
Li Shou, brother-in-law to the
founder of the Tang dynasty,
Gaozu, was given a posthumous
title in recognition of his military
prowess in the war for the founding
of the dynasty; he is buried in
Sanyuan County. His tomb has
been extensively robbed and is in
poor condition.

331. Xingjiao Temple
Xingjiao Temple, on Shaoling
Plateau twelve miles south of Xian,
was one of the eight famous temples
of Fanchuan in the Tang dynasty;
the Huayan Sect of Buddhism is
said to have originated here. The
temple stands facing Shenhe Plateau
to the west and Zhongnan Mountain
to the south in an area noted for its
scenic beauty.

331

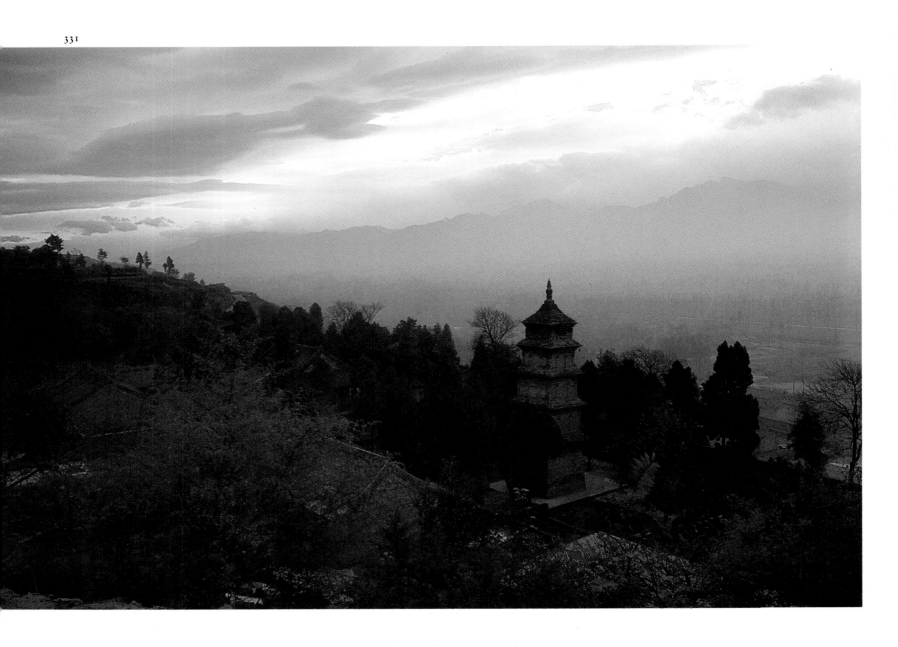

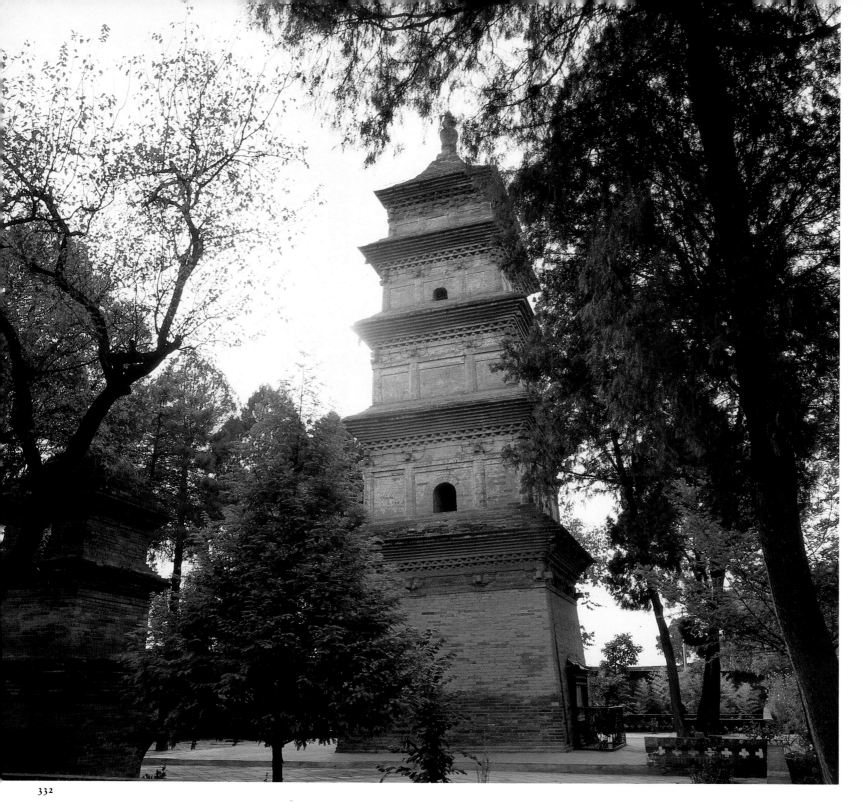

332

332. The stupa of Xuan Zang in Xingjiao Temple
When Xuan Zang, the famous Tang monk, died in 664 he was buried on Bailu Plateau, but in 669 his remains were moved to Xingjiao Temple. This stupa is the oldest surviving wood and brick stupa in China. It is flanked by the stupas of his disciples Gui Ji and Yuan Ce.

333. Main gate of Xingjiao Temple

333

334

334. Repository of the Buddhist classics at Xingjiao Temple
This repository, accommodating many roughly bound copies of ancient Buddhist scriptures and several thousand photostat copies of the Buddhist classics, is in the eastern inner courtyard at Xingjiao Temple.

335. Gilt Buddha

336. Rubbing of the carving on the door lintel of the Greater Wild Goose Pagoda
The lintel over the west door of the Greater Wild Goose Pagoda is decorated with exquisite carvings of Buddhist images, purportedly after sketches done by the famous painters Yan Liben and Yuchi Yi. They provide valuable material for research into Buddhist temple architecture of this period.

337. Tablet to Xuan Zang
This tablet is located in the east niche of the south door at the Greater Wild Goose Pagoda. It bears an introduction to the translations of Xuan Zang, composed in AD 648 by the Tang-dynasty emperor Taizong and written in the handwriting of the famous calligrapher Chu Suiliang. It is still in good condition; the characters are legible and the design of interlaced hydras and vines between intaglio carvings of celestials, dancers and musicians is clear.

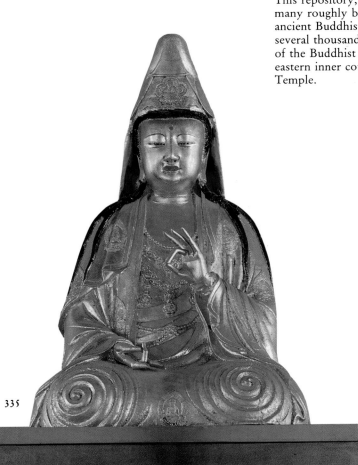

335

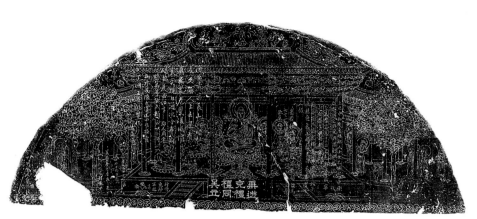

336

337

338. Greater Wild Goose Pagoda
This pagoda to the south of Xian was first erected with five storeys during the reign of Gaozu to house the Buddhist scriptures brought back from India by Xuan Zang. Five more storeys were added in the reign of Empress Wu Zetian, but only seven now survive. The pagoda is made of brick and wood and shows the influence of Indian Buddhist architecture.

339. Lesser Wild Goose Pagoda
(*overleaf*)
This pagoda was built in AD 707. It has fifteen storeys which get narrower and narrower, but it is not as tall as the Greater Wild Goose Pagoda. It is part of Dajianfu Temple, where Yi Jing carried out his translation work.

338

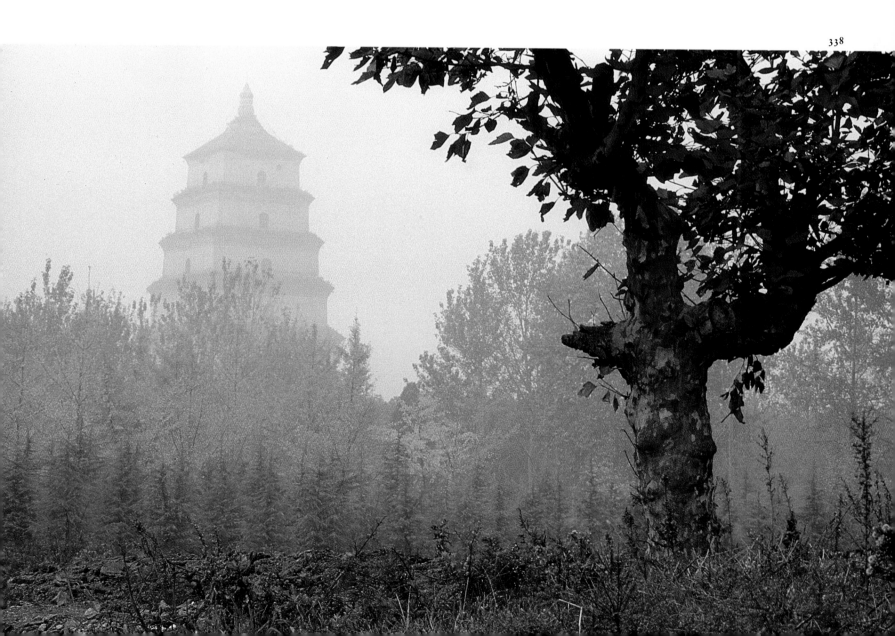

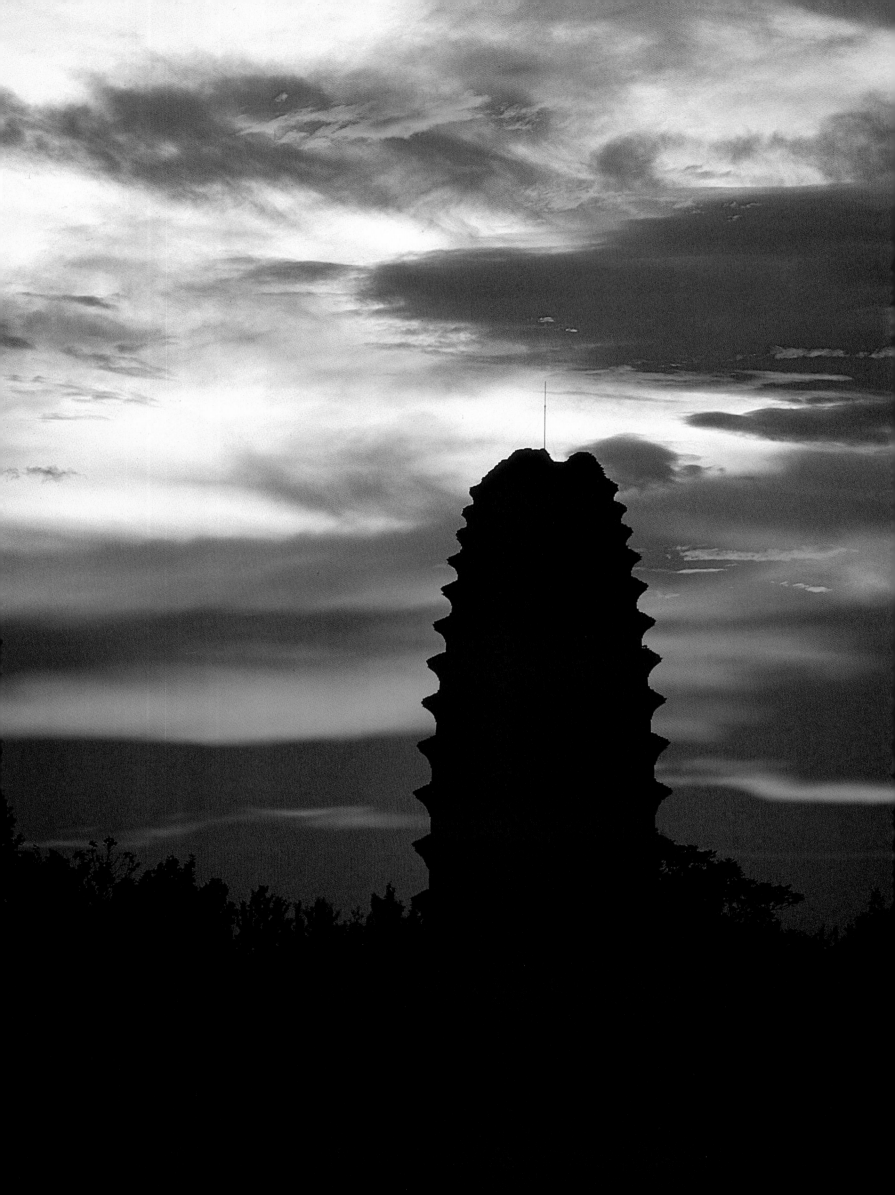

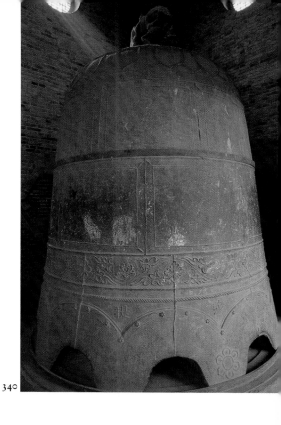

340. Iron bell in Dajianfu Temple

This 22,000-pound iron bell, which hangs in a tower next to the Lesser Wild Goose Pagoda, was cast in 1192 during the Jin dynasty. 'The Resonant Morning Bell Tolls at the Wild Goose Pagoda' was one of the eight sights of the land within the passes.

341. Xiangji Temple Pagoda

Xiangji Temple, purportedly the birthplace of the Pure Land sect of Chinese Buddhism, used to stand on Shenhe Plateau south-west of Changan County. Only the wood and brick pagoda, 108 feet high and dedicated to the monk Shan Dao, has survived the centuries.

341

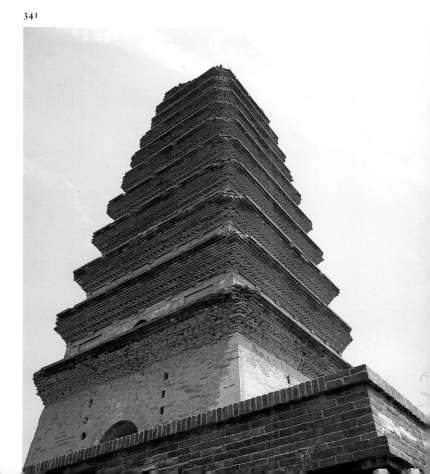

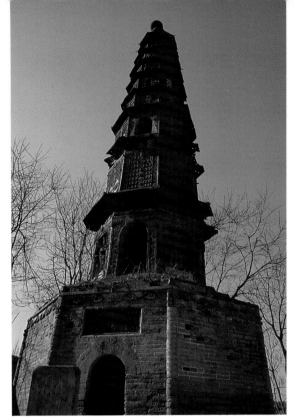

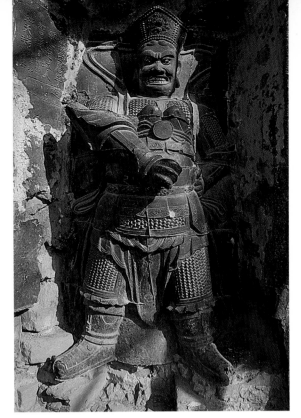

342 343

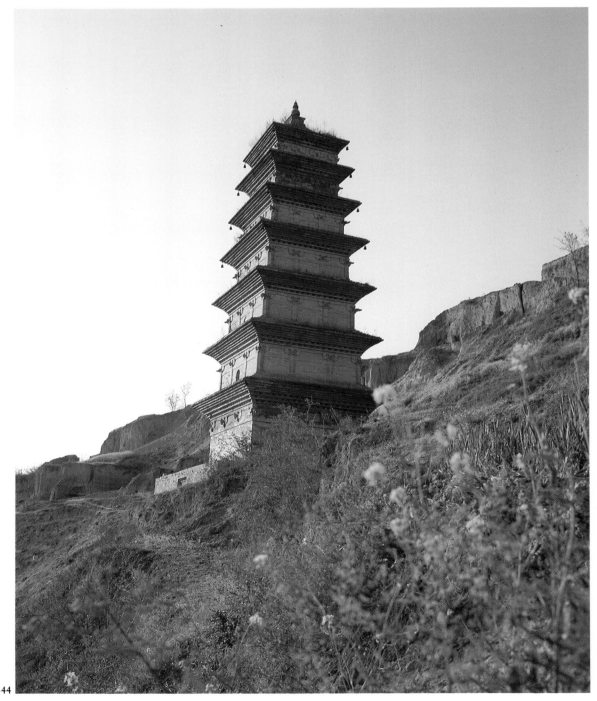

342. Thousand Buddha Iron Pagoda at Xianyang
This ten-storey pagoda made entirely from iron has windows on each storey, with corner pillars cast in the image of vajras. The outside is decorated with numerous iron statues of Buddha.

343. The king of heaven at the Iron Pagoda

344. Du Shun Stupa in Huayan Temple
Huayan Temple was built in AD 803 on Shaoling Plateau south-east of Weiqu, and was the birthplace of the Huayan sect of Chinese Buddhism. Only the stupa, which houses the bones of Du Shun, founder of this sect, now remains of the temple.

344

345

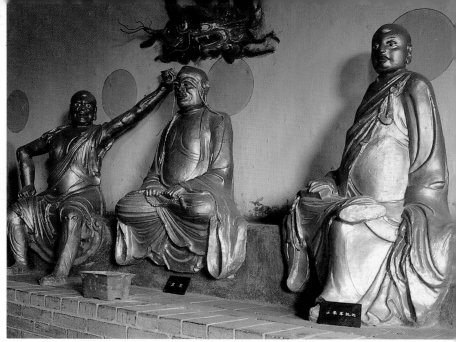

346

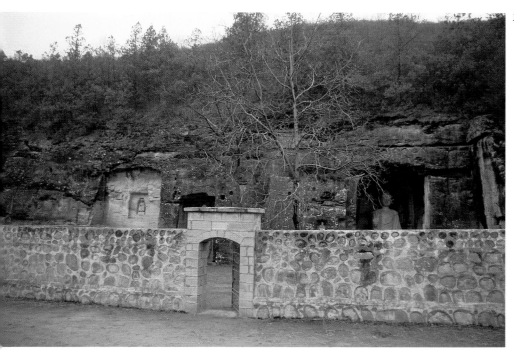

347

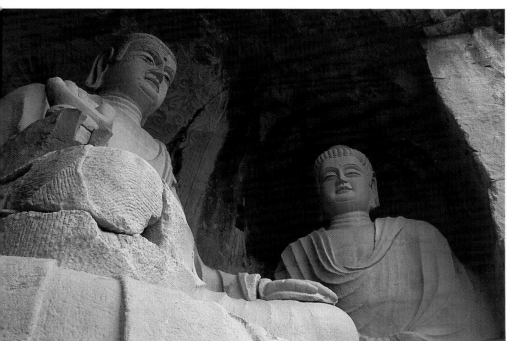

348

345. Daxingshan Temple
This was one of the three centres in Tang-dynasty Changan where Buddhist classics were translated, and it was also the birthplace of the Esoteric sect of Chinese Buddhism. The Indian monks Subhakrasimha, Vajrabodhi and Amoghavajra all preached here and it was also where Amoghavajra completed the translation of 500 volumes of classics of the Esoteric sect.

346. Arhats in Daxingshan Temple

347. Cishan Temple

348. Stone Buddhist statues in Cishan Temple
These statues in Cishan Temple grotto probably date to AD 653.

211

349. Qinglong Temple

This was the main centre of Esoteric ritual during the Tang dynasty and it was where six Japanese monks, later famous with two more of their countrymen as 'the eight Japanese monks of the Tang empire', received the Dharma. One of them, Kūkai, later returned to Japan where he became the founder of Eastern or Japanese Esoterism.

350. Shuilu Convent

This is situated in Lantian County. It was originally part of Beiputuolanzhu Convent, and is famous for its wall sculptures.

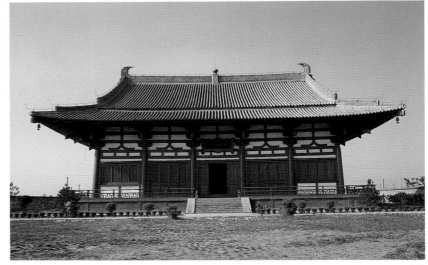

349

350

**351. Clay bodhisattva at Shuilu
Convent**

**352. Wall sculptures at Shuilu
Convent** (*overleaf*)
The clay statues on the wall of this
hall are allegedly the work of the
celebrated Tang sculptor Yang
Hizhi. They tell the life story of
Sakyamuni, the Buddha.

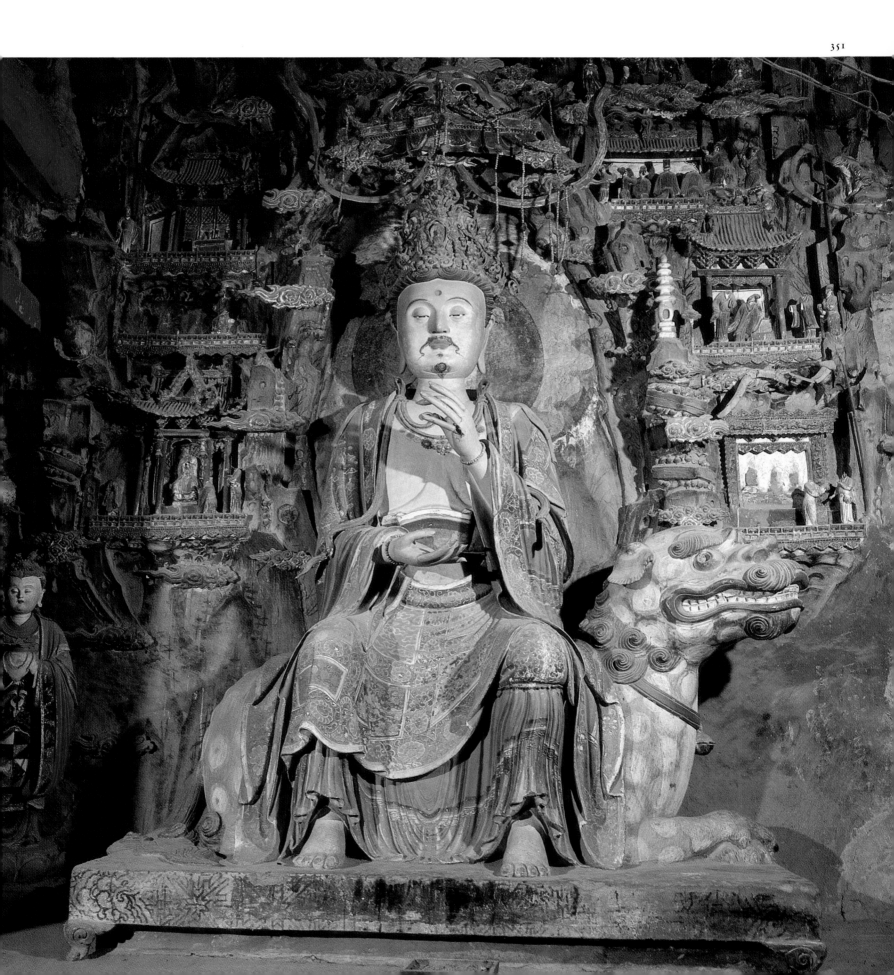

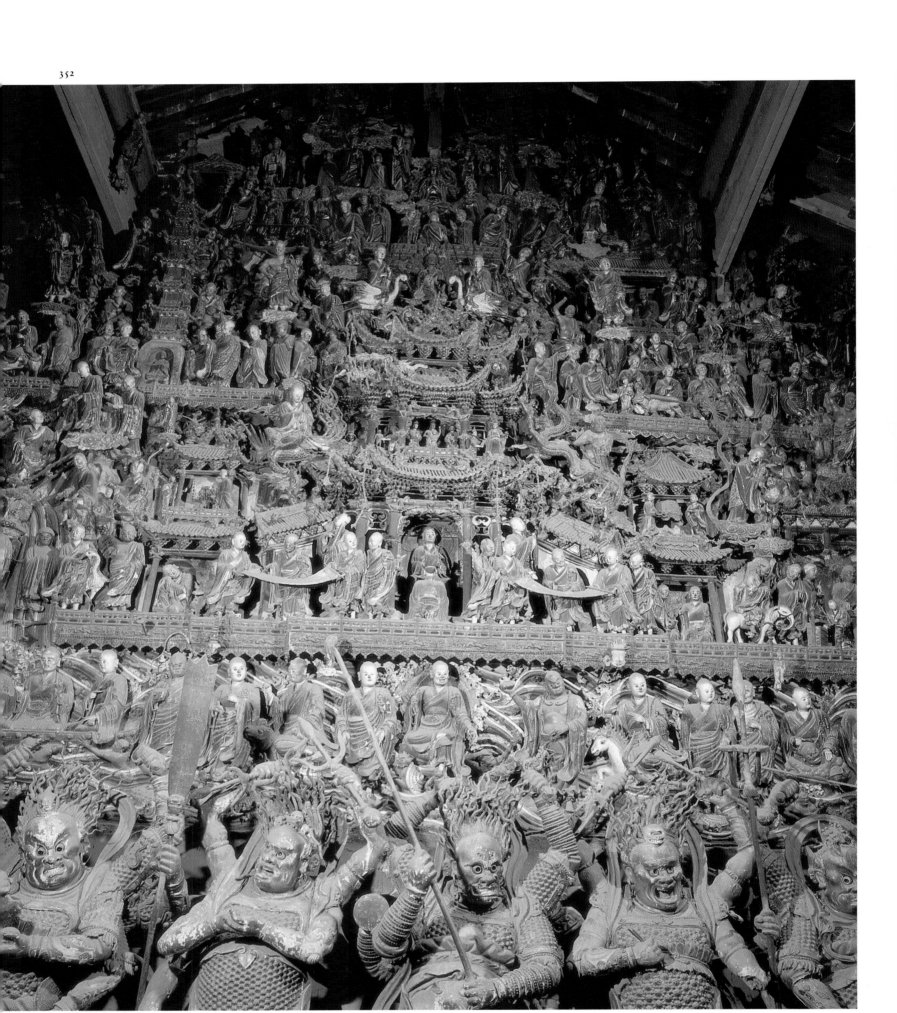

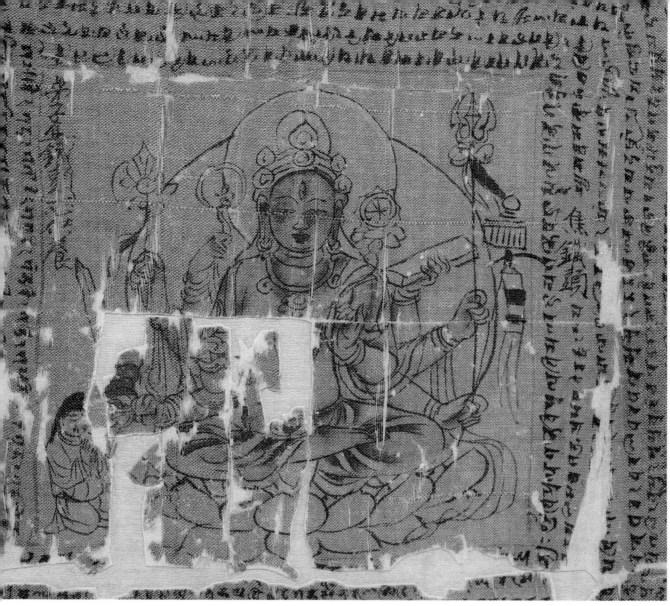

渥唐善
如廳妙
得
妙色
身

353

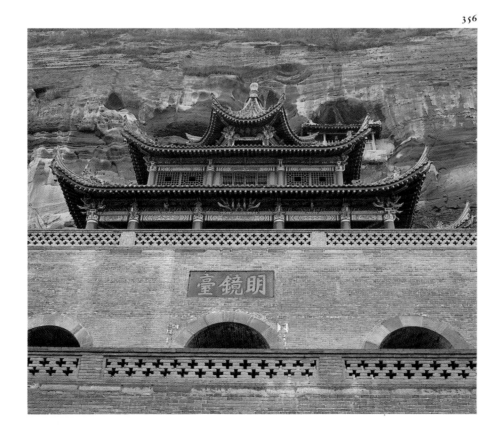

356

明鏡臺

353. *Dharani Sutra*
This painting on a ten-inch square of silk was found in 1983 in a Tang tomb in the western suburbs of Xian. The Sanskrit text of the Dharani Sutra is handwritten around the edges, framing a painting of a bodhisattva with the 'third eye'. He is holding various ritual and symbolic objects in his eight hands. To the upper left of the figure is a line of Chinese characters and to the lower left a layman praying to him. This is considered to be a masterpiece among the few Tang-dynasty silk-paintings still extant in China.

354, 355. Clay rubbings of Shanye

356. Dafu Temple
This temple was built in 628 on a hillside on the south bank of the Jing River, six miles west of Binxian and a few hundred feet from the course of the ancient Silk Road. It derives its name – *Dafu* means Great Buddha – from a huge statue of Buddha in the temple.

215

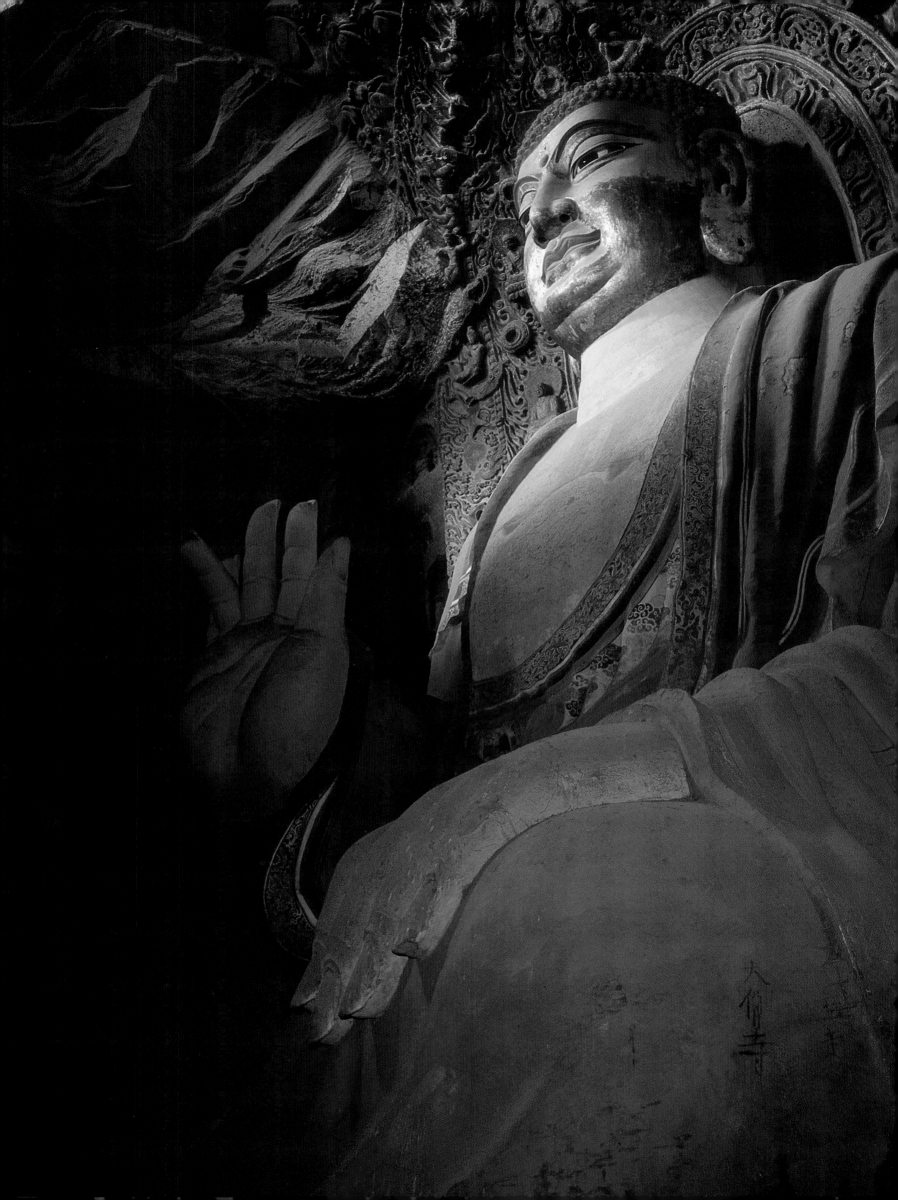

357. The Great Buddha at Dafu Temple

This statue, at seventy-nine feet, is the largest of its kind in Shaanxi Province. He is sitting cross-legged on a lotus throne, a robe draped over his shoulders, his chest bare, left hand on his knee and right arm raised with the hand turned outward and fingers slightly arched, the Buddhist sign for *abhaya* – 'assurance from fear'.

358. Attendant bodhisattva

This statue of a bodhisattva attending the Buddha is sixteen feet high, dressed in fine attire and a gemmed crown.

359. Thousand Buddha niche in Dafu Temple

Some of these niches contain three-dimensional statues of bodhisattvas and Buddhas, while most of them hold relief sculptures.

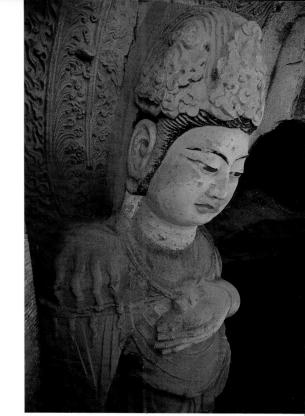

358

359

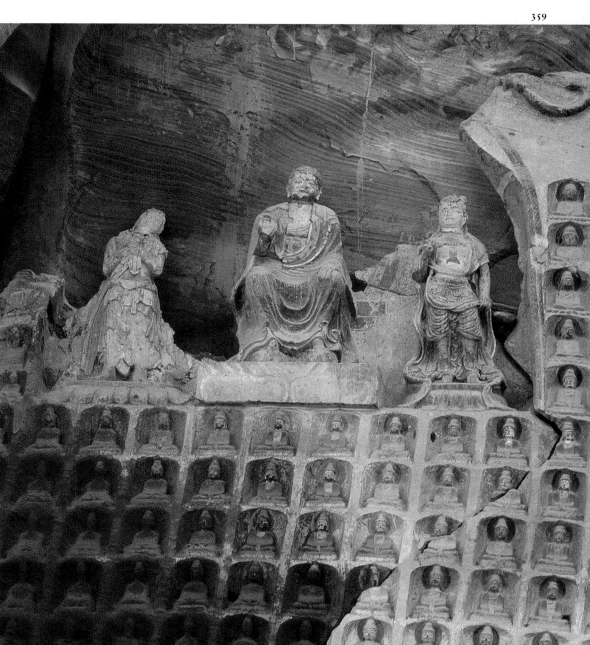

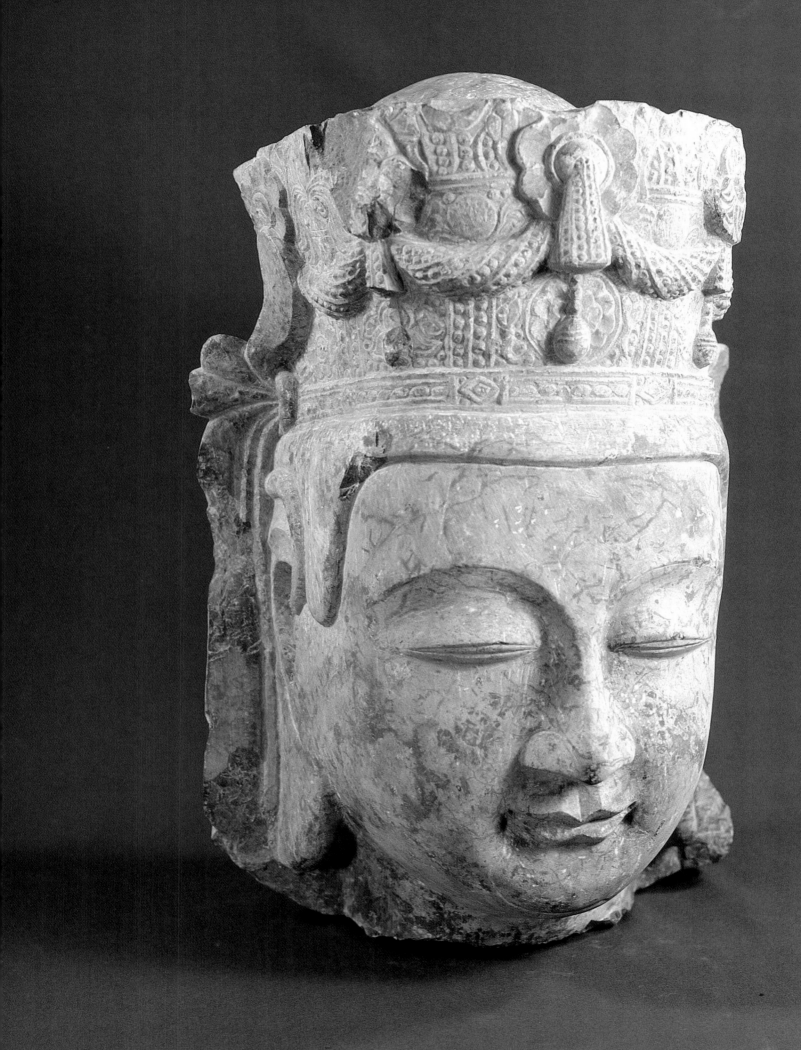

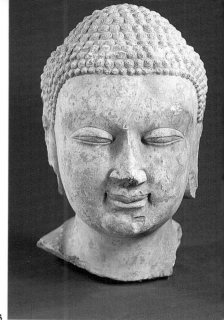

◁ 360

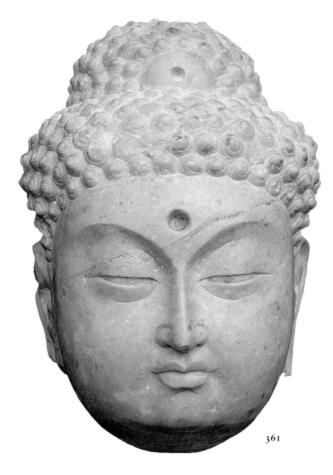

361

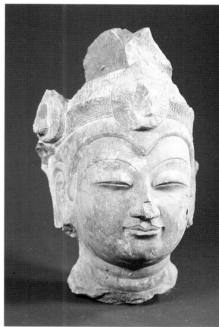

364

360–365. Heads of stone Buddhist statues

In 1983 thirty-two stone heads were discovered on the former site of Leshan Convent in the western suburbs of Xian. The rest of the statues were probably destroyed in the Buddhist persecution of 845, during the reign of Wuzong.

363

365

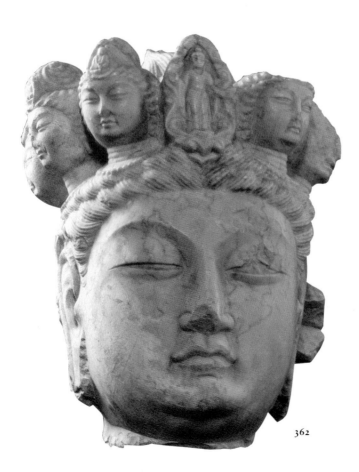

362

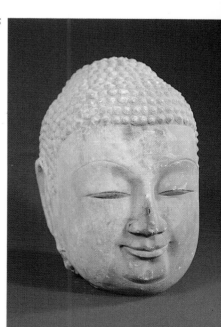

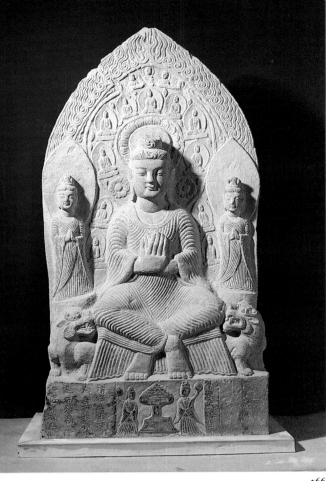

366

366. Statue of Matreiya Buddha with the donors
This statue of Matreiya Buddha, the future Buddha, is forty-three inches high. Two lions crouch before him, and on the base below is a relief sculpture of the statue's donors, Liu Baosheng and his wife.

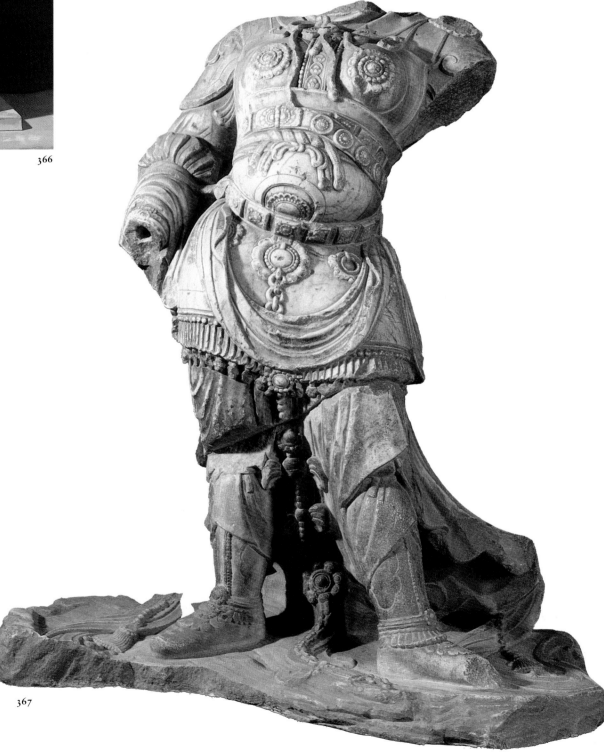

367

367. Statue of a warrior
This heavily ornamented warrior, although damaged, retains his strength and confidence. The statue is a realistic work, 3 feet 8 inches tall.

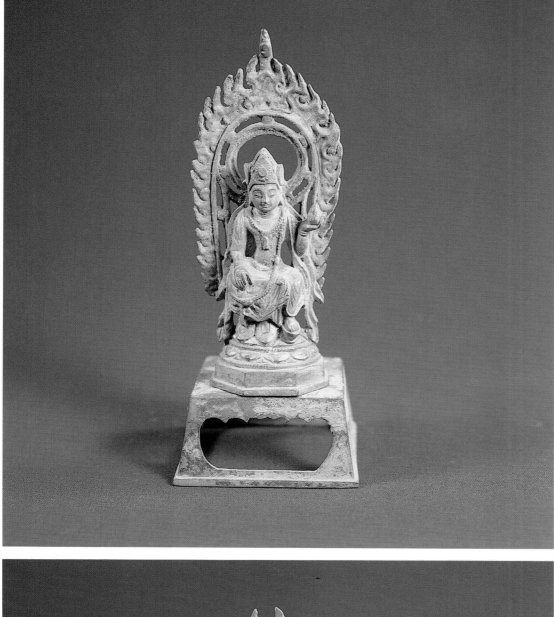

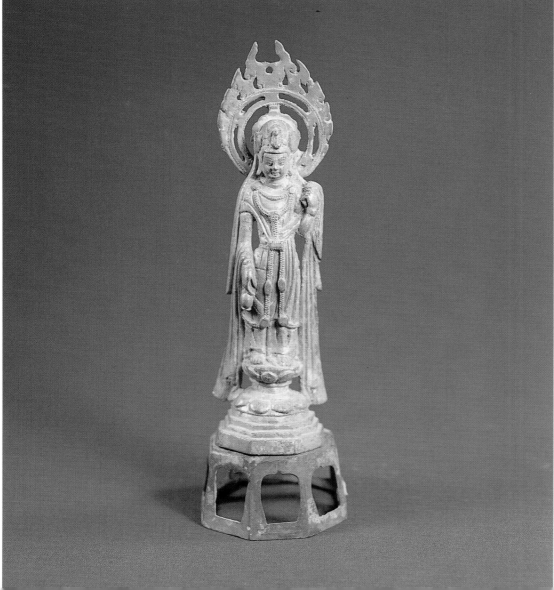

368, 369. Gilded Buddhist images

370. Gilded Buddhist group
This group of Buddhist figures, sixteen inches high, shows Amitabha Buddha sitting cross-legged on the lotus seat, attended by four bodhisattvas and warriors. A pair of lions sits below the stand. The gilded statues were all cast separately and secured to the stand so that they can be detached. On the back and right side of the stand is a lengthy eulogy dating to 592 in the Sui dynasty.

371. Amitabha Buddha (*detail of Plate 370*)

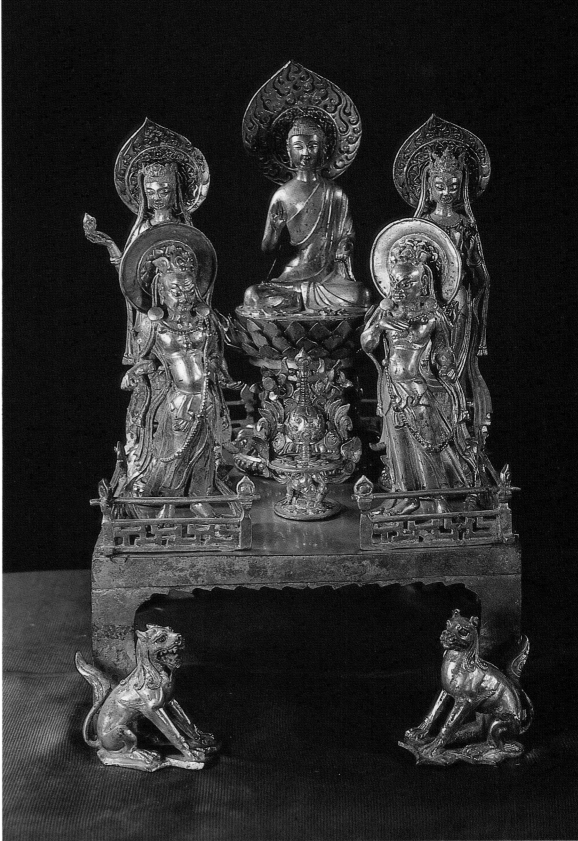

370

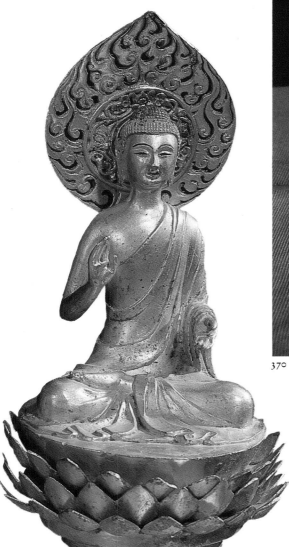

371

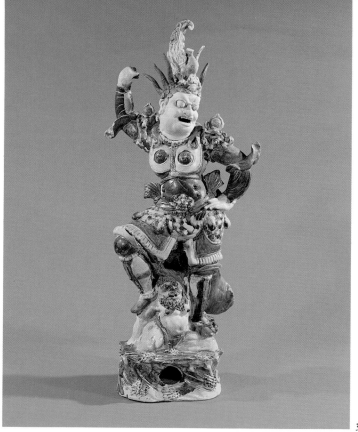

372

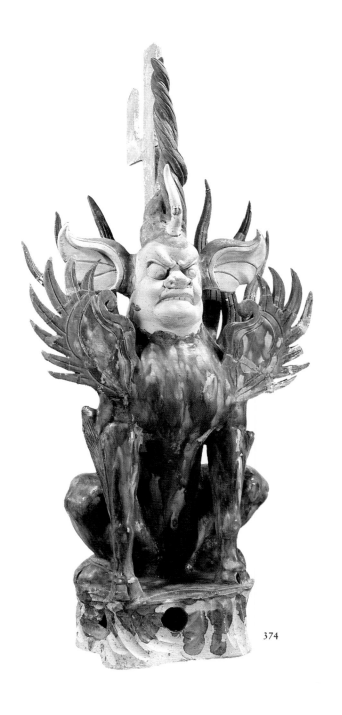

374

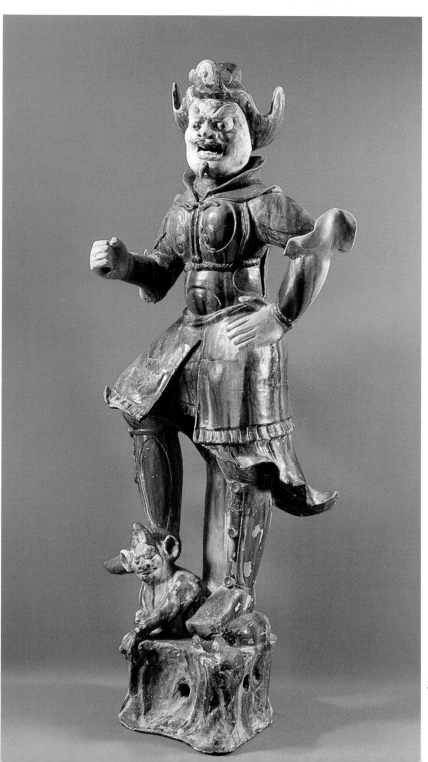

373

372. Tri-colour glazed pottery statue of a heavenly king
Figures of the four heavenly kings guarded the entrances to most Buddhist temples. This one, twenty-six inches tall, was found in 1959 in Zhongbaocun, near Xian. He is clad in armour and a strange headgear, and is trampling a devil underfoot.

373. Tri-colour glazed pottery statue of a heavenly king

374. Tri-colour glazed pottery statue of a tomb-guarding beast
Tomb-guarding beasts were used in burials of the more wealthy people to drive away evil and protect the deceased. This blue-and-brown beast of the Tang dynasty has a human face and an animal body.

223

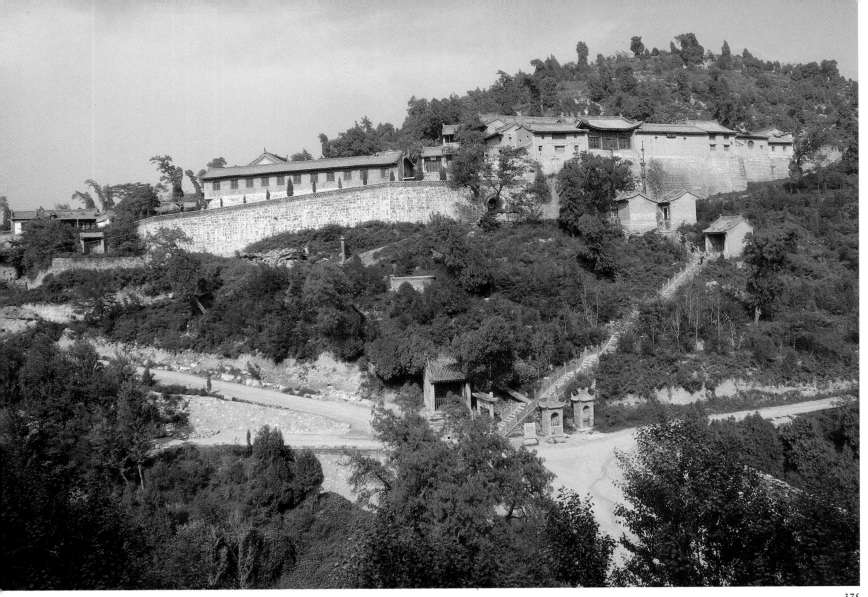

375

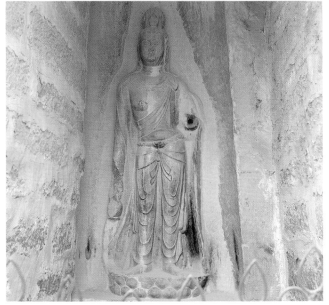

376

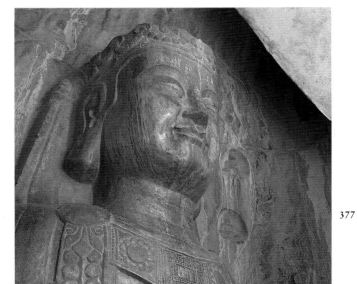

375. Yaowang Mountain
This five-peaked mountain with gentle slopes rises 3,281 feet above sea-level in Yaoxian. It has long been a holy place for both Buddhists and Daoists and the slopes are studded with temples and historic relics.

376. Bodhisattva on Yaowang Mountain
The mountain has seven niches carved in the Sui and Tang dynasties containing over forty Buddhist images. This relief statue in Niche No. 3 is two feet high and shows a bodhisattva in clinging robes with his left arm raised.

377. Maitreya Buddha on Yaowang Mountain
This seated Maitreya, or future Buddha, in Niche No. 2 is over ten feet high.

378. Nanwutai Mountain
Nanwutai Mountain, nineteen miles south of Xian, has five peaks; its name means 'the southern five peaks'. It is another ancient centre of temples and monasteries. Of the several hundred temple buildings constructed here between the Sui and Tang dynasties, only Shengshou Temple Pagoda remains. This is the oldest pagoda in Xian, dating from the Sui dynasty. It has seven storeys and four doors and is similar to the Greater Wild Goose Pagoda in structure.

377

 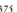

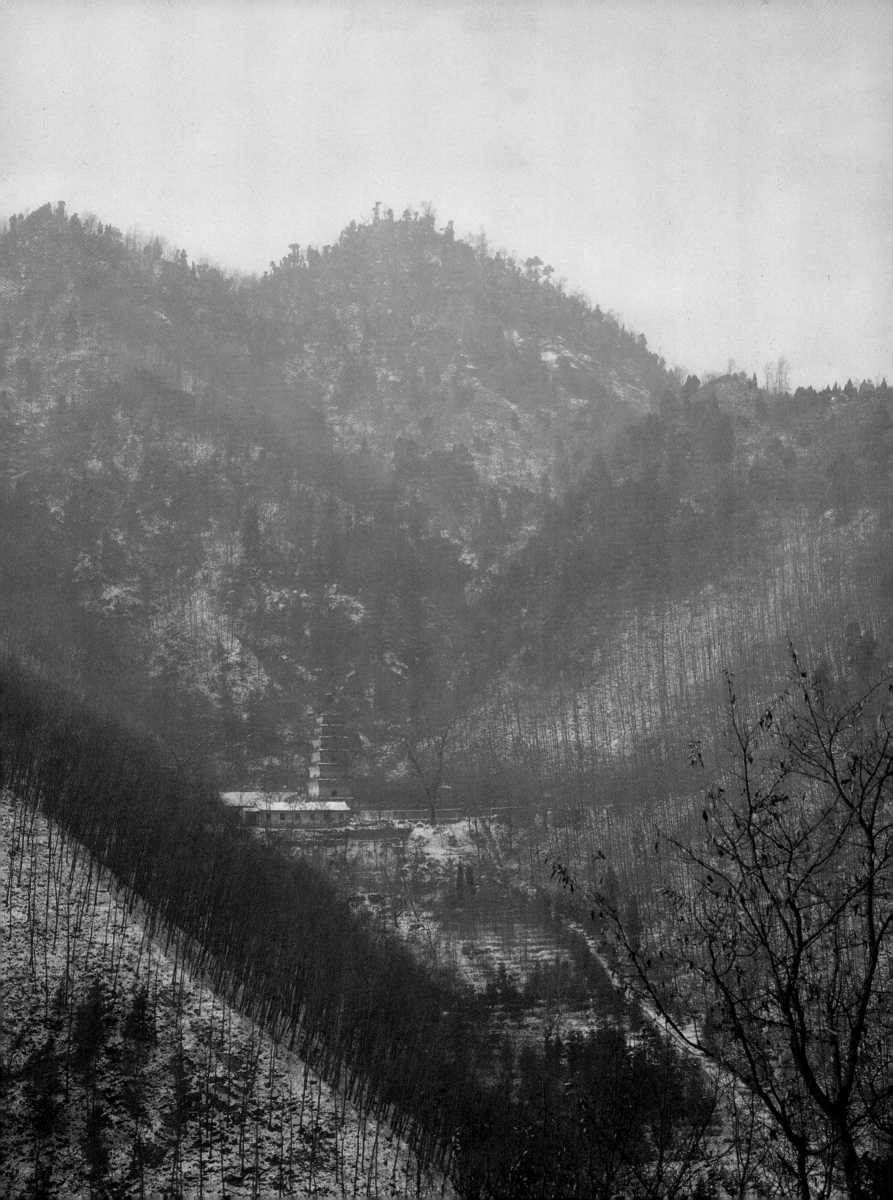

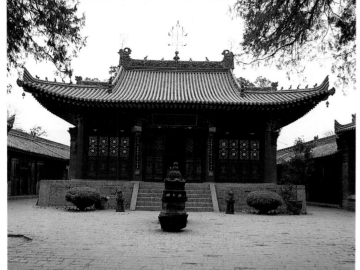

379

380

379. Shoujing Tower
This is one of the buildings comprising Louguan Terrace in the northern foothills of Zhongnan Mountain, south of Xian. Louguan Terrace is said to have first been built in the Zhou dynasty, 3,000 years ago, then rebuilt and enlarged down the centuries. After the Han dynasty it became a sacred place for Daoists, since it was claimed that Laozi, founder of Daoism, wrote the *Laozi* here and built Shoujing Tower to teach Daoist classics to his pupils; *shoujing* means 'scripture teaching'.

380. Ancient tree in Zongsheng Palace
Zongsheng Palace was the main building at Louguan Terrace and was built by Emperor Gaozu, founder of the Tang dynasty, to honour the memory of Laozi. Laozi's real name was Li Er, and the Tang-dynasty rulers, who shared the surname Li, claimed descent from him. Only a few gingko and cypress trees – supposedly planted in the Han dynasty – remain.

381. Daqin Temple Pagoda at Louguan Terrace

381

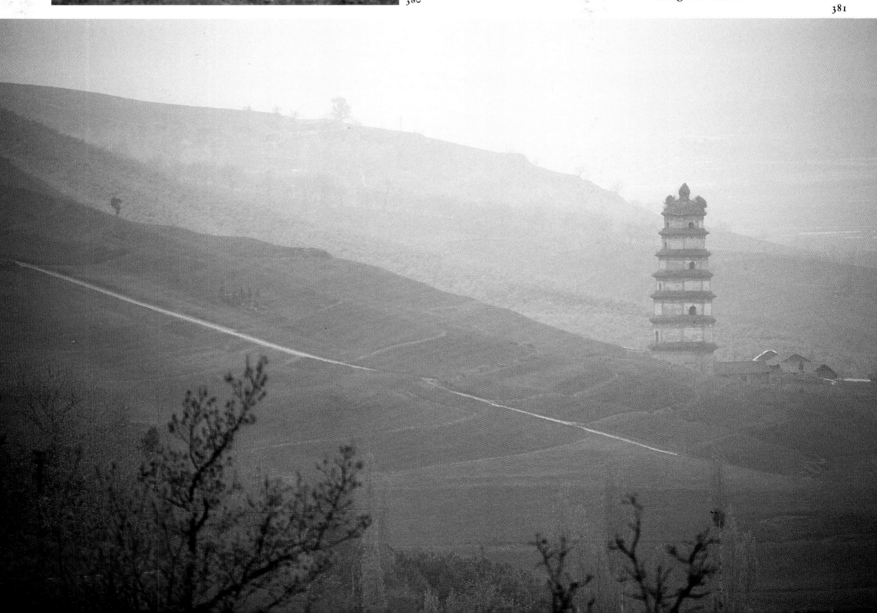

382

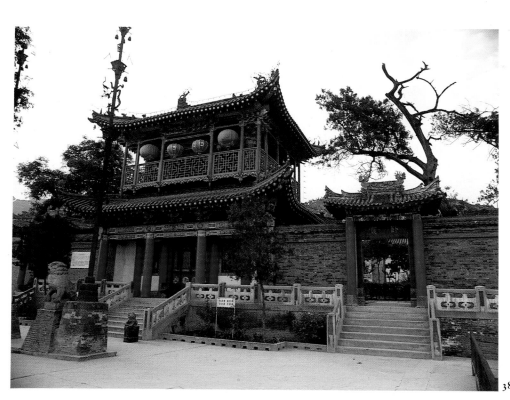

383

382. Eight Immortals Convent
This Daoist temple, the largest of its kind in Xian and purportedly built in the Song dynasty, is located at the site of the Tang-dynasty Xingqing Palace, at Changlefang in Xian.

383. Jintai Temple
This Daoist temple north of Baoji County is where the Ming-dynasty Daoist priest, Zhang Sanfeng, lived.

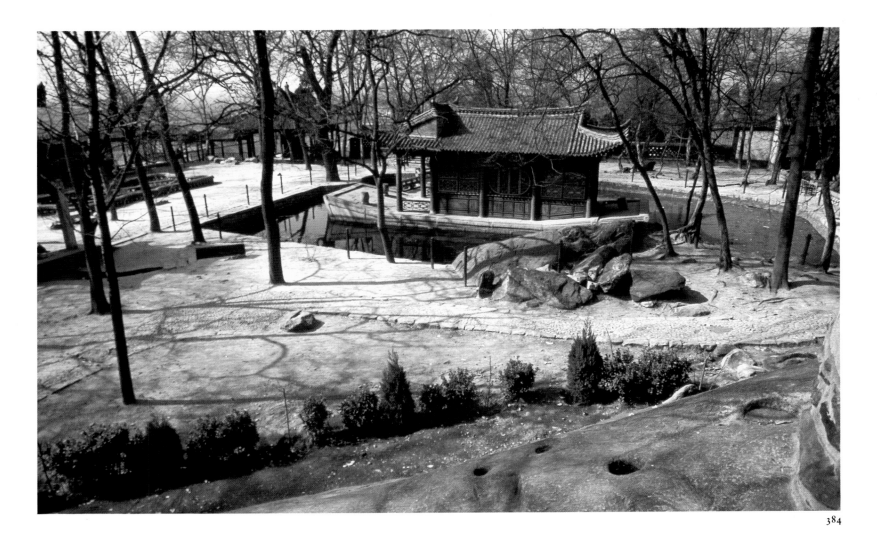

384. Yuquan Temple on Mt Hua
Mt Hua is another sacred place for Daoists. This temple, half-way up the mountain, was allegedly built by the hermit Chen Bo between 1049 and 1054, during the Song dynasty. There is a clear spring in the temple, hence the name, *yuquan*, which means 'jade spring'.

385. Epitaph on the tomb of Lady Ma
This epitaph, discovered in the western suburbs of Xian in 1955, is written in both Pahklavi and Chinese, dated by the Zoroastrian calendar and gives a blessing in the name of the good spirit of Zoroastrianism.

386. Stele recording the spread of Nestorianism to China
This stele was erected in Daqin Temple in 781, during the Tang dynasty. It records the spread of Nestorianism, its doctrine and rites, from Rome (called Daqin in ancient China) to China. It also bears an inscription in ancient Syrian of the names of seventy Nestorian priests. The stele was discovered in 1625 and moved to the Stele Forest Museum in Xian in 1907.

**387. The Drum Tower of the
Grand Mosque**

**388. Shengxin Pavilion in the
Grand Mosque**
The Grand Mosque on Huajue Lane
in the centre of Xian was built in
the Song dynasty and rebuilt in the
Ming in 1392. It is divided into four
sections covering a total area of
23,520 square yards, consisting of
pavilions, towers and halls. This
building in the third courtyard,
called Shengxin or Bangke Pavilion,
is where believers are called to the
main hall for prayer. The mosque is
still in daily use.

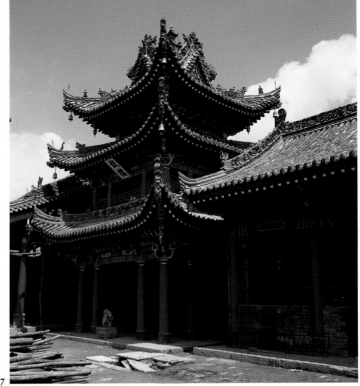

387

388

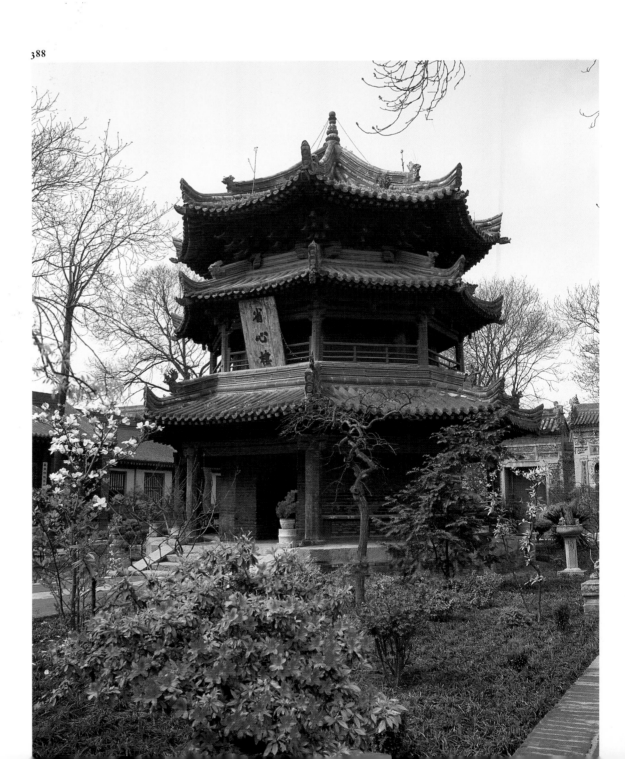

8.

A Gallery of
Oriental Art

Early Pottery

The painted pottery vessels of Banpo and Jiangzhai make up only a small percentage of the pottery vessels found (the majority are plain and intended for everyday use). The painted vessels are made of fine earthenware painted with black slip, burnished and baked. They vary in both shape and design, the designs falling into three categories: naturalistic, abstract and geometric. Deer, birds, frogs and lizards are vividly portrayed using a few simple strokes, as if done spontaneously. The abstract patterns have more rigorous and standardized strokes and show a stage in the move from drawings which record life to drawings intended as patterns, expressing a high level of conceptual and aesthetic ability. The geometric patterns, composed mainly of points and lines, probably also derive from the drawings of fish and animals.

The fish, as the most common design at Banpo, must have been closely related to the people's daily life: the village was near a river and a number of fishing implements were found at the site. The development from this fish pattern to an abstract design which was used in a number of ways can be reconstructed with some certainty. One pottery vessel has a unique design of a human face and fish; the face is round with tightly closed eyes and fish-like triangles embellish the head and cheeks. Whatever the meaning of these designs, they vividly reflect the naïve artistic concepts of these people.

Bronze Wares

In the wake of the protracted pottery cultures, embryonic bronze art appeared about 3,500 years ago in the period the Chinese term the Xia dynasty. According to *Zuo Chuan* (a famous commentary on a classic Confucian text), an early mythical ruler, Yu the Great, had nine tripods cast and inscribed with drawings of many objects, in order to instruct his people how to tell good from evil. The ritual vessels used by the Shang and Zhou kings are identified with these. The earliest archaeological evidence of metal is a fragment of a brass object found at Jiangzhai, a neolithic site, although its provenance is uncertain. The earliest bronze object discovered to date is a knife found at Linjian, a neolithic Yangshao site in Gansu Province to the west of Shaanxi and dating from about 3000 B C. By the Shang dynasty, however, sophisticated bronze wares with intricate designs and superb craftsmanship had become widespread.

The Zhou dynasty saw several new developments in bronze art, including the use of long inscriptions and the introduction of new forms and designs. In general the complex Shang forms were simplified, while designs were elaborated at first but then became simplified and more abstract. Western Zhou bronzes found at sites in the land within the passes are typical of the period, with various shapes, a wonderful lustre, exquisite patterns and excellent workmanship; several of the large *ding* (tripods) and *yi* (rectangular lidded vessels) with their regular shapes and fine designs are among the very best of Chinese bronze wares. The rich hoard found at Fufeng, Qishan and Chunhua in recent years has widened our knowledge of this art.

Bronze wares are often classified according to usage into sacrificial vessels, cooking and food vessels, weapons, musical instruments and miscellaneous articles. Sacrificial vessels consist mainly of the *ding* and *yi*, which kings, princes and aristocrats used in their worship of heaven and sacrificial ceremonies to Shang Di and the

ancestors. The bronze ceremonial vessels of the king were symbolic of *tian ming*, the mandate of heaven; when, after the sacking of the capitals in Shaanxi and the move east to Zhengzhou, the Zhou retained power in name only they were still the only ones with the right to make sacrifices to heaven and Shang Di using these vessels. There were strict rules about the use of all the sacrificial vessels in the Shang and Zhou dynasties. According to an early text on ritual (*Zhouli*), 'The Son of Heaven uses nine *ding*, feudal lords use seven, councillors five and scholars three', and in *Lunyu* (*The Analects of Confucius*) it is stated that: 'No person without official rank should use sacrificial vessels.' The shape and size of the vessels also reflected the strict hierarchical system, varying according to the rank of the user. Thus they also possess an important documentary value in addition to their obvious artistic value. The inside usually bore an inscription recording the sacrificial ceremony, military expedition, admonition, banquet or other important event for which they were cast or used. A Western Zhou bronze *gui* (a deep circular grain container with two or four handles) discovered in Lintong County near Xian bears an inscription alluding to the campaigns waged by King Wu of the Western Zhou against King Zhou of the Shang. Another vessel, called the *Dayu ding* and dating from the same period, records the speech King Wen of the Zhou gave on ascending the throne.

The cooking, food and wine vessels are more varied in shape than the sacrificial vessels, the main examples being the *li*, *yan*, *gui*, *xu*, *dun*, *dou*, *jue*, *jiao*, *jia*, *gu*, *zun*, *you*, *hu*, *yi* and *pan*. The gorgeous patterns and unique shapes of these vessels were modified in countless ways from the stone, bamboo, wood and pottery wares of remote antiquity on which they were originally based; round vessels became rectangular, round-footed vessels were given several additional square feet and pillar-shaped legs assumed animal, bird and human forms. Some vessels were cast entirely in the shape of birds or animals, like the rhinoceros-shaped *zun* now to be seen in the Stele Forest Museum in Xian. This is extremely lifelike and is covered with rich abstract patterns. It has the characteristic dark hues of Chinese bronze wares.

The *leiwen* pattern (a design of rectilinear spirals) was the most common design found on Shang and Zhou bronzes and is believed to have developed from the Chinese character for 'thunder'. Among the less common designs of birds, animals, dragons, cicadas and *taotie* (a sort of mask), the most interesting is the *taotie*. The evolution of this design is still not entirely clear and the term wasn't widely used until the Song dynasty, although it was taken from a late Zhou-dynasty text. However, according to one legend, Taotie was the name of a degenerate son of the celestial Jin Yun, who liked to eat human flesh. During one such meal he stuffed a whole human into his mouth and couldn't breathe. He died, but was transformed into an ogre with a head but no body. The *taotie* motif is also called an ogre-mask or animal-mask design. It usually consists of a pair of protruding eyes and horns above a body ending in a tail, all symmetrically placed, often on either side of a raised flange. However, the design varies considerably; in some, hooks below the eyes appear to depict jaws and teeth, and in others the *taotie* shares its tail with a separate dragon design.

Bronze art prevailed throughout the Eastern Zhou dynasty, when bronze wares were increasingly made as

burial objects and developed a greater range of decoration; they were only superseded in the Han when the economy forced pottery wares to be substituted for bronzes in burials. Bronze wares remain the great achievement of Chinese art in the first thousand years of her civilization.

Tiles of the Qin and Han
In the Qin and Han the *wudang*, a circular or semi-circular tile-end protruding from the roof eaves, was well known for its plain and classic elegance. It originally served to protect the rafters, but later was embellished, giving it a decorative function as well and enhancing the beauty of the building. The earliest tile-ends (from the Western Zhou) were semi-circular. In the Qin and Han circular tiles became more prevalent and were decorated with Chinese characters, pictorial designs and animals, combining the techniques of sculpture and the decorative arts.

Han and Tang Sculpture
Han and Tang sculptures are found mainly in tombs, Buddhist caves and temples, and include free-standing sculptures, relief carvings, stone engravings and pottery figurines.

The statues of the cowherd and weaving-maid in Doumen, near Xian, are the earliest extant stone sculptures in China, purportedly done when the Han-dynasty emperor Wu built the imperial park. They are massive and simple, the hallmark of sculptures of this early period. Other fine examples of Western Han-dynasty stone sculptures are found on the Spirit Way leading to the tomb of Huo Qubin.

Stone engravings and pictorial bricks are found in many Han-dynasty tombs. The stone engravings were made using a chisel like a brush on stone paper, while the bricks were stamped with the design, using a woodcut, before they were fired, or painted on after firing. The pictures cover a wide range of scenes from everyday life and historical episodes. Many of the brick designs have been found at more than one place, suggesting that they were mass produced and did not relate specifically to the tomb occupant's life, but they are nevertheless vivid and full of local flavour. In composition they are similar to the pictures found on bronzes: the figures, landscape, animals and objects all being depicted without perspective in time or space. Sometimes stories are depicted with the episodes arranged from top to bottom or from left to right, like a picture scroll.

The downfall of the Han dynasty was followed by the Three Kingdoms, and then the turbulent Northern and Southern dynasties period. It was during this troubled

time that Buddhism, and with it Buddhist art, began to have a significant influence on many aspects of Chinese culture. Stone Buddhist sculptures found in Changan show the influence of Gandharan and Indian art with their massive, sumptuous and sensuous forms. The short-lived Sui dynasty reunified the war-torn country before it was superseded by the Tang.

The Tang dynasty made its capital in the land within the passes at the site of the Sui capital Daxing, renaming it Changan. During the rule of Taizong, the second emperor, the country prospered, becoming a powerful empire with many vassal states and numerous international exchanges. In this stable political atmosphere Tang art flourished; a new richness and diversity were added to the traditions of the Han with the introduction of western forms and designs.

Remains of Tang stone sculpture come mainly from the mausoleums of emperors and Buddhist temples. The large number of mausoleum stone carvings still express the bold and unrestrained style of the early Han, but at the same time they show the influence of the elegant, decorative style of art from the western regions and achieve a new realism. The winged horses, fierce lions and other auspicious beasts lining the Spirit Ways leading to the eighteen imperial mausoleums are typical examples of this combination of eastern and western art and complement the tombs and their natural surroundings. The Qian Mausoleum of Gaozong was built against a hillside with the statues of the attendants, auspicious beasts, warriors and pillars being arrayed up the slope of the hill so that, looking back on them from the tomb, they appear to continue for ever, symbolizing the boldness of vision of the Tang empire at its peak.

Relief sculptures in stone played an important role in embellishing the imperial mausoleums. The Six Steeds from the Zhao Mausoleum – a depiction of the favourite battle horses of Emperor Taizong – are a prime example of this genre.

Buddhist statues of the Tang show the assimilation of Indian and Gandharan influences to produce a new, realistic and three-dimensional style. The bodies are well proportioned and relaxed. The garments have few folds or pleats yet fall softly to reveal and complement the shape of the body. Hanging ornaments and necklaces are used to highlight the bodies' roundness, while the faces are plump and placid, like those of court beauties. Representative of this style is the damaged statue of a bodhisattva at the Stele Forest Museum in Xian, which has been described as the 'Venus of the East'. The most famous sculptor in the High Tang period was Hui Zhi, known as the Sage Sculptor for his exquisitely coloured works.

Pottery sculpture also reached its peak in the Tang. The beginnings of this genre can be found in the primitive pottery sculptures of the neolithic period. It reached a high point in the Qin and Han dynasties as exemplified by the terracotta tomb figures of the First Emperor and the glazed pottery figurines found in great numbers in Han-dynasty tombs. However, Tang ceramics are characterized by new forms (some influenced by gold and silver wares), polychrome glazes and the perfection of porcelain. The famous tri-coloured glaze was made by mixing copper, iron or cobalt with a colourless lead silicate to produce a range of colours from blue and green to yellow and brown. The tri-coloured wares of Changan are among the most outstanding examples of this genre,

consisting mainly of tomb figurines of women, dancers, musicians, horses and camels.

Gold and Silver Wares

Gold and silver wares reveal, perhaps more than anything else, how completely the Tang craftsman had mastered foreign forms and techniques. Although some pieces were cast, many were made from beaten gold and silver, and gilding also became prevalent. The 200-odd gold and silver objects excavated recently at Hejiacun, and pieces found at Famen Temple, illustrate these techniques.

Tang Painting

Chinese painting, which began with the designs on painted pottery of the neolithic period, developed rapidly in the Jin dynasty, drawing upon the tradition of the murals and silk paintings of the Eastern Zhou, Qin and Han periods. By the Tang, with the added influence of Buddhist murals, Chinese painting heralded the start of a golden era. Of the approximately 400 Tang painters whose names can be found in historical documents, famous artists such as Yan Liben, Yan Lide, Wu Daozi, Li Sixun, Wang Wei, Zhang Xuan, Zhou Fang, Han Gan and Dai Song all lived and worked in Changan. The monk Yici Yi, noted for his monastic frescoes, was a painter from the western regions also resident in Changan.

Zhang Xuan and Zhou Fang, in the mid-Tang were known for their portrayal of beautiful women – previously only the subjects of religious paintings – in pictures recording scenes from court life. A typical Tang lady, under the brush of the painters or the hand of a sculptor, is always plump and dignified, her dress loose-fitting and her hair tied in a bun at the back of her head.

Landscapes did not seem to be considered as decorative in themselves until the Han dynasty, when they are found on bronze wares and ceramics. In the Northern and Southern dynasties there were several Daoist painters who were known for their landscapes, but none of these works survives and it is only in the Tang that the landscape really came into its own with the involvement of such painters as Wu Daozi, Li Sixun, Li Zhaodao and Wang Wei. Although it is recorded in a contemporary book on painting that: 'Wu Daozi painted many scenes along the Sichuan Road, thus forming a genre of his own: the landscape painting', none of his works survives, and descriptions of his paintings by contemporaries concern his figure paintings, the genre with which he is usually associated. However, the other painters do seem to have belonged to two different schools: Li Sixun and his son Li Zhaodao created a highly detailed style, brilliantly coloured often in blue and green; Wang Wei is known for his monochromatic, ink-and-wash landscapes with free brushwork.

Flower and bird painting also developed as a separate genre in the Tang; Xue Ji, Bian Luan and Jiang Jiao being among its exponents. Animal painting was also popular, Han Gan being adept at painting horses, and Dai Cong cattle.

Many of the original murals of Tang Changan have been lost, and the few left are to be found in tombs and mausoleums, such as those decorating the tombs of Prince Zhang Huai and Princesses Yi De and Yong Tai. These murals, although their painters are unknown, provide a glimpse of the achievement of mural painters of this time and are also interesting documents of court life.

234

Calligraphy

Chinese calligraphy boasts a history of over 3,000 years, standing out as a unique genre in world art. Symbols on neolithic pottery probably represent the precursors of Chinese characters, while inscriptions on Shang oracle bones and bronzes can be positively identified as early characters. By the middle of the Zhou dynasty writing had developed into a recognized style known as 'large seal'; but throughout the disunity of the later Zhou it developed many regional variations which the Qin dynasty standardized into the 'small seal' – the style still used for seal carving today. After the Qin this went out of fashion for all but formal and ritual use and was replaced by the 'official script', which was more suited to writing with a brush. There were then two developments: 'cursive script' which, as its name suggests, could be written very quickly, and 'uncular script', which remains the standard form to this day.

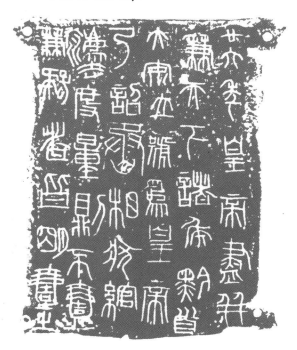

The writing of characters was first recognized as an art form in the period of disunity following the Han and Three Kingdoms period, when two distinct traditions developed in the north and the south of China. Wang Xishi in the south developed his own flowing version of the uncular script, and a more cursive form, called 'running script'. In the north, the more angular form of uncular script continued to be used. According to a Yuan-dynasty work, calligraphy also became a branch of study in this period: 'No one paid much attention to the way characters were written in the pre-Qin period. People began to attach importance to it in the Wei and Jin dynasties, when the emperor, courtiers and scholars took pride in their ability to write varied and beautiful characters, and thus laid down many rules for writing, so that it became a branch of study.' Wang Xianzhi and Zhang You were also famous for their calligraphy at this time.

The calligraphers of the early Tang period reconciled the two traditions, but were especially influenced by the work of the two Wangs. By the High Tang a variety of new calligraphic styles had been developed. There was the wild and unrestrained cursive hand of Zhang Qu. Yan Junqing, one of his pupils, excelled in a free and graceful form of the uncial script while another pupil, Huai Su, was also adept at the cursive script; his brushstrokes were like 'startled snakes and writhing eels, sudden rain and swirling winds', and his style was so original that it was given a name of its own – 'Yan script'. Both the official and seal scripts also developed from the mid-Tang onwards, Han Zimu and Li Yangbing being the most famous calligraphers of each respective style.

Most of the original masterpieces of these calligraphers have failed to survive, but some of their work has nevertheless been handed down through the inscriptions on the 2,300 steles in the Stele Forest Museum.

Seal Engraving

Seal engraving, like writing, developed from a practical skill into a respected art and is still practised today as it was in the Qin and Han dynasties, with each seal, a tiny piece of metal or stone, taking up to a day to carve. There are strict rules concerning the method of cutting, the knob on the top of the seal and the arrangement of the characters. Great diversity is achieved both by the individual style of the engraver and the material used: jade, copper and stone, for example, each having their own characteristics. The ancient seals found in recent years near Xian range from imperial jade seals to those of all grades of officials, providing a general picture of seal engraving in ancient China.

The Tang was a large and powerful empire with many vassal states and a thriving trade in both material goods and ideas with countries to its west and east. In art, as in many other areas, foreign influences had become so assimilated as to give rise to a new, mature and original Chinese style; a style which followed in the traditions of the Han dynasty yet was considerably enriched and which heralded a golden age of Chinese art.

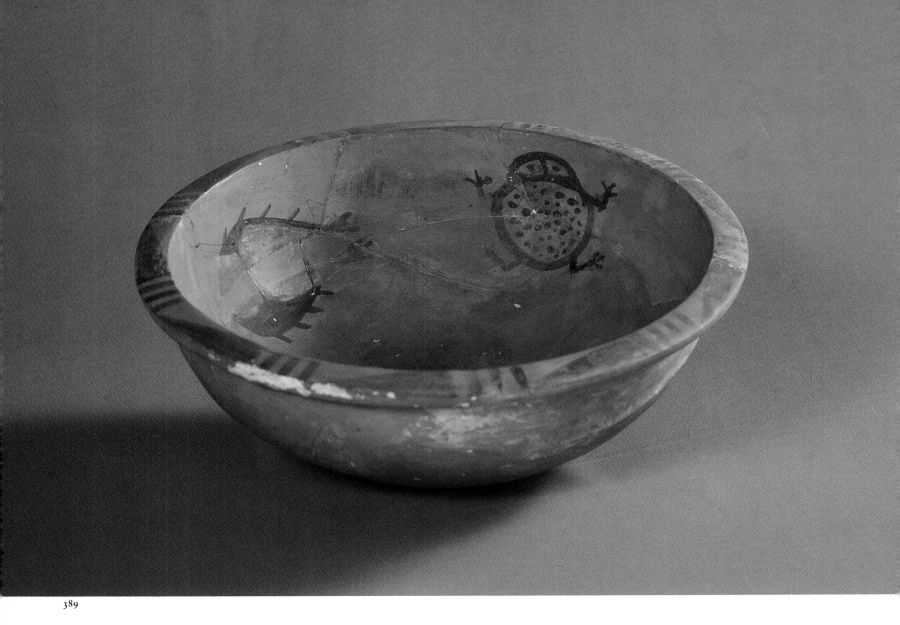

389

389. Basin with fish-and-frog design

This is the only neolithic painted pottery vessel found to date that features both a fish and a frog design. They are painted in black on red earthenware. Both designs are commonly found on Shang and Zhou bronzes, but the discovery of this piece shows that they were also used as motifs in the neolithic Yangshao culture, 7,000 years ago.

390. Basin with human face and fish design

This basin, representative of the neolithic Yangshao-culture painted pottery, has a design of a fish and a human face. The face has two symmetrical fish designs on either side, and the hat also appears to be derived from the same design. The eyes are fish-shaped too, unlike ones found on other vessels from Banpo, where they have been narrowed into slits.

391. Pot with pointed bottom and zigzag design (*opposite*)

This pot is decorated with a saw-tooth design at the top and bottom and a bold zigzag or wave design in the middle. This kind of pattern is unique in neolithic painted pottery.

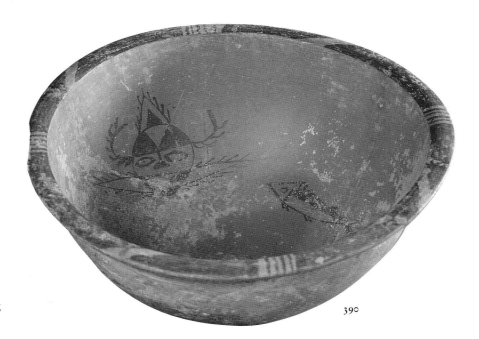

390

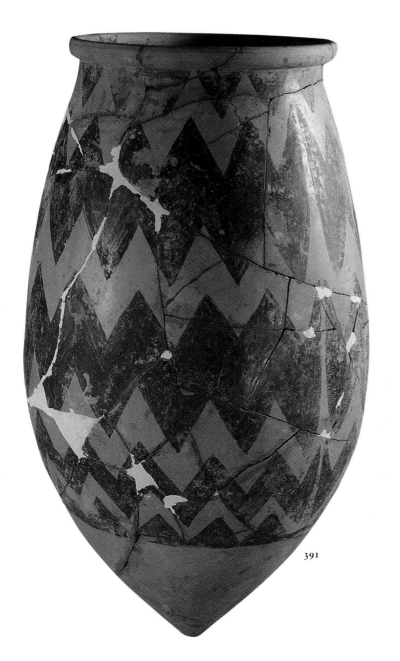

391

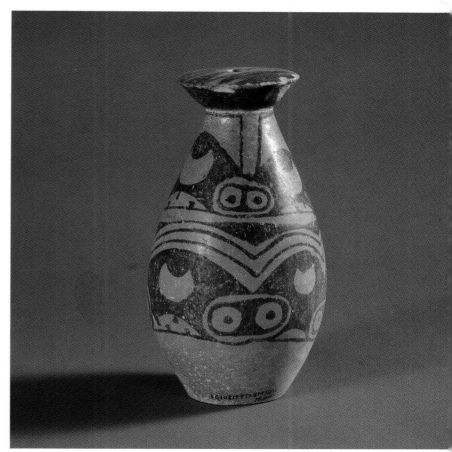

392

392. Vase with pig-mask design
This double-layered pig-mask motif
is unique among pottery of the
Yangshao culture. The eyes are
shaped like crescent moons, the
snout is oblate with two round
nostrils, the teeth are indicated by
uneven lines on either side of the
mouth and two curved lines in the
middle of the forehead of the lower
mask represent folds of skin. There
is a pig-head god in ancient Chinese
mythology and it has been
postulated that this design has
religious or mythological
significance.

**393. Neolithic painted pottery
utensil**

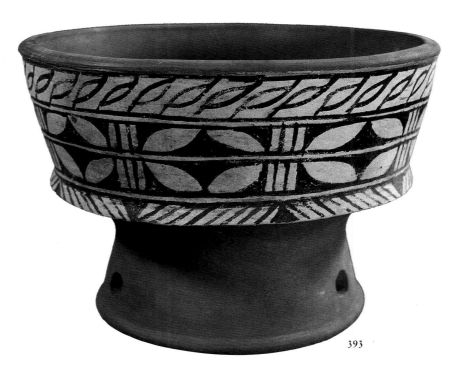

393

394

394. Bronze *ding* with two sets of handles

This tripod, weighing 498 pounds, is the largest Western Zhou-dynasty bronze tripod discovered to date. It has a flat rim, a square lip and straight sides. It is unusual because it has two sets of handles; the two handles rising from the rim are typical of this form, while the three dragon-shaped handles above the legs are more like those found on the *gui*, another ritual vessel. On this piece the *taotie* mask has almost evolved into two distinct symmetrical dragons facing each other across a short line. They have curled tails, round protruding eyes, open mouths, horns, talons and curled jaws. Beneath this mask is a realistic relief motif of an ox-head. Animal masks with outward protruding horns are depicted on the upper part of the legs. They have huge eyes, sharp claws and open mouths. The main patterns all have a background design of rectilinear spirals, known as *leiwen*. The floor of the vessel inside contains three round depressions, seven inches in diameter and extending six inches down into the hollow legs.

395. One of a pair of matching *lei* jars

These jars have flat rims and oblique shoulders, with two rings threaded through the animal mask handles. The whole of the jar is decorated with motifs that include dragons, square spirals, whorls and a plantain leaf pattern. The inner rim of the mouth is inscribed with twenty-five characters in large seal-script style.

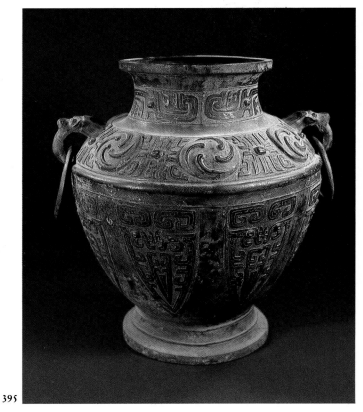

395

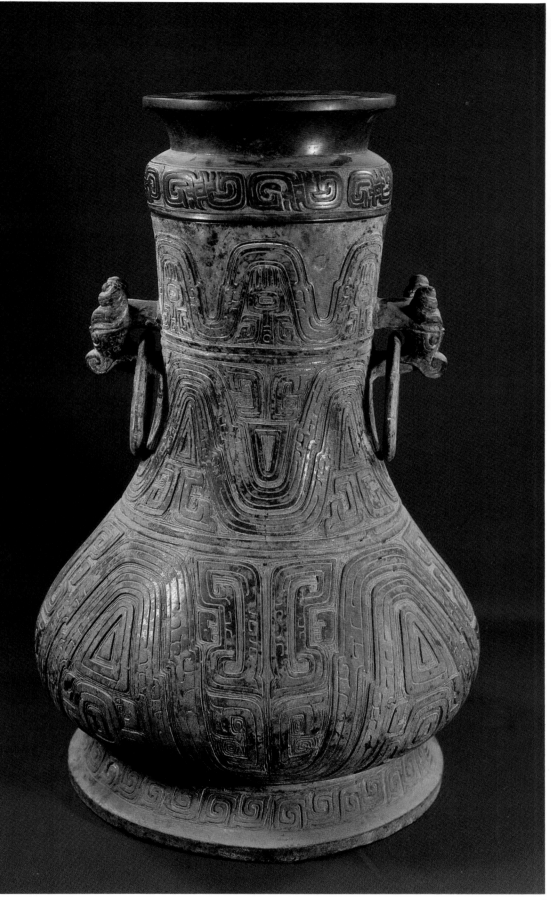

396

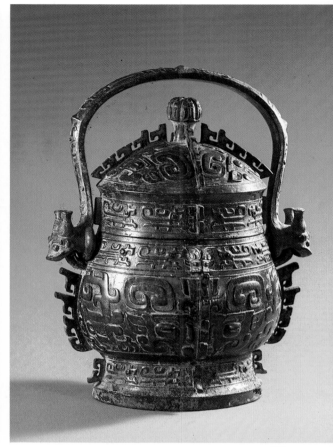

397

396. *Hu* jar
This has a bird pattern on the top of the lid, a square spiral pattern on the lid rim and the ringed foot, and wave and band patterns – a new design of the later Western Zhou period – all over the body. The lid is inscribed with sixty characters in large seal-script style.

397. *You* with loop handle
This *you* is oval, with a knob shaped like a bud. It is embellished with five animal patterns, including a *taotie* design on the belly, which has protruding and glaring eyes and curled horns, dragons and bovine heads of various shapes. There are openwork flanges on four sides. With its opulent decoration and superb craftsmanship this piece is a masterpiece among Western Zhou bronzes. Thirty-two characters are inscribed on the inner side of the lid and the bottom.

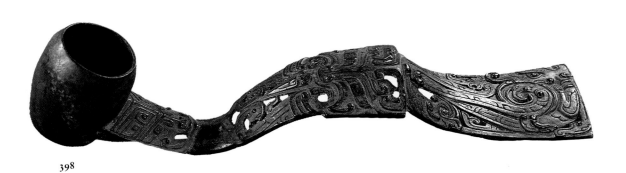

398

398. Bronze ladle
This ladle has a cylindrical scoop and a bow-shaped handle. The design on the handle is of a pair of birds interlaced with two dragons at the end, a *taotie* design in the centre and an animal mask near the scoop.

399. Ram-shaped bronze lidded *zun*
This container is in the shape of a ram with round eyes, curly horns, a fat body and short, sturdy legs. Its mouth is a nozzle and its tail a handle. It has a square hole in its back and the lid has a tiger knob. The tops of the legs are embellished with fleecy cloud patterns and there is an inscription of eight words on the inner side of the lid.

399

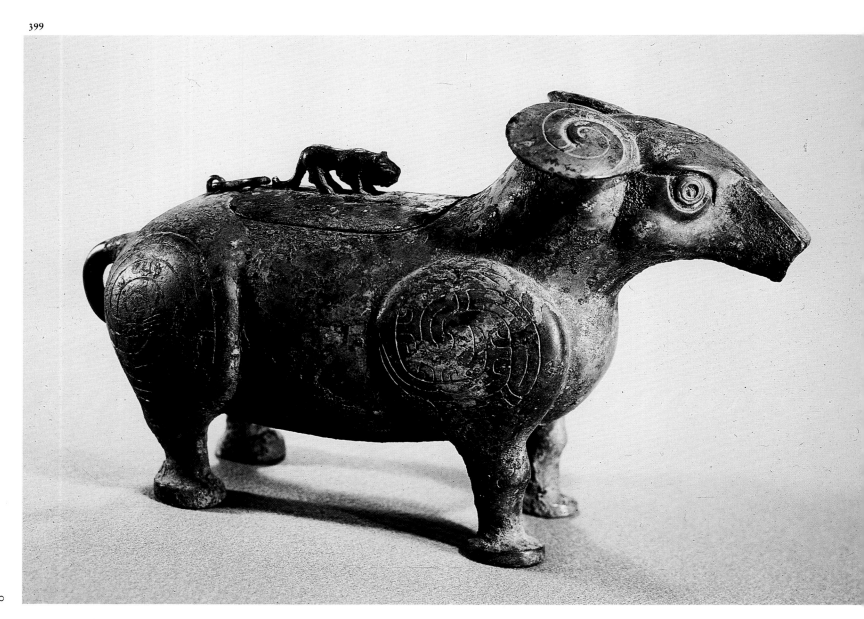

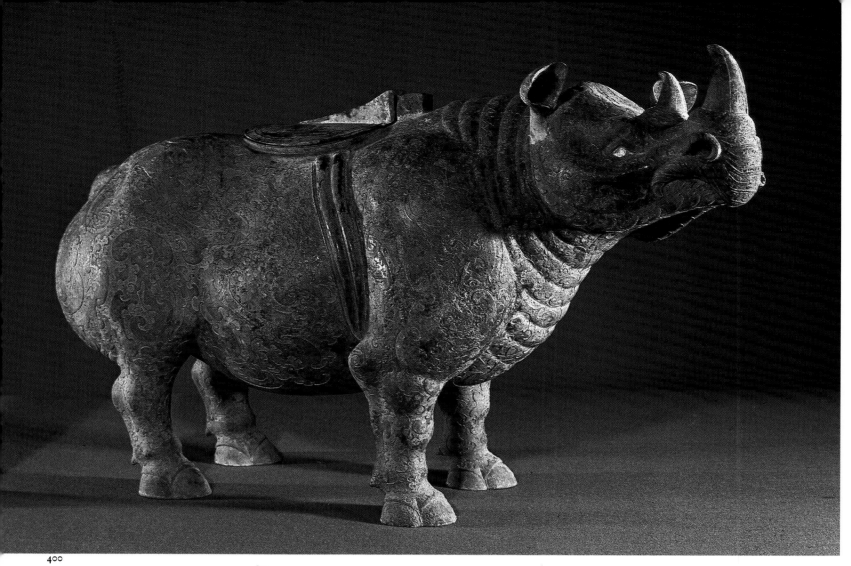

400

401

400. Rhinoceros-shaped lidded *zun* with gold and silver inlay
Gold and silver inlay was a new technique developed in the Warring States period, whereby wires made of gold, silver and other metals, along with metal sheets and turquoise, were inlaid on a bronze vessel to form a pattern and then burnished with a grindstone until they shone.

401. Gourd-shaped *hu* with lid
This *hu* is in the shape of a gourd with a long curving neck. The lid is a bird's head, the beak of which opens and closes, and is linked to the handle by a chain. There are six hydra patterns on the body of the vessel. This exquisite work dates from the Warring States period.

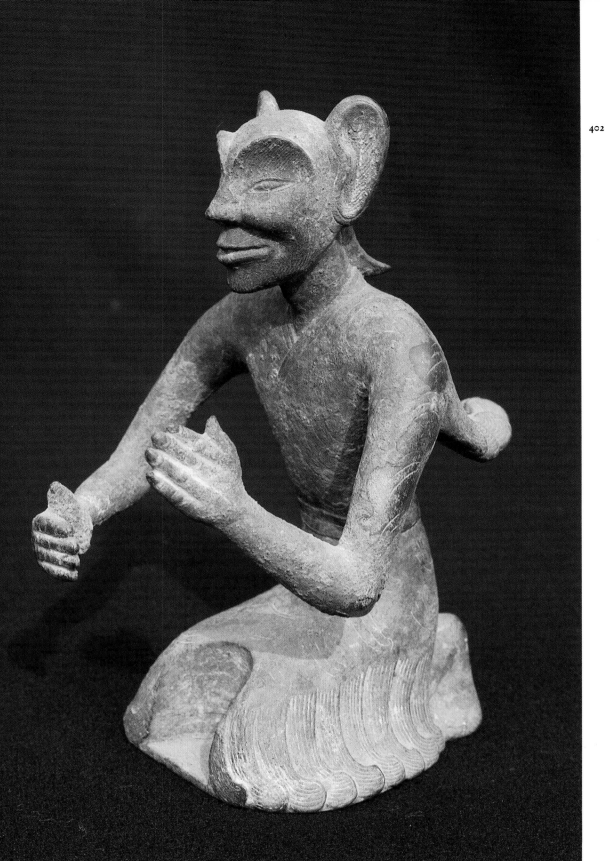

402. Bronze feathered figure
This strange kneeling figure with a smiling human face is dressed in a jacket with a belted waist and has feathers on his face, ears, neck and back; there are also nine rows of feathers on his legs. He is a flying celestial, symbolizing longevity.

403. *Hu* with phoenix head and human faces
This bronze jar with a phoenix-head top, a handle in the shape of a dragon and a bell-shaped base has six human heads in high relief on its belly. They all have full faces, round eyes, small lips, long noses and hair parted in the middle. They show an Indian influence and are probably a product of the rich cultural exchange between China and India in the Tang dynasty.

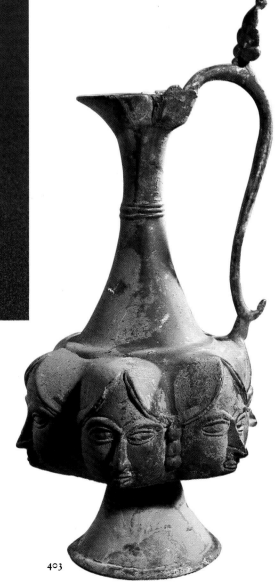

403

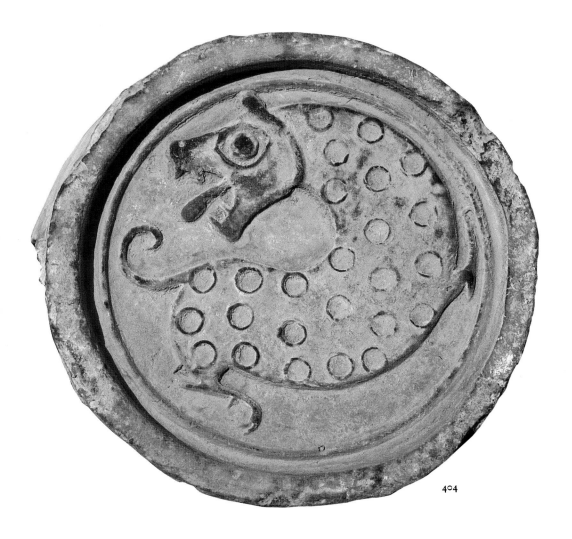

404

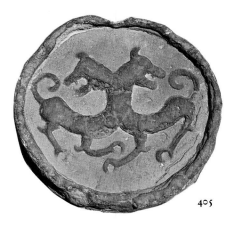

405

406

404. Tile-end with leopard motif
In the Qin dynasty tile-ends were usually decorated with cloud or animal patterns. The leopard, shown here leaping while turning its head, may have been one of the animals in the special imperial hunting parks and this is probably from a pen in one of these parks.

405. Tile-end with double animal pattern
The two animals on this tile-end are joined so that they become one, with two heads and upright, curly tails. This tile was found in the ruins of the Qin-dynasty Dazheng Palace in Fengxiang County and was probably from the palace buildings.

406. Tile-end with whorl pattern
The whorl pattern developed from a bird design and later evolved into the cloud pattern, a very common motif in decorative arts.

407. Tile-end with cloud pattern

408. A Han-dynasty tile-end with the words, 'long life without end'

409. A Han-dynasty tile-end with the words, 'a long life to the court'

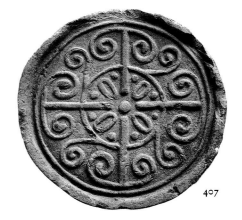

407

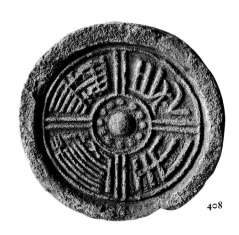

408

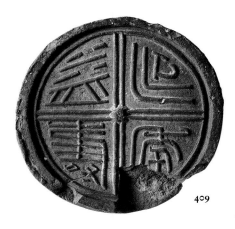

409

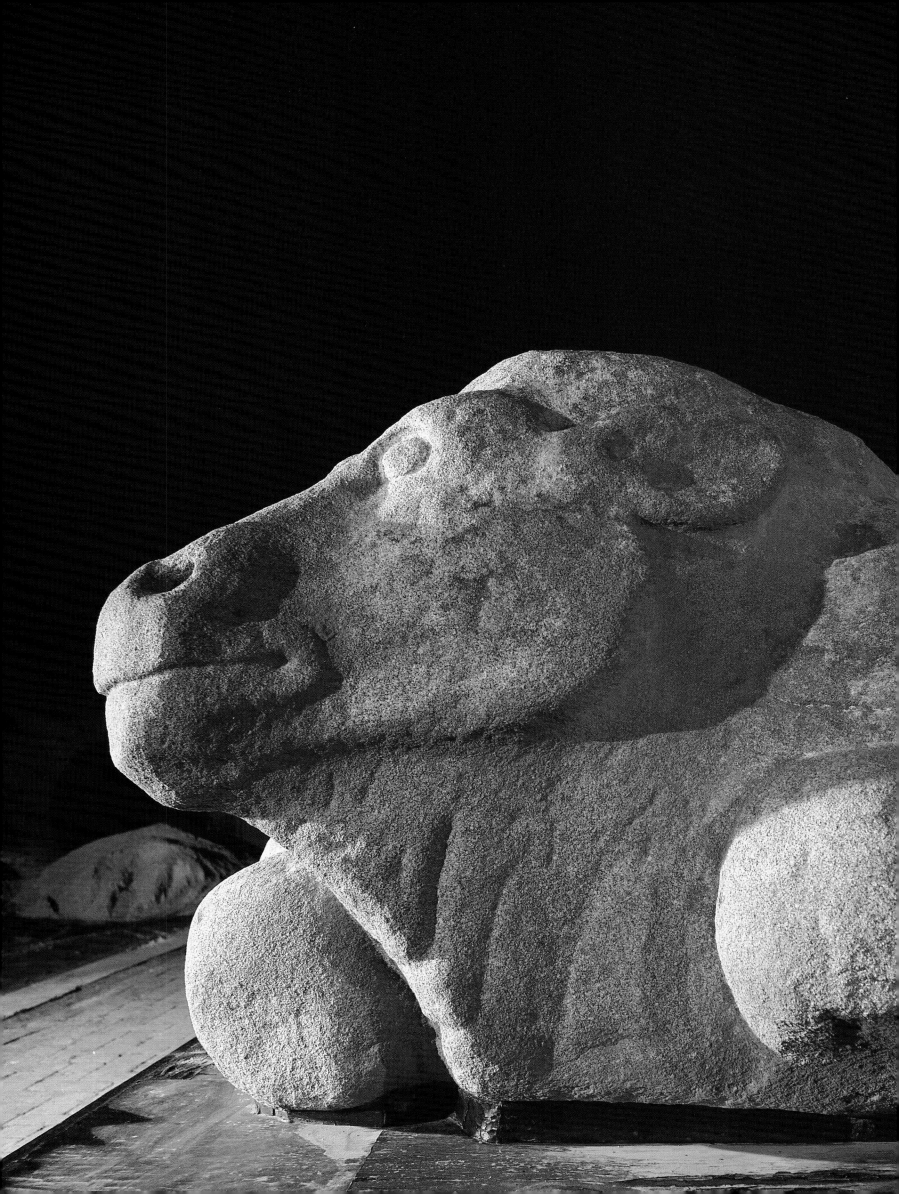

410. Stone ox
The statues in front of the tomb of Huo Qubin, a Han general, were fashioned from huge lumps of stone, using the natural shape and contours of the stone to determine the form of the animal; thus the statues are massive, simply carved and yet full of power. The ox shown here is reclining with its head turned slightly, its eyes gazing into the distance.

411. Horse on top of a Xiongnu warrior
This horse is typical of the stone sculptures in this tomb. The sturdy animal stands erect, head high, while the defeated Xiongnu (Hun) warrior, bow in hand, struggles beneath its hooves.

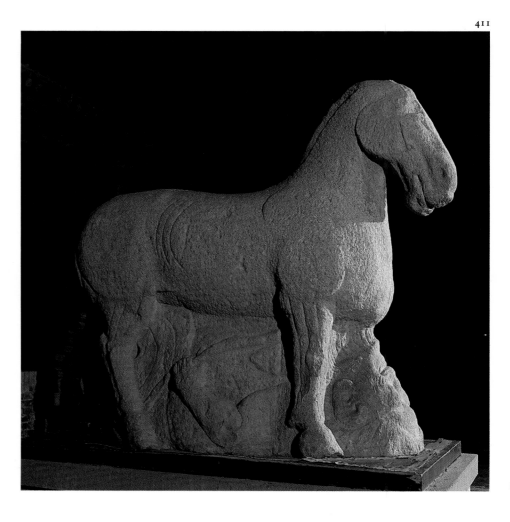

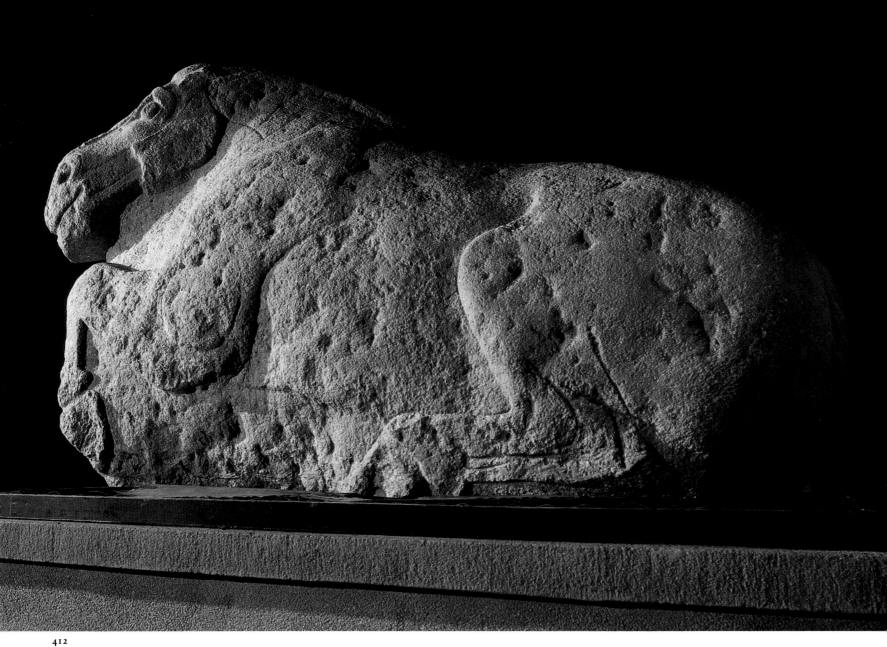

412

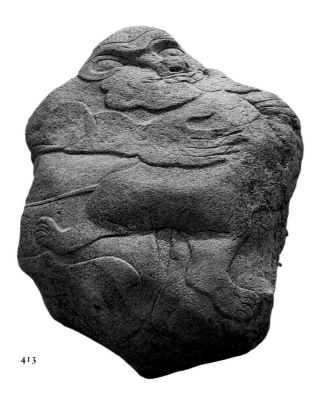

413

412. Leaping horse
Like the other stone statues at the
tomb of Huo Qubin, the form of
the animal is largely determined by
the shape of the stone. This horse
has its forelegs raised in the air, but
the stone underneath has not been
hollowed out.

413. Man and bear
This statue uses low relief carving to
indicate the forms of a man clasping
a small bear, whose hindlegs are
struggling beneath the man's grasp.
This work represents the main
characteristics of Western Han
sculpture, seemingly crude, yet full
of power and vitality.

414. Tiger
The tiger is recumbent, its cheeks
and trunk incised with sparse lines
to signify its hair and stripes.

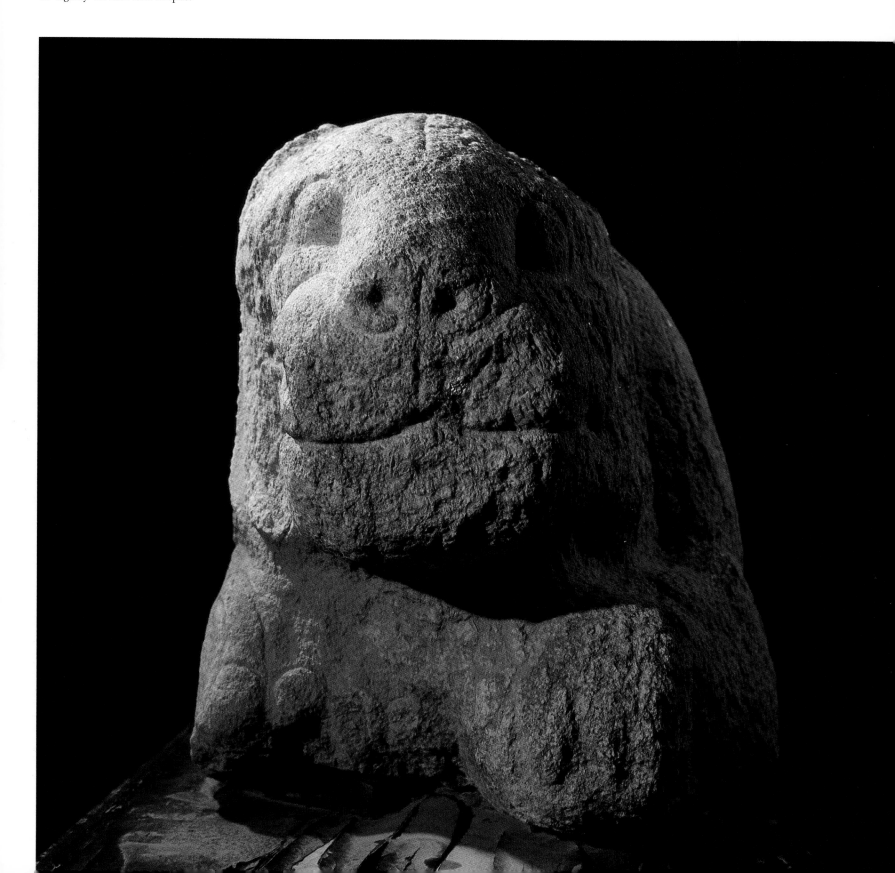

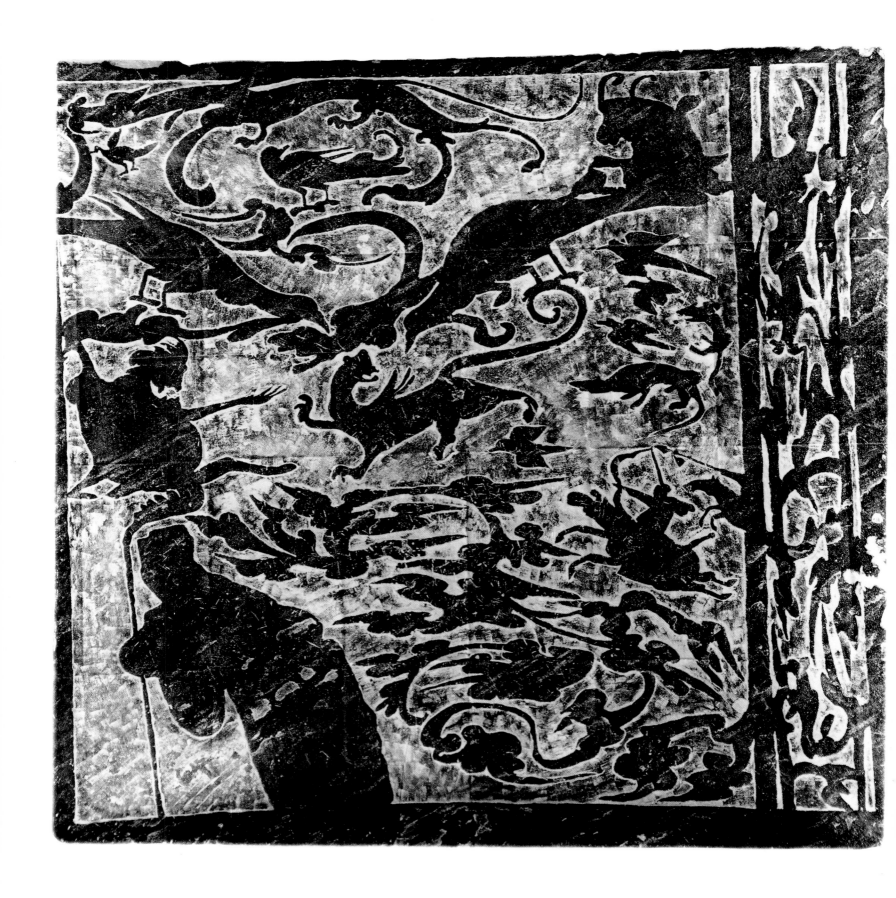

415. Rubbing of a Han-dynasty picture-brick
Picture-bricks, popular in the Han dynasty, were made using a woodcut which was pressed on to the surface of the brick before baking. Such bricks were inlaid into walls in tomb chambers or other buildings and usually portray scenes of battle, hunting, feasting, dancing, singing and travelling.

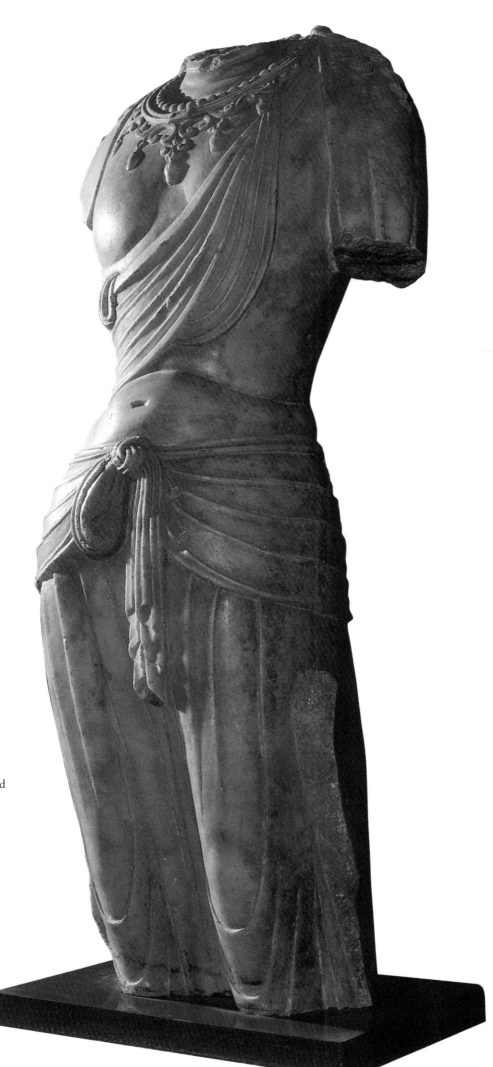

416. Statue of a bodhisattva
This bodhisattva, with its rounded
figure, smooth skin and clinging
robes, has been acclaimed as the
'Venus of the East'.

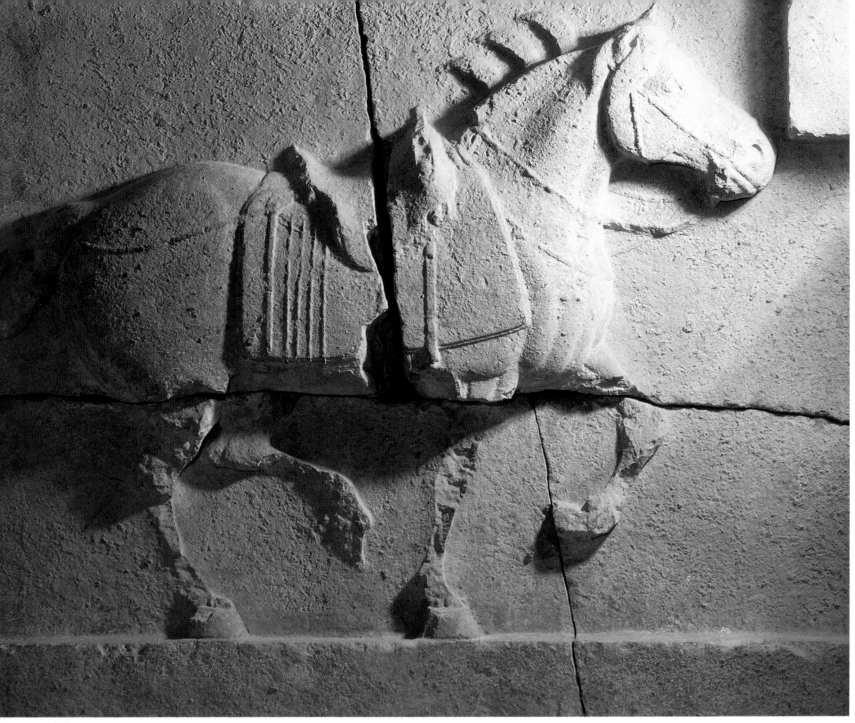

418

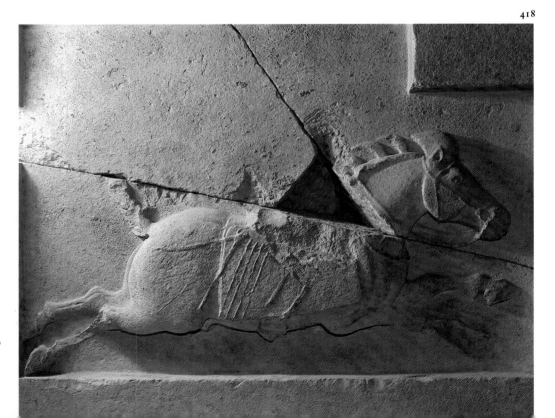

417. The emperor's *tele* steed
This is one of the famous relief
carvings of 'The Six Steeds' at the
Zhao Mausoleum of Emperor
Taizong. The carvings, on slabs of
stone about 8 feet by 10 feet, are
depictions of the emperor's
favourite battle horses and are
considered to be among the best
examples of Tang stone sculpture.
Two of the carvings are now in the
United States, while the other four
are in Shaanxi Provincial Museum.
 The *tele* steed was used by the
emperor in the war against Song
Jingang.

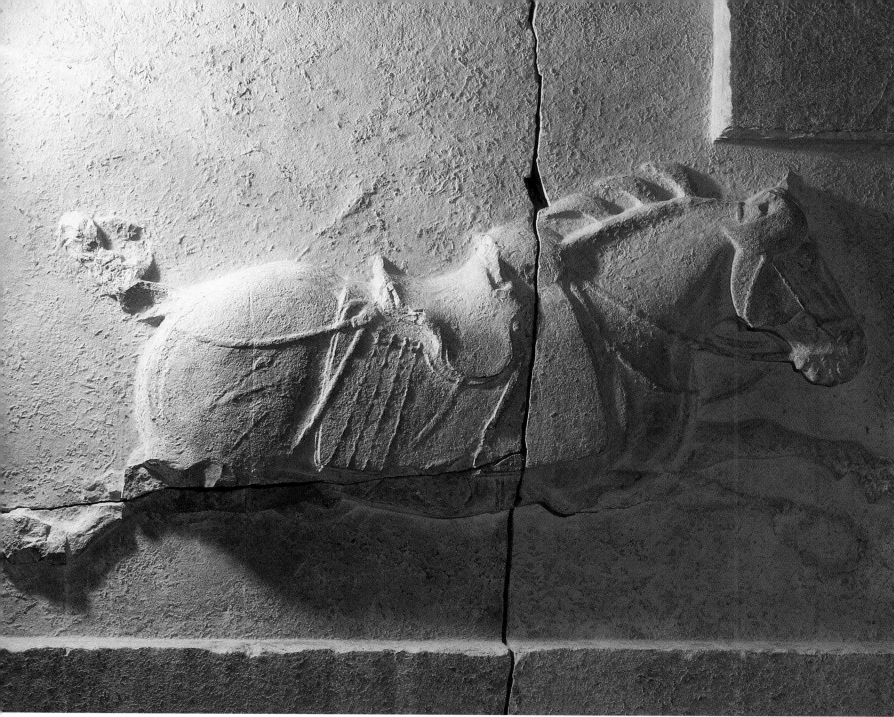

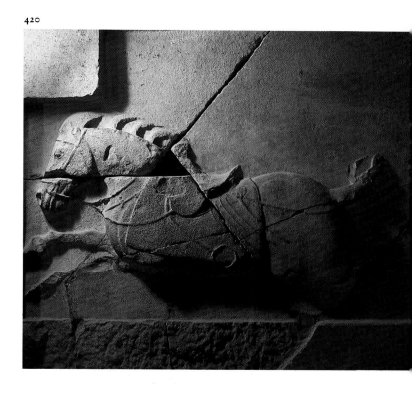

420

418. The emperor's chestnut horse
According to historical records, this 'red-haired' horse, shown here galloping along despite the four arrows in its chest and one in its back, was Taizong's mount in 621 when he fought Wang Shichong, the most powerful warlord in Henan Province.

419. The emperor's grey horse
This was Taizong's mount in AD621, when he fought Dou Jiande.

420. The emperor's piebald horse
This horse was used by Taizong in AD618 when he fought Xue Rengao.

421. Figurine of a kneeling man
This Qin-dynasty figurine is just over two feet high. He is wearing a jacket over a cotton padded robe and his hair is parted down the middle and tied in a bun at the back of his head.

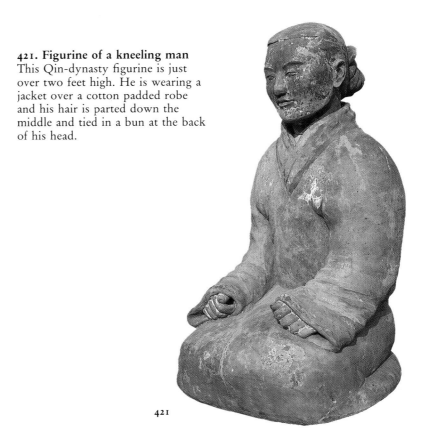

421

422. Tomb-guarding beast
This tomb-guarding beast, used to ward off evil spirits, has long ears, protruding eyes, a broad nose, a tail and a pair of wings.

422

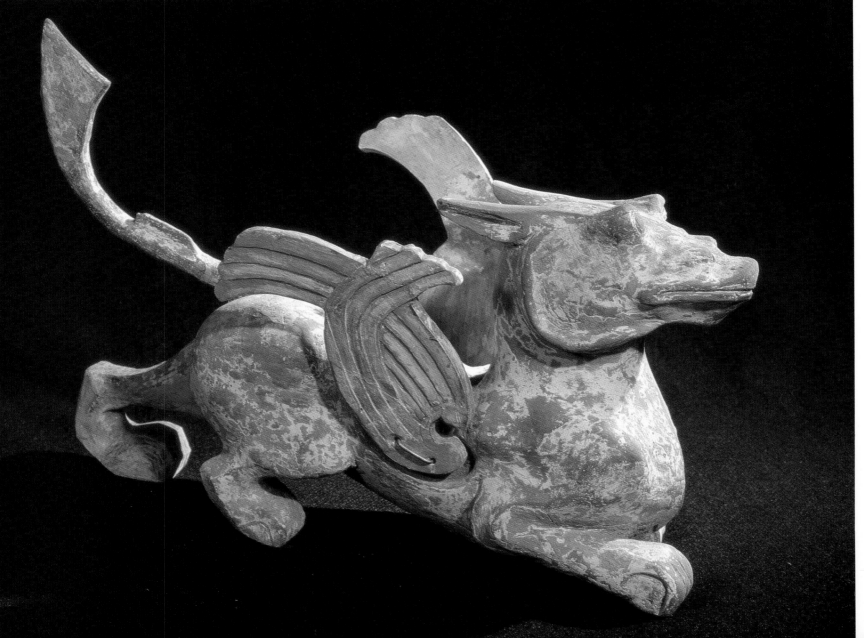

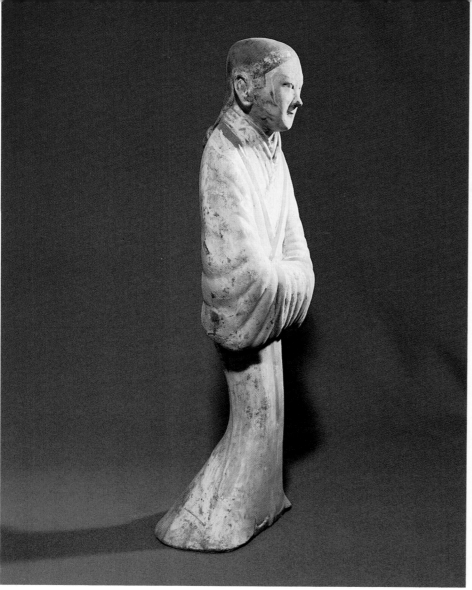

423

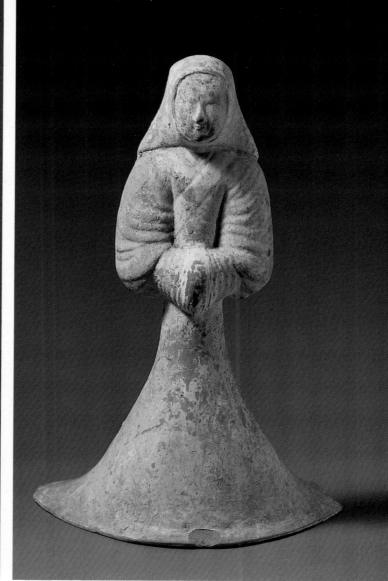

424

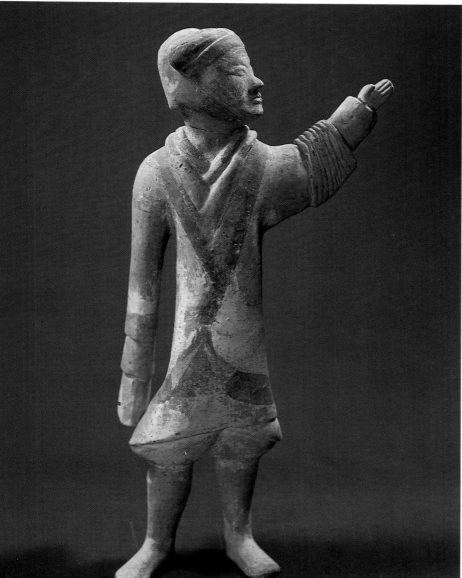

425

423. Figurine of a woman
This figurine, with well-proportioned features and a slender figure, wears a bell-shaped gown which covers her feet and touches the floor. With its fine carving and flowing lines, it is a good example of a Han-dynasty pottery figurine.

424. Figurine of a woman
This woman has a chubby face daubed with white powder, and a kerchief round her head. The bell-shaped gown she is wearing emphasizes her slender figure.

425. Figurine of a military commander
This figurine probably represents a general directing his troops in battle. He is wearing a fur hat, flower-patterned boots and fish-scale armour over a green gown with red and white borders.

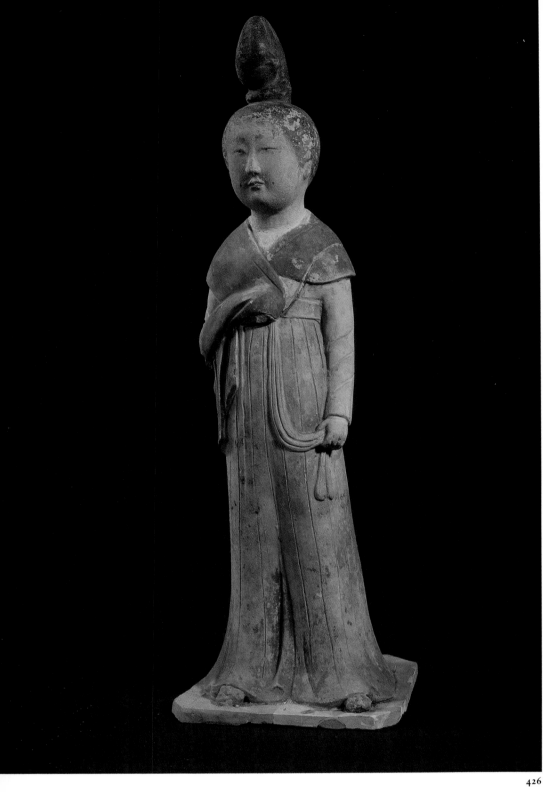

426

426. Painted figurine of a woman
This pottery figurine depicts an upper-class Tang-dynasty woman, with her hair in a high bun on the top of her head, and wearing a narrow-sleeved coat, long skirt and silk-gauze shawl over her shoulders.

427. Woman with a mirror
This figurine, with a *famille rose* glaze, is a fine example of Tang-dynasty art.

428. Tri-colour glazed figurine of a woman
This figurine, sitting with an animated face and raised hands as if talking to someone, represents a Tang-dynasty noblewoman. Tri-colour glaze was a new development of the period.

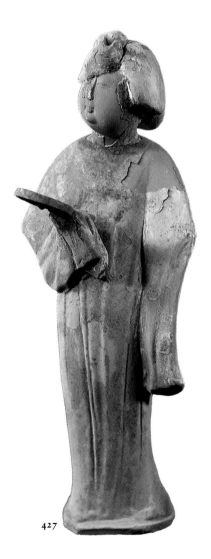

427

428 ▷

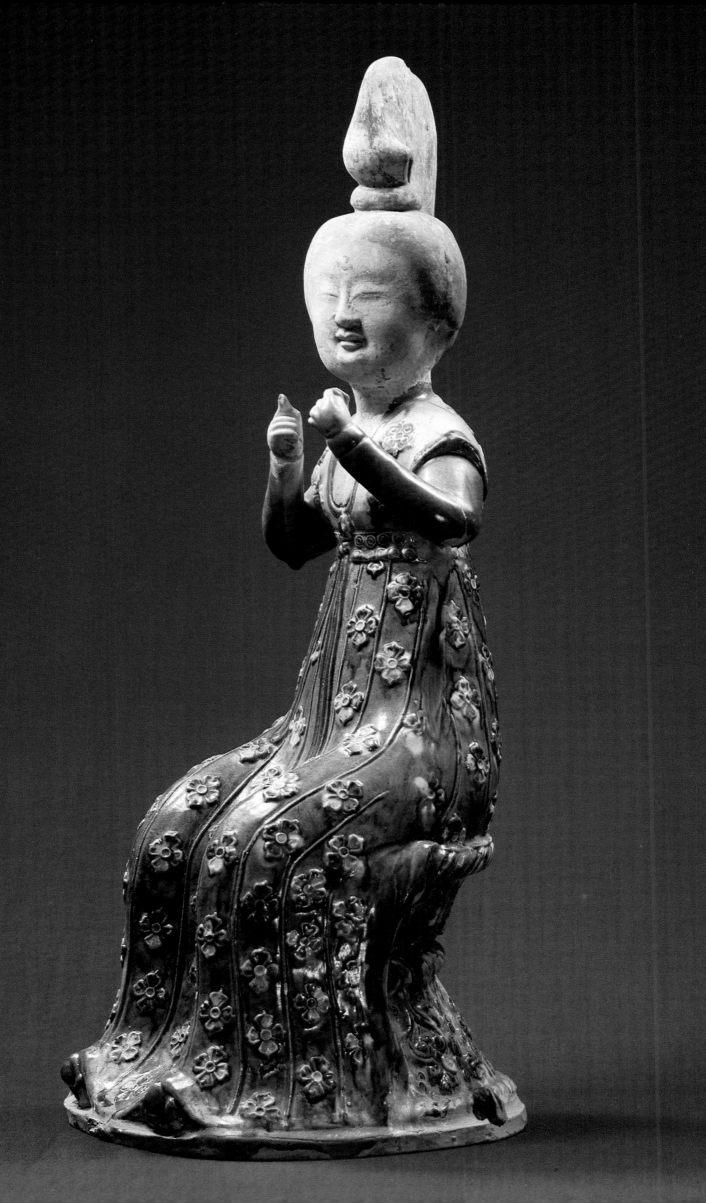

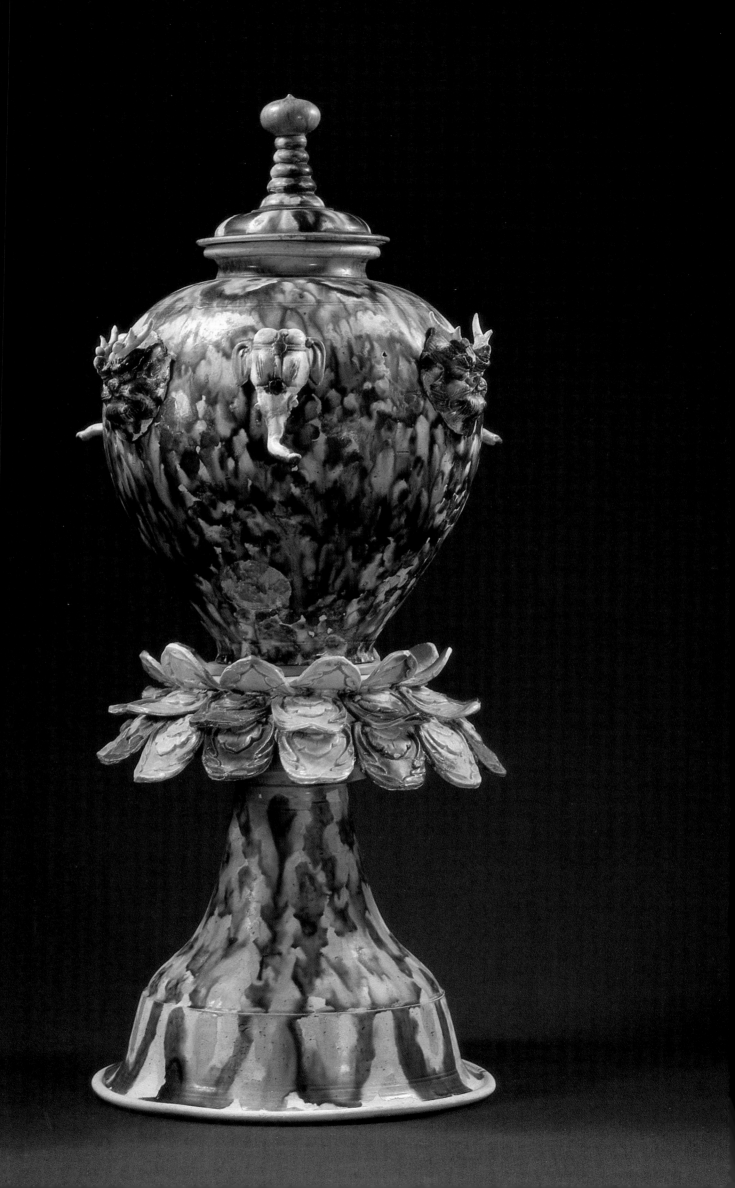

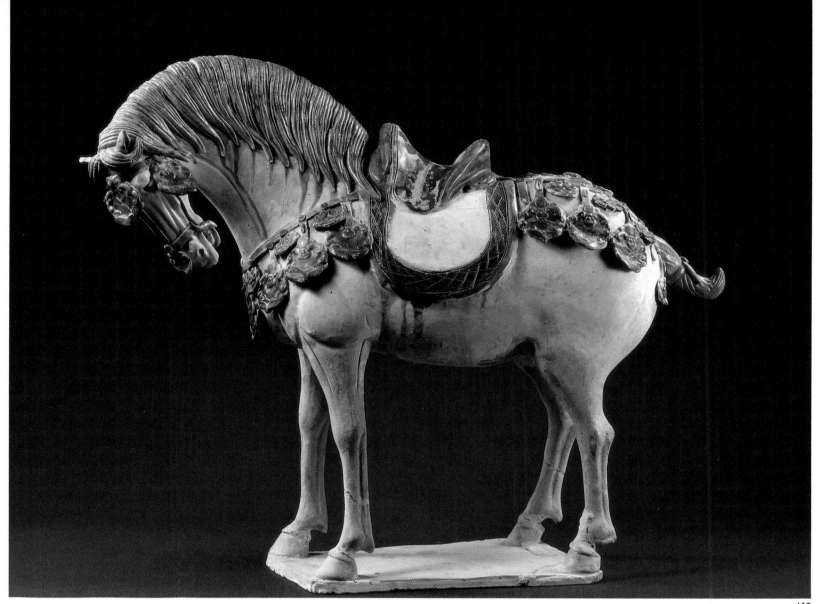

430

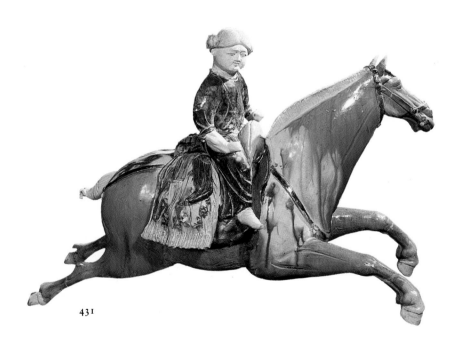

431

429. Tri-colour glazed pagoda-shaped jar
This beautifully glazed jar has a pagoda-shaped lid, a waist like an inverted lotus flower, a bell-shaped base and shoulders with three white elephant heads and four blue dragon heads.

430. Tri-colour glazed horse
Tri-coloured glazed horses are probably the best known examples of Tang-dynasty art. The horse shown here is glazed all over in white, with only its mane and tail in brown and its tack gorgeously decorated.

431. Tri-colour glazed figure on horseback
This lively work shows a horseman in a blue, narrow-sleeved, round-collared gown riding a galloping horse.

◁429

257

432. Gold and silver plated bronze incense burner

This splendid incense burner consists of a round base, a tall stand in the shape of stem of bamboo, a hemispherical bowl and a pineapple-shaped cover. The base, upper part of the stand and bowl are decorated with dragon and wave patterns and there is an inscription on the rim of the mouth. The whole object is plated with gold and silver.

433. Gold dragons

These tiny dragons are each 1.6 inches long.

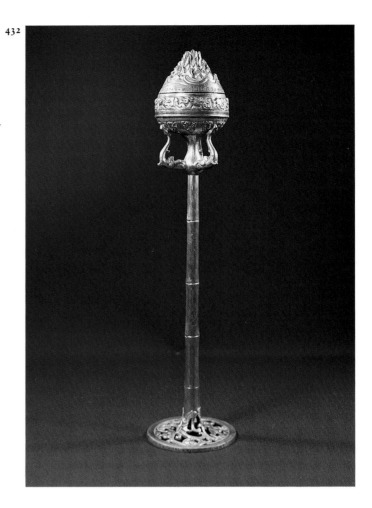

432

433

258

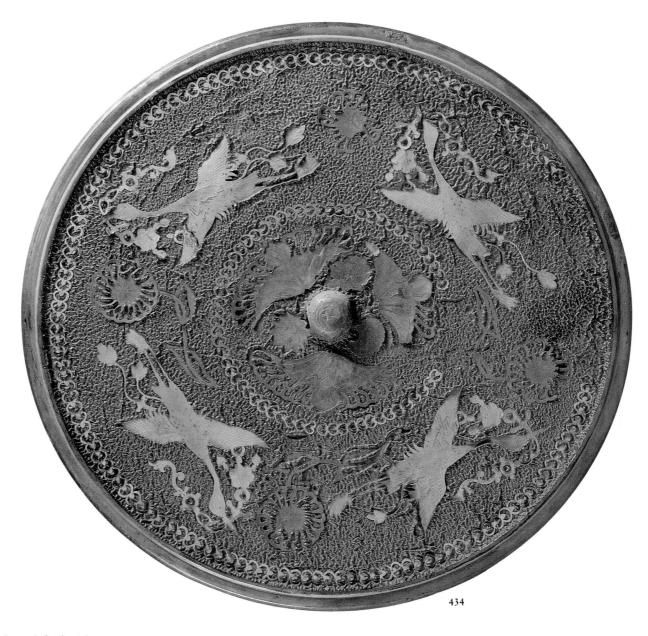

434

434. Bronze mirror inlaid with gold and silver

This method of inlaying patterns of gold and silver was developed in the Tang dynasty. The patterns were cut from sheets of gold or silver and glued to the back of a mirror. The whole of the back was then covered with layers of lacquer which were polished until the metal patterns were level with the lacquer. This mirror back has silver lotus leaves and gold phoenixes, each carrying a ribbon or spray of flowers in its beak. Gold has also been used for the pattern of interlocking circles that surrounds the birds. This is among the finest of all the Tang-dynasty mirrors discovered to date.

435. Silver-plated incense burner with tiger legs and animal-head design

The cover of this burner is shaped like an inverted bowl with perforations like plum or peach blossom. Its base is supported by six tiger legs, with animal masks in between.

435

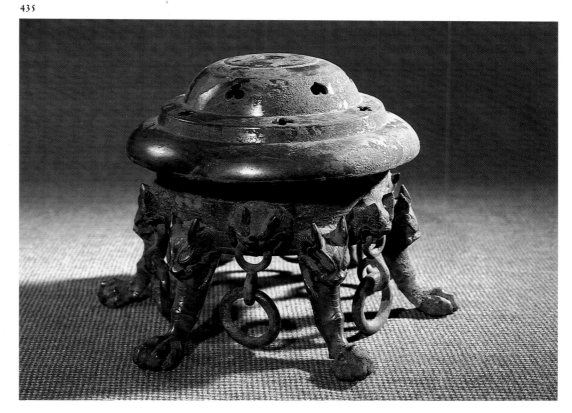

436

437

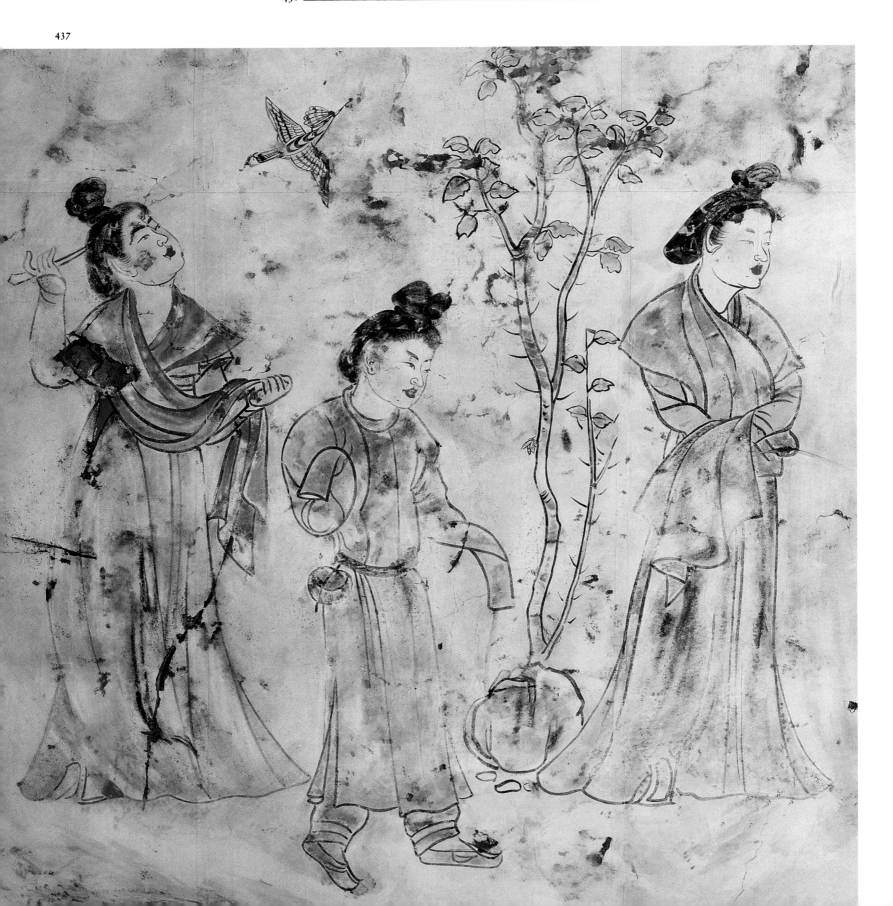

436. *Four Horses* – a mural in
Xianyang Palace
This mural was found in Hall No. 3
of the Qin-dynasty Xianyang
Palace. It depicts four horses
wearing blinkers, pulling a canopied
carriage. Two have white girths and
two black girths.

437. *Watching Birds and Catching
Cicadas* – a mural in Prince Huai's
Tomb
This picture shows three palace
maids. The one on the left is
looking at a bird flying past, the one
in the centre, who is dressed in
man's clothing, is trying to catch a
cicada on the tree and the one on
the right stands as if lost in thought.

438. *Palace Maids* – a mural in
Princess Yong Tai's Tomb
This picture shows palace maids in a
procession. They are all dressed in
the Tang style, with *décolleté*,
narrow-sleeved gowns, long skirts
and cloud-patterned shoes, with
shawls draped over their shoulders,
except for the last one, who is in
male attire.

438

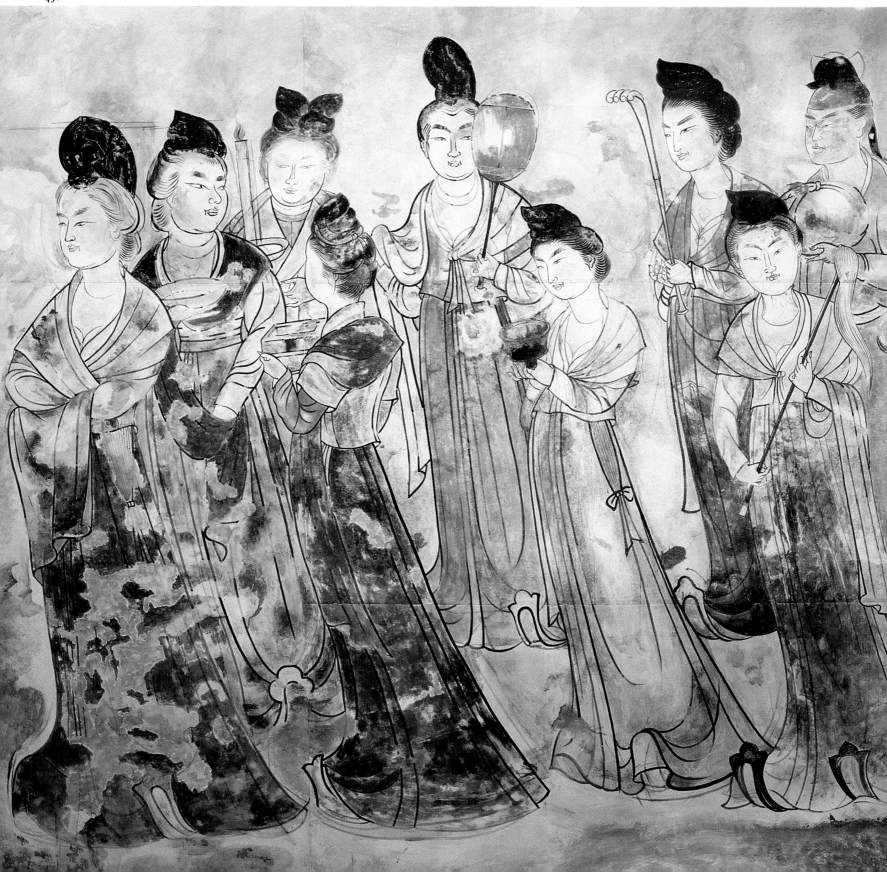

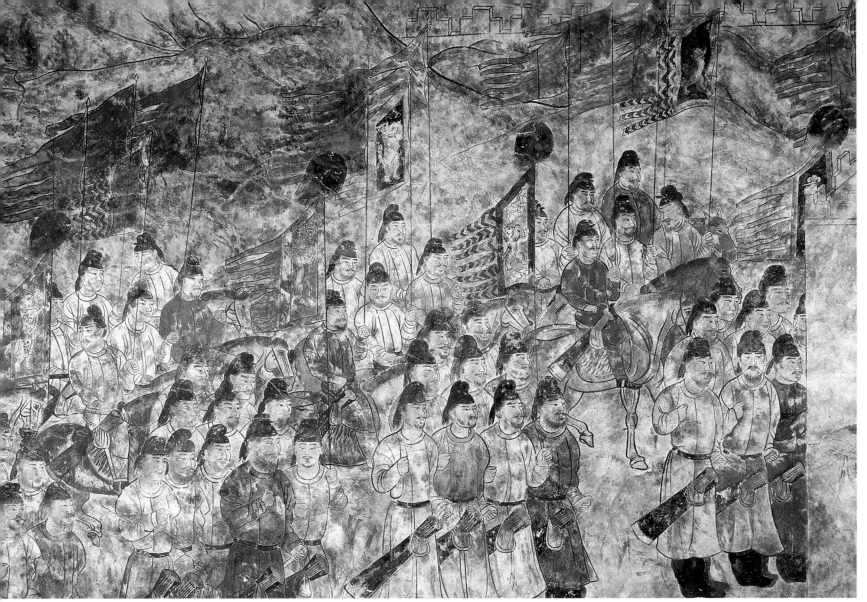

439

440

439. *Procession* – **a mural in Prince Yi De's Tomb**
The procession depicted in this mural consists of charioteers, cavalry and infantry, reflecting the composition of the army in the Tang dynasty.

440. Rubbing of *Portrait of Guanyin*
The carving from which this rubbing was taken is allegedly by the famous Tang painter Wu Daozi, who was adept in Buddhist subjects. Guanyin, a bodhisattva, was assimilated into Chinese culture and often portrayed as a woman or identified with existing female goddesses.

441, 442. Stone engravings on the outer coffin of Princess Yong Tai
These engravings depict Tang-dynasty women, perhaps the princess herself, and are executed with concise but flowing lines.

443. *Woman being Fanned* **by Zhou Fang**
Zhou Fang was a Tang-dynasty nobleman from Changan who specialized in portraits of people at court and Buddhist subjects. He is renowned for his soft, gorgeous colours and concise lines.

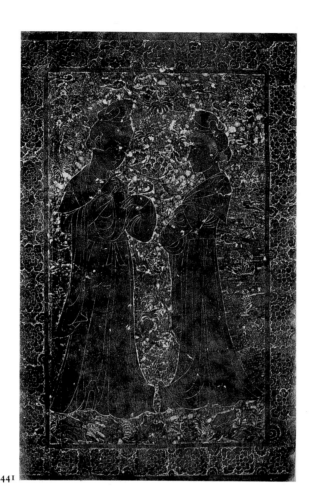

441

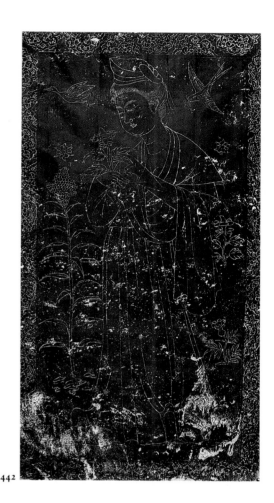

442

443

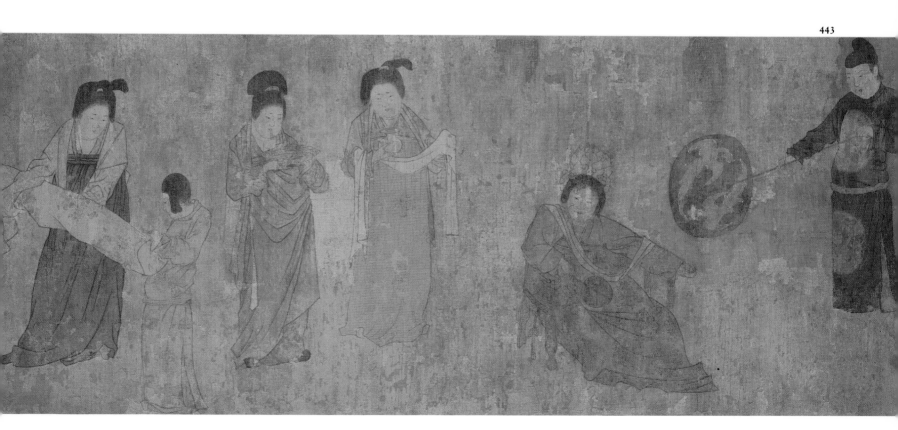

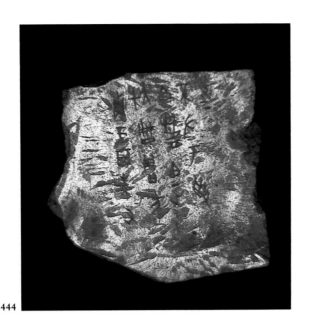

444

444. Oracle-bone inscriptions from the Western Zhou dynasty
This is one of the oracle bones found at the site of a Western Zhou palace in Fengchu. It bears an inscription of twenty characters.

445

446

445. Inscribed tray
This bronze tray, found on the Zhou Plateau near Xian, bears an inscription recording the deeds of the seven Western Zhou kings.

446. Rubbing of an inscription from a stone drum
This inscription is taken from one of ten Qin-dynasty drum-shaped stones found in Fengxiang Province, the oldest extant stone inscriptions in China. Each stone is inscribed with ten poems in the seal-script style, and they have been regarded as a model by generations of calligraphers.

447. The Yishan Stele
The inscription on this Qin-dynasty stele, which records the exploits of the First Emperor, is purportedly in the seal-script handwriting of the famous legalist Li Si. The original stone no longer exists, but of the many reproductions that done by Zhang Wenbao of the Song dynasty, known as the Changan copy, is the most famous, because of its animated strokes and classic elegance.

448. Plate inscribed with an imperial edict of the Qin dynasty
This bronze plate, one of the many inlaid into weights, is inscribed with an imperial edict which records that, after unifying China in 221 BC, the First Emperor ordered his ministers Wei Zhuang and Wang Wan to standardize weights and measures throughout the country.

449. Stele to Cao Quan
This Eastern Han-dynasty stele bears an inscription written in the official-style script, erected by Wang Chang and others to record the services of Cao Quan. It was found on the site of an ancient city in Heyang County, Shaanxi Province, during the Ming dynasty.

450. Stele to General Guangwu

This stele was erected in AD 367 in the Former Qin dynasty to honour General Guangwu. The inscription is in the official-style script.

451. Stele to Sima Fang

The upper part of this Eastern Jin stele was found in 1952 in the city of Xian and is now in the Stele Forest Museum. The remaining part is broken into three sections. The calligraphy is in the official-style script but with hints of both the cursive and uncular styles. The horizontal tablet over the stele is inscribed in the seal script with 'Eulogy to Lord Sima, the Late Commandant and Magistrate of the Capital of the Han dynasty', and is surrounded by hydra patterns characteristic of this kind of horizontal tablet from the Eastern Han, Sui and Tang dynasties. The description about Sima Fang, the father of the famous general Sima Yi, conforms to that in the Jin-dynasty official history.

452. Liquan Stele in Jiucheng Palace

The inscription on this stele was composed by Wei Zheng. It was erected in AD 632 during the reign of the Tang emperor Taizong. The horizontal inscription on top of the stele is in the seal-style script, while the calligraphy of the stele inscription is representative of the work of Ouyang Xun, a famous Tang-dynasty calligrapher, in the uncular style with a suggestion of the official style.

450

451

452

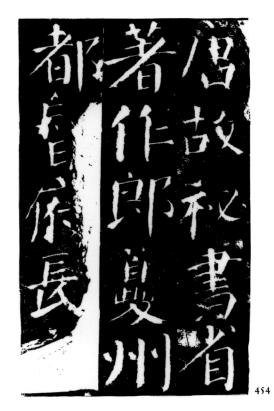

453

454

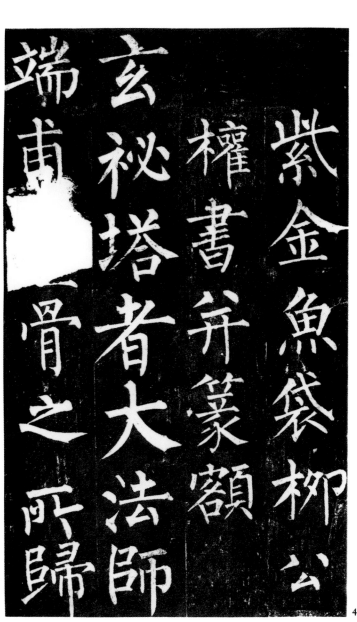

455

453. Stele inscription by Wang Xizhi
This stele was erected in AD 672 during the reign of the Tang emperor Gaozong. The characters on it were collected by a monk at Hongfu Temple, Huai Ren, from the works of Wang Xizhi, a renowned calligrapher of the Eastern Jin dynasty who exerted a great influence on later calligraphers.

454. Stele to Yan Qinli
The inscription on this stele was composed and written in AD 779 in his old age by the great Tang-dynasty calligrapher Yan Zhanqing. It is written in the orthodox style with neat, vigorous strokes and is a eulogy to his great-grandfather, Yan Qinli.

455. Xuanmi Stupa
The inscription on this stupa was composed by Pei Xiu and written in the uncular style by Liu Gongquan. It was erected in AD 841.

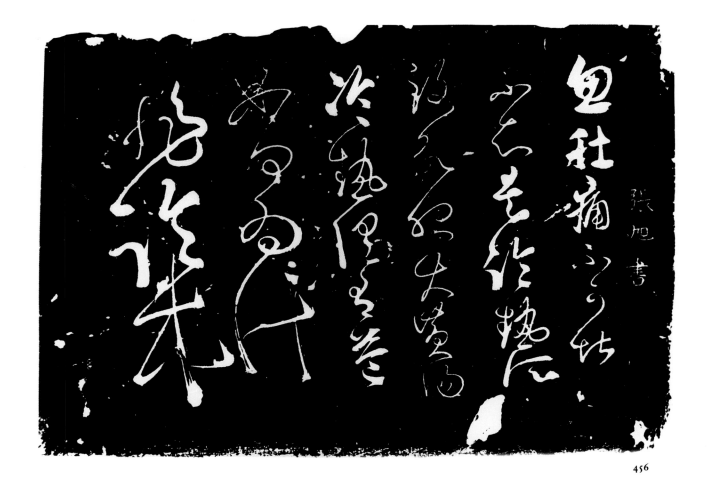

456

456. Record of a stomach-ache

This inscription of thirty-six characters in the cursive style is believed to have been written by the great Tang-dynasty calligrapher Zhang Xu, and there is a reproduction of it done by Wang Shiji of the Ming dynasty in the Stele Forest Museum in Xian, which says that it is 'a masterpiece exemplifying perfection'. The original text reads: 'I was suddenly seized by an unbearable stomach-ache and not knowing whether it was caused by cold or heat I took a decoction of rhubarb which is effective in both cases. I'll see the doctor about what else to do.'

457–462. Official seals

The six seals shown here are mainly official seals of the Han, Wei and Jin dynasties. Seal engraving flourished from the Warring States period through the Qin and Han dynasties, while many seal-engraving masters emerged in the Ming and Qing dynasties. Private seals included name seals, title seals, seals with auspicious words, seals with characters for the animals symbolizing the year of a person's birth and collectors' and connoisseurs' seals.

457. Peace and longevity seal

458. Youth-offering seal

459. Seal of General Zhe Chong

460. Seal of Governor Lian Lu

461. Seal of King Qiang, loyal to Jin

462. Seal of righteous King Qiang of Jin

457

458

459

460

461

462

9.

Ancient Customs
and Lifestyles

Folk customs were an integral part of city life in Changan, reflecting the prosperity of the Han and Tang periods. The customs included traditional festivals, music, dancing and other entertainments, and special activities of the literati. Through a study of them much can be learned about the origins of the beliefs, myths and superstitions of the Chinese people, and they also provide a glimpse of traditional city life outside the court.

Traditional Festivals

Festivals are probably the most representative of the ancient customs of the city, not only embodying the people's knowledge of the natural world but also their belief in myths and legends.

Many of the festivals familiar to Chinese people today, such as Spring Festival, New Year's Day, Lantern Festival, Cold Food Day, Pure Brightness Day, Dragon-Boat Festival, Double Seventh Night and Double Ninth Night, date from Han and Tang times. The most important was Spring Festival, a celebration of the lunar new year, which now falls in late January or early February and is still widely celebrated by Chinese at home and abroad. In imperial times the celebrations began in the twelfth lunar month, when sacrifices were offered to the ancestors and the five gods in charge of travel, the house entrance or door, family, earth and the kitchen. Of these five the door and kitchen gods were the most respected. On the eighth of this month every household in Changan put up door gods carved of peachwood, drawings of fierce tigers and reed ropes on the gates and a portrait of the kitchen god over the range with wine and fruit placed

as an offering before it. In the Han dynasty the door gods were Yu Lei and Shen Tu, but by the Tang had changed to Qin Qiong and Yuchi Jingde and were supplemented by another, Zhong Gui, later in the Tang. The images were supposed to ward off evil and misfortune and bring good fortune to the household.

The most impressive part of the ceremonies that took place during this month was the *danuo* or *chunuo*, the demon-exorcizing ceremony. This was held on New Year's Eve and traces its origins back to shamanistic song and dance ritual created by the Yellow Emperor to exorcize demons. The custom was already observed both in the court and among the people during the Zhou and continued to be practised in the Han and Tang. The *shehuo* ceremony which is performed during the Spring Festival in Changan County today consists of various folk theatricals such as traditional opera, acrobatics and song and dance, and is believed to have developed from the *danuo*.

By the Han and Tang dynasties the *danuo* was held on a grand scale in the imperial palace. An account of the ceremony is given by the Tang poet Shan Quanqu: 'In the hall the lantern holders compete to be the brightest. In the palace the sorcerers compete to exorcize ghosts and spirits.' Another Tang poet, Wang Jian, also described the celebrations: 'The *danuo* was held on New Year's Eve. People dressed in brightly patterned trousers and vermilion coats proceeded in four rows. Lanterns illuminated every courtyard and the lute players strummed among the incense smoke.'

On this night in imperial times every family would gather together for a feast and drink pepper wine. They would stay up late, sitting around the fire to see the old year out and the new year in.

The first day of the new year was called *yuandan* or *zhengdan* (day of the first full moon) and at dawn everyone set off firecrackers to frighten away evil spirits. This was called *paozhu* (exploding bamboo), because at that time firecrackers were made from bamboo stems: the air inside the hollow segments would expand when the bamboo was burnt, causing the stem to split open with a loud crack. Special food and drink was then served; *xinpan*, delicacies made of the five pungent vegetables, were eaten to dissipate the stale *qi* (vital air) in the five internal organs of the body, and wines made with pepper, cypress leaves and herbs were all medicinal drinks.

On the second day of the festival people visited friends and relatives and invited each other to feast. On the seventh day, called Mortals Day, every household presented gifts of swallows (representing spring) cut from silk, and *hua sheng* (a kind of ornament) to friends and posted the two characters for 'Happy Spring' on the door. Some households also carved human figures out of gold leaf and pasted them on screens to symbolize the arrival of

a new phase of life at the beginning of spring. Also, in Changan the people made papercuts of spring butterflies, coins and *hua sheng* along with small pennants which were either worn by young women as hair ornaments or used to embellish plants. This custom has passed down through the generations and developed into the art of making papercuts to decorate windows, popular in Shaanxi Province today.

It was also a Han-dynasty custom on one of the days of the new spring term for the cattle and ploughmen to be exhibited outside the gate of the yamen (the local government office) in order to 'instruct the people' in both the capital and provincial towns. The New Year block print, *Cattle in Spring Ploughing*, has been passed down from ancient Changan.

The Spring Festival celebrations climaxed on the fifteenth day of the first lunar month in the Lantern Festival. This is believed to have developed from an Eastern Han imperial custom of lighting lanterns in the evening of the first day of the new year as an offering to the *taiyi* star.

The exhibition of lanterns at the Lantern Festival in Changan varied in scale from dynasty to dynasty, the most impressive being those in the Sui and Tang dynasties. According to the official history of the Sui dynasty, *Suishu*: 'Envoys from numerous states came to pay homage to the court on the first moon and stayed until the fifteenth day of the month. An exhibition ground was marked out which extended for 2.5 miles from the Duan to the Jiang gates. Officials of all ranks accompanied the honourable envoys who viewed the lanterns from dusk to dawn. Thirty thousand male singers and dancers, all dressed in female attire and decorated with many ornaments, performed on the occasion.' According to historical records the Lantern Festival was just as impressive in the Tang. On the evenings of the fifteenth and sixteenth days of the first month during the reign of Emperor Ruizong a tower 550 feet high was erected outside Anfu Gate, festooned with colourful

silks, gold and silver, and lit by 50,000 lanterns, so that it 'resembled a huge tree in full bloom'. 'A thousand palace serving maids, wearing gauze and fine silk dresses, pearls and jade jewellery and fine make-up, together with a thousand young women from Changan and Wannian counties, sang and danced for three days and nights under this enormous lantern.' In the reign of Emperor Xuanzong twenty lantern towers, each 130 feet high, were erected and decorated with jade and pearls, which tinkled in the breeze to produce beautiful music. The lanterns were in the shapes of dragons, phoenix, tigers and leopards, all wonderfully lifelike in flying and dancing postures. When night fell the emperor climbed the palace gatetower to watch and share the enjoyment of his people as thousands of young girls sang and danced under the light and lantern viewers bustled about the streets. Kinsmen of the imperial house took advantage of the occasion to vie with each other in showing off their wealth. Legend has it that the Lady Han, sister of the famous concubine Lady Yang, had an eighty-seven-foot lantern tree erected, festooned with scores of lanterns, which shone like a burning tree with silver flowers.

In the second lunar month two festivals were observed, one closely following the other: the Cold Food and Pure Brightness Days. The Cold Food Day goes back to the Zhou dynasty, when it was said to have been observed to remind the people of the need to prevent fire. In the Spring and Autumn period it became combined with the commemoration of the loyalty of Jie Zitui, a minister of Duke Wen of the State of Jin. On that day every year residents of Changan put out their kitchen fire and ate cold food that had been prepared earlier. Only on the third day did the ordinary people relight their fires, but on the evening of the second day children in the imperial palace would compete with each other to see who could produce fire first, using the drilling method with sticks, the winner being awarded with three bolts of silk and a bowl. The new fire was sent by special messenger to the houses of the ministers and dignitaries as a sign of imperial favour. Many other activities also went on in Changan on this day, including a form of football using a ball made from skin, swinging, tug-of-war, polo and cock-fighting.

Football was first played in the Han dynasty and had become a popular sport by the Tang. Emperor Xizong, an expert player, once bragged that he could beat anyone in the country. The game was usually played by two people standing opposite each other, and the winner was often rewarded with a prize of money.

Swinging was a favourite pastime of the women, especially among imperial concubines and palace maids, who would compete in the height they could reach, but the game was also popular among the common people. Emperor Xuanzong described it as 'a pastime of semi-celestials' and Li Shanfu wrote: 'The breeze scatters smoke and flowers as girls swing and fly over the wall.' On days when the peach trees were in blossom and the willows showed their new green leaves, the many swings with their colourfully dressed occupants added to the beauty of the scene.

Polo was the most fashionable sport in ancient Changan, and many of the Tang emperors were fine players. There is the following record of a polo match: 'During the reign of Zhongzong a polo match was held in the palace between the imperial team and a team from Tibet. The latter consisted of ten emissaries while the imperial team had only four players, Princes Li Longji and Si Guo, the imperial son-in-law Yang Shenjiao and another relative Wu Ji. At the end the imperial team came out the undisputed winner.'

After he had ascended the throne, Li Longji (Emperor Xuanzong) became addicted to polo and organized large-scale matches which were held near Daming Palace. He also loved to organize tug-of-war competitions on Pure Brightness Day, when often as many as a thousand people would take part amid 'thunderous drum-beating and the deafening cheers of the crowds'.

Cock-fighting on both Cold Food and Pure Brightness Days was popular among the people and at court during the Tang. During the reign of Xuanzong a chicken coop was built outside the palace in which 1,000 cocks were kept, looked after by 500 young children. Because of the emperor's interest the game became popular among people of both sexes in the city, and even those who could not afford the fowls are said to have imitated the fights using wooden models.

In ancient times the last festival in the spring season was the Shangji Festival, which fell on the third day of the third lunar month. According to the official history of the Jin dynasty, on this day people bathed in the streams and rivers to cleanse themselves of filth and pestilent airs. On the same day they would drink on the shores of Lake Qujiang, during which time they filled their cups with wine and placed them on the lake. The cups drifted about with the current, and when a cup landed in front of someone, that person had to drain it in one go; this was called 'Downing the Flowing Cups of Lake Qujiang'.

Lake Qujiang, on Leyou Plain to the south of Xian, was the centre of the activities held on this day during the Tang. Apart from the above activities there was a spring outing, 'treading on green grass', as it was called, and a flower competition. Scholar officials spared no expense to buy the best and rarest flowers and plant them in their courtyard gardens in preparation for this competition. A vivid account tells how, on the eve of the competition, the three-mile-long embankment around Lake Qujiang and Apricot Garden was lined with floral carriages and colourful streamers as crowds of holiday-makers bustled around beating drums and playing vertical bamboo flutes. Women vied with each other in the exotic flowers that they wore in their hair. In this pleasant spring weather the emperor led his ministers and leading scholars to the lakeside where they feasted together. After the feast he treated them to a cruise on the lake in flower-adorned boats.

The celebration of this festival was far more impressive in the Tang than in the Qin or the Han dynasties. It was described by the Tang poet, Xu Tang: 'The whole city revelled in the fragrant morning. Horsemen and chariots rushed back and forth. The birds disappeared in fright among the clouds; the fish vanished in alarm under the waves.'

The Dragon-Boat Festival, held on the fifth day of the fifth lunar month, fell after the end of spring, but before the summer harvest. It is an important festival still observed in China today. In the Han dynasty the residents of Changan usually hung a red rope and peach-wood seal on their doors to ward off 'evil vapours'. The red rope was changed during the Northern and Southern dynasties to a finely woven stranded rope of red, yellow, blue, white and black silk threads, which was tied around children's hands and feet. Sometimes the threads were

woven in the shapes of the sun, moon, stars, birds and animals and embroidered with gold filament. These, called Longevity Strands, were presented to the elders as a symbol of long life. Later these strands were replaced as gifts by pouches filled with medicinal herbs and perfume, while the five-coloured strand was used to ward off evil spirits. At this time it was also customary to drink calamus wine, said to dispel illness and prolong life.

Another activity at the Dragon-Boat Festival was the commemoration of the poet Chu Yuan of the Warring States period. No boat races were held in Changan at this time, but it was fashionable to eat *zongzi* or *jiaoshu* (a mixture of glutinous rice wrapped in bamboo or reed leaves and steamed), and to wear the five-coloured strand as a waist pendant. As the Tang poet Quan Deyu described it: 'The fifth is a day of rejoicing. All wish the elders longevity. Colourful threads provide a riot of colour. Flimsy gowns reveal the graceful bodies of young women.'

Double Seventh Night, or Qiqiao (Begging for Nimble Hands) Festival, was the most romantic of all the festivals. In the Han dynasty it usually only took place in the imperial palace and consisted of two major activities: begging the Weaving-Maid (the heroine of a legend, who had fallen in love with a cowherd; both of them were turned into stars, separated by the Milky Way) to give the supplicant a deft pair of hands, and, also, praying for eternal love. The former request became very popular in the Tang, according to one account: 'On the seventh day of the seventh moon, Emperor Xuanzong and Lady Yang gave a banquet, spreading fruit on a table in the courtyard in front of the Huaqing Hall to seek the benevolence of the Cowherd and Weaving-Maid Stars. The young female guests each had a spider in a small closed box. If by morning it had spun a tight web then the young girl could expect to show the same nimbleness in her weaving. The custom is still observed by young women today.' Another passage in the same book says: 'A hundred-foot-tall tower clothed with silk was erected in the palace. Inside the tower, which could hold scores of people, wine, melons and other fruit were spread on a table to offer to the Weaving-Maid and Cowherd. The young women from the emperor's entourage then held a needle-work contest, whereby each had to thread needles with five different coloured threads. The one finishing first won and was named the most nimble fingered. After this they feasted, sang and danced until dawn. This custom later spread among the common people.' It became so popular that 'All households beg for nimble fingers in the autumn moonlight, and thousands of coloured threads are used.'

Nine was regarded as a Yang (positive or masculine) number, standing for good luck in ancient times, so that the ninth day of the ninth month was a particularly auspicious day, popularly known as Chongyang (Double Ninth) Day. In the Han and Tang dynasties on Chongyang Day it was customary for people to climb to a high place to picnic and pick cornel plants, supposed to be efficacious in warding off evil spirits. The weather at this time of the year was usually fine and pleasant, and people would meet in Changan and leave the city in groups for Leyou Plateau, by Lake Qujiang, where they could see far into the distance as well as having a good view of the city itself. People drank chrysanthemum wine and stuck the cornel plants in the clothes of friends and relatives to avert disaster. Particular thought was given to friends and relatives who were far away. In his poem, 'Thinking of my Brothers in Shandong on Chongyang Day', Wang Wei wrote: 'A traveller all alone in a foreign land, I am doubly homesick on this day.'

Music and Dancing

After the Western Han made Changan its capital, the arts and culture flourished in the stable, prosperous and powerful period at the start of the dynasty. There were many changes in leisure and entertainment activities; for the wealthy, hunting became fashionable, while the common people could watch one of the many forms of theatre. Hunting parks and entertainment centres were built to satisfy these new demands.

The many different varieties of entertainment were called the *Bai Xi*, or Hundred Performing Arts. This term encompassed practically every form of live theatre imaginable, from acrobatics, displays of martial arts, magic shows and farces to music, singing and dancing. In the palace professional musicians often presented shows such as *Lord Huang of the East Sea* or *The Immortal Zong Hui*. According to a record of events in the Western Han, song and dance performances were held in 112 BC, during Emperor Wu's reign, to entertain envoys from foreign lands. In 115 BC the Ping Le Hall in the Shanglin Imperial Park was opened to the public and people came from miles around to see the song and dance performances.

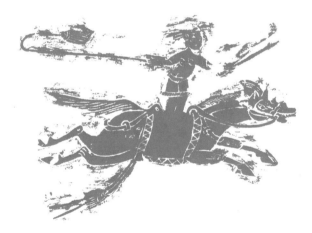

These palace performances were spectacular in scale and covered a wide range of subjects. A very detailed account is given of them in Zhang Heng's poem, *Ode to the Western Capital (Xijingfu)*, where it is recorded that during the festival 'beasts of every description danced with ease and grace, fish and dragons frolicked amid rolling waves. All of a sudden a yellow dragon emerged from the mist and clouds while a white tiger played the zither and a green dragon the lute. The goddesses Ehuang

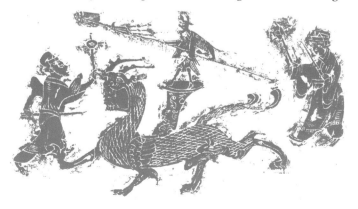

and Nushan sang a duet. Hardly had they finished when, amid the roar of thunder and the fall of snow, exotic beasts, red sparrows and white elephants appeared dancing gracefully. Finally a magician came onstage, swallowed a dagger, spat fire and produced clouds and mist, whisking the audience into a wonderland.'

During the Northern and Southern dynasties the *Bai Xi* became popular throughout the country, with songs and dances being performed everywhere. The five-square lion dance, similar to the modern lion dance, was popular at the palace and among the people. Performances were often staged in the open air to the vocal accompaniment of the audience.

The Tang court inherited and further developed the music and dance of the Northern and Southern dynasties. In AD 637 an additional category was added to the nine-category palace music of the Sui dynasty. Of these ten only two were indigenous Chinese music; the other eight were various types of folk music which either derived from, or had been influenced by, foreign music. Dances such as the 'Barbarians Twirling Dance' and the waltz were performed to this music and were popular in the mid-Tang. After the mid-Tang a large part of the music and dance from the western regions was assimilated to enrich the existing forms yet further.

One of the best known dances of this period was the sword dance, and its most famous performer was a Lady Gongsun. In the preface to his poem 'The Pupil of Lady Gongsun Performs the Sword Dance', the Tang poet Du Fu recalls his childhood days when he saw the Lady Gongsun perform the dance herself: 'At that time the audience gazed breathlessly, mouths agape, her dance causing heaven and earth to rise and fall.' The work of the master calligraphers Zhang Xu and Huai Su is said to have been influenced by the vigorous, graceful and smooth steps of her dance.

Customs of the Literati in Tang Changan

Soon after its founding, the Tang dynasty started to select officials by grading their poems in the imperial civil examinations. This not only precipitated the golden age of Chinese poetry but also nurtured a galaxy of new poets. Reciting and poetry capping, that is, composing poems on the spot to a rhyme-pattern set by another person, were characteristic social customs of the time.

Most of the Tang emperors were good at writing poems and essays. At palace banquets it was not unusual for the emperor to compose a poem and the ministers each write their own in reply, using the same rhyme-pattern. Tang poetry reached its peak of development during the reign of Xuanzong, when Changan was a place of assembly for poets who would gather in wine shops to cap and compose. Some of these poems were set to music and given to girls to sing, and some were passed from person to person so that even the old and very young could recite them from memory.

Writing poems could bring fame, an official post and even imperial favour, and so many Tang literati devoted themselves to it as a lifetime career. Anyone who had been successful in the imperial examinations because of an outstanding poem would be greatly honoured, being feasted in Apricot Gardens and asked to sign a stele at the foot of the Greater Wild Goose Pagoda. Then, according to the *Shaanxi Almanac (Qin Zhong Sui Shiji)*, the youngest two would be sent to the city's famous gardens to hunt for rare flowers. For this reason the banquet in their honour was called 'Flower-Hunting Banquet'.

Another custom of Tang literati was to retire from conventional life, drinking freely, evading worldly gains and following Buddhist and Daoist precepts rather than the Confucian ideals that permeated official life. The poem by Du Fu, 'Eight Immortals of the Winecup', presents a picture of such a life. The characters in the poem, the prince, prime minister, poets and commoners, must have been typical of their time. Among them He Zhizhang called himself the Profligate of Siming, while the celebrated calligrapher Zhang Xu was known as Zhang the Madman. It is said that whenever he had drunk too much he would run back and forth crying and yelling, then he would dip his head in the ink and wield it like an enormous writing brush. Both Li Bai and He Zhizhang frequented the wine shops of the city and once, when they met and found that neither of them had any money, they exchanged the gold tortoises, proof of their official rank, for wine. This *laissez-faire* way of life exerted a great influence on much of the poetry of the period.

Vignettes of Life in the Imperial Capital

Changan in the Tang covered a large area. According to contemporary accounts the two markets thronged with buyers and sellers. Snack-bars and wine shops were numerous, serving meat dumplings, steamed buns, sesame cakes and a wide selection of other local delicacies; the famous deep-fried dough cone was so tempting that people riding past would dismount just to taste it, and the grape wine sold in shops run by nomadic tribesmen from the western regions was noted for its aroma and mellowness. The thriving of the marketplace is reflected in Li Bai's poem, 'Song of Youth':

The youths came from Wuling, riding east into Jinshi
With silver saddles and white horses they passed like
* the spring breeze.*
The falling blossoms fell around, who knows where they
* are going?*
The maid from foreign lands laughs in the wine shop.

Changan was not only renowned for its imposing city walls and flourishing trade but also for being perhaps the greenest city in the world. In the Han the imperial park boasted thousands of pomegranate, chestnut and date trees and many grape vines, and there were innumerable willows lining the city streets. During the Tang the main streets were lined with scholar trees which blossomed profusely and could be seen from Leyou Plateau. There were also numerous persimmons both in the grounds of the Green Dragon Temple and in the city suburbs. Apricot Garden, as its name suggests, was famed for its apricot blossoms. East of the city luxuriant willows lined both banks of the Ba Bridge Post Road. Every year in spring when the trees were covered with fleecy catkins the scene was called Snowstorm at Ba Bridge, as the catkins resembled snowflakes wafting in the breeze. From the Han dynasty this had been the place where people saw off their friends and relatives who were leaving the city.

The peony was the most famous flower in Changan, being called the 'National beauty with heavenly aroma'. The most luxurious peony plants were to be found in Xingqing Palace and Dacien Temple. On fine spring days young people would go there in groups to admire their beauty, some riding on ponies decorated with colourful silk. They would dismount for a feast near the rare and beautiful flowers.

463. Spring-ox almanac

This is a popular peasant almanac which has a picture of an ox ploughing with an attendant god in spring. It gives the twelve months and the twenty-four solar terms along with auspicious words.

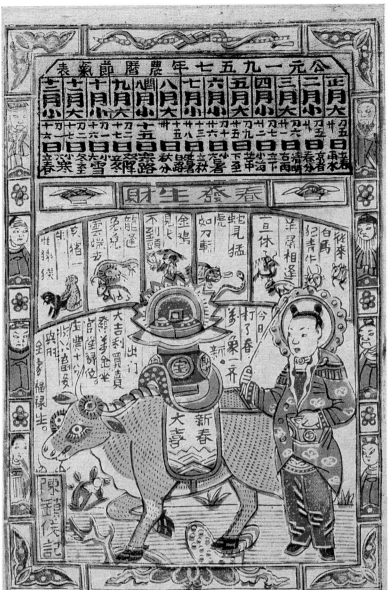

463

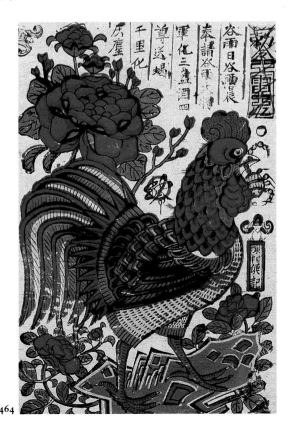

464. Picture of grain and rain – one of the twenty-four solar terms

464

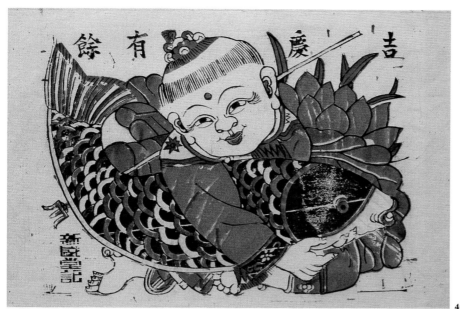

餘有 慶 吉

465

465. Picture representing 'abundance'
Ji Qing You Yu were the four characters, meaning 'abundance', that were used in the New Year Festival to express the desire for enough money and food. This picture of a child with a fish in his arms is symbolic; the Chinese words for fish and abundance are both pronounced *yu*.

466

郡最靈應老少清吉獲禎祥！

手掌宝劍鎮家鄉斬妖除

硃砂神伴下天堂

466. Zhong Kui the ghost-tamer
The custom of sticking a picture of Zhong Kui on the wall during the New Year Festival began in the Tang dynasty. In 1072, the Song-dynasty emperor Shenzong ordered court painters to copy the portrait of Zhong Kui by the painter Wu Daozi and then had it block-printed, to be posted on doors to keep evil spirits out.

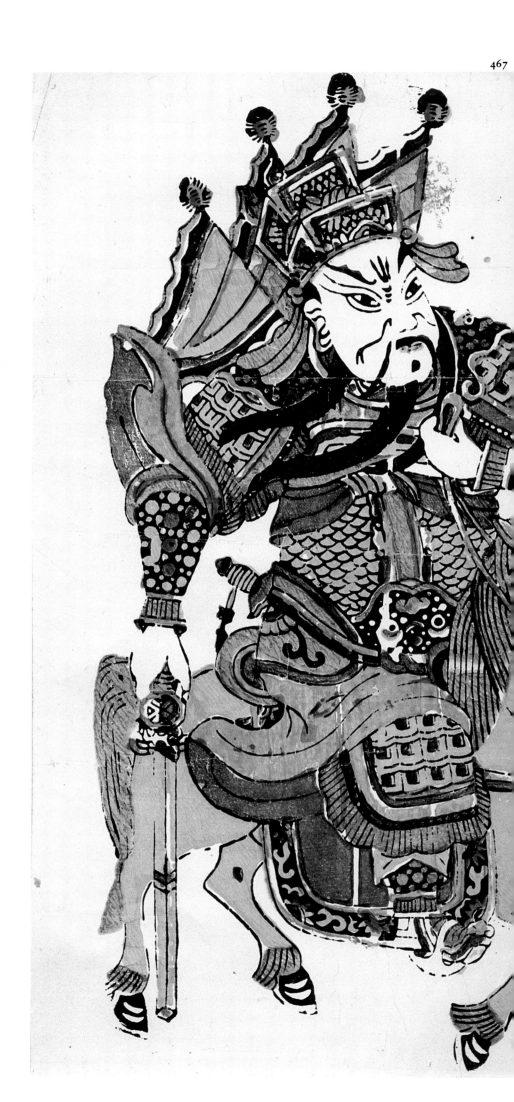

467. Qin Qiong the door god

468. Yuchi Gong the door god
Qin Qiong and Yuchi Gong were famous generals during the reign of Taizong in the Tang dynasty. It is said that once when Taizong fell ill he could hear ghosts howling in his dreams. The noise only stopped when the two generals stood guard at his door. In order to stop the howling permanently he had images of the two generals painted and hung on the door. When this incident became known the common people copied the emperor and also hung pictures of these two on their doors to ward off evil spirits.

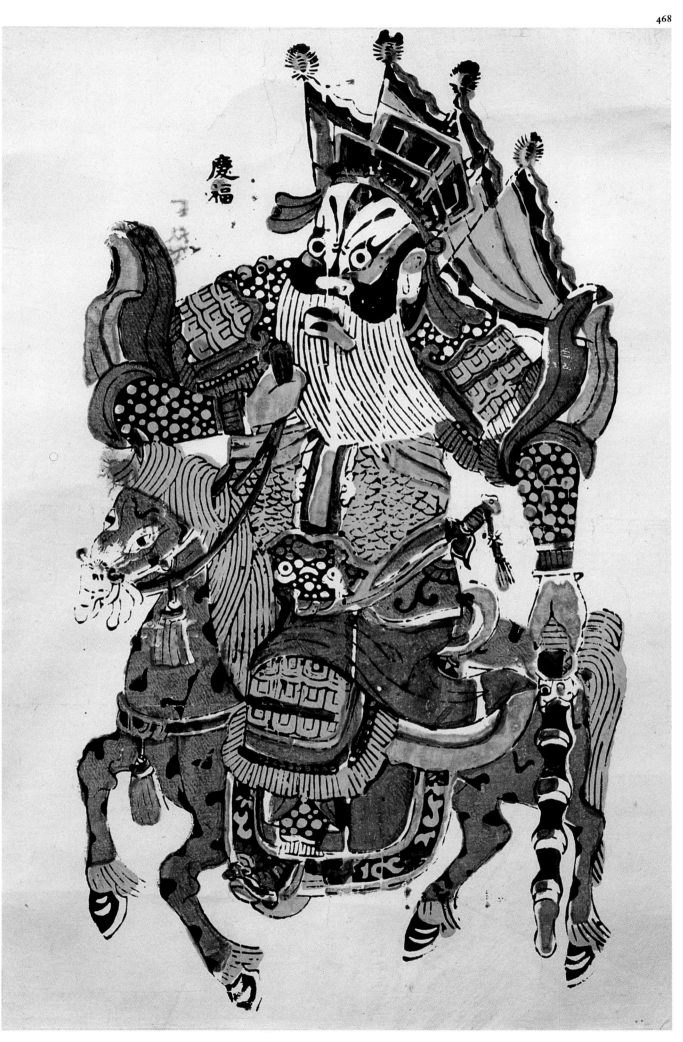

慶
福

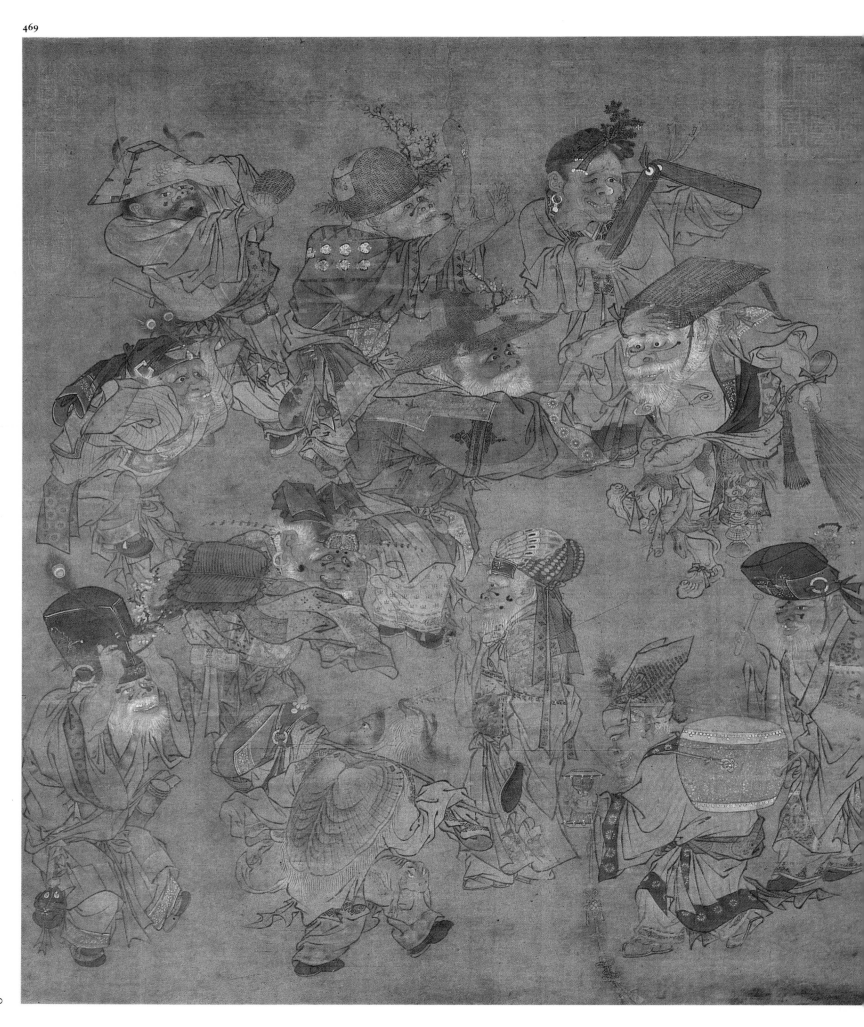

469. *Demon Exorcism*
This is a Song-dynasty painting of the *danuo*, an ancient folk custom to drive away epidemics, sickness and madness by exorcism, which is first recorded in *The Analects* of Confucius.

470

471

472

473

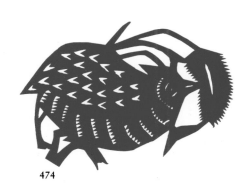

474

470–474. Shaanxi papercuts
During Spring Festival every household in Shaanxi used to paste colourful papercuts like these on their windows to greet the coming of spring. This custom is still popular today and the five papercuts shown here are from window decorations of peasant households near Xian.

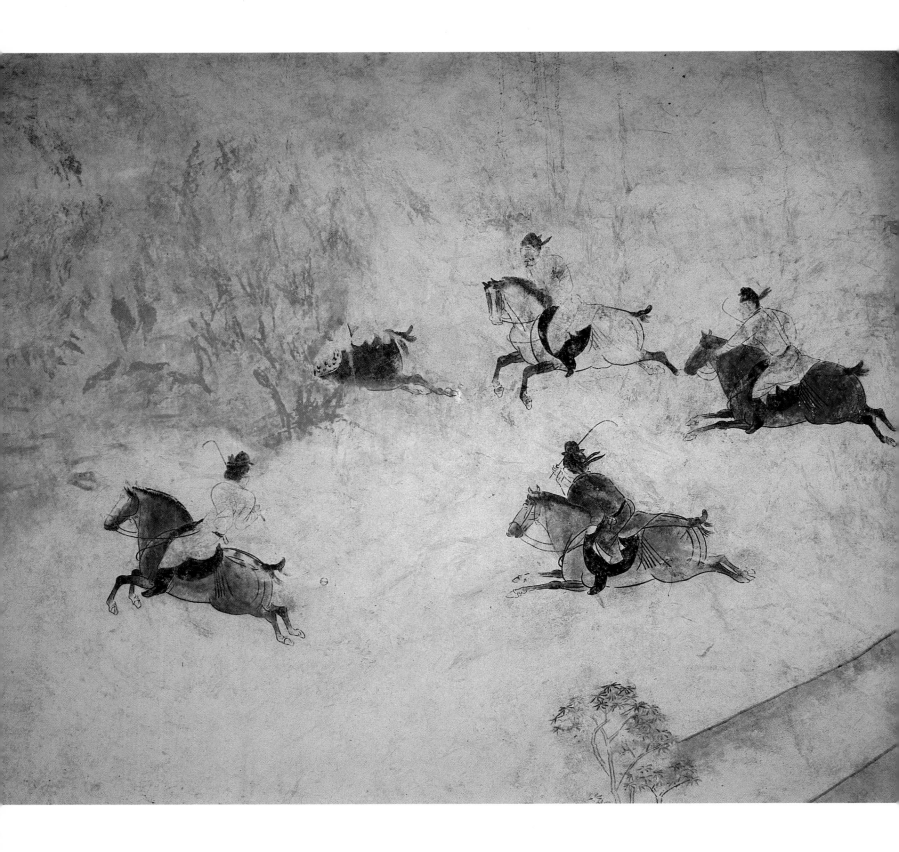

475. *A Polo Match* – **a mural in Prince Zhang Huai's Tomb**
Polo, which is thought to have originated in Persia, spread to China and from there to Japan and Korea. In the Tang dynasty it was a very fashionable sport among the imperial family and noblemen: Emperor Xuanzong was known to be a skilled player. Only a detail of the painting, which is 8 feet by 20 feet, is shown here.

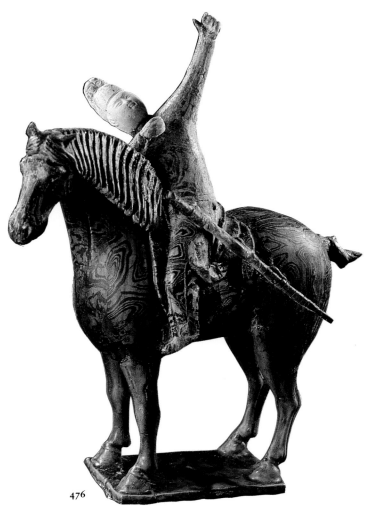

476. Tri-colour glazed-pottery figurine of a hunter
The Tang imperial family loved to hunt, as is shown by the numerous tri-colour pottery figurines of hunters in Crown Prince Yi De's tomb. This one is wearing a long sword at his waist and is in the act of releasing an arrow.

477. *Hunting* – a mural in Prince Zhang Huai's Tomb
In this scene, a detail of which is shown here, there are forty hunters galloping along, some with falcons on their shoulders, some with hounds, and all armed. Like other Tang-dynasty murals, the people are the main subjects, while the landscape of grass-covered hills and trees simply provides background details.

476

477

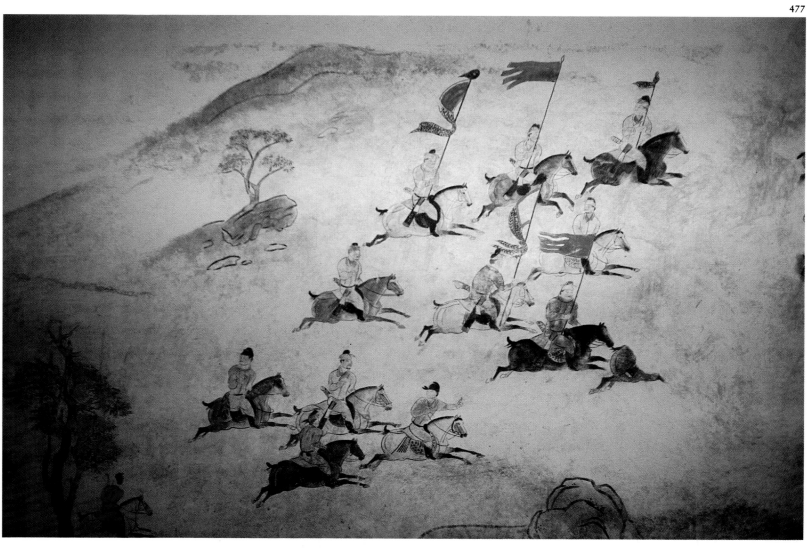

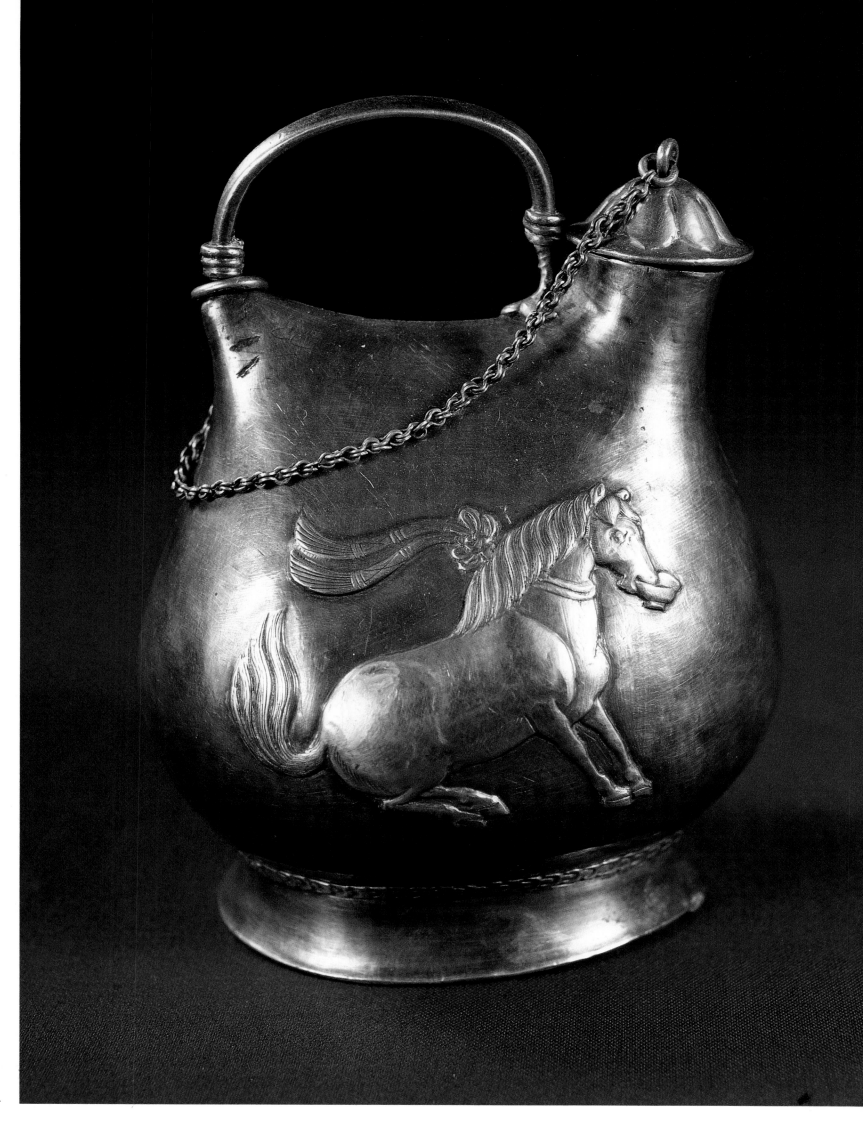

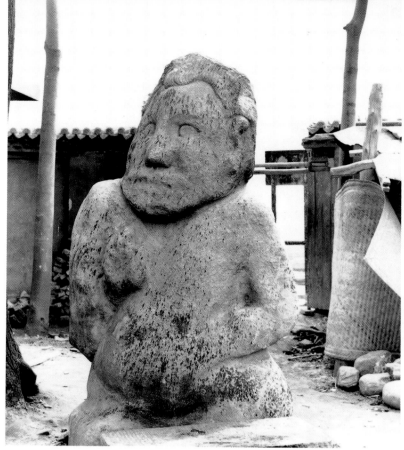

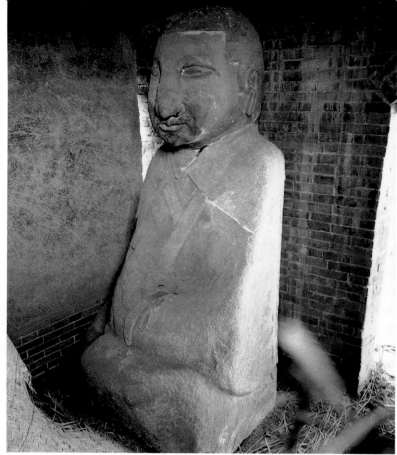

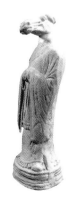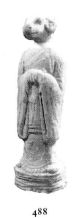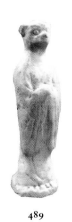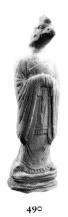

479

480

478. Silver jar with dancing-horse design
According to one source the Tang emperor Xuanzong kept 400 horses that were trained to dance like humans. Every year on his birthday they would be led into the palace to dance to music and then, at the end of the tune, would kneel before the emperor with a wine cup held in their teeth as if offering a birthday toast.

479. Stone statue of the Cowherd at Lake Kunming
According to historical records, when the Han-dynasty emperor Wu had Lake Kunming dug in the imperial park he had statues of the Cowherd and the Weaving-Maid placed on the east and west shores of the lakes. These two are popular figures of an ancient folk tale who fall in love but are eventually turned into stars and placed on either side of the Milky Way, only being allowed to see each other once a year. Kunming Lake was meant to represent the Milky Way, separating the lovers. The statue of the Cowherd, 8.5 feet high, is in good condition, with well-defined features.

480. Stone statue of the Weaving-Maid at Lake Kunming
This statue has been broken and repaired, but is recognizable as a woman with a bun at the nape of her neck. It is 7.5 feet high and similar in style to Western Han-dynasty figurines.

481–492. Animals of the Chinese zodiac
According to the Chinese zodiac, each year in a twelve-year cycle is symbolized by an animal. Twelve Tang-dynasty pottery figurines of the animals are shown here: the mouse, ox, tiger, rabbit, dragon, snake, horse, sheep, monkey, cockerel, dog and pig.

481 482 483 484 485 486

487 488 489 490 491 492

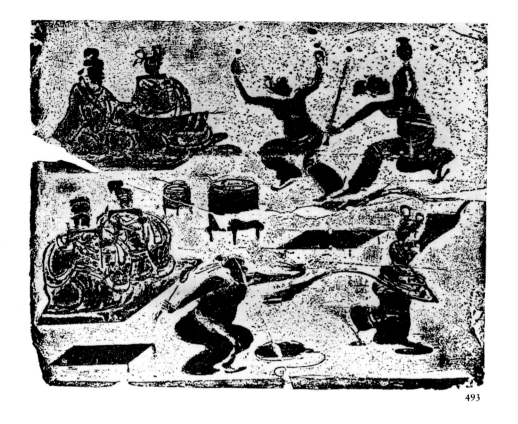

493

493–497. Engravings from *The Hundred Performing Arts*
The Bai Xi, Hundred Performing Arts, first appeared in the Qin dynasty and were very popular in the Han, drawing large audiences. These vivid picture-bricks from the Han dynasty bring to life the performances held in the imperial palaces.

494. *Horsemanship*

495. *Drum-beating*

496. *Dragon Dance*

497. *Tightrope-walking*

494

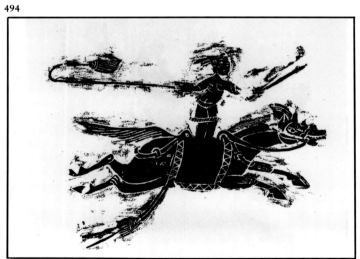

495

286

496

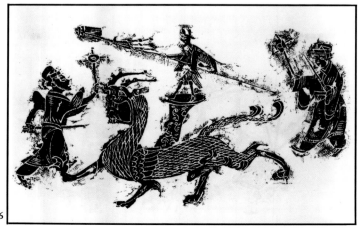

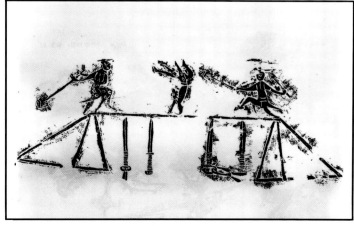

497

498

500, 501. *Han Xizai Gives a Night Feast* (overleaf)
This painting, done by Gu Hongzhong in the Five Dynasties period following the Tang, depicts the scene at a night feast given by the Southern dynasty minister Han Xizai.

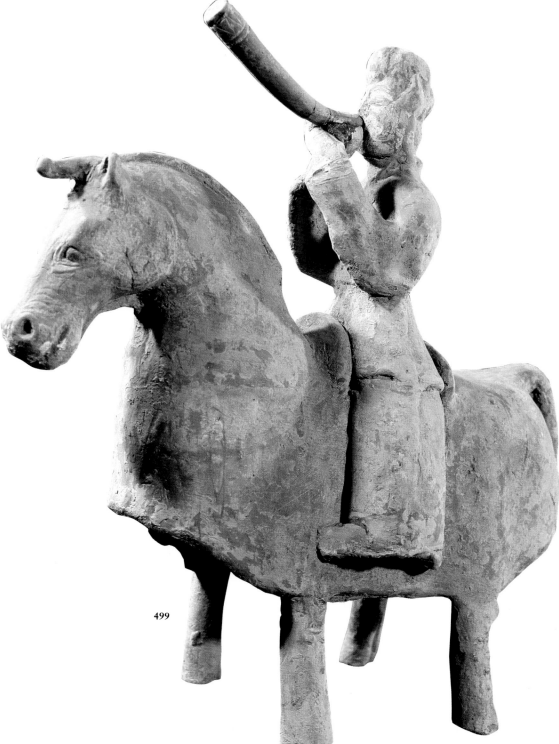

499

498. Engraving of palace maids
In this engraving from the stone coffin of a Tang-dynasty prince, Li Shou, the palace maids sit in three rows, each playing a musical instrument.

499. Pottery statue of a horseman blowing the bugle

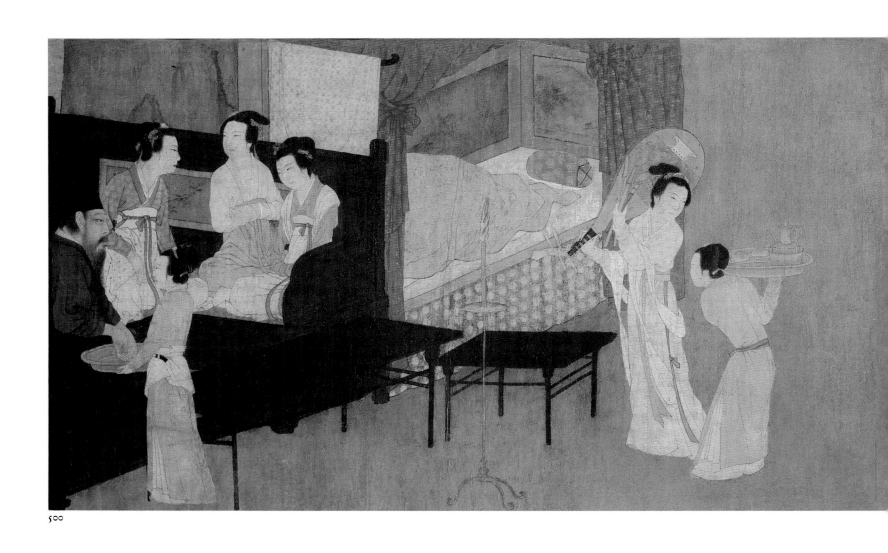

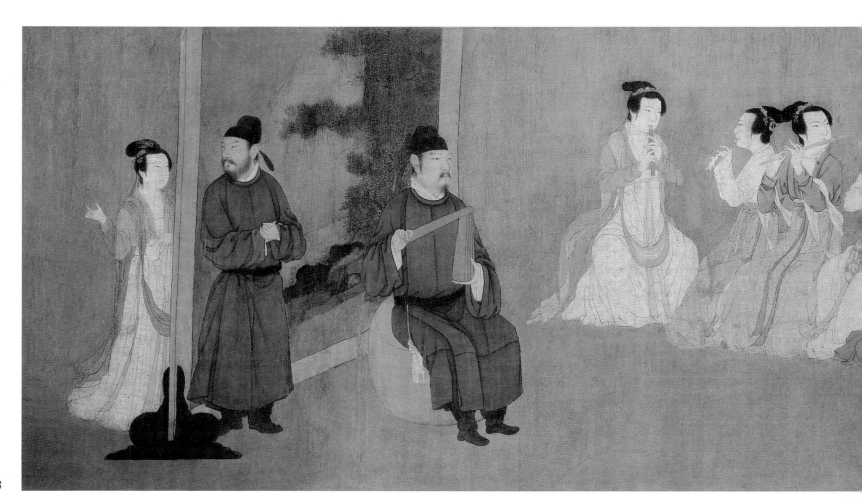

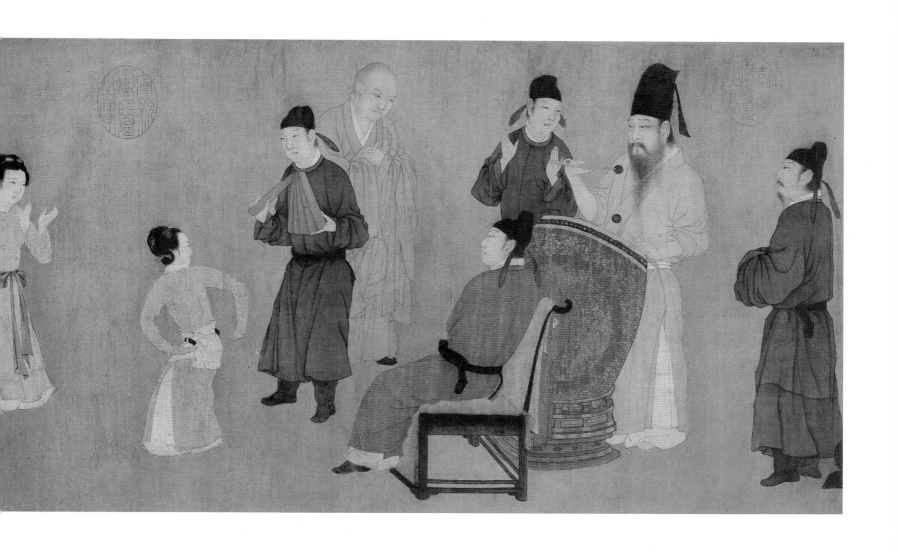

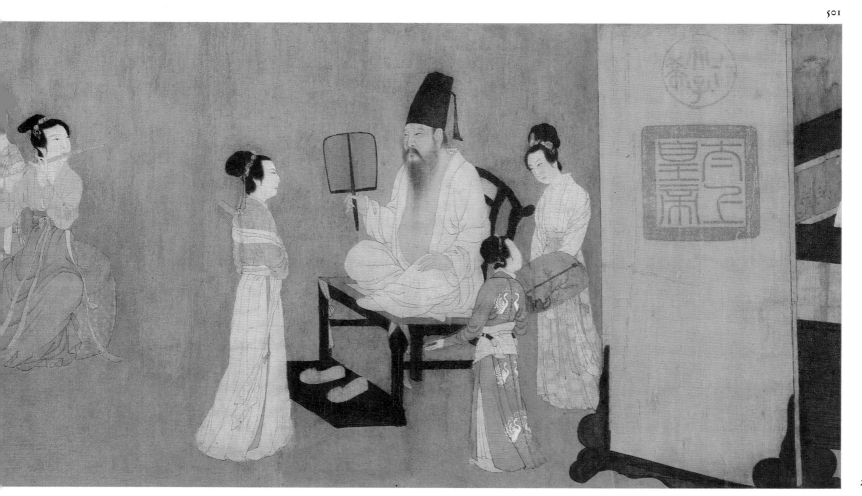

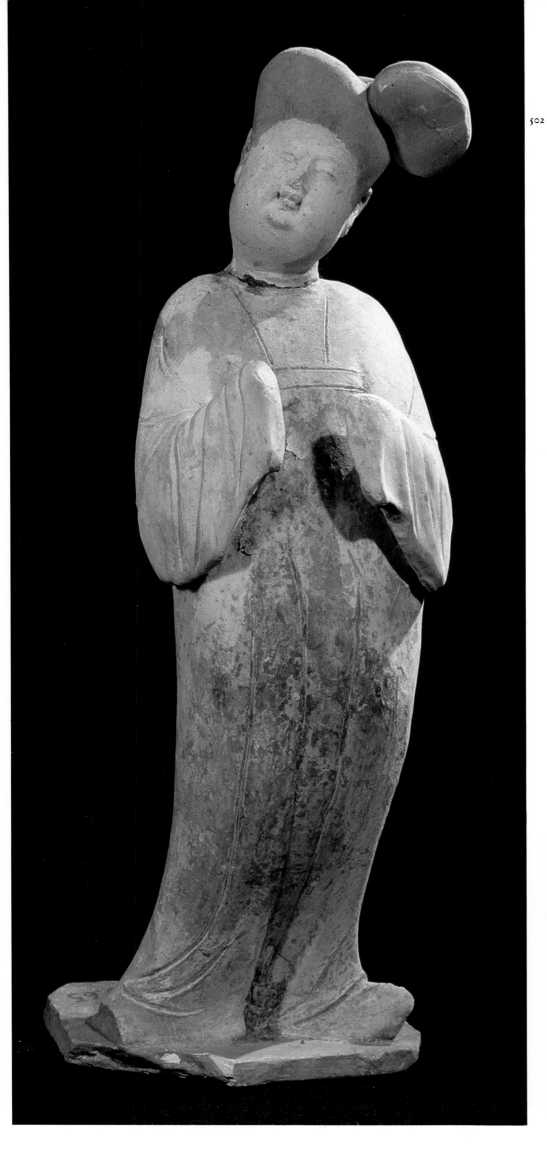

502

**502. Painted pottery figurine of a
woman**

503. *Woman Playing Chinese Chess*
This painting depicts a woman
playing a game resembling chess.
Judging from her dress she must
have been the wife of an official of
the sixth rank. This type of painting
throws important light on the
pastimes of upper-class Tang
women.

503

504

504. Lake Qujiang
Dug in the reign of the Han-
dynasty emperor Wu, this was
called Qujiang (zigzag) River
because of its shape. In the Sui
dynasty it was renamed Hibiscus
Garden. It was a place where the
imperial family went on spring
outings. In the Tang dynasty, after
signing their names at the Greater
Wild Goose Pagoda, successful
candidates in the highest of the
imperial examinations would feast
and go boating on the lake, so that
'Feasting at Lake Qujiang' became
one of the eight sights of the land
within the passes.

505. Signatures of successful
examinees at the Greater Wild
Goose Pagoda
In the Tang dynasty only 1 to 3 per
cent of the candidates for the
highest imperial examinations
passed. They then signed their
names at the Greater Wild Goose
Pagoda. At twenty-nine the famous
poet Bai Juyi was successful, the
youngest of the seventeen successful
candidates, as is recorded in one of
his poems.

505

506

508

506, 507. *Wangchuan Landscape*
(*previous pages*)
Wangchuan, a beautiful canyon in the northern foothills of the Qinling Mountains in Lantian County, is known for the villa belonging to the Tang-dynasty poet and painter, Wang Wei. Men of letters in ancient China liked to have country villas in order to enjoy nature. The original painting *Wangchuan Landscape*, which is attributed to Wang Wei, no longer exists, but this reproduction by the Ming-dynasty painter, Guo Shuliu, is highly regarded and is now in Qingyuan Temple in Wangchuan.

508. Gingko tree allegedly planted by Wang Wei
A devout Buddhist in his old age, Wang Wei renamed his villa Luyan Temple. This gingko tree in its grounds is so big that five people with outstretched arms can barely join hands around its trunk.

509. Du Fu Temple
Du Fu, the great Tang poet, called himself 'Country Elder of Shaoling', 'Old Man of Duling' and 'Country Guest of Duling' because he once lived in this region. This temple, built on the site of his villa, has been repaired many times and is now called Du Fu Memorial Hall.

510. Baqiao Bridge
This bridge was a vital passage across the Ba River east of Changan. In the Han and Tang dynasties people would break off branches from the willow trees which used to line the banks of the river at this point, to give to departing friends and relatives. In the late spring the willow catkins would drift about like snow, hence 'Snowflakes at Ba Bridge', one of the eight sights of this area.

509

511. Shrine to Sima Qian
This temple, located on a precipitous cliff in Hancheng County overlooking the Yellow River in the east and with Liang Mountain to the west, was built to honour the memory of the great Han writer and historian Sima Qian, whose book *Shiji* (*Records of the Historian*), which gives a history of China from early times to the Han dynasty, provided the model for historians and writers thereafter. The stone-paved path leading to the temple is called Sima Slope. The temple itself is built of brick and stone against the rugged terrain and has four terraces, one above another, connected by stone steps.

512. Zhuge Liang Temple
This temple, built at the northern end of Wuzhang Plateau in Qi Mountain, was to honour the memory of Zhuge Liang, Marquis of Wu, a great statesman and military strategist of the Three Kingdoms period following the Han. There are many temples to Zhuge Liang throughout China, this being the oldest.

511

512

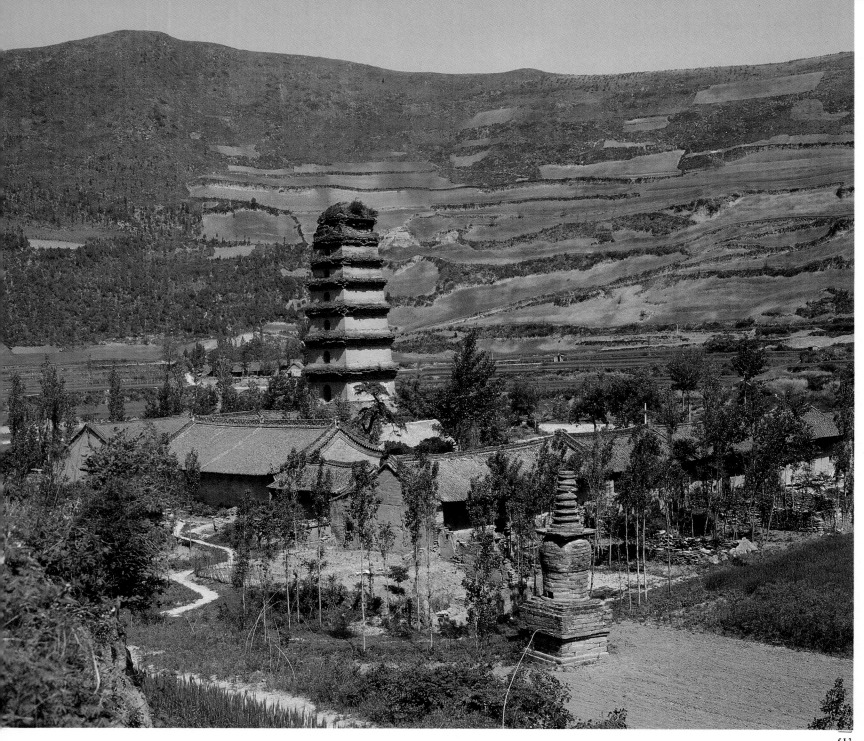

514

296

513. Xianyou Temple
This temple in Zhouzhi County was originally a travelling lodge of the Sui-dynasty emperor Wen. The Tang poet Bai Juyi is said to have completed his famous narrative poem 'Eternal Grief' here.

514. Peach Blossom Village
This village, located near Duqu, south of Xian, was said to be the ideal place to view peach blossoms. A legend says that the Tang poet Cui Hu met a beautiful girl here on an outing on Pure Brightness Day and fell in love, going there the next year on the same day to try to find her, in vain.

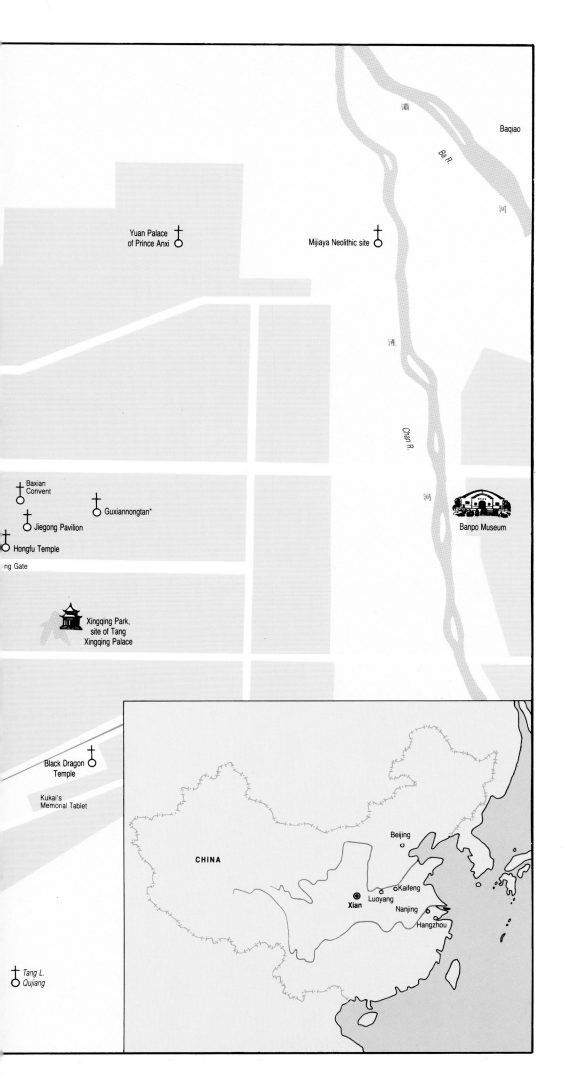

Baqiao

灞

Ba R.

河

Yuan Palace
of Prince Anxi

Mijiaya Neolithic site

滻

Chan R.

河

Banpo Museum

Baxian
Convent

Guxiannongtan*

Jiegong Pavilion

Hongfu Temple

ng Gate

Xingqing Park,
site of Tang
Xingqing Palace

Black Dragon
Temple

Kukai's
Memorial Tablet

CHINA

Beijing

Kaifeng

Xian

Luoyang

Nanjing

Hangzhou

Tang L.
Qujiang

515. Plan of places of scenic and
historic interest in present-day Xian

Index

303